THE LIFE AND WORK OF
EDWARD LAMSON HENRY N. A.

1841–1919

Library of American Art

THE LIFE AND WORK OF EDWARD LAMSON HENRY N. A.

1841–1919

By Elizabeth McCausland

Kennedy Graphics, Inc. • Da Capo Press
New York • 1970

This edition of
The Life and Work of Edward Lamson Henry N.A., 1841–1919,
is an unabridged republication of the first edition
published in Albany, New York, in 1945 as *New York State
Museum Bulletin Number 339.*

Library of Congress Catalog Card Number 74-100614

SBN 306-71866-9

Published by Kennedy Graphics, Inc.
A Division of Kennedy Galleries, Inc.
20 East 56th Street, New York, N.Y. 10022

and

Da Capo Press
A Division of Plenum Publishing Corporation
227 West 17th Street, New York, N.Y. 10011

THE LIFE AND WORK OF
EDWARD LAMSON HENRY N. A.

1841–1919

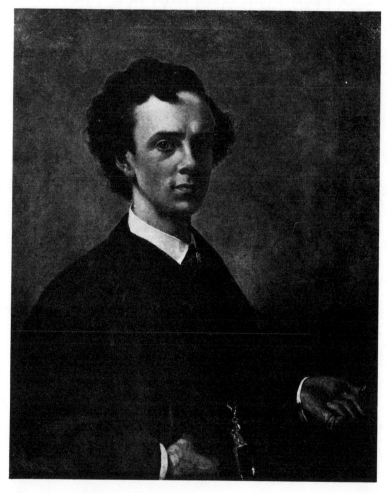

Figure 1 Portrait of E. L. Henry, N.A., by J. G. Brown, N.A., 1868:
CAT. 1218. Presented to the Academy when Henry became an associate.
Collection, National Academy of Design.

The Life and Work

of

EDWARD LAMSON HENRY N.A.

1841–1919

by

Elizabeth McCausland M.A.

New York State Museum
CHARLES C. ADAMS, *Director*

NEW YORK STATE MUSEUM

BULLETIN NUMBER 339

Published by The University of the State of New York

Albany, N. Y. September 1945

Contents

	PAGE
Illustrations	5
Introductory note*by Charles C. Adams*	11
Introduction and acknowledgments	15
Chronology	23
Biographical sketch	25
Education and early life	25
Marriage and maturity	32
The Henrys and Cragsmoor	37
Henry as a person	47
Career as an artist	56
Appreciations of Henry	64
List of Henry's addresses	68
The work of E. L. Henry	81
Introduction	81
Henry's subject matter	83
Henry's method of work	95
The post-Civil War period	101
Esthetic considerations	106
Henry's importance for today	116
A catalog of the work of E. L. Henry, 1858-1919	147
Appendix to the catalog	291
A memorial sketch of E. L. Henry, N.A., his life and his life work, by	
Frances L. Henry	311
Dedication	311
Childhood	311
Student years	314
Young artist in New York	318
Travels in the South	321
Life in New York	323
Travels abroad	325
The Passion Play	327
Life in Cragsmoor	328
Important paintings	330
The artist	340
The man	341
Appreciation	343
Conclusion	345
Bibliography	363
Index	368

List of Illustrations

All illustrations are from the Henry Collection, New York State Museum, unless otherwise credited. The quotations are verbatim transcripts of Henry's own inscriptions on photographs and other items.

PAGE

Figure 1 Portrait of E. L. Henry, N.A., by J. G. Brown, N.A., 1868 .. *(Frontispiece)*

Figure 2 "E. L. Henry. When a young student of art. Taken 1859 in Phila." .. 69

Figure 3 Sketch of E. L. Henry by J. G. Brown, 1868.................... 69

Figure 4 Henry's birthplace: "Old House in Society Street, Charleston, S. C." ... 69

Figure 5 E. L. Henry. "Paris taken 1862." 70

Figure 6 E. L. Henry. "Taken in Phila. 1865.".......................... 70

Figure 7 "Taken in Whittredge's Studio . . . 1866".................... 70

Figure 8 Frances L. Wells .. 71

Figure 9 Frances Livingston Wells [1867-72?] 71

Figure 10 Frances L. Wells, 1873-74 71

Figure 11 Mrs Henry, *circa* 1880 71

Figure 12 "Lake George, Sept. 10th, 1874" 72

Figure 13 "Back of Blakeley's on the Mtn.".............................. 72

Figure 14 "Sam's Point . . . Shawangunk Mountains" 73

Figure 15 Sam's Point ledge, November 1907 73

Figure 16 "Thomas Botsford . . . at the old wall, 1891".............. 73

Figure 17 "Maratanza Clouds . . . 1904"................................ 74

Figure 18 "Pickers' Camp, July 1905" 74

Figure 19 "Full of dear memories where we lived for many years. 218 E. 10th, last of April 1904"........................... 75

Figure 20 The Henrys' studio, 3 North Washington square, *circa* 1888. 75

Figure 21 Henry's studio at Cragsmoor............................... 75

Figure 22 The Henry home at Cragsmoor in Henry's time 76

Figure 23 The Henry home, 1941.................................... 76

Figure 24 Henry at work . . . *circa* 1917.............................. 77

Figure 25 Henry's studio as it looked in 1941........................ 77

Figure 26 The Henry barn ... 78

Figure 27 Another view of the Henry house in his day 78

Figure 28 Henry's garden ... 78

Figure 29 E. L. Henry, 1888... 79

Figure 30 F. L. Henry, 1888 .. 79

Figure 31 Mr and Mrs Henry at their cottage, 1910.................. 79

Figure 32 Portrait of E. L. Henry N.A., by Charles C. Curran N.A., 1909 .. 80

Figure 33 E. L. Henry [1867?]... 125

Figure 34 *From A Window, Newport*, 1866............................. 125

Figure 35 "Taken at Mr Jessup's House, Marine ave., Newport, R. I., August 1866." ... 125

Figure 36 "Mrs A. D. Jessup's Rig . . . Newport, 1866"............. 126

[5]

Figure 37 *Porch Scene, Newport, R. I., 1866* 126

Figure 38 *Four-in-Hand, Central Park, 1867* 126

Figure 39 *The Library of Jonathan Thorne, 526 Fifth avenue, New York, 1868* .. 127

Figure 40 *A Parlor on Brooklyn Heights, 1872* 127

Figure 41 *Portrait of Mrs Henry, London, 1876* 128

Figure 42 *In the National Academy of Design . . . 1882* 128

Figure 43 *The John Hancock House, 1865* 129

Figure 44 "The Hancock House . . . about 1865" 129

Figure 45 *Beach Wagon* ... 130

Figure 46 *On the Beach* ... 130

Figure 47 *On the Beach: Waiting for the Bathers, 1879* 130

Figure 48 *East Hampton Beach, 1881 . . . an earlier version of figure 49* .. 131

Figure 49 *East Hampton Beach, 1881* 131

Figure 50 *Bathing Hour, East Hampton Beach, 1889* 131

Figure 51 *After David, circa 1875* 132

Figure 52 *Taking Life Easy, 1911* 132

Figure 53 A photograph used as a detail for figure 52 132

Figure 54 *The Mountain Stage, 1881* 133

Figure 55 "Stage built 1845 Concord, N.- H. Ran from Newburg to Ellenville. Photographed in Otis yard 1881." 133

Figure 56 *Capital and Labor, 1881* 134

Figure 57 *In the Roaring Forties, 1884* 134

Figure 58 *The Old Lydig House on the Bronx, Near Fordham, 1887* 134

Figure 59 A pencil drawing . . . used as a detail for figure 56 135

Figure 60 A pencil drawing . . . used as a note for figure 57 135

Figure 61 A sketch . . . to document figure 58 135

Figure 62 *Village Post Office, 1891* 136

Figure 63 The old Jesse Low store . . . in 1941 136

Figure 64 "Winter Scene, Jan. 6, 1880." . . . A drawing by . . . Legrand W. Botsford .. 137

Figure 65 Cragsmoor landscape ... 137

Figure 66 *Country Scene, circa 1890* 137

Figure 67 *Sunday Morning (Old Church at Bruynswick)*, 1898 138

Figure 68 The church at Bruynswick, N. Y., in 1941 138

Figure 69 [*Bruynswick Church*] .. 139

Figure 70 The Dutch Reformed Church, Napanoch, N. Y., in 1941 139

Figure 71 [*Maud Powell Plays the Violin*], 1904 140

Figure 72 Maud Powell in Henry's studio at Cragsmoor 140

Figure 73 "R. R. Coach. From Boston and Providence Railroad." 141

Figure 74 "Mr Armstrong . . . in one of my old fashioned coats and vest. July 1900." .. 141

Figure 75 Carriages collected by Henry 142

Figure 76 Mrs Lawrence Stetson and Mr Martin E. Albert in Governor Gansevoort's coach . . . 1900 142

Figure 77 "Old Brown House (as it was in the old days)." Photographed by Henry in 1880 and copied by Botsford in 1904. 143

Figure 78 The Peter P. Brown house, 1941 143

Figure 79 *Bear Hill*, 1908.. 144
Figure 80 Bear Hill as it looked in 1941 ... 144
Figure 81 *A Mountain Post Office*, 1900.. 145
Figure 82 Transparency of a corn shock, possibly a detail for figure
 205 ... 145
Figure 83 *In the Valley* ... 146
Figure 84 Dutch Reformed Church, Ellenville, 1941 146
Figure 85 *Great Bend, Susquehanna*, 1858 255
Figure 86 *Mauch Chunk, Pa.*, 1859 .. 255
Figure 87 *On the Susquehanna*, 1860.. 255
Figure 88 *[Barnyard: 1]*, *[1859]*... 256
Figure 89 *[Barnyard: 2]*, *[1859]*... 256
Figure 90 *[Barn Interior]*, *[1859]*.. 256
Figure 91 *[Barnyard]*, *[1860]* ... 257
Figure 92 *Barnyard Scene*, 1860 ... 257
Figure 93 *Farm Scene in Pennsylvania*, 1860.................................... 257
Figure 94 *Una Via in Napoli*, 1861.. 258
Figure 95 *Street Scene in Naples*, 1864... 258
Figure 96 *The Market Place, Washington*, October 1864.................... 259
Figure 97 *The Great Horse Depot at Giesboro on the Potomac below
 Washington*, 1864.. 259
Figure 98 *Near Harrison's Landing, Lower James River*, November
 1864 ... 259
Figure 99 *Presentation of Çolors*, [1869 ?]....................................... 260
Figure 100 *A Presentation of Colors to the First Colored Regiment of
 New York by the Ladies of the City in front of the old
 Union League Club*, 1869.. 260
Figure 101 *A New York Regiment Leaving for the Front*, 1864–67........ 260
Figure 102 *Westover, James River*, 1864... 261
Figure 103 *Westover*, 1865 ... 261
Figure 104 *The Warning*, [1864–67 ?].. 261
Figure 105 *City Point*, October 1864.. 262
Figure 106 *City Point, Va.*, 1864.. 262
Figure 107 *City Point, Va.*, 1865–72.. 262
Figure 108 *Station on "Morris & Essex Railroad,"* 1864...................... 263
Figure 109 *The 9.45 a. m. Accommodation, Stratford, Connecticut*,
 1867 ... 263
Figure 110 *Old Dutch Church, New York*, 1869.................................. 264
Figure 111 *St George's Chapel, Beekman and Cliff Street, New York*,
 1875 ... 264
Figure 112 *St John's Church, Varick Street, New York, 1866, 1868*.... 264
Figure 113 *St Paul's Church, 1766, 1868* ... 264
Figure 114 *A Chat After Meeting*, 1868... 265
Figure 115 *Alt Kirche, Oberammergau*, 1872....................................... 265
Figure 116 *The Doctor*, 1873 ... 265
Figure 117 *The Widower*, [1873 ?]... 266
Figure 118 *A Quiet Corner by the Door*, 1873.................................... 266
Figure 119 *The Old Paternal Home*, 1874... 266
Figure 120 *Les Fosses Communes*, 1876... 267
Figure 121 *Les Fosses Communes, Cimitiere de St Owen, Paris*, 1876...... 267

Figure 122 Off for the Races, 1876.. 267
Figure 123 [Feeding the Geese], [1876].. 268
Figure 124 [Taking a Rest], [1888] .. 268
Figure 125 Departure of the Brighton Coach, 1878.......................... 268
Figure 126 The Old Hook Mill, East Hampton, 1881........................ 269
Figure 127 The Country Store, 1885.. 269
Figure 128 Joseph E. Mance, [1887 ?].. 270
Figure 129 Peter Brown, 1886 .. 270
Figure 130 Martin Terwilliger, [1886 ?]... 270
Figure 131 Fred Thomas alias Black Fred, 1887................................... 270
Figure 132 Nelly Bloomer, 1890.. 271
Figure 133 John S. Billings, 1883.. 271
Figure 134 A snapshot of Joseph E. Mance ... 271
Figure 135 Mrs Nancy Evans, 1896.. 271
Figure 136 Sharpening the Saw, [1887 ?] .. 272
Figure 137 A Mountain Road, 1881.. 272
Figure 138 Bracing Up, 1883.. 272
Figure 139 A Hard Road to Travel, 1882... 272
Figure 140 Reading the Story of Bluebeard, [1880]..................... 273
Figure 141 Kept In, 1888 ... 273
Figure 142 Meditating Revenge, 1892... 273
Figure 143 Uninvited Guests, 1883... 274
Figure 144 The Old Forge, [1887 ?].. 274
Figure 145 The Country Carpenter, 1890... 274
Figure 146 The Summer Boarders, 1881.. 275
Figure 147 "School's Out," Below Cragsmoor, N. Y., 1887................. 275
Figure 148 A Country Doctor, 1886.. 276
Figure 149 A Country School, 1890.. 276
Figure 150 A Country Lawyer, 1895 .. 276
Figure 151 The Watering Trough, 1884... 277
Figure 152 Thanksgiving Sleigh Ride, 1886.. 277
Figure 153 One Hundred Years Ago, 1887 .. 278
Figure 154 A Temperance Preacher, 1888... 278
Figure 155 A Virginia Wedding, 1890.. 278
Figure 156 Negro Stableboy . . . a detail for figure 157.................... 279
Figure 157 The Relay, 1881 .. 279
Figure 158 The Arrival of the Stage, 1904.. 279
Figure 159 Indian Queen Inn, Bladensburg, Md., in 1795, 1899............ 280
Figure 160 Changing Horses, 1905... 280
Figure 161 Leaving in the Early Morn in a Nor 'Easter, 1918................ 280
Figure 162 The First Railway Train on the Mohawk and Hudson Road,
 1892–93 .. 281
Figure 163 Waiting for the New York Boat, Stonington, Conn., 1905.. 281
Figure 164 "Built in England by Stevenson".. 281
Figure 165 Waiting at the Ferry, 1899... 282
Figure 166 Waiting at the Ferry, 1899 . . . a detail for figure 165.... 282
Figure 167 Crossing the Ferry, 1893... 282
Figure 168 Fulton's First Steam Ferryboat, [1901]............................ 283
Figure 169 Waiting at the Ferry, [1899] . . . a detail for figure 165.... 283

Figure 170 *The Tow Path, 1891* .. 284
Figure 171 *Late Afternoon on the old Delaware and Hudson Canal at Port Ben, N. Y., 1894* 284
Figure 172 *Scene Along the Delaware and Hudson Canal, 1907* 284
Figure 173 *On the Tow Path, 1* .. 285
Figure 174 *On the Tow Path, 3* .. 285
Figure 175 *On the Tow Path, 2* .. 285
Figure 176 *On the Tow Path, 4* .. 285
Figure 177 *A Disturber of the Peace, 1905* 286
Figure 178 *Contrasts, 1914* ... 286
Figure 179 *The New Woman, [1892 ?]* 287
Figure 180 *Early Autumn, 1906* .. 287
Figure 181 *The Gossips, 1908* ... 287
Figure 182 *The County Fair, 1891* 288
Figure 183 *[News Office], [1894 ?]* 288
Figure 184 *Food for Scandal, 1907* 288
Figure 185 *Passing the Outposts, 1903* 289
Figure 186 *Burgoyne's Army on the March to Saratoga, September 1777, [1902 ?]* 289
Figure 187 *Good-bye, Sweetheart, 1900* 289
Figure 188 Statue of General Gansevoort, 1906 . . . Designed by Henry 290
Figure 189 *The Pedler, 1879* .. 295
Figure 190 *A One-Sided Bargain, 1902* 295
Figure 191 *The Village Huckster, 1913* 295
Figure 192 *Testing His Age, [1892 ?]* 296
Figure 193 *The Huckster, 1914* .. 296
Figure 194 *The Flower Seller, 1906* 296
Figure 195 *Testing His Age, [1892 ?]* . . . a detail for figure 192 ... 297
Figure 196 *Horse and Pedler's Wagon* . . . a detail for figure 193 ... 297
Figure 197 The Husson-Buxton cottage at Cragsmoor 297
Figure 198 *Forgotten, 1894* . . . a detail for figure 199 298
Figure 199 *Out in the Storm, 1899* 298
Figure 200 *A Village Street, 1916* 298
Figure 201 The Cragsmoor Post Office, 1941. Seen in Figure 202 299
Figure 202 *An October Day, 1903* 299
Figure 203 *The Bill Collector, 1913* 299
Figure 204 *The Four Seasons—Spring, 1914* 300
Figure 205 *The Four Seasons—Autumn, 1914* 300
Figure 206 *The Four Seasons—Summer, 1914* 301
Figure 207 *The Four Seasons—Winter, 1914* 301
Figure 208 *A Private View, 1906* 302
Figure 209 *In East Tennessee, 1906* 302
Figure 210 *The Uplands at Bow, 1914* 302
Figure 211 *Main Street in Johnstown, N. Y., in 1862, 1916* 303
Figure 212 *Main Street, Johnstown, 1917* 303
Figure 213 *The Floating Bridge, 1917* 303
Figure 214 *The Old Clock on the Stairs, 1917* 304
Figure 215 *St Mark's in the Bowery, 1917* 304
Figure 216 *Waiting for the Stage, 1918* 305

Figure 217 *Waiting for the Stage, 1872. . . . A note for figure 216*.... 305
Figure 218 *Florida Landscape, 1919* .. 305
Figure 219 *Talking Politics, 1900* .. 306
Figure 220 *Return from the Wars*.. 306
Figure 221 *Colonial Doorway . . . details for Nos. 110 and 116*........ 307
Figure 222 *Doorway. . . . A detail for No. 109*.............................. 307
Figure 223 *Negro Girl. . . . Compare with figure 124*...................... 308
Figure 224 *The Lafayette Coach. . . . Compare with figure 75*.......... 308
Figure 225 *Woman with a Basket*.. 309
Figure 226 *Negro Boy and Girl on Oxcart*.. 309
Figure 227 *Frances Livingston Wells (Henry), 1875* 310
Figure 228 Henry's first press notice in 1859................................ 347
Figure 229 *Off to Europe, 1860* .. 347
Figure 230 From a ticket for diligence fare from Florence to Genoa,
April 21, 1861 .. 348
Figure 231 *Traveling Coach, Italy, 1862* 348
Figure 232 *An Italian Vettura, 1863* .. 348
Figure 233 *In Bella Firenze, 1861* .. 349
Figure 234 *Colico, Lake of Como, 1861* 349
Figure 235 *Cannstadt in Wurtemberg, 1861* 349
Figure 236 *In Stuttgart, 1861* .. 350
Figure 237 *Berlin Omnibus, 1861* .. 350
Figure 238 *Prussian Canal Boat, 1861* .. 351
Figure 239 *In Amsterdam, 1862* .. 351
Figure 240 *Rotterdam, 1862* .. 352
Figure 241 *Icebergs off Banks of Newfoundland, 1862* 352
Figure 242 *The Clermont, 1904* .. 353
Figure 243 *Near the Brandywine* .. 353
Figure 244 *Stonington* .. 353
Figure 245 *On the Old Gully Road, 1889–91* 354
Figure 246 *Study for "Alt Kirche"* .. 354
Figure 247 *St John's Park and Chapel, New York, 1905*.................. 355
Figure 248 *St John's Chapel, [1905 ?]*.. 355
Figure 249 *In the Old Stagecoach Days, 1907* 356
Figure 250 *News of the War of 1812, 1913*.................................. 356
Figure 251 *[Getting Out the Vote], 1913* 357
Figure 252 *Election Day [1914]* .. 357
Figure 253 *Forgotten, 1888* .. 358
Figure 254 *Off the Main Road* .. 358
Figure 255 *Entering the Lock, 1899* .. 359
Figure 256 *The MacNett Tavern, 1904* .. 359
Figure 257 *"The MacNett Tavern, Germantown Road . . . 1868"*.... 359
Figure 258 *Tenth Street Studio Building, 1877* 360
Figure 259 *Marketing Saturday Morning* 360
Figure 260 *Happy Go Lucky, circa 1890*.. 361
Figure 261 *What Luck, 1910* .. 361
Figure 262 Mrs E. L. Henry, 1914 .. 362

Introductory Note

In 1836 the State of New York inaugurated a policy of cultivating a knowledge of the natural and human resources of the State. This agency was named the Geological and Natural History Survey, and later in 1853 under the Board of Regents, the State began to form an Historical and Antiquarian Collection. These organizations were fused in 1870 to form the New York State Museum, and in 1892, 50 years ago, the duties were expanded with specific instructions that: "All scientific specimens and collections, *works of art, objects of historic interest* and similar property appropriate to a general museum, if owned by the State and not placed in other custody by a specific law, shall constitute the State Museum" (italics mine).

During the State Capitol fire in 1911, a large amount of the ethnological and historical material collected by the State Cabinet was destroyed. The State Museum was at the time of the fire in the old Geological Hall on State street and thus escaped damage. It was not moved to the Education Building until 1912.

There has since been an increasing emphasis given to the accumulation of materials illustrating the history and arts of the State, including the culture of the New York Indians, and progressively more and more attention has been given to the industries as well as to the cultural development of the State. When the threatened loss of the cultural objective materials of the Shakers became imminent, the State Museum devoted considerable attention to salvaging as much as possible of their cultural and industrial history. The results of this effort have been elaborated elsewhere (Adams '40, 103d Annual Report. State Mus. Bul. 323, p. 77–141; and Andrews, State Mus. Hdbk. 15, 1933). In recent years there has been a rather widespread awakening of interest in the esthetic value of Shaker industries and their cultural significance.

In the spring of 1940, two devoted friends of the State Museum, Wilfred Thomas and Frank M. Thomas, found an important collection of art material which had been accumulated by the artist Edward Lamson Henry (1841–1919) National Academician, of New York City and Ellenville, which was in the possession of his wife's relatives, Mr and Mrs Lawrence Stetson, Mr and Mrs E. C. Wells and Margaret L. Wells of Johnstown. Through the cooperation of this group the Henry materials,

including sketchbooks, letters, sketches, photographs, paintings and other materials were presented, at the suggestion of Wilfred Thomas, to the State Museum for the History and Art Collection and to form the *Stetson-Wells, E. L. Henry Collection*, and as a memorial to the artist. This series included a manuscript on the life and work of the artist by his wife, Frances Livingston Wells Henry, which was presented by Mrs Lawrence Stetson. The Messrs Thomas and Thomas also made several valuable donations to this Henry Collection, as have also a few other friends of the memorial. The State Library contains a number of volumes from the Henry library.

Here was considerable material for a study of Henry and a sketch of his life that seemed worthy of study and publication. He was a leading artist of the rural scene during the "Horse and Buggy" period in New York State between 1880 and 1919. He lived in New York City and spent his summers south of the Catskills, at Cragsmoor, near Ellenville.

To make an original study of these extensive materials, and to make a careful evaluation of his work I could learn of no better qualified person for the study than Elizabeth McCausland, art critic and author of New York City, whose judgment and appreciation of the work of American artists qualified her for organizing the mass of material and for making an estimate of these and the allied materials which she and others obtained from friends and acquaintances of the Henrys.

I wish also to take this occasion in order to emphasize what I have previously advocated for a number of years, that the State Museum should be made, as has been provided by law for 50 years, the State's central agency for developing a representative collection of the fine arts, which will clearly portray the contributions which New York State artists, both living and dead, have made to the graphic arts, painting and sculpture. We have long persisted in a period of excessive concentration of such cultural materials in the metropolitan centers, and now we need to inaugurate a certain amount of diffusion or decentralization so that a larger public will have the benefit of these collections. Certainly the State of New York should lead in this matter, and the state capital, at Albany, is the logical place for the State to develop such a collection, as a part of the state educational system. Too often education is considered exclusively a juvenile subject instead of being a lifelong activity. The thousands of tourists and school children who visit each year the exhibition halls of the State

Museum have no other opportunity to learn what has been accomplished through the fine arts in this State.

To provide adequately for such a collection and exhibition would be one more reason for a new building for the State Museum, which 20 years ago outgrew its present quarters in the Education Building (*Cf.* State Mus. Bul. 293, p. 81–110).

It has been suggested that this expansion of art materials be delayed until the new building is provided, but there is much practical experience which indicates that the valuable collections must be secured *first,* and then the importance of their exhibition, care and storage will be appreciated and be provided for. Furthermore, such a building should be built along the newer lines with adequate storage as well as exhibition space. Appropriate donations are therefore welcomed which will portray the past and contemporary history of the fine arts in this State.

Finally, the State Museum should have on its staff artists who are capable of doing original work, just as it has botanists and geologists conducting original ("creative" is the current art term) studies of the plants and rocks of the State. There is just as much reason for the cultural development of art as for science, but we have been slow to recognize this and have not adapted our social and economic system to this end.

This is also the proper place to emphasize the need of the artists, their families, relatives and friends, realizing that the artists' sketches, studies and models should not be allowed to become scattered and lost because of the relative neglect of emphasis on this phase of art, education and history. These materials should be kept intact and preserved in such public institutions as will protect and use them to advantage. As far as I have been able to learn this has not been a general, definite policy of many leading public museums. Something more than a passive attitude is needed toward such material. There should be a constructive policy. The Henry Collection and study is an important step toward the realization of this general policy and program of the New York State Museum.

CHARLES C. ADAMS
Director, New York State Museum

January 11, 1943

Introduction and Acknowledgments

INTRODUCTION. The Henry study was undertaken because a gift to the New York State Museum of extensive materials on E. L. Henry's life and work provided opportunity to develop a function conferred on the State Museum by legislative act half a century ago but not adequately put into practice. The State Museum has long appreciated the need of integrating the arts into its active program. Without question, the arts no less than the sciences have built the State. Therefore, to preserve and to make of public use the State's complete culture, history and art must be explored, as well as the natural history sciences.

The Henry gift made a particularly appropriate occasion for assuming the new function. E. L. Henry was intimately associated with the life of New York State. For almost 40 years he lived and worked at Cragsmoor in the Shawangunk mountains, south of the Catskills. He incorporated a wealth of local subject matter in his paintings. The people of the "Mountain" (Cragsmoor had no legal place name for many years) and much of the terrain around Ellenville, Napanoch, Stone Ridge, Pine Bush and Bruynswick could be recreated by reference to Henry's work, if no other clue to their existence survived. In an especial sense, Henry was the historian of a sector of New York State. Not to utilize the Henry Collection's source materials would have been a social waste.

In the Henry study, the problem was *what* to study. In a very limited period of time and with limited facilities, how much could be accomplished, and what was of prime importance? The Henry Collection comprises a large amount of physical material, ranging from photographs of Henry's paintings to souvenirs of his personality, such as flute, flask, prayer book, fans and the Livingston family coat-of-arms. What use should be made of this material? And how should the resultant findings be presented? Questions like these had to be decided in an experimental spirit, as the problem posed by the Henry study is exceptional.

Rarely does the "immortal residue" of a man, whether a genius or an obscure individual, survive in such sheer, quantitative bulk. In the New York State Museum's Henry Collection there are a score of large files (4x14x18) packed solid with photographs of Henry's work and of related subjects. There are a half dozen

larger boxes and an equal number of letter files, full of more photographs, clippings, documents, correspondence. There are 28 sketchbooks and two diaries; a manuscript biography left uncompleted by Mrs Henry at her death; quantities of large photographs and prints; relics of Henry's library; an album (16x14) containing about 150 photographs of paintings, of which 66 are not found elsewhere; over 200 sketches in oil, pencil or pen-and-ink, on canvas, wood, cardboard or paper; and a number of works by Henry or by persons associated with him, such as the portrait of him by Charles C. Curran N.A., and the landscapes by Worthington Whittredge and Arthur Parton, probably gifts to Henry. In organizing these study materials, I have sorted out into tentative chronological sequence photographs of more than 300 paintings. In addition, the 225 sketches are for the most part preliminary drawings or details. Correspondence, dating from 1860 to 1931, provides collateral data.

Here is a concentration of materials unusual even in the case of artists whose reputations had not waned before death. With multitudinous documents at hand, it was desirable to examine them to learn what we could of Henry's life and work. In six months, the Henry Collection's materials have been studied fairly intensively. At the same time a search has been made of museum collections and of some exhibition catalogs and literature of Henry's period. In addition, numerous contacts have been followed up for further data. Finally, three weeks were spent in the field at Cragsmoor, Ellenville and surrounding countryside to record as much information as possible from surviving friends and acquaintances of the artist.

My field trip was made at the suggestion of Dr Charles C. Adams, who emphasized the importance of recording informal recollections of those who knew Henry and of seeking other local influences and facts. Henry has been dead 23 years. If he were alive, he would be over a hundred years old. Even so, there are living in Cragsmoor and Ellenville many people who knew him well and whose memories are valuable. My Field Journal in three manuscript volumes (McCausland '41) is a further source of information about Henry. The comparison photographs I made on this field trip, some of which are reproduced in the report, have the value of providing a measuring stick by which we can gage how exactly documentary was Henry's work. In fact, the field trip was an indispensable tool for the study, because it gave me firsthand knowledge of the region where Henry

worked and so has enabled me to make better informed judgments about his paintings. Exploration of the terrain where an artist worked is plainly essential for a thorough understanding of both his subject matter and his spirit; and the technic of field work, imported from the sciences, should be applied to the arts more.

The Henry study presented, as said before, somewhat unusual problems. The State Museum possesses abundant source materials: data are at hand. But connections had to be established. Even if not one fact had been learned outside the Henry Collection, we should still have been able to construct a remarkably detailed and faithful report of this artist's life and work. An evidence of the wealth of material available is the fact that the great majority of illustrations in this report are from our own files. The visual image of Henry's art is well preserved.

The short time allotted the Henry study, compelling a choice between objectives, resulted in one phase of research necessarily being elided, namely, the investigations needed to establish the present location of paintings. The catalog lists 345 items whose present location is known. Of these 118 are oils, water colors and important drawings in the possession of museums, private collectors and dealers. The remainder, 227 in all, are in the Henry Collection of the New York State Museum and comprise chiefly sketches and drawings, although the State Museum owns four canvases by Henry. It is hoped that the exhaustive listing and illustration of unlocated or "lost" works will bring forward information to fill in the lacunae indicated in this preliminary cataloging of Henry's work.

Data were included in the Henry catalog on the principle of exhausting all known facts, which makes not for compactness but for completeness. Under the circumstances, it seemed wise to provide the report's readers with clues which may help unravel remaining snarls. A simple chronological order was chosen since time did not permit elaborate classification and cross references. If a definitive study of Henry should be desired, revision can be made at that time.

Important though the preservation of source materials and the recording of the State's culture are, the Henry study has a value beyond its immediate usefulness. It is intended to encourage the general public to deposit in public institutions those materials which constitute the living archives of our country's achievement. The letters, photographs, diaries, newspaper clippings and other documents of the Henry Collection are a potential source of great

information about Henry, and also about many other matters. About the life of every person of public interest, no matter how minor a figure, there accumulates this increment or matrix, which becomes of value from the historical or documentary point of view. This is an intangible value, rarely capable of being converted into cash. For this reason, these documents are too often destroyed, and their potential of knowledge lost. Obviously, the care and preservation of such material is a public duty; private individuals can not be expected to assume the responsibilities of custodians of culture. More and more, public institutions need to develop this function throughout the country. For our American past has been a rich one, richer than we have imagined, and to reclaim our heritage is an important task.

Acknowledgments. The Henry study has been most happily and gratifyingly cooperative in character. In stressing this fact, I can not thank too warmly the Director of the New York State Museum, Dr Charles C. Adams. He originated the Henry project and brought to its direction the sound common sense of the scientific method, as well as a robust pioneering courage in undertaking a new enterprise. His creative social vision in understanding the need for broad cultural functions and in putting his understanding into effect has been a great stimulus and encouragement in making the study. My work with Doctor Adams has been an education in how state institutions and officials can develop public ends with imagination and intelligence.

I found widespread interest in and support for the study in many quarters, public and private. During my field trip at Cragsmoor and Ellenville, I met many of Henry's old friends, who assisted not only with information but also with gifts of Henry material such as sketches, photographs, prints and related items. As news of the study spread, more gifts came in from various sources. Frequently they provided needed missing links.

For individual gifts subsequent to the large gift from Mrs Henry's heirs, thanks are due: Julie M. Husson, Mary D. Buxton, Jessica Bruce, Annette Mason Ham, Mrs Anna M. Rhoades, Mrs Thomas Wade, Mrs Charles A. Brown, Charles C. Curran, Mr and Mrs Frederick G. Kraft, and Mr and Mrs Charles Peters, all of Cragsmoor; S. D. Mance, Ellenville; Marie Antoinette DuBois, Kingston; Mrs Grace Livingston Hill Lutz, Swarthmore, Pa.; Bernard H. Cone, New York; Wilfred Thomas and Frank M. Thomas, Albany; Mr and Mrs Lawrence Stetson and Margaret

Livingston Wells, Johnstown; Harry Gottlieb, Charles W. Folks, Mrs C. T. Hall and Sidney E. Dickinson, all of New York City.

The donation by Mrs Estelle Wright Bouton of Cragsmoor of almost 50 negatives made by Legrand W. Botsford, "the hermit of Cragsmoor," was invaluable in providing photographs of otherwise unknown Henry paintings and in giving a well-rounded picture of the countryside where Henry spent half his time for 37 years. Supplementary visual material was the loan from Mrs Anna M. Rhoades, Cragsmoor's summer librarian, of negatives of contemporary (1938–41) Cragsmoor landscape and personalities.

Many private individuals, museums and dealers assisted by supplying photographs for reproduction in this report. Thanks are due them as follows: Martin E. Albert, Mrs Francis P. Garvan jr, and Ernest duPont Meyrowitz, New York; Mrs Harcourt Wesson Bull, Springfield, Mass.; Dr and Mrs H. M. Sassaman, Easton, Pa.; the Metropolitan Museum of Art, the National Academy of Design and the New York Historical Society, New York; the Yale University Gallery of Fine Arts, New Haven; the Village of Ellenville; the First Church of Christ, Scientist, Boston; the estate of the late Frances P. Garvan, New York, and the Babcock Galleries, the Bland Gallery, Albert Duveen, James Graham and Sons, John Levy Galleries, M. Knoedler and Company, the Macbeth Galleries, I. Snyderman, and Guy Mayer Galleries, New York City.

Individuals and institutions were unfailingly cooperative in supplying data. Grateful acknowledgment is hereby made of the assistance of: Lloyd Goodrich, research curator, Whitney Museum of American Art, and director, American Art Research Council, who read the manuscript and made invaluable criticisms in a most friendly spirit; John I. H. Baur, curator of paintings and sculpture, Brooklyn Museum, who made valuable suggestions on procedure at the outset of the study, kindly lent the writer the then unpublished autobiography (Whittredge '42) of Worthington Whittredge, a contemporary and friend of Henry, and who further read the manuscript and made proposals, particularly on esthetic points, which were incorporated in the report; Herman Warner Williams jr, Metropolitan Museum of Art, now on leave for service with the armed forces; Bartlett Cowdrey, registrar, Brooklyn Museum; G. E. Kaltenbach, museum registrar and keeper of archives, Art Institute of Chicago; Mrs Cordelia Sargent Pond, director, George Walter Vincent Smith Art Gallery, Springfield,

Mass.; Leicester B. Holland, chief, division of fine arts, Library of Congress; John D. Hatch jr, director, Albany Institute of History and Art; C. Powell Minnigerode, director, Corcoran Gallery of Art, Washington, D. C.; Earl Rowland, director, Haggin Memorial Art Galleries, Stockton, Calif.; R. P. Tolman, acting director, Smithsonian Institution, Washington, D. C.; the late Charles C. Curran, corresponding secretary, National Academy of Design, New York City; Aline Kistler, then assistant director of exhibitions in charge of public relations, National Academy of Design, New York City, and Frick Art Reference Library, New York City.

The receipt of information is gratefully acknowledged from many private individuals, including: Harcourt Wesson Bull jr, and Mrs William B. Kirkham, Springfield, Mass.; Mrs Warren van Kleeck, Brooklyn; Dr Ewen van Kleeck, Hartford, Conn.; Kathrin Cawein, Pleasantville; Winifield Scott Clime, Old Lyme, Conn.; George J. Corbett and Katherine Greves, for the estate of the late Francis P. Garvan; Victor D. Spark; F. Newlin Price; Joseph Gotlieb of the Milch Galleries; Frank Lord, chairman of the Union League Club's art committee, and Theodore Bolton, librarian, Century Association. Publications which assisted by printing notices are the Art Digest, the Springfield (Mass.) Sunday Union and Republican, the Ellenville Press and the Kingston Freeman.

Finally, warmest thanks are due those who aided me at the outset by cooperating enthusiastically in the investigations of my field trip. A personal word of thanks is especially due Mrs Florence T. Taylor, librarian, Ellenville Public Library, who took a keen interest in the purposes of the study and who supplied invaluable leads to other informants. Of equal good will and cooperativeness was Mrs Anna M. Rhoades, librarian, Cragsmoor Free Library, already mentioned for a gift and the loan of negatives. The list of those who assisted with information is proof of the social nature of all such studies.

Thanks are due, besides those already given, to: Mary D. Buxton, Mrs Estelle Wright Bouton, Mrs Addison Brown, Mrs Charles A. Brown, Jessica Bruce, Mrs R. J. Compton, Charles C. Curran, Mrs R. L. Foster, Annette Mason Ham, Julie M. Husson, John Kindberg, Grace J. Kudlich, Mrs Walter P. Long, Mr and Mrs Charles H. Peters, Mrs C. Stevens Polk, Mrs R. H. Rulison, Winifred Sturdevant, Sidney Terwilliger, Helen M. Turner, Mrs Thomas Wade, of Cragsmoor; R. T. Cookingham, Casper S.

Cosenza, Raymond G. Cox, Bertha Demarest, C. G. A. Fischer, Mrs Richard Hayden, Mr and Mrs Arthur V. Hoornbeek, Mrs Henry Horton, Mrs Lilah Deyo Johnson, Stephen D. Mance, Alice I. Moffit, Mrs Bert Terwilliger, Mrs Nelson Terwilliger, of Ellenville; Bert Goldsmith, Mount Meenagha; Mrs J. G. M. Hilton, Saugerties; Mrs Lawrence Stetson, Margaret Livingston Wells and Mrs Charles B. Knox, of Johnstown; Mary Hartshorn Woodruff, Nyack, and M. J. DuBois, Kingston.

In thanking those who have cooperated in the Henry study, I wish to mention especially an unseen collaborator, the State Museum's staff photographer, N. E. Baldwin, who copied hundreds of objects for use in this report. The illustrations are for the most part from his photographs. His cooperation is the more appreciated as the fact that I worked in New York and he in Albany complicated the work.

Finally, I wish to stress once more the essentially cooperative and social character of the Henry study and to thank again all those who made possible the publication of this report.

December 18, 1942

E. McC.

Chronology

1841 Edward Lamson Henry born January 12th, at Charleston, S. C.

1858 Art student in Philadelphia

1859 Exhibited first painting at the National Academy of Design

1860 To Europe to study art

1862 Returned to United States and set up as professional artist

1864 Saw service as a captain's clerk in the Union Army
 Painted his. first railroad picture this year, *Station on "Morris & Essex" Railroad*

1865 Painted his first Civil War subject, *Westover*
 Began *City Point, Virginia,* finished in 1872

1866 Elected member of Century Association
 Visited Newport and painted there

1867 Elected associate, National Academy of Design
 Visited Ellenville and stayed at Mrs Terwilliger's
 Painted *The 9.45 A.M. Accommodation, Stratford, Connecticut*

1869 Elected National Academician
 Painted *Presentation of Colors*

1871 Abroad again

1872 Finished *City Point,* his Civil War masterpiece

1873 Met Frances Livingston Wells at an artists' reception

1874 Became engaged to Miss Wells

1875 Married and went abroad for honeymoon

1879 The Henrys spent a few days at the Bleakley farm on the "Mountain"

1881 Began to paint genre subjects of Cragsmoor country life

1883 Bought land for home at Cragsmoor

1884 Built home from his own plans

1887 Sale by Ortgies & Co., auctioneers, of Henry's antiques

1888 Travels in the south

1890 Painted *A Country School* and *A Virginia Wedding*
 During the decade 1890–1900 painted many transportation subjects, especially scenes along the Delaware and Hudson Canal

1892-3 Painted *The First Railway Train on the Mohawk and Hudson Road,* shown in the Transportation Building, Chicago World's Fair

1898 Painted *Sunday Morning (The Old Dutch Church at Bruynswick)*

1905 Painted his first automobile subject, *A Disturber of the Peace*

1914 Painted a commission for the First Church of Christ, Scientist; also *The Four Seasons* and *Contrasts,* a second automobile theme

1917 Painted *The Floating Bridge* and *St Mark's in the Bowery*

1919 Died at Ellenville, May 11th

Chronology

1841 Edward Lamson Henry born January 12th, at Charleston, S. C.

1858 Art student in Philadelphia

1859 Exhibited first painting at the National Academy of Design

1860 To Europe to study art

1862 Returned to United States and set up as professional artist

1864 Saw service as a captain's clerk in the Union Army

Painted his. first railroad picture this year, *Station on "Morris & Essex" Railroad*

1865 Painted his first Civil War subject, *Westover*

Began *City Point, Virginia,* finished in 1872

1866 Elected member of Century Association

Visited Newport and painted there

1867 Elected associate, National Academy of Design

Visited Ellenville and stayed at Mrs Terwilliger's

Painted *The 9.45 A.M. Accommodation, Stratford, Connecticut*

1869 Elected National Academician

Painted *Presentation of Colors*

1871 Abroad again

1872 Finished *City Point,* his Civil War masterpiece

1873 Met Frances Livingston Wells at an artists' reception

1874 Became engaged to Miss Wells

1875 Married and went abroad for honeymoon

1879 The Henrys spent a few days at the Bleakley farm on the "Mountain"

1881 Began to paint genre subjects of Cragsmoor country life

1883 Bought land for home at Cragsmoor

1884 Built home from his own plans

1887 Sale by Ortgies & Co., auctioneers, of Henry's antiques

1888 Travels in the south

1890 Painted *A Country School* and *A Virginia Wedding*

During the decade 1890–1900 painted many transportation subjects, especially scenes along the Delaware and Hudson Canal

1892-3 Painted *The First Railway Train on the Mohawk and Hudson Road,* shown in the Transportation Building, Chicago World's Fair

1898 Painted *Sunday Morning (The Old Dutch Church at Bruynswick)*

1905 Painted his first automobile subject, *A Disturber of the Peace*

1914 Painted a commission for the First Church of Christ, Scientist; also *The Four Seasons* and *Contrasts*, a second automobile theme

1917 Painted *The Floating Bridge* and *St Mark's in the Bowery*

1919 Died at Ellenville, May 11th

Biographical Sketch

THIS SKETCH is based almost wholly on source materials in the Henry Collection. Its purpose is to present all available facts about Henry's life; for biographical entries in various reference works are brief and not too accurate. The sketch is therefore thoroughly documented, the source of a statement being indicated in parentheses by the following abbreviations:

BIOG. Biographical
CL. Clippings
CORR. Correspondence
DOC. Documents
PH. Photographs

The date follows the designation. References to the Henry catalog and to illustrations in the report are abbreviated to CAT. and FIG.

Education and Early Life

Childhood. E. L. Henry was born in Charleston, S. C., on January 12, 1841, the son of Frederick and Elizabeth (Fairbanks) Henry. At seven he was taken to New York (Anonymous, 1928–36, 8547–48). Although his life is copiously documented, there is little material on his childhood. In the Henry Collection there are two photographs of his birthplace, one of which (FIG. 4) is inscribed *Old House in Society Street, Charleston, where I lived when I was a little One.* Another inscription records the fact that it was built in 1820. In Sketchbook 9 (CAT. 1193) there is a drawing of the house, apparently made in the eighties.

There is no information about his moving north. He was an orphan, living with his cousins, the Stows (McCausland '41, p. 207). Mrs Henry in her Memorial Sketch (p. 313) describes Henry as a talented child, put to drawing to keep him quiet in church. She adds that he had to overcome opposition from his family before he was permitted to study art. A small oil painting in the Henry Collection (No. 1628)—$6\frac{1}{2}$ by $9\frac{1}{4}$ inches, oil on paper, by Walter M. Oddie—adds further data. It is inscribed in Henry's writing as follows:

A Sketch by W. M. Oddie, 1854. Presented to me in 1855 while at school and my first visit to a studio and Mr Oddie kindly presented me this sketch. I studied a short time with him in painting, 1855. W. M. Oddie's studio was on Broadway below Canal Street, East side.

The first direct datum on Henry is the photograph in the Henry Collection of him (FIG. 2) as a youth of 17, studying art in Philadelphia in 1858. He studied there at the Pennsylvania Academy of Fine Arts and also with F. Weber.

Education. From 1858 on, there is a quantity of data about his development as an artist. He studied formally in Philadelphia, as later he would with Suisse, Gleyre and Courbet in Paris. At the same time he sketched industriously from nature, as he did throughout his life. The sketches in the Henry Collection—*Great Bend, Susquehanna,* 1858 (CAT. 1; FIG. 85), *West Point from Prof. Weir's,* 1858 (CAT. 2), *Bethlehem, Pa.,* 1859 (CAT. 3), *On the Lehigh, Penn.,* 1859 (CAT. 4), and *Mauch Chunk, Pa.,* (CAT. 5; FIG. 86)—show how he scoured the countryside for subjects. There are numerous related scenes in his sketchbooks (CAT. 1185–1212). The barnyard series (CAT. 6–9, 11–15; FIGS. 88–93) testifies that Henry thoroughly explored a subject when it interested him.

A barnyard scene, in fact, brought his first public recognition, in a press notice printed in the New York Daily News, Wednesday morning, June 8, 1859 (FIG. 228). At 18, Henry was exhibiting in the National Academy of Design exhibition, in which he continued to show his work for 60 years. The notice reads:

ACADEMY OF FINE ARTS—NO. VII

Northeast Gallery

No. 187, Barn-Yard Scene—Ed. L. Henry, Philadelphia. *A very natural, conscientious and well painted picture, beautiful in composition, by a young and most talented artist. We do not feel like seeking for its fault, being satisfied that Mr Henry only requires experience, combined with that judgment which we think he possesses, to enable him to repair and improve effectually any deficiencies which may be in this picture. We are much mistaken if there is not a foreshadowing of great excellence in this "Barn-Yard Scene."*

Critical encouragement may have served to persuade young Henry's family of the seriousness of his purpose and to induce them to send him abroad. At any rate, *Off to Europe,* 1860 (CAT. 17; FIG. 229) documents the start of the young art student's European studies and travels, which are well recorded in a number of drawings (CAT. 18–32; FIGS. 233–41). Mrs Henry's Memorial Sketch, quoting from diaries which have been lost, gives his itinerary. He left New York September 22, 1860, for London, remaining there till October 29th, then went to Paris, "where he

began his studies." (p.315). His passport is pasted on manuscript p. 11 of Mrs Henry's life.

Interests which influenced Henry's work in later life had appeared before he went abroad. His enthusiasm for all forms of transportation, from horse, oxcart and bicycle to steamboat, railroad train and early automobile, is shown in drawings like *U. S. Sloop of War Lancaster*, May 23, 1859; several sidewheelers, including *King Philip*, New York, 1859; *Launch, Navy Yard, Brooklyn*, 1860; a horse car, *Astor House. 3rd Ave. Line*, and *Le Chemin de fer du New York*, all in Sketchbook 1 (CAT. 1185). His interest in architecture, testified to by scores of photographs of historic buildings and their interiors in the Henry Collection as well as by the architectural subjects he painted, had an early expression in the drawing, *Old Church, near Limerick, Pa.*, dated April 10, 1859, in Sketchbook 1.

Travels. In Europe, Henry's energies were devoted to conventional art education. He studied with Suisse, Gleyre and Courbet, went to the gymnasium, took French lessons, sketched in the Louvre, and developed the graphic talent already revealed in his early drawings (CAT. 1, 5–8; FIGS. 85–86, 88–90) and sketchbooks. The grand tour was still part of a privileged young man's education, so Henry may be found making the circuit early in 1861, as told by Mrs Henry (p. 315). In Rome he made friends. In Sketchbook 1 (CAT. 1185) there is a pencil drawing of the sculptor, Edward Valentine. From Rome, he went to Florence, as may be seen in *In Bella Firenze*, 1861 (CAT. 20; FIG. 233), and saw the spring races, later the subject of *The Races at Florence*, 1864 (CAT. 53); then through the Italian lakes (FIG. 234) and into Germany (FIGS. 235–38).

We could reconstruct Henry's travels in 1861 from drawings annotated with place and date even if we did not have Mrs Henry's report from her husband's missing diaries. *Una Via in Napoli; The Campagna from Frascati; In Bella Firenze; Au Fond du Lac, Colico, Lac du Como; Luino, Lake Maggiore; Cannstadt in Wurtemberg; In Stuttgart; A Berlin Omnibus; A Prussian Canal Boat* (CAT. 18–28; FIGS. 233–38) chronicle Henry at work. He rounded out his European studies in 1862, as recorded by the drawings *In Amsterdam* and *Rotterdam* (CAT. 30, 31; FIGS. 239, 240). Sketchbook 3 (CAT. 1187) fills in gaps—Paris to London, to Chester, to Dublin, to Cork, to Queenstown and back to the United States, attested by *Icebergs Off Banks of Newfoundland* (CAT. 32; FIG. 241).

Henry's method of work is documented early in his working life. A drawing from his ticket for diligence fare from Florence to Genoa (FIG. 230), pasted on the back of manuscript p. 11 of Mrs Henry's sketch, is the first step toward the painting *An Italian Vettura*, 1863 (CAT. 34; FIG. 232). Intermediate is a drawing *Traveling Coach, Italy*, 1862, in Sketchbook 2 (CAT. 1186), reproduced in this report (FIG. 231) to indicate how Henry developed a picture.

Highlights of Henry's social life in Paris were invitations to parties at the United States' minister's. He was beginning to blossom out as the young dandy whom we see in several photographs (FIGS. 3, 5, 6, 12, 33, 35). He was not idle, however. *Italian Scene*, 1861 (CAT. 29) was entered in the National Academy of Design catalog of that year with the note *Now in Rome, Italy*.

Back Home. Home again, Henry carried on two parallel lines of work, painting from European material and at first hand from contemporary American life. The small oil, *The Arno, Florence*, 1863 (CAT. 33), his "diploma picture" on election to the Academy, is related to the drawing of 1861, *In Bella Firenze* (CAT. 20; FIG. 233). *An Italian Vettura* has already been referred to. In 1863 and 1864, Henry painted a number of canvases, none of which has been located, based on notes from European travel, including *Via Pallomette, Via San Lucia, St Maria del Sasso, Canal in Venice, The Italian Man-of-War, Near Palestrina, Street Scene in Naples, Souvenir de Lac Maggiore* and *The Races at Florence* (CAT. 35–37, 39–43, 53).

At the same time, he worked on subject matter of American life, Americana of a character which anticipated his genre painting of the 80's and 90's but which had its own distinct quality. Drawings in Sketchbook 3 (CAT. 1187) of a cow on a treadmill and of a dog on a "dog churn" (FIG. 59), the latter inscribed *Sparta N. J., 1862*, indicate Henry's interest in the world around him. The "dog churn" detail was incorporated in a later painting *Capital and Labor*, 1881 (CAT. 150; FIG. 56). A drawing in the same sketchbook shows Henry at work near Philadelphia in 1863. By 1864, he had painted his first railroad picture *Station on "Morris and Essex" Railroad* (CAT. 44; FIG. 108), which has not been located. Another "lost" picture which arouses curiosity is *Russian Fleet at Anchor in the North River*, 1863 (CAT. 38). To judge from extant data it was painted on a topical theme and so represents about the only known instance of Henry showing concern with current foreign affairs in his work.

Civil War. In the fall of 1864, Henry saw service in the Union Army as a captain's clerk (p. 319). Small, homemade Sketchbook 4 (CAT. 1188), called *War Sketches Oct. & Nov. 1864,* is filled with quick sketches of Negro soldiers; a battleship's foredeck; *The Sinking of the Florida, Newport News; Guard Ship Old Confederate 'Iron Clad' Captured at Savannah, Ga.; Gen. Ingals Hd'Qtrs City Point, Nov. 1864, Appomatox River; Washington from the Potomac; Westover; U S Army Wagon; City Point; Fairfax Church; James River 1864, Harrison's Landing.* In its 24 4x6-inch pages, Henry set down his first rapid notes from what he always called "nature."

Five drawings in the Henry Collection (CAT. 45-48, 51; FIGS. 105, 96–98, 102) and the wash drawing *City Point, Va., November, 1864* (CAT. 49; FIG. 106) represent the second stage of subjects later worked up into finished paintings. *City Point, Virginia, Headquarters of General Grant, 1865–72* (CAT. 96; FIG. 107), perhaps Henry's masterpiece, evolved from two of these sketches (FIGS. 105–106). Other sketches were developed into *On The James River, Va., 1864* (CAT. 52), *Westover, 1865* (CAT. 57; FIG. 103), *Gen. Fitzjohn Porter's Headquarters, James River, 1868* (CAT. 74), *After the Battle, 1868* (CAT. 75), and *The Old Westover Mansion, 1869* (CAT. 84). Civil War themes for which documents have not been found are *A New York Regiment Leaving for the Front, 1864–67* (CAT. 66; FIG. 101) and *Departure for the Seat of War, 1869* (CAT. 85), and *The Warning, 1867* (CAT. 67, 67-a; FIG. 104). An important painting on a Civil War theme, not a front line subject, is *Presentation of Colors to the First Colored Regiment, 1869* (CAT. 82; FIG. 100). The original sketch and commission for this painting are in the Henry Collection—a scrap of paper three and three-eighths by four and three-fourths inches (CAT. 82-a; FIG. 99). The picture was to be painted for $500, according to a note on the back of the sketch.

The Civil War did not effect a radical break in Henry's life, as it did in the lives of many American intellectuals. In 1864 and 1865, he painted more Italian subjects, for which presumably there was a good market. Among these were *The Races at Florence* (CAT. 53) and *St Erasme, Gaeta, Italy* (CAT. 56). At the same time, he continued to document American life with paintings such as *The John Hancock House* (CAT. 54; FIG. 43) and the lost *Residence at Poughkeepsie* (CAT. 55), which to judge from the

photograph on page 39 of the Henry Album was a fine piece of Americana.

Success. Henry settled into a pleasant and prosperous way of life. He did not seem to suffer from frustration. Photographs in the years immediately following the Civil War show him as a young man apparently in affluent circumstances, popular, personable, invited to fashionable Newport homes, feted, successful in the exhibition and sale of his work. The photograph made in Philadelphia in 1865 (FIG. 6) shows the personality evident in later portraits (FIGS. 20, 24 and CAT. 1220; FIG. 32). His smallness of stature, frequently mentioned by those who knew him, doubtless accentuated a kind of cockiness visible in the photographs.

The photograph (FIG. 33) by Sarony (Taft '39, p. 342 *seq.*) in particular expresses this quality. Perhaps it was but natural in a young man, highly successful at the outset of his career. Already Henry included among his patrons James Thomson, B. H. Moore, J. P. G. Foster, Robert Sanford, William E. Dodge, John Taylor Johnson, C. J. Peterson, T. A. Vyse, A. D. Jessup, Henry Dallett, Robert Gordon of London, Dr. J. D. Haren White, J. W. Pinchot, Robert Hoe, the Union League Club, S. P. Avery, Charles E. Gregory, a Miss Ward, the daughter of A. H. Ward (CAT. 89), James W. Drexel, G. F. Tyler, Albert Bierstadt, John Bullard. A decade later William Astor and E. T. Stotesbury are listed among his purchasers.

There was a ready sale for Henry's paintings, to judge from the fact that many were sold even before they were shown in the annual Academy exhibitions. In later life, Henry had the reputation of always selling on varnishing day. The character of his patronage may be gathered from photographs of the Jessup House at Newport (FIG. 35) and of Mrs Jessup's driving rig (FIG. 36). *Porch Scene, Newport, R. I.,* 1866 (CAT. 61; FIG. 37) and *Four-in-Hand, Central Park, New York,* 1867 (CAT. 64; FIG. 38), both apparently commissions from T. A. Vyse, suggest the scale of income and manner of life of Henry's patrons. That he was on friendly terms with them may be learned from the photograph of the party on the Jessup front porch (FIG. 35) and from the note inscribed by Henry on a photograph of the painting *From a Window, Newport,* 1866 (CAT. 62; FIG. 34), which reads *From a Sketch After Nature, July 1866, Jessup's, Newport, R. I.*

Financial success was reinforced by the prestige of election to the National Academy of Design as an associate in 1867, this at the age of 26. The portrait by J. G. Brown (FIG. 1), presented

by Henry to the Academy as is customary on election, and the
pencil drawing by Brown (FIG. 3), show the young A.N.A. as
something of a dandy, an impression given also by the stereopticon
view of him at Lake George in 1874 (FIG. 12).

Patronage. Life was not all sales and success, however, even for
a young, talented, dashing painter. A letter from Mrs Blomfield
H. Moore of Philadelphia suggests that in the eyes of some wealthy
patrons the artist was not rated highly. The letter writer is
recorded in the Henry Collection by a faded photograph, touched
up in pencil. The letter (CORR. '68), well worth considering as
a sample of the code of manners between patron and artist, follows:

> *My dear Mr Henry:*
>
> *Who is responsible for the blunder concerning Mr Hubbard's picture?
> I am extremely mortified by it. You will remember that I ordered through
> you duplicates of the two pictures painted by Mr Brown and Mr Hubbard
> for Miss Cushman's Album. The size that they could paint for $100.
> Mr Brown's arrived, and was entirely satisfactory, bill included. But here,
> upon my return to the city, I find Mr Hubbard's with bill of $150!*
>
> *Judging from the price of similar paintings, I expected one at least twice
> the size for $100. Of course, had he not exceeded my order, I should have
> been obliged to retain this one, small as it is; but as he has charged me $50
> more, Mr Moore says that I must return it to him, which I shall do by
> today's express.*
>
> *I shall order no more pictures, but wait until I can purchase them already
> painted, as there seems to be so much uncertainty about the way in which
> they are filled etc. You remember that Mr Beard would not take an order
> from me, excepting with the understanding that he could do as he chose
> about filling it.*
>
> *After all, it is much the better way to wait until you see a picture that
> takes your fancy (as we did with yours) and then purchase it, when
> there is sure to be no misunderstanding. I expect to be in New York soon,
> and then I shall visit the studios.*

Studio Life. Henry worked during this period in the Tenth
Street Studio Building, 51 W. Tenth street, which housed almost
every successful artist of the time. Apparently he lived with his
cousins, the Stows, at No. 218 E. Tenth street (FIG. 19). A
stereopticon view, taken in 1866 in Worthington Whittredge's
studio (FIG. 7), records the solid middle class character of the
artistic life, certainly by no stretch of the imagination Bohemian.
The group shown in the photograph were: Thomas Le Clare,
J. F. Weir, Whittredge (Whittredge '42), John W. Casilear, S. R.
Gifford, J. G. Brown (CAT. 1218; FIG. 1, FIG. 3), Jervis Mc-
Entee, William Hart, William Beard, Regis Gignoux, R. W.
Hubbard, S. J. Guy, and Henry himself.

Henry had a studio at this address till 1885, when he moved to even more luxurious quarters at No. 3 Washington Square North (FIG. 20). The view along Tenth street is the subject of his *Tenth Street Studio Building,* 1877 (CAT. 132; FIG. 258), which Henry gave to the National Academy in 1911, with a note of the circumstances connected with the painting. It was at an artists' reception here that he met Frances Livingston Wells (FIGS. 8–11), an event which Mrs Henry describes in her Memorial Sketch (p. 320).

Before Henry settled down to the placid tempo of his married life, however, he made another trip abroad, carrying with him letters of introduction (CORR. '71) from Benjamin Franklin Reinhart to Col. D. D. Muter, editor, Anglo-American Times, and H. Graves, "art publisher, Pall Mall." Sketchbook 8 (CAT. 1192) records his travels in Ireland, Belgium and Germany. The only paintings we know of from this trip are *The Passion Play, Oberammergau,* 1872 (CAT. 99) and *Alt Kirche, Oberammergau,* 1872 (CAT. 100; FIG. 115).

Marriage and Maturity

Courtship. Henry's courtship and marriage are relatively undocumented. The Henrys' love letters were destroyed. What remains in the Henry Collection gives a rather dry, sparse picture of his romance. Nevertheless, marriage was unquestionably a turning point in Henry's life. In the first place, as a result he put down roots at Cragsmoor, which thereafter became his artistic base of operations. His genre paintings of New York state rural life and characters are the products of this new way of life.

Furthermore, it is not inconceivable that marriage fostered his drive toward success. Interesting aspects of his earlier painting are lost in the work of his middle years, when he expresses satisfactorily the standards of middle class patrons. Yet judged by all records and accounts, Henry's marriage was eminently happy. Mrs Henry's Memorial Sketch, undertaken after Henry's death, was surely no light labor of love. She herself (FIG. 31) was not young, 74, and unfitted by experience for the hard task of writing. Her manuscript (pp. 311–46) is a tribute to their relation.

The Memorial Sketch relates that Mrs Henry, *nee* Frances Livingston Wells of Johnstown, met Henry at an artists' reception at the Tenth Street Studio Building (p. 320). Possibly their meeting

may have taken place at the event documented by a note (CORR. January 29, 1873) pasted in the Henry Scrapbook, which reads:

> *Mr McEntee will be happy to see you, with the other artists of the Studio Building, at his room, tomorrow (Thursday) from 11 to 12 a.m. to show you for your free and frank criticism his last picture (not entirely completed) "Sea from Shore."*

At any rate, it was one of these functions, of which another document in the Henry Collection (DOC. '67) is a printed invitation to the *Private View of William Page's Paintings.*

On May 15th of this year, Henry wrote Miss Wells (CORR. May 15, 1873) as follows:

> *Would you like to go on Tuesday afternoon to the private view etc.—which I enclose. If so, I will call or will be pleased to escort you there. The card of admission I retain as it is too large to place in the envelope. I have rec'd them before, but never availed myself of them. Also made a member but resigned, and I should like to go to this last one. And if you care to go, I will be delighted to have your company, as the card says 'yourself & Ladies.' I may ask Emma & Dot, so don't ask or say anything about it to Miss McCreedy till I know whether they can go.*
>
> *I may go out of town tomorrow and return Saturday p.m. If so I will call and see you Sunday.*
>
> *On the other page is your Enoch Arden, a rough sketch in pen & ink which you suggested.*
>
> <div align="right">

Yours sincerely

E L H
</div>

The sketch on the third page of Henry's letter shows Enoch Arden looking through a window into a brightly lighted room. It is signed, lower left, *F M Wells, del. 1873.*

This brings up an interesting though minor point. Throughout their married life, the Henrys used the twin sets of initials E L H and F L H. An unidentified newspaper clipping of their wedding names the bride Frances Livingston Wells. Yet there are a number of initialed signatures with the middle initial M, probably for the family name Murray, that of her aunt. In Sketchbook 9 (CAT. 1193) there is a sketch inscribed *Sunday Afternoon Aug 3d. 1873. F M W del.* In Sketchbook 11 (CAT. 1195)—inscribed on the cover *Fait pour cher petite Frank Pour mon cher Edward. Aug. 10/74*—there is a drawing of Henry sitting on a campstool before an easel, painting a thumbbox panel, which is inscribed *E. L. Henry. Sketch by F M W.* Did Mrs Henry drop one family name as a middle name and adopt another so that her initials might be similar to her husband's?

There are a few souvenirs in the Henry Collection of this important time in Henry's life. One is the photograph (PH. '73), inscribed *nee Frank Wells. Taken 1873–4 in dress of 1803–4* (FIG. 10). Another is a small drawing (too stained and faded to reproduce) inscribed *Where I was engaged to Frank Aug. 1873, at Crapsew, Catskills. E L H.* The engaged couple may be found the next summer sketching together. In Sketchbook 11 (CAT. 1195) there is a drawing of Henry which shows him rowing, with Miss Wells in the stern of the rowboat and a small black dog in the bow; it is inscribed *Near Fort Miller, N. Y., Sept. 4, '74, Friday, 5 p.m.* A sketch in Sketchbook 10 (CAT. 1194) is inscribed *Frank & Peter & little Thompson child in hammock at Thompson's, upper Hudson, Aug. 1874.* Peter is the little black dog. In the same sketchbook, there is a drawing initialed F L H. It is inscribed *Edward L. Henry. Near Fort Miller. Sept. 22d 1874.* A photograph of *The Old Clock on The Stairs* (CAT. 70), pasted on the back of manuscript p. 9 of Mrs Henry's sketch, is inscribed *To Miss Frances M. Wells, 1874.*

Marriage. The Henrys were married in June 1875 (CAT. 117; FIG. 227). The unidentified clipping referred to above gives the following account:

> *Henry and Wells*
>
> In Johnstown, N. Y., last Thursday morning, Mr Edward L. Henry, N.A., and Miss Frances Livingston Wells, daughter of the late Edward Wells Esq., by the Rev. Charles M. Livingston, uncle of the bride. Mr and Mrs Henry left in the afternoon for New York, received the congratulations of their friends from one till eight p.m., Friday, at the Fifth Avenue Hotel, and sailed for Europe on Saturday in the Britannic. They will remain in Europe for a year, spending most of their time in Italy, where Mr Henry will employ his graceful pencil in the pursuit of his art.

The documents reveal some relatively unimportant discrepancies. Frances L. Wells was born in 1845. After her father's death in 1869, she and her mother moved to New York in 1870 (McCausland '41, p. 208, 229) to stay with her aunt, Mrs Margaret Livingston Murray, who from 1841 to about 1889 kept a boarding house, first on Bleecker street when it was fashionable and then at 24th street and Madison avenue. An uncataloged sketchbook in the Henry Collection is inscribed inside the cover *Fannie Wells, Flushing, L. I., Winter Cottage, 1860–1861.* Were the Wellses in New York this early?

Another interesting minor detail is the fact that Henry bought on April 30, 1872, from A. M. Sypher, 593 Broadway, "2

dimonds," paying $160 for them (DOC. '72). The appraisal of
Mrs Henry's jewelry, after her death in 1928, lists, among other
items, the following:

1 cluster diamond ring (9 small diamonds) $60
1 small diamond ring.. 10
1 three stone diamond ring, old fashioned............................... 250
1 four stone diamond ring, old fashioned............................... 300

Were the "2 dimonds" in this lot?

A third question mark is a letter (CORR. JUNE 25, 1874) from
Charles Collins to Henry:

> Your kind invitation has just reached me . . . It would have been
> very pleasant to be with you and I hope at some time later to have that
> privilege. I am glad to believe that you are both in good health again
> and enjoying your charming home. With my love to Mrs Henry.

Perhaps the date is a typographical error on the writer's part?

Honeymoon Abroad. There is much visual documentary matter
about the Henry's honeymoon. No doubt memories of their ocean
trip on the *Britannic* supplied Henry with material for the pen-
and-ink drawing *Newly Married* (CAT. 1142). A water color
sketch in Sketchbook 13 (CAT. 1197) is possibly a forerunner of
the portrait of 1876 (CAT. 122; FIG. 41), which shows Mrs Henry
standing at an easel, brush in hand. The water color is inscribed
Mrs E. L. Henry, London, Oct. 1875, by E. L. H. Recorded in
sketches in Sketchbook 13 and also in larger sketches (CAT. 1029,
1052, 1067) is *St John's, Warwick, where we passed two summers,*
according to the inscription on a photograph (PH. '75) in the
Henry Collection. Other English subjects are commemorated in
sketches in the Henry Collection (CAT. 1008, 1009, 1091).

From Warwickshire, the Henry's went to Paris, later returning
to England. In Sketchbook 14 (CAT. 1198), inscribed inside the
cover in Henry's handwriting *Frances Wells Henry's Sketchbook,
London, 1875,* there is one drawing by Mrs Henry, inscribed in
her writing *Churchyard, Coventry.* Most of the sketches, however,
are clearly by her husband. She continued to draw and paint for
a while, even exhibiting at the National Academy of Design in
1885 a painting *Rhododendron,* price $60 (CAT. 1221). This
was reincarnated (McCausland '41, p. 92) on the glass doors
leading from the living room of the Henrys' Cragsmoor home to
the little library. Gradually Frances Wells Henry slipped into
the role of wife, whose chief duty was to aid and to admire her
husband.

She had not yet been molded, however, to the wifely pattern and may be found noting down her impressions of travel and the British. In Sketchbook 14 (CAT. 1198), we find the following:

Sitting here in Boulogne Harbor, what a medley presents itself to my eyes. This poor little boat is already full, mostly English, judging by their broad, harsh accents. Some already looking pale in anticipation of the sea, some jolly & noisy. By me sits a John Bull sort of a man, who has deigned not even a look at me since I so emphatically said, No, I'm American. On his other side, a blind man. Here they come, each one looking as if he were the important one on earth, all more or less looking like "Butchers Meat" men.

Sketchbooks 15 and 16 (CAT. 1199, 1200) contain more notes on travel in France and England. While abroad, the young couple enjoyed various cultural opportunities, among them a *Réunion Musicale,* at the Magasins du Bon Marché in Paris (DOC. July 3, 1875). In Paris, too, they were invited to an "amateur drawing room" at the apartment of Lucy Hooper, wife of Robert Hooper, American vice-consul, in the Rue Neuve des Petits Champs (DOC. '75). Similar incidents of their trip are set down in Mrs Henry's Memorial Sketch, especially the account of their stay with a French family (p. 325f).

Married Life. Back in the United States, the Henrys settled down to a comfortable, prosperous middle class existence. Henry did his work, they gave dinners, spent summers with friends on Long Island, lived in expensive quarters. A drawing in Sketchbook 5 (CAT. 1189), inscribed *Dec. 31st, 1880, Tenth St. Studio Building,* shows a woman at the piano and a man leaning against it. This subject is not unlike that of the photograph of the Henrys in their Washington Square studio (FIG. 20). The flute shown in the latter—now in the Henry Collection—reveals Henry's love of music. In the Henry correspondence, there is a letter (CORR. February 26, 1895) inviting the Henrys for the week end, with a postscript that he will not be welcome without his flute.

At this time, Henry spent considerable time with Judge Charles P. Daly and his wife at Sag Harbor. In Sketchbook 16 (CAT. 1200) there is a drawing of Judge Daly and his dog (CF. p. 252); also a sketch of horses at Sag Harbor dated September 6, 1879. A lighthouse, dated 1877, is shown in Sketchbook 17 (CAT. 1201), while in Sketchbook 18 (CAT. 1202) there are several drawings of East Hampton subjects, dating from 1877 to 1880. This gives background for a lost painting which seems from photographs to have been a fine canvas, *East Hampton Beach,* 1881 (CAT. 154; FIG. 49). Henry's method of work is illustrated again in the series of studies for this picture (FIGS. 45–50).

The Henrys and Cragsmoor

The Region. Why the Henrys located at Cragsmoor, known till the late '90's as "The Mountain," records do not show. A certain amount of mystery surrounds the drawing in Sketchbook 5 (CAT. 1189), inscribed *At Mrs Terwilliger's, end of Oct. 1867.* Henry's early visits to the region are not otherwise documented. We know, however, that he visited Professor Weir at West Point (CAT. 2) in 1858. It is not unlikely that he had gone exploring in the Shawangunk mountains before he visited them again and decided to make his home on "The Mountain."

Cragsmoor is about five miles from Ellenville, in southeastern New York in the Shawangunk (pronounced "Shongum") mountains. In recent years, Ellenville has become a center of summer resorts. In Henry's time, however, it was populated only by farmers; he and the artists who followed him were pioneers. Cragsmoor is an arrow-shaped plateau four miles long, overlooking Ellenville and the valley of the Rondout river. It is bounded by Bear hill (FIGS. 79, 80) and Sam's point (FIGS. 14, 15).

Different accounts of the birth of the Cragsmoor colony have been given. The facts seem to be as follows, however. In 1879, the Henrys stayed for a few days at the Bleakley farm on "The Mountain." Mrs Catherine W. Bleakley was already an institution then, taking in summer boarders and being widely known for the quality of her hospitality (McCausland '41, p. 82, 226). A drawing in Sketchbook 5 (CAT. 1189) shows that the Henrys were in Ellenville the next year, being inscribed *Peter & Charley. Sunday June 27 '80, Ellenville.* There is a very interesting small water color in Sketchbook 6 (CAT. 1190), signed lower right *F S Dellenbaugh, 1881,* which shows a blazing fire on Sam's point, frequently set on fire by the huckleberry pickers (McCausland '41, p. 130). A photograph (FIG. 55·) in the Henry Collection (PH. '81) is inscribed *in Otis yard 1881.* Dellenbaugh has recorded that the Henrys stayed with the Otises in Ellenville in 1881 (McCausland '41, p. 91, 153 *seq.*, 227-30). Dellenbaugh, who had been with Major J. W. Powell on his second expedition down the Colorado river (Taft '39, p. 288–89), married Harriet Otis, whose memory is still a Cragsmoor legend. Later the Powells stayed in Ellenville, the violinist Maud Powell hiring an empty house on Canal street to practise in (CAT. 319; FIG. 71). A friendship grew up between the Henrys and Maud Powell which lasted throughout life (FIG. 72).

Building a Home. After another trip abroad in 1881 and 1882, witnessed by Sketchbook 19 (CAT. 1203), the Henrys began to build their own home, from plans drawn by Henry, to be seen in Sketchbook 20 (CAT. 1204). According to deeds (DOC. '83) in the Henry Collection, Henry purchased land from Hattie L. Keir on August 3, 1883, paying $200. This property had formerly belonged to the Mance family, descending to George R. Mance from his father, Jacob Mance. Both are immortalized in photographs by Legrand W. Botsford in the Henry Collection. In 1888, Henry bought more land from Mrs Keir for $150. In 1894, he again bought land from her, paying $500. These purchases comprised the Henry property, part of which was sold in 1910 to Julie M. Husson and Mary D. Buxton. The remaining Henry land is now owned by Mr and Mrs R. L. Foster. The Ellenville lawyer, George G. Keeler, central character of Henry's painting *A Country Lawyer* (CAT. 264; FIG. 150), made the original search of title (McCausland '41, p. 137). In addition to the deeds noted, the Henry Collection includes two surveyor's sketch maps of the property, made in 1910. These facts explode the myth that Henry "swapped" paintings for a "hummock of rotten shale" (McCausland '41, p. 145) on "The Mountain."

Henry was his own architect, hiring the local carpenter, "Joe" Mance, to build the house. Mance died in 1896, aged 64. He was a millwright and, according to his son, Stephen D. Mance of Ellenville, "built all the mills around here" (McCausland '41, p. 47, 49). The photograph of Mance (FIG. 134) shows him in back of the Ellenville knife factory, where "Artist Henry" is also said to have hung out. Mance is seen in a number of Henry's Cragsmoor canvases, notably *Joseph E. Mance* (CAT. 193; FIG. 128) and *The Country Carpenter* (CAT. 234; FIG. 145). A letter (CORR. May 5, 1884) from Mance to Henry reads:

> *Mr Henry,*
>
> *I Rec. your Letter. your Door and Frame and Box etc. arived by Canal all in good shape. The Freight is $4 $\frac{1}{00}$ I will git it up to House This week. the Road is quite good. I am going to work at house tomorrow.*
>
> *I have got to get my Brick and Lath and Lime carted up.*
>
> *In Regard to money I whould like to have 300\frac{00}{,,}$ by the 9th to put things threw as quick as possible.*
>
> *Send money as soon as Can and Oblidge your*
>
> *Frind Joseph E Mance*
>
> *Ellenville, Ulster Co. N. Y.*
> *Rain Today*

The problem of building a home entailed not only financial and practical difficulties, but also esthetic. A quotation from The Summer Haunts of American Artists (Champney '85, 847) published in the Century elaborates the point from the angle of the artist-outsiders. The reference to Henry reads:

> . . . At Ellenville a group of artists have taken possession of one of the old farm-houses. Here Mr and Mrs E. L. Henry have established themselves. Mr Henry, in building a studio, found great difficulty in impressing his ideas of architecture on the local carpenters. "If you have the rafters show like that," they complained, "and stick the roof all over with little gables, you'll make your studio look like one of them old Dutch manorhouses at Kingston."

Whether "Artist Henry" won out or not, at least the Henry house did not look like the beautiful old Dutch houses of the region, surely some of the finest vernacular architecture produced in the United States.

A further document in regard to the Henry home at Cragsmoor is a legal paper presented in the summer of 1942 to the New York State Museum by Fred G. Kraft of Cragsmoor, who is the owner of the painting *Pillory and Whipping Post* (CAT. 282). It reads:

> STATE OF NEW YORK ⎱ *Edward L. Henry being duly sworn says that*
> COUNTY OF ULSTER S.S. ⎰
>
> *he is by occupation an artist, formerly resident of No. 3 North Washington Square, New York city and State. That he severed his residence with said New York city on or about the first day of April 1887 and became then and ever since has been a resident of Town of Warwasing, Ulster County, in said State of New York and that he intends to make for the future until further determined his residence at said Town of Warwasing, Ulster County, New York, where he now resides and is a householder and owner of residence and real estate.*
>
> *Sworn before me*
> *this 29th day of August* ⎱ EDWARD L. HENRY
> *1887* ⎰
>
> C. A. VAN WAGENER
> NOTARY PUBLIC ULS. CO. NY

Cragsmoor home built, the Henrys settled into a rhythm of living which continued till Henry's death. From early spring to late fall, they lived in the country, going to New York for the winter. Letters and a frantic telegram from Mrs Henry (CORR. '94) record the problem of finding temporary quarters in the city after they had given up their Washington Square studio. Toward the end of Henry's life, they made the Hotel Chelsea their winter

home, except when they went to Florida. Henry's last, unfinished painting is a Florida scene (CAT. 391; FIG. 218), the Henrys having come directly from Daytona to Ellenville where he died. When weather was too bad to open the house up on "The Mountain," they boarded in Ellenville, with Mrs Nelson Terwilliger, at whose home Henry died (McCausland '41, p. 17) and with Mrs John F. Morse.

Cragsmoor Then and Now. Here Henry developed his particular gift of observation into what is his most interesting expression, genre paintings of country life. In the early days when summer people began to visit the community now known as Cragsmoor, conditions were primitive (McCausland '41, p. 146). The stage-coach ran from Newburgh to Kingston, crossing the Shawangunk mountains by the "plank road," now route 52, the Shawangunk trail. It took two hours from Ellenville to Cragsmoor by the "plank road" (McCausland '41, p. 133). The old road followed a different course than the new, the "horseshoe turn" for example having been eliminated. Today one can not see from route 52 the same view Henry painted in *Bear Hill* (CAT. 347; FIG. 79). The old "gully road," shown in several paintings (CAT. 153, 162; FIGS. 137, 139), takes about the same route and seems scarcely less bumpy than when Andrew Carnegie bought one of Henry's paintings as propaganda for better roads in the eastern states (CAT. 247; FIG. 245). Some of the cottages are gone. The Peter P. Brown house (FIG. 78) is visibly altered from the house of 1880 shown in Legrand W. Botsford's photograph (FIG. 77). The mansion of George Inness jr, Chetolah, is now a Roman Catholic home, Vista Maria. Bleakley's barn, home of the first post office on "The Mountain," (CAT. 298; FIG. 81) has been rebuilt into a summer theater. Sam's point no longer boasts Thomas Bots-ford's Mountain House, famous for fried chicken and green corn. Henry's old home has been remodeled (McCausland '41, p. 166) by its present owners (FIGS. 23, 25). Most of his old friends and artist-confreres are dead (McCausland '41, p. 14). The character of Cragsmoor as an artists' summer colony is changing.

Sixty years ago, Cragsmoor was a different story. Ascent to "The Mountain" from Walker valley was so steep that oxen were used to haul heavy loads, including the community's trunks and food supplies. The climb to the final plateau of Sam's point was up a grade so steep that oxen which *trotted* were used to haul parties to the summit. (McCausland '41, p. 88, 133). Orchards and cornfields covered the top of the plateau. These Henry would

paint in numerous sketches and canvases, particularly his *Four Seasons* (CAT. 372; FIGS. 204–07). Architecture was of an earlier, simpler kind, as the Peter P. Brown house indicates and as does a fine photograph in the Henry Collection (PH. undated) showing a log cabin opposite Tice's, a dwelling of a type more characteristic of the south than of eastern building.

After the proprieties of atelier, Academy and the Tenth Street Studio Building, to say nothing of No. 3 Washington Square North, Cragsmoor must have seemed a wilderness. The Henrys quickly conquered it, imposed their Victorian rococo (FIGS. 21, 22, 24, 26-28) and established a regimen of life composed of charades, readings from the drama by Harriet Otis Dellenbaugh, musicales and teas (McCausland '41, p. 132). Yet there was a poetry in this countryside, surviving even today and recorded in the Dellenbaugh water color, mentioned before (p. 37). Today at sunset, the plateau above Sam's point is a blighted heath, burnt over by fires set by berry pickers (FIG. 18). It stretches out like a plain, but without life—this watershed for the Ellenville water supply (FIG. 17). The romanticist could still find here stimulus for the imagination. How much more so 60 years ago!

Henry's Choice. Henry did not choose to devote himself to the chronicle of nature on Sam's point. An early member of the Cragsmoor colony, Mrs Addison Brown, had first been charmed by the region's wealth of botanical specimens, then brought back her husband and children a decade later (McCausland '41, p. 190). But Henry, though he painted *Bear Hill* (CAT. 347; FIG. 79) and had in his possession photographs of Sam's point (FIG. 14), chose rather to paint life at the lower altitude of Cragsmoor.

The scene Henry found appealing was the rolling slope down from Cragsmoor to the "plank road" (FIGS. 14–16). Legrand W. Botsford, indigenous primitive, made his own naive record of the view Henry expressed in more orthodox style in *Country Scene* (CAT. 233; FIG. 66). To many Botsford's vision will be more acceptable. Nevertheless, in Henry's day the gloss on nature was in demand. Nature was not to be presented as a terrible, uncontrolled force, but as a superior lawn. So, in Henry's landscapes we get so much of the earth and sky as may be compressed within studio walls. Botsford, "the hermit of Cragsmoor," with his innocent eye, kept closer to the real aspect of nature in his photograph of Cragsmoor landscape (FIG. 65). Yet this is, perhaps, saying too little on the credit side for Henry. The undated,

unlocated painting *In The Valley* (CAT. 929; FIG. 83) has a poetic quality, which appears again in *The Country Store* (CAT. 181; FIG. 127). Henry particularly fastened on obvious appeals of the world he chose. *In The Valley* shows the ubiquitous spire of the Ellenville Dutch Reformed Church (FIG. 84), which Henry worked into many scenes, regardless of whether it actually appeared in them in nature.

Henry, however, did not need to be a romantic poet of nature. In the country scenes he found congenial, there was a content of genuine significance and value. At his death, the Ellenville Press wrote in its May 15, 1919, issue that *much of his valuable work has been done in the studio of his mountain residence.* Truly valuable was Henry's work in recording American rural life in one locality, with some revision. His paintings show us today how people, buildings and objects made by people *looked,* and thus Henry supplied a quantity of visual data on the American scene.

The World of Cragsmoor. Life at Cragsmoor was simple. The world was divided into the summer people and the so-called "natives." The "natives" had been there first. But they had to give way to the newcomers, selling them their land and supplying food and services. The Mances, Terwilligers, Deckers, Coddingtons, Kindbergs, Peter P. Brown, Botsfords, Bleakleys, Cooks— these are some of the people who settled "The Mountain" and still live there. Almost all of them appear somewhere or somehow in Henry's work. They built his house, supplied eggs, chickens, butter and milk, plowed his garden, housed and fed the Henrys on flying trips to Cragsmoor before they opened their own house.

A few letters from Cragsmoor survive. They stress tangibly the difference between summer people and "natives," being written on odd scraps of paper and not always too literately. The first, aside from "Joe" Mance's letter already quoted, is from Bleakley. His first name has not showed up in the Henry documents. The letter (CORR. January 3, 1892) reads:

Dear Mr Henry

> *Your letter is to hand. Sorry to hear of your sickness. I hope you will soon be all right. It has been a very sickly time. The roof is painted. He wanted more oil and wanted to know your address. But told him you forgot to leave it with me. Nothing new here. Saturday it was very wet all day from five o'clock in the morning. Could not get out all day. Will send bank book so you will get it tomorrow. With kind regards to you and Mrs Henry and wishing a happy New Year.*

A letter from Mrs Keir (CORR. February 20, 1894) has to do with the sale of land mentioned above and reads:

> *Mr Henry—*
>
> > *Dear Sir.*
> >
> > *I am sorry we do not know the dimentions of that lot, as it would save some bother. Mr Mance is not at home or we would get him to measure it for you. Do not forget to mention the ten feet. My given name is Harriet L.*

A note from M. J. Wright to Mrs Henry (CORR. July 29, 1895) portrays the domestic economy of "The Mountain." It reads:

> *My dear Madam—*
>
> > *I am sorry I cannot let you have any more eggs, as our hen we have now have chicken and the rest was killed and sold last Saturday.*

A postscript inquires: "Was chicken all right?"

A letter to Mrs Henry from Mrs C. H. Mance (CORR. March 19, 1894) follows:

> *We will try and not let you go off the mountain hungry. Dinner will be ready soon after you arrive here.*

This is annotated in Henry's hand: "Charley Thomas & I came up and dined. Warm, lovely day." What happened to Mrs Henry?

A letter from Thomas Boyce (CORR. March 24, 1896) has more to relate about the Henrys' domestic affairs. It incloses a bill dated November 14, 1895. The letter reads:

> *To*
>
> *Mr E. L. Henry*
>
> *Dear Sir: If it is Convenient to you, would you kindly send me the amount of my Bill. as I need it. It would oblige me very mutch.*
>
> > *I hope you and Mrs Henry have Ben well. Wee have had a great deal of sickness here. Mrs Bleakley is not feeling well. We hav had lots of snow. I remain yours*
>
> > > > *Thos Boyce*

The bill, evidently for a summer's supply of milk etc., was for a total of $24.13 and was itemized as follows:

105 qts milk 5 cts pr qt	*5.25*
8 qts ½ Butter Milk 2 cts qt	*.17*
9½ lbs chicken 18 ct lb	*1.71*
11 Loads Manuer 1.50 pr Load	*16.50*
plowing garden 50 cts	*.50*

Finally, the "natives" were the studies from nature for Henry's genre pictures. We find Henry sketching "Joe Mance's" in Sketchbook 22 (CAT. 1206), paying a school tax of $13.50 to Lawrence S. Keir in a note in Sketchbook 25 (CAT. 1209), painting "Old Jimmy Mance" in 1886—a sketch in oil on cardboard in Loose Notes (CAT. 1213). Interested in the picturesque and salable aspect of rural life, Henry went farther afield and exploited Ellenville local characters. The six original oils (CAT. 193, 187, 188, 194, 230, 167; FIGS. 128–33) given by Henry to the village of Ellenville in 1918 and exhibited on August 6th and 7th at the Hunt Memorial Hall in Ellenville for the benefit of the Red Cross —admission 35 cents—are portraits of well-known Ellenville and Cragsmoor people (McCausland '41, p. 42–44, 54–59).

That the countryside responded to Henry's use of local subject matter may be gathered from what the Ellenville Press wrote of this exhibition in its issue of August 8, 1918:

> It has always been a matter of local pride that so many artists of note have found inspiration and worthy subject matter in our beautiful environs, but with rare exceptions we have not been privileged to enjoy the fruits of their labors. The art exhibition held at Memorial Hall this week marks a notable event in Ellenville's history. . . .
>
> The largest exhibitor was Mr E. L. Henry. For many years his friends have looked forward to the annual return of Mr Henry to his mountain home, and perhaps more than any other, we feel that he belongs to us. In a very real sense, he has been our historian and on Tuesday he made the village eternally his debtor by the gift to us of six portraits of well-known local characters painted some time ago, but still remembered. The presentation was made by Mr H. W. Coons and accepted by Mayor Potter for the village and board of trustees. It was a unique and thoughtful gift and cannot fail to be appreciated by those to whom Ellenville and its traditions are dear.

How much Henry depended on his local subject matter may be judged from a remark in the Cragsmoor Journal for September 12, 1912, to the effect that "Peter's death [Peter P. Brown] was a great loss to Mr Henry, for he had utilized him as a model in some of his most striking pictures. Among these may be named *Uninvited Guests, Peter Brown, Bracing Up, A Hard Road to Travel* (CAT. 169, 187, 168, 162; FIGS. 143, 129, 138, 139).

It is rather interesting that Henry did not use as a subject one of the more unusual Cragsmoor characters, Thomas Botsford (FIG. 16). They are said to have been great friends, Botsford, senior, being uneducated but intelligent. He built a house on Sam's point, which had to be bolted down. At that, it lasted only

one winter. It "blew away, or something," report has it. Then he built below the point itself, setting the second house against the rock wall (FIGS. 14–16). A spring ran through the main room, ferns grew from the walls, and fissures in the rock were chimney flues. In this Botsford anticipated modern architects, who bring natural elements into the interior of dwellings. People from the valley used to come up to dance. For 50 cents they had a wonderful dinner of fried chicken, green corn and ice cream. His son, Legrand (pronounced *Lee*-grand on "The Mountain"), built the road to the top of Sam's point, now a toll road. Botsford, junior, died only a few years ago, leaving behind him the photographic negatives, many of which have supplied illustrations for this report. He, too, painted, but in quite a different spirit than Henry. It is said that he used to take his primitive oils to Henry for criticism. Centainly., the academician could have done little to encourage this child of nature (McCausland, '41, p. 128–30).

The Summer Colony. Who should be credited with being the founder of the Cragsmoor summer colony is a question. Local accounts have given Dellenbaugh the honor, with Henry second. The 1867 entry in Sketchbook 5 (CAT. 1189) mentioned above, however, should certainly raise the question if it were not Henry who introduced every one else to "The Mountain." At any rate, by 1886 the summer colony was well on its way. Mrs Eliza Hartshorn of Newport, a connection of Mrs Henry's on the Livingston side, had begun to buy land and to build at Cragsmoor. She is shown in a sketch in Sketchbook 23 (CAT. 1207), which is inscribed *Mrs Hartshorn of Newport, R. I., taking a rowboat ride on the canal basin below Ellenville, 1910.* In fact, Mrs Hartshorn was the social pivot of life at Cragsmoor, especially as Mrs Henry, the Otis sisters, the Woodruff sisters and Annette Mason Ham were all cousins in different degrees (McCausland '41, p. 40, 86, 207, 227, 229).

The summer colony grew gradually, first, the Henrys and the Dellenbaughs, then Mrs Hartshorn. In 1886 J. G. Brown stayed at the Bleakley farm. Later came Eliza Greatorex, whose property was subsequently sold to George Inness, jr. Then came Edward Gay. Through Dellenbaugh, Charles C. Curran was introduced to "The Mountain," and through him Helen M. Turner came. In its heyday, the colony included Henry, Dellenbaugh, Gay, George Inness, jr, Miss Turner, Keller, Frederick Baker, Carol Brown, Arthur Parton (McCausland '41, p. 127, 130, 131).

Life at Cragsmoor was simple, not only in the structure of the community but also in the character of the pursuits of the summer people. Harriet Otis Dellenbaugh gave readings from Ibsen. The Henrys held teas for the benefit of the Cragsmoor Improvement Association—cause, better roads on "The Mountain." People played croquet, witness Sketchbook 6 (CAT. 1190) and a photograph in the Henry Collection showing Mrs Henry, Dr Howard Crosby and Nicholas Crosby with mallets in hand. Coming up for the summer, the summer colonists left the train at Pine Bush and rode up in carryalls (McCausland, '41, p. 89).

Settling Down. In 1887, the Henrys cut their moorings and made Cragsmoor their real home. This year Henry held the sale of his antiques and paintings which gives a good cross section of his interests (Ortgies '87). Total receipts were $6700.60, according to the annotated catalog (DOC. '87) in the Henry Collection. China, antique furniture, mirrors, clocks, glass, engravings and paintings and a number of works by Henry himself are listed, a total of 258 items. The Henry paintings, 27 in all, brought $2117. None of these has been located. It is possible that No. 53, *Learning the Trade* might be *Sharpening The Saw* (CAT. 195; FIG. 136).

The first decade of life at Cragsmoor was devoted to country scenes. About 1890 Henry began to paint the canal themes which have particular interest in relation to his whole transportation series (FIGS. 156–78). Sketchbook 23 (CAT. 1207), inscribed *Canal Studies,* contains many details of local landscape and village scenes, some still recognizable. The first dated sketch is of the Delaware and Hudson Canal at Ellenville, in Sketchbook 5 (CAT. 1189), this in 1890. The "Old D. and H." canal was a vital fact in the life of the region, in the era before it was outmoded by rail transport (Sciaky '41), and so naturally made an appeal to artists' imagination. Ellenville children played around the locks. Summer people from Cragsmoor "used to have picnics on the canal. They would go up the canal on regular canal boats, towed by horses. It was very, very smelly." Henry loved the canal (p. 330), which as one drove up "The Mountain" and looked back was like a silver ribbon winding through the Rondout valley (McCausland '41, p. 4–5, 59–61, 96, 137, 247).

Henry did not restrict himself to scenes of rural life at Cragsmoor or to canal scenes. He ranged the countryside. In the Henry Collection, there are quantities of photographs of subjects at Napanoch, including some of the "Vernooy Place," featured in

A Wedding in the Early Forties (CAT. 976). There are photographs, too, of the Hoornbeek grist mill at Napanoch which is the subject of a small oil (CAT. 386). Street scenes in Ellenville and Napanoch attest Henry's interest in the document. A fine photograph shows the Rondout at Napanoch, which figures in the titles of several unlocated paintings. Other photographs show the post office at Cragsmoor, the "gully road" and a scene on "The Mountain" with three children in a child's express wagon, the apple trees in blossom on all sides. No doubt, Henry ranged the countryside to a greater extent even than the documents show. Mary M. Woodruff's account of a trip to Bruynswick with the Henrys, in the catalog under *Sunday Morning* (CAT. 283; FIG. 67) suggests this. It was the anecdotal and topical which interested Henry, however, rather than the land itself.

Henry as a Person

Mode of Life. At Cragsmoor Henry settled into a matrix composed of equal parts of work, practical details, social intercourse and the interests related to his paintings—architecture, antiques, photography, music and collecting historic carriages and costumes. Hereafter there would be little change in Henry as a human being, almost none in him as a painter. Note that it is impossible to date his paintings by style after, say *City Point,* 1865–72, (CAT. 96; FIG. 107).

The quality of his life was not extraordinary. Henry refers to a pass to sketch in the Smithsonian Institution (CORR. April 10, 1899). Frederick Dielman, president of the National Academy, writes to thank Henry for information about treating plaster casts with shellac and wax (CORR. March 17, 1907). W. Bradford, "artist painter of icebergs," urges Henry to send work to an exhibition in Minneapolis, on the ground that "last year they sold over $3000 worth!" (CORR. July 21, 1891). Beers Brothers, manufacturers of picture frames at 1264 Broadway, write to Henry about a lost picture (CORR. June 4, 1895) and add:

> *The trouble we think about your pictures is this, you change your address so often Glad to hear that you are going to send us some money soon as we need all we can get.*

Henry's social life went along on an equally unadventurous level. The Dalys remained his good friends all their lives; they are frequently found corresponding with the Henrys, inviting them to dinner, and so forth (CORR. January 17, 20, 1896). Thomas

Waterman Wood, a president of the Academy, writes to Henry from Springfield (CORR. April 23, 1896). W. J. Havemeyer writes (CORR. February 2, 1896) to make a social appointment. H. W. Bookstaver writes (CORR. April 16, 1891) regarding an appointment for lunch. Abraham Lansing of Albany writes (CORR. December 21, 1894) in regard to a pageant of Albany history. Brother Gilbert of the Order of Brothers of Nazareth writes (June 13, 1896) asking for the loan of sherry or port for the communion service at Cragsmoor. Earlier correspondence (CORR. December 31, 1882) is from Sam Chew, owner of two Henry paintings, *The Reception Given to Lafayette* (CAT. 114) and *The Battle of Germantown* (CAT. 144).

The Cragsmoor rector, Dr Howard Crosby, previously mentioned, writes (CORR. June 19, 1888) to thank Henry for *Corner of Ulster,* adding that "The paper is a capital exhibit of the beauties and wonders of Sam's Point." No clue to this water color has turned up. Other names which appear in the correspondence are H. C. Dallett, G. G. Stow, Mary N. Moran, J. G. Brown, George H. Smillie, Charles Collins, Fred Linus Carroll, F. D. Millet, W. H. Beard, A. R. MacDonough, Richard S. Ely, George H. Galt, Stephen Harris, L. M. McCredy, C. B. Foote, Mrs Lilian Livingston Remsen and scores of others. There is a quantity of autographs cut from their context; and among these we find the names of H. D. Martin, John Rogers, J. G. Brown, Eastman Johnson, Worthington Whittredge and A. D. Shattuck, this last annotated by Henry as follows: "Landscape painter. Gave up Art & Went to Farming. Early in 1870 at Granby, Conn." There are a number of letters thanking Henry for the gift of a photograph of one of his paintings, such as the letter of Elizabeth H. Tobey (CORR. July 1895).

Architecture. Henry's earliest drawings show a keen interest in static forms of buildings. The quantity of photographs and prints on architectural subjects in the Henry Collection indicates how he pursued this interest all his life. The first we can locate is a photograph (FIG. 44) of the Hancock House in Boston, "Taken down (according to Henry's inscription) for common modern houses about 1865." This is, writes A. Hyatt Mayor of the Metropolitan Museum of Art, "the best record I have ever seen of that great lost monument of our early architecture." The photograph was used to document the painting *The John Hancock House* (CAT. 54; FIG. 43).

Photographs by Rockwood of St John's Church on Varick street, taken down about a quarter of a century ago, have a comparable interest. The agitation to demolish this Wren church began soon after the Civil War. There is much evidence in the Henry Collection that Henry fought to mobilize public opinion to preserve historic landmarks. He painted several pictures of St Johns (CAT. 79, 324, 325; FIGS. 112, 247, 248), as well as writing to city officials (CORR. June 6, 1813) and to the Times (p. 215f.). Although Henry often took liberties with the realistic presentment of his subject, nevertheless paintings of this kind have a genuine documentary value, especially when they are buttressed by faithful documents from nature lie the photographs in the Henry Collection.

The sincerity of Henry's interest in architecture is indicated by an appeal made to him in 1870 by William Kulp, an antiquary of Philadelphia (CORR. June 18, 1870) in regard to saving old Newport houses. Kulp himself is documented by an advertisement (CL. '70), in which Martin Brothers, auctioneers, announce a *Sale of Choice Antique Furniture, The Selection of Mr Wm Kulp.* His letter reads in part:

> *I recd your letter this morning. I am sorry you can't come on. It disappoints me. However, it is all right. The next thing that grieves me is about those Newport mansions. Can't you write an eloquent letter praying Mr Fiske for the sake of Art, of all that is sacred from antiquity and more valuable in time to come, that ere it be too late, spare those gorgeous reliques that all the mechanic art of the day can never replace. I realy feel it a duty encumbent upon you to make this effort. It is quite likely if the man has a real insight into the rare merits of these reliques he would spare them. If however nothing can save them, do get the N. Y. Moran to photograph them. Oh, it is most grevious. Why did you tell me when I am so feeble in health?*

What success Henry had the Henry memorabilia do not show. A quarter of a century later he was still interested in the preservation of historic buildings, witness an editorial he saved in regard to the Jumel Mansion, this from the New York Times, January 8, 1903 (CL. '03). It ends with a plea—unquestionably congenial to Henry's own point of view—that the mansion be retained "In a dignified condition, as one of the municipal monuments of a city which has too few."

Henry's interest in architecture found outlet in building his own home at Cragsmoor. In Sketchbook 20 (CAT. 1204) there are plainly recognizable perspective drawings. There are also floor plans and a sketch for a cottage, which must be I-Enia, purchased

in 1910 from Henry by the Misses Husson and Buxton. This house appears in several Henry paintings, notably *The Flower Seller* (CAT. 335; FIG. 194). Henry's love of antiques expressed itself when he brought up, presumably from the Second Avenue wreckers (McCausland '41, p. 132), the carved staircase to be seen at the rear of the photograph of his studio (FIG. 21).

Note, also, a newspaper reproduction (DOC. '04), inscribed by Henry as follows:

> *This Mansion was built for Wm L. Stow in 1893–4 from Designs and Plans by E. L. Henry, N.A. Mr Stow sold it to Cord Meyer about 1900, and [it] is now the residence of his widow, 1916. This print was cut from the Herald, 1904.*

A letter from Robert V. S. Sewell (pasted on manuscript p. 55 of Mrs Henry's sketch), dated August 16, 1907, shows that Henry kept up his unofficial architectural work. It reads, in part:

> *The sketches you sent were of the greatest interest to me. I shall try to copy the stair rail, as well as other details in the charming old house.*

A note by Henry adds the information that Sewell was an artist, "building a fine house (time Edward VI) at Oyster Bay."

Antiques. Henry's interest in antiques was of as long standing as his interest in architecture. A letter from Thomas Peterson of Philadelphia (CORR. January 23, 1865) reads:

> *I take pleasure in sending you this day by Kingsley Express freight paid, an antique, which please accept with my compliments. Hoping it may reach you in safety & afford you some gratification.*

The letter was annotated by Henry "Formerly the property of G. M. Dallas, V.P.U. States, [1792] a present from the Tycoon, Japan. Perry Exptn 1848." The antique was No. 98 in the Ortgies catalog (Ortgies '87) and was sold for $26. Its description follows:

> *Richly decorated cabinet, with scroll on top, epoch of Louis XIV, presented to the late Hon. Geo. M. Dallas by the Mikado, at the opening treaty with Japan, 1850, U. S. Commissioner with the Com. Perry expedition; purchased at the sale of his effects after Mr Dallas' death.*

Henry often acted as agent for collectors. A letter from him to J. W. Pinchot (CORR. July 1867) gives the details of a transaction in behalf of Pinchot. Purchases included

> *an antique Bureau and Case of Drawers Chipendale style of 1760. And if the man could find you a Sofa same style as the one I have he was to send it along with the others to your address, 6 Courtland Street. The case of Drawers was $50, the Bureau $15.*

Henry embellished the letter with a drawing about an inch and a half high, to describe the case of drawers.

The letter from Kulp above quoted also discusses a piece of furniture Kulp was making for Henry. In 1871, J. W. Drexel wrote (CORR. September 5, 1871) on a letterhead with the address 53 Exchange place, authorizing Henry to draw on him up to the sum of $150. The order reads: "Dear Ned. Go Ahead. I'll back you $150." Henry annotated this: "An order of Joseph W. Drexel to E. L. Henry at Paris to draw on him to purchase some Antiques." In 1872, there is a receipt for an outlay of $20 to buy a bureau (DOC. April 19, 1872).

The Ortgies catalog gives information about Henry's taste in antiques. In his own circle he was established as an authority, and his friends used to consult him about the purchase of antiques (McCausland '41, p. 52). The carved staircase in his Cragsmoor home has been mentioned. He gave the Century Association (CORR. March 9, 1891) a "fine carved mantelpiece, now placed in the Committee Room on the first floor of the new clubhouse." Miss Annette Mason Ham of Cragsmoor and Providence, a connection of Mrs Henry, relates that Henry found much fine wood carving for his friends (McCausland '41, p. 154).

Costumes. Related was his interest in costumes and carriages. Numerous drawings, both in his sketchbooks and in the loose sketches (CAT. 1001 *seq.*), demonstrate this. His collection of costumes was famous. He and Mrs Henry often dressed up for charades (FIG. 31); and he found in his costume cupboard attire for his models to wear in period pictures (FIGS. 74, 76). A letter from J. G. Brown (CORR. December 20, 1895) requests the loan of a costume for his son-in-law. Julian Scott writes (CORR. June 18, 1897) about a coat of 1800, regarding which he wishes information. In Cragsmoor and Ellenville the memory of Henry's costume collection is still green. He had, local report has it, a costume for "every period, every age, child, man and woman" (McCausland '41, p. 21).

The bulk of these costumes went to the Brooklyn Museum in 1921 (CORR. June 16, 1941). Among them were caps, collars and dresses of the 30's, 40's and 50's, a uniform coat from a Connecticut regiment of 1776, men's dress suits of 1840 to 1850, women's dresses of the post-Civil War period, a straw scoop bonnet of 1850, bonnets of horsehair, a child's fancy braid bonnet, and finally a "covered wagon" calash of 1835–50, which inspired a 1940 copy

by a New York designer (McCausland '41, p. 14, 148, 149, 206, 237–43.)

Carriages. Henry's old carriages at Cragsmoor are not listed in the inventory of his estate. There are, however, a number of photographs in the Henry Collection (BIOG. 1900–09), as well as a copy of duties paid at the Port of Albany. The coaches are mentioned in Mrs Henry's Memorial Sketch (p. 331). She gave them in 1922 to the Johnstown Historical Society (FIG. 75). The papier mache horse which Henry used as a model to pose harness on—just as he used the mannequin "Miss Wood" (FIG. 24) for costumes—is now owned by James E. Knox of Johnstown. It is the size of a polo pony or 1600-pound horse, dapple gray, with mouth on hinge. It needs restoration, especially new mane and tail; but it is hard to find "horse painters" these days (McCausland '41, p. 12, 120, 205, 206, 217).

Among the sketches in the Henry Collection a number show Henry's archeological passion for things of the past. Some of the historic vehicles sketched are: *The Lafayette Coach* (CAT. 1051; FIG. 224), *"Rockaway" 1850 to 60* (CAT. 1151), *Old Conestoga Wagon* (CAT. 1143), *Old "Rockaway" 1845 to 60* (CAT. 1144), *Beekman Coach about 1772* (CAT. 1135), *Runabout 1835 to 1845* (CAT. 1152), *"Stage Waggon" of 1821* (CAT. 1155), and a stage which ran from South Ferry, Brooklyn, to East Hampton in the 30's and 40's (CAT. 1153). Other catalog entries having to do with vehicles are: Nos. 1137, 1145, 1154, 1010, 1138, 1157–59. Henry supported his sketches with photographs. The back of General Gansevoort's coach, Governor Bouck's coach or runabout of 1810, the stage which ran from Newburgh to Ellenville (FIG. 55), are some of these objects.

Photography. Hundreds of photographs in the Henry Collection proclaim Henry's interest in photography. Cragsmoor recalls that after his death Mrs Henry broke up two barrels of plates Henry had taken himself. People of Cragsmoor and Ellenville remember "Artist Henry" going about carrying a camera, and especially around the knife factory, so that the snapshot of "Joe" Mance may be Henry's work (FIG. 134). The inventory of his estate lists one large camera at $50 and two small cameras at $3 each. For the most part, he employed professionals to copy his work. A score of 8x10 plates are still at the Shadowland Studios, Ellenville, successor of the photographers of an earlier day, Davis and Tice (FIG. 11). In the Henry Collection there is a 16x20 plate of the painting *A Morning Call* (CAT. 937), the negative being

the gift of the Misses Husson and Buxton. This seems to be the only survivor of Henry's photographic hobby. The prints listed in the Klackner catalogs (Klackner '06), are many of them platinotypes or photogravures made from 16x20 plates (McCausland '41*, p. 11 seq. 96, 99, 120).

Two objects in the Henry Collection (p. 208), large photographs mounted on canvas on stretchers, one of them partly colored in oils, raise a question as to how many apparent paintings are in existence, which are actually duplicates made by semimechanical means. Henry was, however, merely anticipating a common practice of painters today when he made use of photographs as notes for his pictures.

Organizations. Henry was not organizationally minded, as we interpret the phrase today, nor was he a "joiner." When he belonged to art societies, it was because membership in these groups conferred prestige, important in the life of an artist who depended on conventional patronage. Membership in the Academy was indispensable to worldly success, though a great painter like Eakins was not elected till he was 56 (Goodrich '33, p. 135). Election to the Century Association (this in 1866) was another accolade. Henry belonged also to painting groups, like the American Water Color Society. He joined the Salmagundi Club in 1901 (CORR. March 16, 1901). Mrs Henry comments in her Memorial Sketch (p. 343) on Henry's feeling about the societies to which he belonged. He was not apparently active in any of them, although he acted on the committee of admissions for the Century (DOC. 1881–83) and gave that club the carved mantelpiece mentioned above (p. 51). In the Henry Collection, there is a New Year's Eve songbook from the Century, dated 1897–98, and inscribed by Henry: "Drinking the old year out and the New Year in" (DOC. 1897–98). As for the National Academy of Design, Henry is to be found in 1863 (DOC. '63), soliciting for its fellowship fund. In 1888 (CORR. January 7, 17, 1888) he made a gift to the Academy's library of some books, including Nash's Old Halls of England, perhaps a source for paintings like *The Grand Hall, Levens* (CAT. 59).

Henry did not take part in art world politics of the time, apparently. He was asked to support Harry Watrous for election as an associate (CORR. April 25, 1894). A circular letter in this year (DOC. July 25, 1894) shows that the Academy was considering selling its replica of the Doges Palace at the corner of Fourth avenue and 23d street. The next year the Academy took

up a subscription to purchase two paintings from **William H.**
Beard (DOC. April 4, 1895), to be presented to the **Century,**
pledges limited to $20. About the same time Beard wrote **Henry**
(CORR. May 5, 25, 1895) on what was evidently a burning issue
in the Academy, personnel and policy. His letter follows:

> *You were not at the Century last eve, and I felt a little nervous. Don't*
> *fail to be on hand Wednesday! If we gather our full available strength,*
> *we are triumphant! We have nothing to fear but the apathy of our own*
> *people. Not all, but if a few fail our cherished institution falls into the*
> *hands of these designing pretenders and our opportunity is gone forever.*
>
> *All the sculptors seem against us. But we still have a goodly majority if*
> *all will do as well as Carl Brandt, who is already here from his southern*
> *home, and Sellstedt comes from Buffalo, Shattuck from Con., Haseltine is*
> *already here and to be with us.*
>
> *The other party are doing their utmost to elect Dielman president (!),*
> *Maynard vice, and get Swain Gifford on the council etc. Their purpose is*
> *obvious. They too must succeed now or never! And this is therefore*
> *the deciding point of the future of the Academy. Come without fail, and*
> *be there at lunch.*

Henry apparently did not consider the issue as **burning as did**
Beard. Beard's second letter reads in part:

> *I think you were quite excusable in not coming down to the meeting*
> *under the circumstances . . . Thank heaven, we came out with flying*
> *colors! And elected two new Academicians of our own stripe. We got 13*
> *majority over the whole and Wood had 15 over Dielman, two scattering,*
> *and this settles it, unless we let go the advantage we have gained through*
> *supine neglect. The other party had gathered their full strength and*
> *seemed perfectly confident of success. It shows a waning cause when we*
> *draw secret votes from the ranks of our opponents. But the tide is turning.*

In 1899, however, the "other party" triumphed. A printed
list of nominations for officers of the National Academy of Design
(DOC. May 10, 1899) shows Dielman slated for president. If
Henry was a supporter of the Wood faction, it did not win him an
extra privilege to judge from a letter (CORR. March 18, 1898)
from Thomas Waterman Wood, quoted later (p. 62).

Other Interests. Other interests of Henry were more personal.
His love of music has been mentioned. A letter from a friend
(CORR. April 5, 1894) invites the Henrys to spend the evening,
but adds: "Do Not Dare to Come without your flute." Henry
had a habit of collecting obituaries. Two large scrapbooks of
clippings, collected by Henry, were left on the porch of the Henry
home at Cragsmoor after his death and ruined by rain (McCaus-
land '41, p. 15). The demolition of old buildings, murders,

divorce cases, articles on church music, are some of the subjects which interested Henry sufficiently so that he saved clippings on them. His flute and music for the flute are in the Henry Collection.

Personality. In person Henry was short and frail. An old friend, Martin E. Albert (FIG. 76), who used to pose for Henry and who owns a number of excellent examples of Henry's work (CAT. 152, 308, 315, 341, 347, 381) is authority for the statement that Henry never weighed over 110 or 115 pounds. He was not apparently much taller than five feet two or three inches, to judge from photographs (FIGS. 5, 24, 31, 32). In later life he settled down to the discreet routine of tableaux (CL. '90) and teas, witness the Cragsmoor Journal of August and September 1912. But in his youth he made the appearance of a gay blade (FIGS. 33, 35, 38). A medley of objects in the Henry Collection gives a composite portrait—a small flask, about four ounces capacity, with the monogram *E L H*; a prayerbook with the name *Edward Henry, 1860* on the cover and inscribed inside the cover "From my friend Frederick A. Guion, September 1860"; Wells family records from Johnstown; the Livingston family coat-of-arms, framed; two fans with ivory ribs; also the flute.

In Henry's 1898 diary (CAT. 1214) there are items of expense for wine, an item which seems to be a bet on the races, and a drinking song, as well as hymns and religious poems. A card of admission to the Newport Casino (DOC. '91) suggests that Henry's passion for horses was not confined to esthetic appreciation. His love of dogs has been referred to, and there are many drawings with the family dogs, Peter and Charley, as chief actors, especially one dated at Ellenville, 1880, in Sketchbook 5 (CAT. 1189). Mrs Henry's niece, Mrs Lawrence Stetson of Johnstown, relates that once when she was to visit the Henrys at Cragsmoor (FIG. 76), her visit was put off because a pet dog had died!

From Henry's Cragsmoor friends and acquaintances, one gets a sense of Henry as a person. There is some conflict of testimony. But outlines are clear. Traits of character frequently mentioned are that he was quick-tempered, swore like a trooper, teased Mrs. Henry a great deal, was somewhat penurious and liked to wear old clothes. He had a parlor trick so remarkable that it is still a legend at Cragsmoor, of "a summer night's electric storm." Regarding Mrs Henry, there is also general agreement. She was "very precise" and "rather prim and proper," while "every one liked Mr Henry." On the other hand, "They were a darling old-fashioned couple, who pretended to quarrel." Or, "Mrs Henry kind of henpecked

the old gentleman. But she just adored him. She worshipped him." A typical Henry joke, reported in Ellenville, was: "I gave Mrs Henry fifty cents last week. I guess she needs some more." (McCausland '41, p. 25, 131, 148).

There was a touch of the practical joker in Henry's character, to judge from *A Private View* (CAT. 334; FIG. 208). The only clue to this painting is a photograph in the possession of Mrs Charles B. Knox of Johnstown, inscribed on the back "A Caricature Exhibition held at the Century Club. This Caricature Picture on the style of dress & hats of 1905–6. *Private View of the Natnl Academy Exhbtn,* showing the Absurdities in Dress." Henry added a legend in the lower righthand corner, under three feathered creatures. It reads "How we Three, a Tumbler Pigeon, a Top Knot Hen, and a Goose, Suggested the Present Styles of A.D. 1905–1906."

Career as an Artist

Honors and Awards. Henry exhibited in the National Academy exhibitions every year from 1859 to 1919, except 1862, 1873 and 1913. Altogether he showed 147 pictures, not counting the years 1920, 1925 and 1942. He exhibited regularly with the American Water Color Society after its formation, showed at his various clubs, and was a particular favorite in the annual Gill exhibitions in Springfield, Mass. (Gill, 1878–1928). From 1878 to 1919, Henry exhibited there on 16 occasions, showing a total of 20 works, many of which must have found their way into Springfield homes though inquiry has located only two (CAT. 139, 162; FIGS. 189, 139).

During his long exhibiting career, Henry received numerous honors of the academic order, including honorable mention at the Paris Universal Exposition of 1889, a medal at the World's Industrial and Cotton Centennial Exposition in New Orleans in 1885, a special medal for his railroad painting (CAT. 257; FIG. 162) shown in the Transportation Building at the Chicago World's Fair of 1893 (CORR. October 10, 1893, pasted on MS. p. 39), a bronze medal at Buffalo in 1901, a silver medal at the South Carolina Inter-State and West Indian Exposition held at Charleston in 1902, and a bronze medal at the St Louis World's Fair of 1904. In the Henry Collection (DOC. '02) there is the certificate of award from the Charleston Exposition for the oil painting *Waiting for the Ferryman* (possibly CAT. 277). Mr and Mrs Charles Peters of Cragsmoor (McCausland '41, p. 179) have presented to the State

Museum Henry's certificate of award at the New Orleans Exposition and his diploma of award at the Paris Exposition, with many other items.

Sales and Success. Election to the Century Association in 1866 and to the National Academy as A.N.A. in 1867 and as N.A. in 1869 started Henry on the road to formal success. His sales up to 1870 have already been noted (p. 30). Throughout his life he found patrons for his art, making steady sales, though for the most part, his sales were not spectacular. Catalogs of the annual Academy exhibitions show that in the years 1880–96 (National Academy of Design, 1859–1919) he priced his work from $125 to $2000. Two canvases are listed at $1000 and $1500; but the median is around $500. Martin E. Albert reported to me that Mrs Henry told him Henry received $15,000 for the large railroad painting now in the Albany Institute of History and Art (CAT. 257; FIG. 162). Henry's 1898 diary (CAT. 1214) notes an item on May 19th, *chk NAD for big church, $1620.* Entries in this diary and the 1899 diary (CAT. 1214) show that he sold water colors as low as $50. A letter from John H. Weiss of Harrisburg (CORR. December 26, 1889) to W. S. Howard and Howard's note to Henry (CORR. December 27, 1889) indicate that Henry received $900 for *Marriage in the Olden Times* (CAT. A–222). An unidentified newspaper clipping among the obituaries pasted in at the end of Mrs Henry's manuscript notes that *"For the Railway Station* [CAT. 58] he received $530, which in 1876 was a price that meant fame and fortune to a rising American painter."

In the two diaries—sole known survivors of Henry's undoubtedly meticulous personal records—there are accounts of the year's sales for 1898 and 1899. In 1898, he received from the sale of *pictures etc.* $2226.60 and from *coupons* $150, a total of $2376.60, against expenditures of $1212. From Klackner royalties, he got $96.85 in three payments. Paintings sold variously at $50, $75, $100 and $135. For a music design for a Mr Hadley Henry was paid $25. The sale of the "big church"—the large canvas now owned by J. G. Myers Hilton of Saugerties, *Sunday Morning* (CAT. 283; FIG. 67)—for the sum of $1620 was certainly a red letter day. This is one of Henry's outstanding canvases, 34 by 62 inches, painted with great attention to detail. The diary further records the history of the work put into this painting by Henry. From January 4th to March 1st, he painted almost every day on the big church, not completing it in time to send to the

Century, but finishing it so that it could go to the Academy on March 9th. In 1899, Henry's total sales were $2037.13, with an additional $400 presumably again from coupons. The item for expenditures is not clear, being either $1731 or $731. Royalties from Klackner came to $132.50. One picture, *A Rainy Day* (CAT. A–293) sold for $435, *Bound to Shine* (CAT. 223) for $100, while a check from the Academy for $270 paid for several unnamed works. This year Henry sold well at the Gill exhibition, with items for *Saturday Morning* (CAT. A–294) at $175 net and for *Off the Main Road* (CAT. 941; FIG. 254) at $75. It is strange that none of these pictures turned up in the Springfield investigations.

Vogue. Henry's success depended not only on popular vogue but also on his willingness to cut his cloth to suit his customers. A letter from H. C. Henry of Minneapolis (CORR. November 30, 1888) suggests the complacence with which successful artists of the period met their market's demand. It reads:

> I saw a small painting of yours ("Forgotten") at the Exposition here that I desired to have but was too late. I should like a scene from your hands about as follows. The time near sun-rise on a cold winter morning. An open room which may be comfortably furnished with a stove or fireplace, a bed and other furniture. The room and especially the bed are inhabited by a man and his wife. Whether or no there is a baby will depend on you. The unmistakably nightcapped head of the wife plainly appears above the coverings on the front side of the bed. The poor shivering husband in his nightgown only & bare feet is building or lighting the fire in the stove or grate. The room is in disorder with the clothing, pants, dresses, boots, shoes etc., scattered about, as thrown off & stepped out of the night before. There may be a pair of pants hanging by the suspenders from a chair. I think the marked idea of the painting should be the excessive cold of the morning. A good size window opening out, with glass partly frosted, icicles suspended on the outside, snow covered hills with the morning light just falling on them etc., as you will best know. I am not drawing rigid lines for you to follow, but wish to indicate what I want. Can you do this satisfactorily to your reputation for say $150 or $175 & if so how long would it take you? You have a fine painting on exhibition that I would like if I could afford it (Smith has it on exhibition at the West Hotel.) P.S. What branch of the Henry family do you belong to?

The painting referred to in the first sentence may be *Forgotten* (CAT. 208; FIG. 253). Whether "Artist Henry" ever painted the picture according to the Minneapolis Henry's specifications is not known. At any rate, requests for pictures cut to pattern were not unique. In the Peters gift, there is a letter (McCausland '41, p. 175) dated March 16, 1899, from Oliver H. Durrell of Boston

to Henry at 111 East 25th street, New York, which states that the writer is sorry the water color is sold and asks if Henry would paint a similar subject for him in oil, which would remain in a private collection and never go on the market.

Reproductions. The popularity of Henry's kind of art is gauged by the quantity of reproductions of his work made during his lifetime. Many of these are still very much in evidence. Frequently during my field trip in the Cragsmoor-Ellenville country I would be told that Mr or Mrs So-and-So owns a Henry "painting." Investigation almost always showed the alleged "painting" to be a platinotype or photogravure, sometimes colored by hand, sometimes in black and white. As early as 1887, C. Klackner, 7 West 28th street, New York (Klackner '06), was publishing reproductions of Henry's paintings (CL. '87). The demand for Henry prints warranted the publication of a catalog of 12 pages with 40 illustrations and a list of seven titles not illustrated. In the Henry Collection there are three copies of this catalog, which I have not been able to date. In 1906 the Klackner firm published a more elaborate catalog, comprising 16 pages with 80 entries and 60 illustrations. The State Museum owns two of these. According to Martin E. Albert, Klackner bought all the paintings Henry did not immediately sell, and when Mrs Henry did the bargaining, she got top price. Two letters from Klackner to Henry (CORR. March 17, 19, 1894) discuss terms, Henry apparently considering Klackner's offer too low. The records of this firm, now out of existence, are not available, though a nephew, George C. Klackner of the same address, has a number of large Henry prints in fine condition.

Many of the Henry reproductions were colored by hand by Mr and Mrs Henry, and also by a Mrs Anna Saxton Hartshorn of Ellenville (McCausland '41, p. 1, 20, 62). The "big church" painting referred to above was immediately photographed and copyrighted on its completion; and on April 14, 1898, we find Henry noting in his diary that he "colored all day big church print." Among the documents in the Henry Collection are a number of copyright applications, including those for *The Opening of the First Railroad in New York State* (CAT. 257; FIG. 162), *Home from the War* (CAT. A–303) and *The Old Clock on the Stairs* (CAT. 379; FIG. 214) (DOC. April 22, 1893; February 12, 1903; June 27, 1910).

The case for reproductions is made by the unidentified newspaper clipping quoted under *Sunday Morning* (CAT. 283). It reads, in part:

[The painting] *ought to be engraved, or well printed in colors, so that when the original is in the possession of some private owner, or placed in some public gallery, people who will never have the opportunity to look at it may have a copy to hang in their homes.*

With the objective of a democratic, popular use of art there can only be the most general agreement. Today artists meet the genuine need for art for the home by working directly in some practical "multiple original" medium, like the recently developed silk screen color print (See 107th Annual Report of the New York State Museum (p. 43.) In Henry's time, however, direct graphic work had fallen into a decline. The ambitious Academy piece was fashionable. The smaller and less conspicuous print was not. Hence, artists depended on indirect, semimechanical methods for the reproduction of their work.

If an objection is to be raised to these reproductions, it is that they lack of the quality of direct multiple original prints. To be sure, there are some good etchings, such as *Near the Brandywine* (CAT. 939; FIG. 243) and the large print of *Sunday Morning* seen at George Klackner's. But on the whole, the platinotype process produced what amounts to a record rather than an esthetic expression. When the large photographs were "water colored" by a number of hands, the result got rather far away from Henry's original color scheme. There is a picture in the Springfield (Mass.) Museum of Fine Arts which was once thought to be a Henry original but now seems to be a print or photograph painted over (CAT. 907). No doubt, focusing of attention on Henry will bring to light many similar instances.

The mere repetition of a subject, however, does not in itself seem unethical. Most artists repeat themselves; and it is only when the style a man employs is realistic or representational that the repetition is glaringly evident. A contemporary of Henry, the very interesting still life painter, William M. Harnett (Downtown Gallery '39) painted the same "nature-vivre" arrangement over and over again in canvases such as *With the New York Times, With the New York Herald, Flute and Times, The Daily Telegraph* and *Public Ledger,* or his numerous violin pictures. As to the ethics of coloring photographs, there is no question at all if the colored photographs are described as such. On the other hand, there may be a need for more common sense than has been shown toward this question. Is it vastly different to use a still photograph to take the place of handcraft drawing or to project by motion picture technic a design on a wall for the mural painter to paint?

The experience of John Kane (Janis '42, p. 78) in coloring photographs gives a somewhat more human orientation to the problem. Kane questioned a narrowly puristic interpretation. In the ultimate effect, probably we had better judge art by its content and communication rather than by its materials and means.

At any rate, the reproductions not only served to spread Henry's name and fame, but from the documentary point of view, they insured that these visual records of life in America have a better than fair chance of surviving the uncertainties of time and social change. Moreover, they filled a need which persists even to today. The use of Henry's paintings on calendars, which began in his lifetime (CAT. 302, 304, 313, 321, 331), continues. Almost life size is the color reproduction of *The 9.45 a.m. Accommodation* (CAT. 65; FIG. 109) used by the West Virginia Pulp and Paper Company on its 1941 calendar. That the appeal of Henry's work is superior to the often sneered at "calendar art" may be gathered from a story told by a museum curator. He, with two well-known photographers, stopped in a west coast saloon for a beer. The only work of art was the above calendar. Sequel: The museum curator liked the painting so much he got a copy of the calendar too! In 1942, the same company reproduced *The Clermont* (CAT. 323-a) in an edition of 30,000. An interesting *obiter dictum* connected with this calendar is that the best efforts of the writer and the advertising agency handling the calendars could not locate the painting itself, in spite of the fact that correspondence in the Henry Collection gave what seemed a first class "lead." All this shows that there exists a real audience for Henry's work.

Economic Pressure. The artist's life is not all popularity and affluence, however. A brief sentence in a letter from James Henry Moser (CORR. November 2, 1894) tells another story: "I find it gives me all I want to do to keep the 'pot biling' this year and sometimes I am quite discouraged." Henry himself knew phases of potboiling, such as the music design above-mentioned and the sketch for Ed. E. Ayer (DOC. '77). This was *A Portrait from life by E. L. Henry of the late Edward Ayer, father of Edwd E. Ayer, one of the pioneers of Chicago, taken at Geneva Lake, Wisconsin, 1877.* The drawing was used on the checks drawn by *Ed. E. Ayer, Ties, Telegraph Poles, Post by Cargo* on the North Western National Bank of Chicago and shows the "pioneer" sitting in a rocking chair, cane against his knee. That there were times of economic pressure may be gathered from a letter from George W.

Stow (CORR. May 11, 1895) saying he will be happy to lend Henry $50 and Henry should have asked him before. A letter from Henry to J. H. Smith, dated August 15, 1915, in the possession of Martin E. Albert, advising against the sale of *In the Old Stage Coach Days* (CAT. 341; FIG. 249) reads, in part:

> *That stage picture I considered one of my best works At present, no one seems to have any money for pictures just now. I haven't sold anything except one small work since last Christmas and all the other artists' complaint is the same except a few portrait painters, and in Europe it is deplorable.*

Waning Reputation. The above quotation seems to imply a gradual decline in reputation and popularity. Lucia Fairchild Fuller A.N.A., writing in Scribner's after Henry's death (Fuller '20), suggests this when she discusses the amalgamation in 1906 of "the National Academy of Design . . . with the Society of American Artists—which was made up of these now successful younger men." She continues:

> *Consequently, an academician, instead of having a right to hang several pictures on the line in every exhibition, was allowed only one picture, and that hung where the hanging committee pleased. . . .*
>
> *As a matter of fact, although during the first years of this regime, Mr Henry's small canvases were sometimes discourteously used, it was not for long. After a picture or two of his had been "skyed" or hung in what is known as the Academy's Morgue (a room lit only by artificial light), back to the light and back to the best gallery they came.*

A letter to Henry (CORR. March 18, 1898) from Thomas Waterman Wood, president of the Academy, suggests that the process of attrition had begun sooner. It reads:

> *You know by our Constitution, the President is carefully excluded from any connection whatever with the Hanging Committee. The place where you hear your picture is hung, would be a very good one if that "cussed" heater was out of the room.*
>
> *I hear that my portrait of Gay is in the South room, and so is his landscape. I will see Weldon in the morning to ascertain if a change can be made, although I am afraid it is too late.*

Henry's Estate. As he grew older, Henry's production slowed up, as well as his sales. At his death, he left only a few canvases, according to Arthur V. Hoornbeek of Ellenville, who appraised the estate (McCausland '41, p. 41). The inventory (McCausland '41, p. 118 *seq.*) made by Raymond G. Cox, Ellenville lawyer, executor of both Mr and Mrs Henry's estates, listed the following paintings at the Milch Galleries in New York:

1 water color 10x12 inches
Reading the Story of Bluebeard (CAT. 145; FIG. 140)
Waiting for the Stage (CAT. 387; FIG. 216) 7x10 inches
Old St Mark's, Bowery (oil) (CAT. 381; FIG. 215) 25x27 inches

The following were listed as being at the Brooklyn Warehouse
Storage Company:

1 frame containing 4 framed paintings, *The Four Seasons*
 (CAT. 372, 1–4; FIGS. 204–7) each 6x9 inches
1 large oil painting
2 life size lay figures $4
2 easels
1 black mirror used by artists

Probated in the Kingston Surrogate's court June 6, 1919,
Henry's estate was valued at approximately $10,000 to $11,000
personal property and $5000 real estate. At her death nine years
later, Mrs Henry left an estate valued at approximately $47,000.
In the inventory of her estate, the following were listed:

2 wax figures
Old fashioned costumes
Studies for paintings
Swords and pistols
5 studies for paintings
1 large camera $50
2 small cameras each 3
1 large oil painting *Lady* 3
Old cuts, prints, sketches, photos and studies
Small chest of paints and brushes
Portfolio of photographs
Many little sketches, studies, photographs and other details used in
 his work.

The bulk of the drawings, photographs, prints and sketches are
now in the Henry Collection.

Henry's Death. Henry died in Ellenville at the home of Mrs
Nelson Terwilliger on May 11, 1919, having contracted a cold on
the train coming up from Florida (McCausland '41, p. 18). He
was buried in Johnstown, where Mrs Henry was later also buried.
His last painting, unfinished, was *Florida Landscape* (CAT. 391;
FIG. 218). Henry's death evoked a flood of tributes. recorded in
part below.

Appreciations of Henry

Obituaries. The American Art News wrote in its issue of May 17th, seeking a just evaluation for a kind of painting which had already then gone out of vogue:

> *Some critics have considered Henry more as an illustrator than as a painter as he deals with minute details and carefully finishes his canvases to the end, like his early fellows of the old Hudson River School—but this estimate is hardly a fair one.*

An unidentified newspaper clipping pasted at the end of Mrs Henry's manuscript reads:

> *Only the older generation recalls familiarly the paintings of E. L. Henry His pictures today are miles out of fashion in manner and subject In his own metier, Mr Henry had no superior. His simple, homespun genre paintings, too full of precision and detail to suit the tastes of the moment [1919] are the best of their kind*
>
> *The tendency of the day is to slight the fact that every true picture tells a story. The apostles of "art for art's sake" are in the ascendancy. They try to relegate the story-telling picture to the realm of illustration*
>
> *Mr Henry never failed to tell a story with his pigments and to tell it as well as any one who painted in the same style. It was the style of Meissonier and Knaus, and with them he was one of the great masters of the style into which he never failed to put something that was his own.*

A second unidentified newspaper clipping pasted at the end of Mrs Henry's manuscript reads in part as follows:

> *. . . occupies a place in American art history . . . that is absolutely unique. He is the Washington Irving of a painted "Sketch-Book," the genial and gracious old-school picture chronicler of the nation's colonial period and of the early and middle nineteenth century*

The recently discovered paintings of Quidor (Baur '42) make the comparison with Washington Irving seem a little inappropriate. This is the advantage of hindsight, however, and should not be held against Henry's critics of a quarter of a century ago. The lack of accurate knowledge which bedevils the student of art is made evident, though, when the obituary goes on to state that Henry produced in all less than 200 works. The catalog of this report—by no means an exhaustive listing—indicates how folk error is spread even about facts of so recent occurrence that they could be checked and verified. The clipping continues:

> *He was slow, not so much from technical virtuosity as from his habit of meticulous documentation in every detail. These pictures occupy places of honor in the principal art museums and historical societies of the country, as well as in many of the best of the conservative private collections of native painting.*

Here is a further error. If the principal art museums and historical societies of the country owned work by Henry in 1919, they have managed to lose it since; for of the 57 American museums of 59 replying to a questionnaire sent out by the New York State Museum in the summer of 1941, none had any paintings by Henry. Public institutions, other than the State Museum, which own work by Henry today are the Metropolitan Museum of Art, the Corcoran Gallery, the Albany Institute of History and Art, the New York Historical Society, the Yale University Art Gallery and the Haggin Memorial Galleries. The notice continues with a remark which sheds light on the critical values of the time:

> Then the New Moment intervened, and garish impressionism eclipsed the pale-lighted and lavender-shaded canvases [of Henry].

Finally it ends with what is surely, to our later eyes, a dubious compliment:

> The technical style of E. L. Henry underwent no change or evolution in the full 50 years of his professional career.

A third unidentified newspaper clipping pasted at the end of Mrs Henry's manuscript places what probably informed opinion today will consider a more correct value on Henry's work. It is headed *Pictures as History* and reads in part:

> a phase of pictorial art too little understood or appreciated . . . pictures as historical records
>
> As an American social historian, Henry may have failed of recognition in his lifetime . . . But there can be no doubt of the value of his pictures to the social student of future years. Now that St John's Chapel in Varick Street is gone forever, Henry's charming picture of it (CAT. 79; FIG. 112) preserves a social and architectural record that American art could ill spare.

A sound evaluation was expressed by Will Low in the Evening Post (Low '19). His criticism follows in part:

> His work . . . will remain . . . unique . . . and a typical American product little affected by his early training in France, devoted to the perpetuation of truly national types and forming, when the day comes for its better appreciation, a life work of which an American artist may well be proud . . .
>
> With such patriotic interest can we regard Mr Henry's art, that our Metropolitan Museum could hardly undertake a more pious task than assembling a really comprehensive exhibition of his varied work; varied indeed more than is generally realized, though always related to our American life.
>
> Without claiming for Mr Henry a dominant place, there are few American artists who have better served their country in preserving for the future the quaint and provincial aspects of a life which has all but disappeared since we have become the melting pot for other races than our own.

Memorials. The memorial from the annual report of the president, Herbert Adams N.A., read at the annual meeting of the National Academy of Design, April 28, 1920, presents the judgment of his lifelong colleagues. It follows:

> No one can doubt the peculiar historic interest as well as the genuine charm of the paintings of Edward Lamson Henry—a full-fledged Academician for over half a century. Mr Henry was born in Charleston, South Carolina, January 12, 1841; was elected an associate in 1867; an Academician in 1869. Although he studied in Paris with Gleyre (that same Gleyre who had perhaps more influence upon the art of Whistler than is generally admitted) Mr Henry's art has a characteristic American quality, no doubt enhanced by his subjects, yet not wholly due to them. In depicting on canvas the manners and customs, the inventions and habitations, the politics and pioneering of his native country during the first half of the nineteenth century, Mr Henry stands unrivalled. Surely he may be called the Meissonier of America. His contribution to our art is historic, unique. No other painter approaches him in the delicate delineation of such subjects as "The First American Railway Train" in the Albany Historical Society.

From the Century Association also came a memorial, printed in Mrs Henry's Memorial Sketch (p. 344). Pasted at the end of her manuscript is a letter to Mrs Henry from H. Bolton Jones, secretary, in behalf of the Artists Fund Society. It reads:

> I am directed by the Board of Control to convey to you its deepest sympathy in your bereavement and to assure you that the Society feels deeply the loss of one of its honored and beloved members. Mr Henry occupied a unique place among the artists of America and I know of none who can fill it.

Contemporary Critical Opinion. Appreciation of Henry during his life was not undiscriminating, to judge from various clippings in the Henry Collection. A letter from Frank T. Robinson (CORR. July 25, 1895) inclosed a clipping from the Boston Transcript for Saturday, July 6, 1895. In the article, Robinson has called for the founding of a National Museum of Art which would be a truly *American* institution, devoted to the encouragement of work by living Americans. He also urged the creation of a new post "minister of art for our cabinet" and suggested for the office the president of the Metropolitan Museum of Art, Henry G. Marquand. Evidently he ranked Henry among those deserving of support; for he wrote:

> Once I get interested in an artist I never let go. Perhaps I like to endorse myself. At all events, I am with you and your future and want to know you personally as I do your efforts on canvas.

An unidentified newspaper clipping, probably of 1904, discusses Henry's work as follows:

> . . . a confirmed academician . . . This pupil of Gleyre . . . with the Meissonierlike technique, paints avowedly in a style that is long since out of date; even his old friend J. G. Brown has been influenced by modern ideas caught in the currents of impressionism. Not so Mr Henry. He calmly continues to paint those delicate studies of a vanished epoch in this country with the knowledge of an archeologist Not so broadly human nor so humorous as W. S. Mount or Eastman Johnson, nevertheless Mr Henry has made his own niche and fills it admirably This evocation of sweet, brave, old fashioned days when paint was paint and neither poetry or drama, Mr Henry has mastered the secret of, although he seldom dives deeper than, the anecdote.

Finally, the American Art News may be found writing in 1906, as follows:

> . . . is in a sense almost the Doyen of American figure and landscape painters. He is really the art historian of American early life and customs, for his pictures have had for their subjects the life of the United States during the late 18th and early 19th centuries. To the depiction of these scenes and times, their quaintness of custom and costume, Mr Henry has given a life of persevering study and research, and his portrayals of such scenes . . . are familiar to the public everywhere through countless reproductions. He is still painting [this at the age of 65], and no American collection or exhibition is really complete that has not an example of his able brush.

Such is the sum of the life and activity of this typical and therefore significant nineteenth century painter.

List of Henry's Addresses

The following list of addresses is taken verbatim from entries in the annual catalogs of the National Academy of Design.

1859 No address
1860 Philadelphia
1861 Now in Rome, Italy
1863 15 Tenth street [New York]
1864 Studio Building, 15 Tenth street
1867 51 West 10th street
1885 3 North Washington square
1887 Ellenville
1888 58 West 57th street
1892 77 West 45th street
1893 35 West 14th street
1894 51 East 59th street
1895 7 West 43d street [Century Association]
1896 111 East 25th street
1899 7 West 43d street [But Henry lived at 111 East
 25th street (see McCausland '41, p. 175).]
1900 111 East 25th street
1901 7 West 43d street
1904 222 West 23d street (Hotel Chelsea)
1905 7 West 43d street
1906 222 West 23d street
1907 7 West 43d street
1909 222 West 23d street
1910 "The Chelsea"

The Chelsea Hotel continued to be Henry's New York home until his death, though there are no more entries in the N. A. D. catalogs.

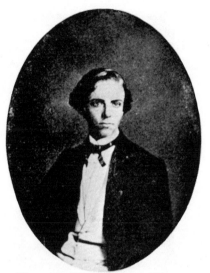

Figure 2 "E. L. Henry. When a young student of art. Taken 1859 in Phila. at the age of 17." (Photograph, Henry Collection, New York State Museum)

Figure 3 Sketch of E. L. Henry by J. G. Brown, 1868. (Henry Collection, New York State Museum)

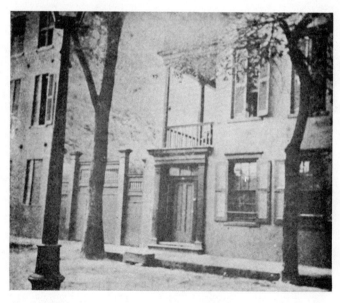

Figure 4 Henry's birthplace: "Old House in Society Street, Charleston, S. C., where I lived when I was a little one." It was built in 1820. (Photograph, Henry Collection, New York State Museum)

[69]

Figure 5 E. L. Henry. "Paris taken 1862"

Figure 6 E. L. Henry. "Taken in Phila. 1865"

Figure 7 "Taken in Whittredge's Studio, Tenth St. Studio Building, N. Y."
(Reading from left to right and alternately from row to row) "Thos. Le Clare,
J. F. Weir, Whittredge, Casilear, S. R. Gifford, J. G. Brown, McEntee, Wm Hart,
Wm Beard, Regis Gignoux, R. W. Hubbard, S. J. Guy, E. L. Henry—1866.
All have passed away (1912) except J. G. Brown, J. F. Weir & E. L. Henry."

Figure 8 Frances Livingston
Henry. 1876

Figure 9 Frances Livingston
Wells [1867–72 ?]

Figure 10 Frances L. Wells,
1873–74, wearing a costume
from Henry's collection

Figure 11 Mrs Henry, *circa* 1880
(Tice's Fine Art Studio, Canal
street, Ellenville, N. Y.)

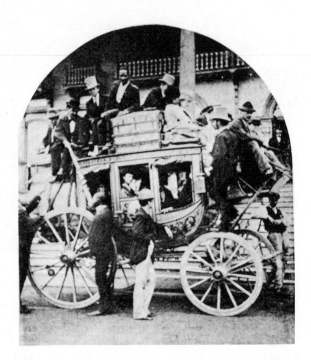

Figure 12 "Lake George, Sept. 10th, 1874." Henry is on top of the coach, at the left, wearing a top hat

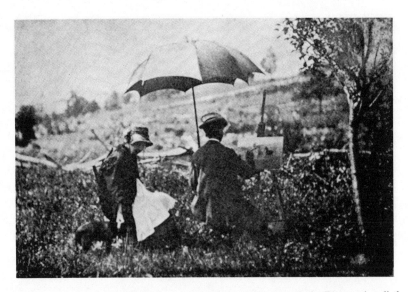

Figure 13 "Back of Blakeley's on the Mtn. Taken by Robt Blum who died 1903, about 1883. Moi, Frances & little Peter who died Dec. 1884"

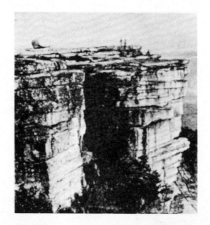

Figure 14 "Sam's Point, 2234 feet, overlooking the Hudson Valley, Cragsmoor, Shawangunk Mountains."

Figure 15 Sam's Point Ledge, November 1907

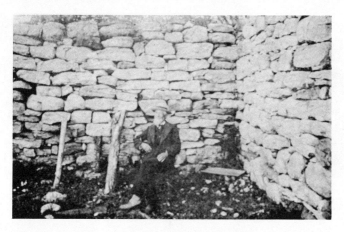

Figure 16 "Thomas Botsford (born 1824, died 1899) at the old wall, 1891"

Figure 17 "Maratanza Clouds. Looking south across the lake September '04"

Figure 18 "Pickers Camp, July 1905." Where the migrant huckleberry pickers "squatted" on Sam's Point

Figure 19 "Full of dear memories &
where we lived for many years. 218
E. 10th, last of April, 1904."

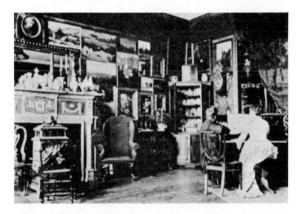

Figure 20 The Henrys' studio, 3 North Washington
square

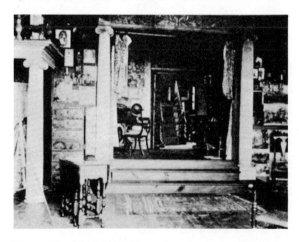

Figure 21 Henry's studio at Cragsmoor. "Newel post
40 inches tall, base 9 inches, ☐. Carved handrail 30, 17
columns. Small mantle 77 inches long"

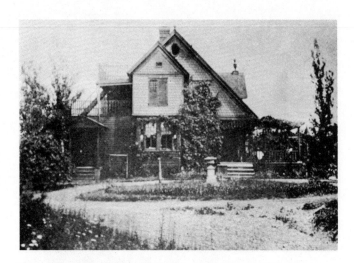

Figure 22 The Henry home at Cragsmoor in Henry's time

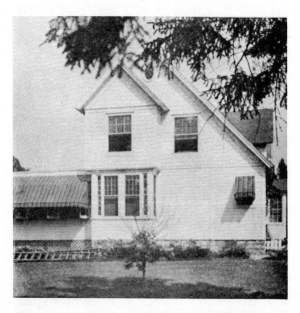

Figure 23 The Henry home, 1941, now the residence of
Mr and Mrs R. L. Foster

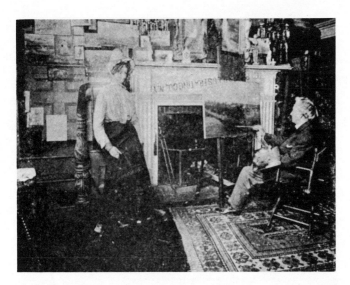

Figure 24 Henry at work, *circa* 1917. "Miss Wood," model. looks on. On his easel may be seen *The Floating Bridge*, CAT. 380

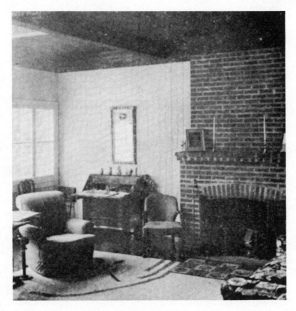

Figure 25 Henry's studio as it looked in 1941

Figure 26 The Henry barn, where Henry had his studio
when the Henrys first moved to Cragsmoor

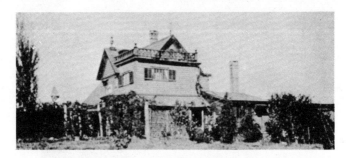

Figure 27 Another view of the Henry house in his day

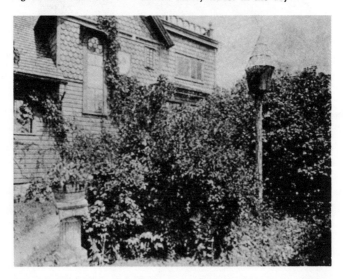

Figure 28 Henry's garden (Photograph by Jessie Tarbox Beals)

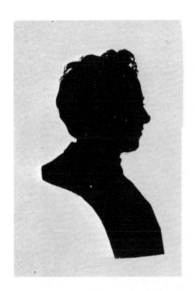

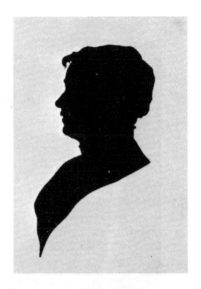

Figure 29 E. L. Henry, 1888:
CAT. 1215. A silhouette. Col-
lection, Bernard H. Cone

Figure 30 F. L. Henry, 1888:
CAT. 1216. A silhouette. Col-
lection, Bernard H. Cone

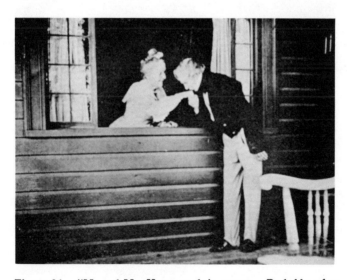

Figure 31 "Mr and Mrs Henry at their cottage. Probably taken
by Dr Northrup in August 1910"

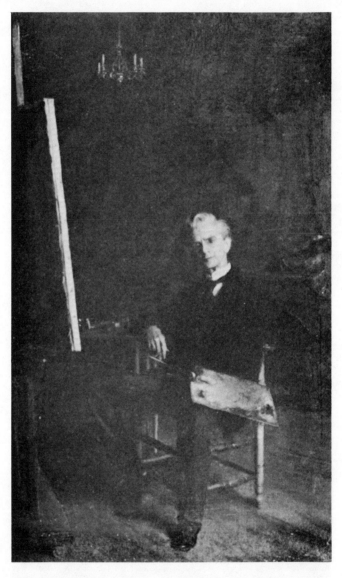

Figure 32 Portrait of E. L. Henry, N.A., by Charles C. Curran,
N.A., 1909: CAT. 1220. Collection, New York State Museum

The Work of E. L. Henry

Introduction

THE HENRY CATALOG lists about 150 known oils and water colors in museums and private collections and about 250 oils, water colors and sketches in the Henry Collection, and over 200 paintings are recorded by other evidence. Henry's paintings range in size from 6 by 5 inches—the small portrait of Mrs Henry (CAT. 117; FIG. 227)—to 42¾ by 110 inches—*The First Railway Train on the Mohawk and Hudson Road* (CAT. 257; FIG. 162)—though in the main his pictures were small. Henry worked mostly in oils; however, the catalog lists a number of water colors and black-and-white wash drawings, the latter usually early. A considerable body of work thus exists from which to evaluate his painting.

The exhibition of about 70 of Henry's oils and water colors, held in May 1942 at the Century Association in New York, while not a wholly accurate cross section, afforded an exceptional opportunity to compare his development period by period. Such events —and especially a project like this study and the publication of this report—emphasize the need for re-examination and revaluation of America's typical 19th century academic painters. It would be possible to argue that they fulfilled their function, produced their work, made their contribution, passed into oblivion as their vogue waned, and need not be exhumed. Henry illustrates the cycle; only in the past few years has his name come to notice again. That attitude, however, seems unhistoric, and, indeed, present-day criticism more and more focuses attention on the origins and evolution of American art so that by understanding the roots of native culture we may more successfully encourage living art in America.

The need for re-examination and revaluation of the past, of course, is not confined to the immediate American past. In all fields of human endeavor genius rises from the average or typical activity of the time. The promotion of scholarship leading to humanistic knowledge requires that we more and more survey the characteristic qualities of every country and every craft in every age; such knowledge supplies the background against which continuous human progress may be plotted.

Growing interest in the American tradition has brought critical attention to bear on the minor artists who form the base of average or typical activity on which genius builds. The point is well

formulated in John I. H. Baur's introductory note to the auto-
biography of Worthington Whittredge (Whittredge '42, p. 5), a
contemporary and friend of Henry. Baur writes:

> Perhaps most interesting . . . is the fact that Whittredge's experiences and
> ideas come as close to being typical of his time as those of an individual
> can. The obstacles that he faced in obtaining an art education in the still
> primitive Middle West, the search for more adequate training in Duesseldorf
> and Rome, the conscious striving to contribute to the building of a native
> American school—these were the problems faced by almost every artist
> of the time, and Whittredge's solutions were, too, those of the majority.
> He was not a man in conflict with his day, and the Autobiography is in no
> sense a document of revolt; he was if anything too much of his era for
> his own good as an artist, but for the same reason the story of his life
> may well stand as a symbol of the experiences and esthetic judgments of a
> generation of American painters.

Holger Cahill makes a further statement of the principle (Cahill
'36, p. 18), writing in part as follows:

> . . . it is not the solitary genius but a sound general movement which
> maintains art as a vital, functioning part of any cultural scheme. Art is not
> a matter of rare, occasional masterpieces. The emphasis upon masterpieces
> is a nineteenth century phenomenon. It is primarily a collector's idea
> and has little relation to an art movement. When one goes through the
> galleries of Europe which preserve, in spite of war, fire, flood and other
> destructive forces, an amazing quantity of works from the past, one is struck
> by the extraordinary amount of work which was produced in the great
> periods. During the early part of the twentieth century it is said that some
> forty thousand artists were at work in Paris. It is doubtful if history will
> remember more than a dozen or two of these; but it is probable that if
> the great number of artists had not been working, very few of these two
> dozen would have been stimulated to creative endeavor. In a genuine art
> movement a great reservoir of art is created in many fprms, both major and
> minor.

Not only does present-day critical opinion seek better knowledge
of the immediate American past for the sake of throwing light on
the present, but particularly it stresses that rediscovery of our
tradition necessitates that "periodic revaluation of the past" which
Lloyd Goodrich has called "one of the most important functions
of criticism." Such revaluation is valuable and indeed essential
because the function of time added to experience makes it possible
to obtain a clear view of what was not necessarily always seen
clearly in its own period; and historical logic may be observed, as
clichés, slogans, hypocrisies and mediocrities fall into order. In
regard to this study, the forces which beat on artists in the post-
Civil War period are plain in retrospect, as is the period's typical

esthetic expression. That expression is described in this report as "the visual, sentimental image," a conception defined in the section on esthetic effects in this chapter. (110 f)

The foregoing is a statement of the point of view of this discussion. The thesis that the new patronage for artists after the Civil War helped mold and direct Henry's development as a painter will be considered after his subject matter and method of work have been described and his work placed in the matrix of its period. It may be noted that when a reputation waxes, wanes and revives, the process is likely to be attended by disproportionate judgments. Critics may be found today who totally reject what a painter like Henry represents, while others will say that work of the kind Henry produced is the goal at which painters of our time should aim. It is plain that neither position is just. A study of this character, on the contrary, should endeavor to arrive at a conclusion as to the importance of Henry's painting both in its own time and for today, but especially for the present.

Henry's Subject Matter

Stories in Pictures. Henry's subject matter falls into the two main groups of American genre themes and re-enacted historical events, though as a student abroad and infrequently later in life he painted European scenes. Landscape and portraiture were not his forte. Whatever the subject, he always told a story in pictures; for his was the age of the story-telling picture, and he did not depart from its convention. Essentially, his story was the visual sentimental image, with record values secondary. Typical is the anecdotal *A One-Sided Bargain* (CAT. 305; FIG. 190), which shows a scene at Cragsmoor on the side of the mountain toward Newburgh. Peddler Oliver Evans and his wife, Nancy, who traveled about the countryside with "store goods" and pears, apples, onions and such, are shown dickering with Farmer "Mattie" Wright, a local character, who was still alive on the occasion of the field trip to Cragsmoor in the summer of 1941, but who preferred describing the region's snakes to reminiscing about its old-time artists. Another example is *Food for Scandal* (CAT. 343; FIG. 184). On the back of a photograph of the painting, Henry penciled at some time: "A village girl has picked up a 'Drummer' & invited him out for a Ride in her Buggy." He noted, further: "A sketch of a village News Depot. The old women watching a village girl who has picked up a 'Drummer' and taking him for a

Buggy Ride.' The oldest saying—'I wouldn't have believed it if I hadn't seed it with mine own eyes. The hussy!'" Has this not the ring of Aunt Samanthy, Mr Dooley and George W. Peck?

Broadly classifying Henry's painting as historical reconstructions and genre, we may list his early student work with his genre subjects, as it deals realistically or naturalistically with everyday scenes. Examples are early drawings (CAT. 1–9, 17) and notes in Sketchbook 1 (CAT. 1185). His Civil War paintings also are observed from nature, as were early American subjects like *Station on "Morris and Essex Railroad"* (CAT. 44; FIG. 108). Henry did not begin to paint historical themes until 1869, and his turning from genre to historical subject matter seems to reflect a changing demand. In the 80's, Henry began to paint Cragsmoor and Negro subjects, his material being derived from direct observation, the former at his summer home and the latter from travels in the South.

Though of greater interest today, Henry's genre subjects are not as well-known as historical works like *The First Railway Train on the Mohawk and Hudson Road* (CAT. 257; FIG. 162) or *The Clermont* (CAT. 323; FIG. 242) or the fine example of Americana, *The 9:45 A. M. Accommodation* (CAT. 65; FIG. 109). A criticism already quoted, from the clipping pasted on page 41 of Mrs Henry's manuscript, states:

> *Perhaps Mr Henry is best known by his pictures of the period following the Revolution, during the latter part of the eighteenth and the early part of the nineteenth century.*

Another clipping, pasted on the back of page 63 of her manuscript, says:

> *Mr Henry is an authority on the costumes and life of early days of the century.*

In view of the growing interest in all kinds of information about the American past, and especially the immediate past, it is probable that Henry's real life subjects will come more and more into vogue. They have more authentic historical status than pictures reassembled, like jigsaw puzzles, from bits of facts, prints, costumes, vehicles and so forth, and they are more expressive.

Student Work. Henry's student work survives in two oils and a number of drawings made before he went abroad in 1860, also the sketchbooks before mentioned. Since much of his work has not been located, it is fortunate that the two oils may be consulted; they are *Barnyard Scene* (CAT. 12; FIG. 92) and *Farm Scene in*

Pennsylvania (CAT. 13; FIG. 93). These are related to the draw-
ings [*Barnyard: 1*] (CAT. 6; FIG. 88), [*Barnyard: 2*] (CAT. 7;
FIG. 89), [*Barn Interior*] (CAT. 8; FIG. 90) and [*Barnyard*]
(CAT. 11; FIG. 91), as well as to paintings not illustrated or
located, *Barnyard Scene Near Philadelphia* (CAT. 9), [*Barnyard
Scene*] (CAT. 14) and *Woodpile* (CAT. 15).

That Henry had native talent as well as sound graphic training
his student drawings witness. Among these are *Great Bend, Sus-
quehanna* (CAT. 1; FIG. 85), *West Point from Prof. Weir's*
(CAT. 2), *Bethlehem, Pa.* (CAT. 3), *On the Lehigh, Penn.*
(CAT. 4), *Mauch Chunk, Pa.* (CAT. 5; FIG. 86), and *Off to
Europe* (CAT. 17; FIG. 229), as well as the carefully observed
Pennsylvania landscapes and New York City scenes in Sketch-
book 1 (CAT. 1185). These drawings, with many others, are in
the Henry Collection. There are over 200 sketches and drawings
plus the sketchbooks (CAT. 1185–1212), all of which give a good
account of Henry's skill and method of work.

Training Abroad. Henry's European training developed his
native graphic gift, as may be seen in a series of sketches: *Una Via
in Napoli* (CAT. 18; FIG. 94), *The Campagna from Frascati* (CAT.
19), *In Bella Firenze* (CAT. 20; FIG. 233), *Au fond du Lac, Lac
du Como* (CAT. 21), *Colico, Lake of Como* (CAT. 22; FIG. 234),
Luino, Lake Maggiore (CAT. 23), *Livorno* (CAT. 24), *Cannstadt
in Württemberg* (CAT. 25; FIG. 235), *In Stuttgart* (CAT. 26;
FIG. 236), *A Berlin Omnibus* (CAT. 27; FIG. 237), *Prussian
Canal Boat* (CAT. 28; FIG. 238), *In Amsterdam* (CAT. 30; FIG.
239), *Rotterdam* (CAT. 31; FIG. 240), and *Icebergs Off Banks of
Newfoundland* (CAT. 32; FIG. 241). The paintings Henry made
abroad, during his student years, are not remarkable. They are
pertinent, however, as suggesting how American artists felt com-
pelled to pay homage to a foreign ideal. *The Arno, Florence* (CAT.
33) and *Street Scene in Naples* (CAT. 42; FIG. 95) are the only
two of this group located to date, though the character of others
is visualized in many photographs in the Henry Collection. Prob-
ably they showed no great difference in quality; and certainly they
expressed a respect for the wonders of the Old World proper in an
age when America was beginning to be a nation of innocents abroad.

Civil War Sketches. When Henry began painting, the American
genre tradition had not fallen into decline. His Civil War sketch-
book (CAT. 1188)—indorsed by him on the cover *War Sketches
Oct. & Nov. 1864*—demonstrates how he worked to set down a

literal transcript of nature. The five large pencil and chalk draw-
ings in the Henry Collection minutely detail episodes in Henry's
service in the Union Army, as may be noted in the catalog entries,
based on the data inscribed on the sketches by Henry. Their titles
also suggest what Henry found interesting in the life about him;
the drawings are *City Point Oct. 1864* (CAT. 45; FIG. 105), *The
Market Place, Washington* (CAT. 46; FIG. 96), *The Great Horse
Depot at Giesboro on the Potomac* (CAT. 47; FIG. 97), *Near
Harrison's Landing, Lower James River* (CAT. 48; FIG. 98) and
Westover, James River (CAT. 51; FIG. 102).

In addition, we have located two excellent black-and-white
drawings done on the spot, *City Point, Va.* (CAT. 49; FIG. 106)
and *U. S. Transport on the Potomac* (CAT. 50), as well as a
small oil *On the James River* (CAT. 52). Two fine black-and-
white drawings apparently made a few years later are *A New York
Regiment Leaving for the Front* (CAT. 66; FIG. 101) and *The
Warning* (CAT. 67-a; FIG. 104). Henry had not then abandoned
that naturalistic style of Americana now particularly appealing to
Americans who seek to re-establish connections with the American
past. Four canvases have been located dealing with Civil War
themes, which were painted after the war. They are *Westover, Va.*
(CAT. 57; FIG. 103), *A Presentation of Colors* (CAT. 82; FIG.
100), *The Old Westover Mansion* (CAT. 84) and *City Point, Vir-
ginia, Headquarters of General Grant* (CAT. 96; FIG. 107). Paint-
ings on Civil War themes which have not been located but of which
there is record are *Gen. Fitzjohn Porter's Headquarters, James River*
(CAT. 74), *After the Battle* (CAT. 75), *Departure for the Seat of
War* (CAT. 85) and [*U.S. Transport on the Potomac*] (CAT. 90).
City Point, Virginia (1865–72), the culmination of Henry's work
in this line, is a painting of considerable formal interest, though
not perhaps as emotionally evocative as Blythe's *General Doubleday
Crossing the Potomac*, illustrated on the same page of Life in
America (Metropolitan Museum of Art '39, p. 45). By this time
Henry had assimilated his Civil War experiences and was about to
pass on to other subjects and styles. Here, he most closely
approached his model, Meissonier.

Americana. Before his Civil War service, Henry had begun to
paint Americana, applying to that category his habit of observation
and exact transcription. The earliest painting of this kind is the
unlocated *Station on "Morris and Essex Railroad"* (CAT. 44;
FIG. 108), recorded by a photograph in the Henry Album (Henry

1864–68, p. 9). In this painting—which looks from the photograph to be a first-class work—Henry painted in the manner of his early barnyard scenes, from life around him. Was the same quality to be seen in *Russian Fleet at Anchor in the North River* (CAT. 38)? The only record of this painting is a letter written by Henry in 1863 to the Russian consul general in New York (p. 153), offering to present the painting to the Russian government. Though Henry rarely showed interest in politics, his painting this subject and offering it to the Russian government suggests that he responded to general public interest in the visit of the Russian fleet in the critical Civil War years when Russia was one of the United States' best friends (Horwitt '42, Pomeroy '43).

On his return from war service, Henry painted—in 1865—two more American subjects, one of them *The John Hancock House* (CAT. 54; FIG. 43), which has been located, and the other *Residence at Poughkeepsie* (CAT. 55), which has not been located. The Hancock house painting is interesting as showing how Henry combined historical and contemporary subject matter. The records do not say whether or not Henry painted the picture after the house was torn down (p. 128). At any rate he had a photograph of the house taken from the same angle of view as the painting (FIG. 44), which he may have used to document the painting. Probably this canvas should be classed as a historical reconstruction, especially as it is somewhat wooden in feeling. *Residence at Poughkeepsie,* on the other hand, known only through the photograph in the Henry Album (Henry 1864–68, p. 39), is an attractive painting, which one would like to see in order to learn how well it bears scrutiny.

Another unlocated painting, *An American Railroad Station* (CAT. 58), may have been a successor of Henry's first railroad subject, above mentioned, and a forerunner of *The 9.45 a.m. Accommodation* (CAT. 65; FIG. 109), the latter undoubtedly one of Henry's best paintings. About this time, he painted a number of American documents, such as *Porch Scene, Newport* (CAT. 61; FIG. 37), *From a Window, Newport* (CAT. 62; FIG. 34), *Four-in-Hand, Central Park* (CAT. 64; FIG. 38), *The Library of Jonathan Thorne* (CAT. 72; FIG. 39), *A Chat After Meeting* (CAT. 77; FIG. 114), *St John's Church, Varick Street, New York* (CAT. 79; FIG. 112), *St Paul's Church* (CAT. 80; FIG. 113), *Old Dutch Church, New York* (CAT. 83; FIG. 110), *No. 217 E. 10th, N. Y.* (CAT. 97), *A Parlor on Brooklyn Heights* (CAT. 98; FIG. 40), *The Doctor* (CAT. 105; FIG. 116), *St George's Chapel* (CAT. 119; FIG. 111), and *Tenth Street Studio Building* (CAT. 132;

FIG. 258). Henry's visual records of such fine examples of American architecture as St John's, St Paul's and St George's, have historic as well as esthetic value, as do the railroad station pictures. Interiors like *A Parlor on Brooklyn Heights* and *The Library of Jonathan Thorne* record both the exterior fact of American Victorian baroque and the interior fact that they were painted to immortalize their owners and their possessions.

Historical Themes. Henry's historical pictures are foreshadowed in *The Grand Hall, Levens, Westmoreland* (CAT. 59), in which rendering of detail is his chief concern. The first historical reconstruction cataloged is *Graeme Park, Near Philadelphia* (CAT. 86), painted in 1869 on a Revolutionary War theme. In 1871 Henry painted *Independence Hall* (CAT. 91), showing the Declaration of Independence's signers immediately after that event. This painting, Henry's first on an important historical theme, is known only by photographs in the Henry Collection. Henry painted other historical subjects, from 1869 to 1872, including *Lady Elizabeth Ferguson Sending a Letter to Gen. Joseph Reed* (CAT. 92), *A Courtship: Time, 1817* (CAT. 104), *The Meeting of Gen. Washington and Rochambeau* (CAT. 109), *[Colonial Couple]* (CAT. 113), *A Reception Given Lafayette . . . July 20th, 1825* (CAT. 114), *Going Out to Ride: New York, about 1796* (CAT. 115), *William Floyd* (CAT. 130), *The Battle of Germantown* (CAT. 144), *[Revolutionary Scene]* (CAT. 157), *The Battle of Germantown* (CAT. 161) and *Meeting's Out, about 1849* (CAT. 164). None has been located, so that the only visual knowledge of them comes from photographs and reproductions in the Henry Collection. None is especially noteworthy, although the resemblance between Lafayette's face in Henry's picture and in the Morse portraits (Wehle '32, FIGS. 34, 35) may be noted. Did Henry use these for his reconstruction?

English Scenes and Long Island. Before Henry's genre paintings of Cragsmoor, Ellenville and related countryside subjects are discussed, works which do not fit into the general scheme may be noted. His portraits of Mrs Henry, painted in 1875 and 1876 (FIGS. 227, 41), reveal an atypical tenderness. In a few English scenes, notably *Off For the Races* (CAT. 124; FIG. 122), he used material at hand without regard for what proved popular with his American clients. According to Martin E. Albert, Henry's English themes were not particularly salable, as American colonial views were in demand.

A few pictures suggest that Henry had a potential lyric gift. Sketches and paintings made at East Hampton, Long Island, from 1879 to 1881, are well executed and poetic, implying that Henry had a sensitivity to form not always evident in his work. Did he perhaps consult a good model like Boudin? These paintings, none of which has been located except *Old Hook Mill, East Hampton* (CAT. 151; FIG. 126), express light and air, to judge from photographs in the Henry Collection. Two apparently important paintings are *On the Beach: Waiting for the Bathers* (CAT. 140; FIG. 47) and *East Hampton Beach* (CAT. 154; FIG. 49). Should the publication of this report bring these canvases to light, it will be interesting to note how they bear inspection. In the photographs, they seem to have genuine esthetic appeal. Henry's work often looks better in photographs, however, than in actuality, so on this point judgment may be reserved.

In addition, at this time Henry capitalized on the popularity of his railroad station pictures. Two subjects, not located but known from photographs and reproductions, are *The Approaching Train* (CAT. 146) and *The Way Station* (CAT. 147), neither especially interesting. Characteristic of the period was the pressure on artists to repeat successful subjects.

Cragsmoor Genre. At Cragsmoor Henry put down the roots described in the biographical sketch. For two score years, he made Ulster county subject matter his most typically American theme. At the same time he continued to paint historical reconstructions, and as genre petered out around 1900, he gave greater attention to historical subjects. At Cragsmoor he painted the daily routine of a life whose scale was modest. *The Mountain Stage* (CAT. 155; FIG. 54) served the whole countryside, passing through Cragsmoor on its swing around from Newburgh to Kingston. In *The Latest Village Scandal* (CAT. 178), country neighbors in two buckboards pause on a rocky road to gossip. Henry's early Cragsmoor paintings frequently pictured Cragsmoor people, especially Peter P. Brown. Peter Brown fell asleep after noonday dinner, and the chickens came in and walked on the table; see *Uninvited Guests* (CAT. 169; FIG. 143). Brown drank, being by Cragsmoor general report the "village drunk," and Henry painted him *Bracing Up* (CAT. 168; FIG. 138). Other paintings in which Brown figures are *A Mountain Road* (CAT. 153; FIG. 137) and *A Hard Road to Travel* (CAT. 162; FIG. 139), which emphasize pictorial and anecdotal elements rather than plastic. In the latter painting, the carriage and buffalo robe are well painted, but the surrounding

landscape is less successful. An outstanding canvas of this group is Henry's first recorded genre painting on a Cragsmoor subject, *The Summer Boarders* (CAT. 152; FIG. 146), painted in 1881, which shows Mrs Henry and Mrs Hartshorn in a buckboard driven by Brown, coming down the "gully road" from the "Mountain." This is purely a story-telling picture, with local characters, contemporary costume and vehicle, and characteristic Cragsmoor terrain, which depicts everyday life realistically in visual sentimental images.

For the record, the six small paintings presented by Henry to the village of Ellenville may be listed here, again. These are portrait sketches of Ellenville and Cragsmoor characters—John S. Billings, Peter P. Brown, Martin Terwilliger, Joseph E. Mance, Fred Thomas and Aunt Nelly Bloomer (CAT. 167, 187, 188, 193, 194, 230; FIGS. 133, 129, 130, 128, 131, 132). In these he portrayed well-known local people, in characteristic poses and actions, a mood probably closer to genre than to portraiture.

The range of Henry's Cragsmoor subject matter is plotted in an incomplete list of titles, as follows: *The Watering Trough* (CAT. 179; FIG. 151), *Sharpening the Saw* (CAT. 195; FIG. 136), *The Old Forge* (CAT. 200; FIG. 144), *Thanksgiving Sleigh Ride* (CAT. 191; FIG. 152), *Coming from Church* (CAT. 203), *The Mail Stage on the Mountain* (CAT. 206), *The Country Store* (CAT. 181; FIG. 127), *The New Scholar* (CAT. 241), *School's Out* (CAT. 199; FIG. 147), *At The Toll Gate* (CAT. 242), *The Country Carpenter* (CAT. 234; FIG. 145), *On the Old Gully Road* (CAT. 247; FIG. 245), *The County Fair* (CAT. 246; FIG. 182), *The New Woman* (CAT. 253; FIG. 179), *A Country School* (CAT. 232; FIG. 149), *Testing His Age* (CAT. 254; FIG. 192), [*News Office*] (CAT. 263; FIG. 183), *A Country Doctor* (CAT. 189; FIG. 148), *A Country Lawyer* (CAT. 264; FIG. 150), *News of the Nomination* (CAT. 272), *Morning Prayers* (CAT. 273), *A Mountain Post Office* (CAT. 298; FIG. 81), *Talking Politics* (CAT. 299; FIG. 219), *A One-Sided Bargain* (CAT. 305; FIG. 190), *Disturber of the Peace* (CAT. 326; FIG. 177), *The Flower Seller* (CAT. 335; FIG. 194), *Early Autumn* (CAT. 338; FIG. 180), *Taking Life Easy* (CAT. 359; FIG. 52), *The Huckster* (CAT. 370; FIG. 193), *The Bill Collector* (CAT. 365; FIG. 203) and *Contrasts* (CAT. 371; FIG. 178).

Thus Henry covered the gamut from buggy *(On The Old Gully Road)* to bicycle *(The New Woman)* to automobile *(Disturber of the Peace* and *Contrasts)*, making a record of how people lived

in a typical New York State rural community 60 years ago. He visualized the countryside's artisan carpenter and smith at work, neighborhood food supply in numerous marketing pictures, dwellings of wooden frame construction, transportation in buggy, buckboard and stage, farmers at work and stopping to talk of news of the nomination, and a score of similar simple anecdotes of the daily round of life. Especially do Henry's pictures record the slow tempo of farm life before modern mechanization of agriculture: a dozen show the easy, unhurried pace of existence as a bearded old man files his saw or a sun-bonneted young girl goes out to feed the chickens. Working in the fields, men have time to stop and lean on the rail fence and chat with a neighbor passing by. Farmer and wife jog leisurely to town on market day or to meet the train, perhaps to pick up summer boarders at Walker Valley. This life has now been drastically modified by technology. Its portrait is therefore doubly valuable and welcome.

Negro Life. Side by side with Cragsmoor genre subjects, Henry painted themes of Negro life, based on trips to the South, episodes of which are recorded in Mrs Henry's Memorial Sketch (321 ff.). In the Henry Collection there are numerous sketches based on direct observation in the field, and there are also casual notes in Henry's sketchbooks. Henry's first known painting on a Negro subject is *A Study in Black and Tans* (CAT. 133), dated 1877, which shows a little girl playing with two brown dogs. Next comes *Reading the Story of Bluebeard* (CAT. 145; FIG. 140), probably painted about 1880. This seems to be a Cragsmoor scene; the same woman and child appear in other Cragsmoor paintings. Though Henry sentimentalized the Negro, nevertheless his frequent use of Negro subject matter is significant as suggesting a widespread interest in Negroes in that period. He painted 30 known pictures in which Negroes appear prominently. Of the sketches in the Henry Collection, three (FIGS. 223, 225 and 226) are reproduced in this report. (Porter, 1943, p. 82 *seq*, 98 *seq*.)

Other paintings on Negro themes listed in the catalog are, in chronological order: *What Am Dat?* (CAT. 182), *Fred Thomas alias Black Fred* (CAT. 194; FIG. 131), *School's Out* (CAT. 199; FIG. 141), [*Taking a Rest*] (CAT. 204; FIG. 124), *A Temperance Preacher* (CAT. 212; FIG. 154), *A Vender of Simples* (CAT. 213), *Smoky Mountains, N. C.* (CAT. 214), *Street Scene, Knoxville, Tenn.* (CAT. 215), [*Family Party*] (CAT. 216), [*Southern Scene*] (CAT. 217), [*A Clean Sweep*] (CAT. 218), *Bound to Cut a Shine* (CAT. 223), *In Doubt* (CAT. 224), [*Young Merchants*]

(CAT. 225), [*Negro Girl Ringing Doorbell*] (CAT. 226), *Happy-Go-Lucky* (CAT. A-241; FIG. 260), *Studying Her Sunday School Lesson* (CAT. 240), *Meditating Revenge* (CAT. 255; FIG. 142), *The Sweetest Fruit* (CAT. 271), *A Virginia Post Office* (CAT. 274), *A Chip Off the Old Block* (CAT. 284), [*Maud Powell Plays The Violin*] (CAT. 319; FIG. 71), *In East Tennessee* (CAT. 337; FIG. 209), *Taking Life Easy* (CAT. 359; FIG. 52). In addition, Negro boys figure in *Capital and Labor* (CAT. 150; FIG. 56) and *Sharpening the Saw* (CAT. 195; FIG. 136), and Negro servants in *The Relay* (CAT. 156; FIG. 157), *A Virginia Wedding* (CAT. 231; FIG. 155), *Waiting at the Ferry* (CAT. 287; FIG. 165) and *News of the War of 1812* (CAT. 366; FIG. 250). The illustrations in this report show how Henry treated his Negro themes.

Henry's Humor. A number of paintings by Henry fall into the category of humor, as judged by the standards of his time. Among these may be named most of the Negro subjects listed above and the following: *Bracing Up* (CAT. 168; FIG. 138), *Uninvited Guests* (CAT. 169; FIG. 143), *The Latest Village Scandal* (CAT. 178), *The New Scholar* (CAT. 241), *The New Woman* (CAT. 253; FIG. 179), *Testing His Age* (CAT. 254; FIG. 192), [*News Office*] (CAT. 263; FIG. 183), *One-Sided Bargain* (CAT. 305; FIG. 190), *A Disturber of the Peace* (CAT. 326; FIG. 177), [*What's That You Say*] (CAT. 328), *A Private View* (CAT. 334; FIG. 208), *Food for Scandal* (CAT. 343; FIG. 184), *The Tramp* (CAT. 364), *The Bill Collector* (CAT. 365; FIG. 203), [*A Dog's Life*] (CAT. 383) and [*A Buggy Ride*] (CAT. 908). Typical, also, is Henry's use of such a detail as the dragging diaper of the baby in *The Pedler* (CAT. 139; FIG. 189).

Transportation. From a record point of view, an important group of paintings is that in which Henry is revealed as a "transportation artist par excellence." He painted vehicles of all kinds, including oxcarts, phaetons, stage coaches, buckboards and buggies, automobiles, early locomotives and railroad coaches, ferry boats, canal packets, ocean liners and bicycles. The number of Henry's paintings on transportation themes suggests that popular enthusiasm for the new inventions, as they came along, created a market for paintings representing such subjects. The motive power of transportation in premotorized days was a favorite theme of Henry's. He loved horses, liked to go to the races at the Newport Casino, and (329 f.) worked both from life, hiring horses from

local farmers to pose them, and from plaster casts. Rare is the canvas in which a horse does not appear in some manner. In the Henry Collection there are a quantity of sketches of horses, drawn from life, in pencil and in oil, some quick notes and others ideas which were not finished. They show excellent observation and draughtsmanship, as well as real feeling for the subject. In regard to vehicles, Henry studied them with great care for exact detail, as is suggested in the section in the biographical sketch on his carriage collection at Cragsmoor (p. 52) and is developed further in this chapter in the section on Henry's method of work.

The now vanished Delaware and Hudson Canal (p. 46) passed practically through Henry's front yard. From the higher elevations of Cragsmoor, it was possible to look down and see its silver ribbon shining in the sun. It quite naturally supplied Henry with material for another chapter in his pictorial history of transportation. Besides the canal sketches (FIGS. 173–76) and the sketchbook devoted to canal studies (CAT. 1207), there are the following paintings on canal subjects: *The Tow Path* (CAT. 249; FIG. 170), *Late Afternoon on the Old Delaware and Hudson Canal* (CAT. 261; FIG. 171), *Scene Along the Delaware and Hudson Canal* (CAT. 342; FIG. 172), *Entering the Lock* (CAT. 289; FIG. 255) and *A Canal Boat Entering a Lock* (CAT. 362). The first two show scenes along the canal in or near Ellenville and can be roughly identified even now, despite changes in the town and the gradual filling in by time of the old canal bed. Architecture in particular has changed little.

Historical Subjects. Henry painted historical subjects all through his working life, turning more and more to this genre as he grew older. Besides the titles previously mentioned, he painted the following pictures on historical themes, reconstructing events from old prints and books and verifying physical detail from actual costumes, vehicles and objects: *Traveling South in the Thirties* (CAT. 170), *A Virginia Wedding* (CAT. 231; FIG. 155), *The First Railway Train on the Mohawk and Hudson Road* (CAT. 257; FIG. 162), *Waiting for the Ferryman: Time About 1844* (CAT. 277), *The Childhood of Rapid Transit* (CAT. 281), *Sunday Morning (Old Church at Bruynswick)* (CAT. 283; FIG. 67), *Crossing the Ferry* (CAT. 288-a; FIG. 167), *Indian Queen Inn. Bladensburg. Md., in 1795* (CAT. 290; FIG. 159), *The Battery at New York in 1660* (CAT. 302), *Fulton's First Steam Ferryboat* (CAT. 304; FIG. 168), *Burgoyne's Army on the March to Saratoga, September 1777* (CAT. 306; FIG. 186), *Passing the Outposts*

(CAT. 309; FIG. 185), *Sir Wm Johnson Presenting Medals to the Indian Chiefs of the Six Nations at Johnstown, N. Y., 1772* (CAT. 310), *The Surrender of New York to the English by Stuyvesant, 1664* (CAT. 313), *The MacNett Tavern* (CAT. 317; FIG. 256), *Arrest of Major William Dyre for Treason* (CAT. 321), *The Clermont, Fulton's First Steamboat* (CAT. 323; FIG. 242), *St John's Park and Chapel, New York* (CAT. 324; FIG. 247), *St John's Chapel* (CAT. 325; FIG. 248), *Changing Horses* (CAT. 327; FIG. 160), *Waiting for the New York Boat at Stonington, Conn., the First Railroad from Stonington to Boston* (CAT. 329; FIG. 163), *Residence of Capt. William Kidd, 1691* (CAT. 331), *The Inn at Bladensburg* (CAT. 333), *In the Old Stage Coach Days* (CAT. 341; FIG. 249), *Bear Hill* (CAT. 347; FIG. 80), *Stenton* (CAT. 348), *News of the War of 1812* (CAT. 366; FIG. 250), *[Getting Out the Vote]* (CAT. 368; FIG. 251), *Election Day* (CAT. 373; FIG. 252), *Main Street in Johnstown, N. Y., in 1862* (CAT. 374; FIG. 211), *The Floating Bridge* (CAT. 380; FIG. 213), *St Mark's in the Bowery in the Early Forties* (CAT. 381; FIG. 215), and *Leaving in the Early Morn in a Nor'easter* (CAT. 388; FIG. 161).

Miscellaneous. The above cover the main classes of Henry's subject matter. A painting may be mentioned here which is surely a "sport"—*Les Fosses Communes, Cimitière de St Owen, Paris* (CAT. 128; FIG. 121) painted in 1876. The small pen-and-ink sketch for this canvas (CAT. 128-a; FIG. 120) shows how the painting was studied from nature. Dealing as it does with a mass funeral after an epidemic, can it be called Henry's one example of "social content"? Seriously, is it possible that Henry was influenced by Courbet's *Funeral at Ornans,* a very large canvas of a long narrow shape, 10x26 feet, painted in 1850, showing a subject superficially similar? According to Mrs Henry's memorial sketch (p. 314) and to other biographical references, Henry studied with Courbet in Paris. This has always seemed open to question, in view of Courbet's sound plastic and realistic contribution to modern painting. But it may be that Henry was influenced in this instance.

Landscape and portraiture were not Henry's forte, as said before. Nevertheless, besides the portraits of Mrs Henry mentioned above (p. 34 ff.), he did produce a few landscapes which are sincere and expressive. Two or three village street scenes have poetic feeling; and it is not exaggeration to state that these paintings—some of them known only from photographs or reproductions—have an

idyllic mood. They represent a romantic quality in Henry of which we know almost nothing from other sources. Among these may be listed: *Main Street, East Hampton, L. I.* (CAT. 163), *A Country Store* (CAT. 181; FIG. 127), *A Village Street* (CAT. 190), *Coming from the Train* (CAT. 207), *Vacation Time* (CAT. 210), *Country Scene* (CAT. 233; FIG. 66), *On the Way to Town* (CAT. 237), *Toward Evening* (CAT. 245), *Village Post Office* (CAT. 248; FIG. 62), *A Village Street* (CAT. 293), and *In the Valley* (CAT. 929; FIG. 83). The small panels *The Four Seasons* (CAT. 372; FIGS. 204–07) illustrate how Henry paid meticulous attention to naturalistic detail, each season having been painted at its appropriate calendar time, according to his note (p. 226). Was this a belated influence of Impressionism, a reminiscence of Monet's haystacks and water lilies? *Old Hook Mill, East Hampton* (CAT. 151; FIG. 126), already mentioned as an example of Henry's best work, belongs here also.

These categories make it clear that above all else Henry was a story-teller in pictures. In so far as he continued to paint pictorial anecdotes when "light and air had become the real subjects of painting"—as Goodrich has written (Whitney Museum of American Art '35, p. 8)—he was an esthetic survival. Before his esthetic expression is considered, however, his method of work may be examined.

Henry's Method of Work

"Meticulous Documentation." Henry collected visual facts with great industry, using as sources sketches, photographs, old prints and written descriptions—a method with which his contemporaries were well acquainted, both personal friends and art critics often referring to his practice. An unidentified newspaper clipping pasted on a blank sheet at the end of Mrs Henry's manuscript, quoted in full in the Biographical Sketch (p. 64), speaks of Henry's "habit of meticulous documentation in every detail." He followed this method to his death, as the late catalog entries show. The data on *The Floating Bridge* (CAT. 380; FIG. 213), begun at the end of the 19th century but finished in 1917, are a case in point.

Henry's method of work was established early in life, as may be read in a letter to Henry (CORR. June 28, 1871) from Frank M. Etting, author of History of Independence Hall and restorer of the State House in Philadelphia in 1876. The letter reads in part:

> *. . . I went immediately . . . to the Sunday Despatch office and examined their files for the picture of the Pine St. House. It turns out that while it was referred to in the text, the picture was a house of Logan's*

Your specialite delights me, and the photographs of your pictures you were so kind as to bring on with you have really enraptured many of my antiquarian friends who are anxious to make the acquaintance of the artist, My friend S. C. [Sam Chew] wishes to give you a couple of orders when you can execute them, the subjects just such as you will delight to paint and hence they must please every one.

I am much in hopes that the city will be induced to order a large painting of the Committee coming out of Independence Hall July 8th, 1776 [see CAT. 91]. *I shall take the liberty in such case to give you a few points about introducting actual likenesses among the spectators that will be consistent chronologically and that will tell upon their descendants [sic] of this day*

I have found a letter among my Mss of Th. Graeme [see CAT. 86] *which I have put away for you*

We shall certainly go to Stenton [see CAT. 348] *together when you come on.*

Henry's "habit of meticulous documentation in every detail" was almost apocryphal. Charles C. Curran N.A. relates that Henry drove to Grahamsville—in those days a half day's journey from Cragsmoor by horse and buggy—to verify a special belly band detail (McCausland '41, p. 144). For *The First Railway Train on the Mohawk and Hudson Road* (CAT. 257; FIG. 162) he posed Cragsmoor people, among them Mrs Henry, Harry Cook (McCausland '41, p. 171) and Martin E. Albert, the latter for a man running beside the train and for a coach passenger. Mr Albert, who knew Henry from about 1886 till his death in 1919, reports that Henry worked—in paintings in which horses figure—both from casts of horses' legs and from living equine models, paying local farmers to pose their nags for him.

Henry's Use of Sketches. Henry's working up of specific sketches into paintings has been referred to frequently in this report. *In The Roaring Forties* (CAT. 175; FIG. 57) is based on two drawings in Sketchbook 2 (CAT. 1186), one illustrated in this study (FIG. 60). Henry revised his first draft from nature; for the sketchbook's color notes are not carried out exactly in the painting (see p. 134 f.). *Capital and Labor* (CAT. 150; FIG. 56) is documented by a drawing in Sketchbook 3 (CAT. 1187) of a dog and a "dog churn" (FIG. 59). The sketchbooks contain many notes for paintings, already identified. If more paintings had been located, without question more drawings could be matched to them. Sketchbook 24 (CAT. 1208) has a detail for *The Floating Bridge* (CAT. 380; FIG. 213). In Sketchbook 21 (CAT. 1205) there are drawings for *At The Toll Gate* (CAT. 242) and *A Temperance Preacher* (CAT. 212; FIG. 154). Loose Notes (CAT. 1213) has a detail for

the ragpicker's dog cart seen in *St Mark's in the Bowery* (CAT. 381; FIG. 215).

Further sketches for paintings are: Sketchbook 5 (CAT. 1189) —a Negro servant putting a trunk on the back of a carriage, used in *A Wedding in the Early Forties* (CAT. 976); drawings for *Election Day* (CAT. 373; FIG. 252), and [*Getting Out The Vote*] (CAT. 368; FIG. 251), showing *a chimney sweep 1836–7* and *bootblack 1837;* sketch for *A Morning Call* (CAT. 330). Sketchbook 6 (CAT. 1190)—a pen-and-ink drawing for *The Ancestral Home* (CAT. 131). Sketchbook 8 (CAT. 1192)—*Dr H. P. Farnum's visiting Buggy W. 23d St N Y April 1874,* used for *The Doctor* (CAT. 105; FIG. 116), with color notes *silver, yellow line* and *2 yellow lines on Hub & spokes.* Sketchbook 10 (CAT. 1194) —*a dwarf street cleaner working front of St Mark's Stuyvesant St. N Y April 1874, related to St Mark's in the Bowery* (CAT. 381; FIG. 215). Sketchbook 13 (CAT. 1197)—*Mrs E. L. Henry, London Oct. 1875 by E L H* for the portrait done in 1876 (CAT. 122; FIG. 41), and a sketch for *The Departure of the Brighton Coach* (CAT. 136; FIG. 125). Sketchbook 21 (CAT. 1205)— besides details already mentioned, a sketch for *Coming from Church* (CAT. 203). Sketchbook 22 (CAT. 1206)—besides the above comparisons, a sketch for *A Moment of Terror* (CAT. A-244); and a scene in front of an inn, related to *Changing Horses* (CAT. 327; FIG. 160). In Sketchbook 23 (CAT. 1207), inscribed *Canal Studies,* there are the following details: *Pumping out the Bilge, On the Tow Path, Hoods on the Mules Heads to Keep the Flies off, A Canal Lock, On the Tow Path, a canal store house and entrance to a lock,* as well as a direct detail for *The Tow Path* (CAT. 249; FIG. 170). In Sketchbook 24 (CAT. 1208), besides the detail mentioned, there is *Fulton's first steam ferry boat. From Paulus Hook (Jersey City) to N. Y. 1813* for the painting of that title (CAT. 304; FIG. 168).

A number of the Henry Collection's larger sketches are related to paintings also, including drawings of mules on the tow path (FIGS. 173–76) used in *The Tow Path* (CAT. 249; FIG. 170). There is also the drawing of a man examining a horse's mouth (FIG. 195) used in *Testing His Age* (CAT. 254; FIG. 192). A fairly complete series is seen in *Beach Wagon* (CAT. 1010; FIG. 45), *On the Beach* (CAT. 1068; FIG. 46), *On the Beach: Waiting for the Bathers* (CAT. 140; FIG. 47), *East Hampton Beach* (FIG. 48), *East Hampton Beach* (CAT. 154; FIG. 49) and *Bathing Hour, East Hampton Beach* (CAT. 154-a; FIG. 50).

This method of work explains why Henry did not produce more titles. Entries in his 1898 diary (CAT. 1214) in regard to *Sunday Morning* (CAT. 283; FIG. 67) indicate that from January 4th to March 1st he painted steadily on the canvas, which is one of his largest, being 34x62 inches. A recurring entry is *Painted all day big church.* Later he noted *Big church pas able to finish it on time to go to Century on coming Saturday,* then *Nearly finished* and finally *Photo for copyright.* On March 9th he sent the painting to the Academy.

Henry's Use of Photographs. The earliest instance of Henry's using photographs to document a painting is the print in the Henry Collection, inscribed: *The Gap, from the East Side of the River. Evening. No. —— Scenery in the Region of the Delaware Water Gap, Pennsylvania. Photographed by Moran & Storey, Philadelphia.* The view is almost identical with *On the Susquehanna* (CAT. 16; FIG. 87), a painting known only through the photograph of it in Henry's Album (Henry 1864–68, p. 8). Henry probably used photographs collaterally with sketches at this time; for there is a drawing of the same subject (CAT. 1; FIG. 85) in the Henry Collection. Drawings in Sketchbook 1 (CAT. 1185) of New York buses in 1860 are matched by photographs of the same subject in the Henry Collection.

The John Hancock House (CAT. 54; FIG. 43), painted in 1865 —the year it was *taken down for common modern houses*—is documented by a photograph (FIG. 44). Though in the painting the house is considerably foreshortened, the comparison shows how Henry worked for literal accuracy. There are also photographs in the Henry Collection of the end and side views of Graeme Park (see CAT. 86, 92; p. 163 f.). Henry went further in the photograph of old Peter P. Brown's house at Cragsmoor (FIG. 77), which he took in 1880. This was copied in 1904 by Legrand W. Botsford, *the figures by the woodpile being playfully painted in, as he* [Henry] *talked of the old days.* Though touched up, the picture supplies a gauge for comparison with the house as it looks today (FIG. 78). Henry used a photograph (FIG. 55) as a detail for *The Mountain Stage* (CAT. 155; FIG. 54). In addition, Dick Elting, probably the driver in the photograph, posed for the picture (McCausland '41, p. 63).

The Henry Collection offers many examples of Henry's use of photographs to document his paintings, among them FIGS. 74 and 76, not yet matched to paintings but obviously made for the

purpose. Both Mrs Stetson and Martin E. Albert (McCausland '41, p. 203, 209) speak of Henry's using them as models (FIG. 7.6). Cragsmoor reports that Henry frequently took photographs of local people for details (McCausland '41, p. 181). Mrs Charles (Bertha Mance) Peters of Cragsmoor relates that Henry took many photographs of her mother, the late Mrs Charles Mance, to use in paintings. Mrs Peters has a photograph which shows her brother, Ralph Mance, at the wheel of a righthand drive Winton, wearing a chauffeur's cap, and Mrs Henry, in linen duster and veil, in the back seat. The car's registration plate reads "N Y 1914, 89828." In the painting Contrasts (CAT. 371; FIG. 178), the number is 18750. A drawing in Sketchbook 25 (CAT. 1209) shows the number as 41744. Thus, though Henry studied visual facts carefully, he altered them as he saw fit. Another drawing in Sketchbook 27 (CAT. 1211) shows a woman in a veil, a driver's cap and a car's brasswork.

Also, compare Taking Life Easy (CAT. 359; FIG. 52) and the photograph in the Henry Collection (FIG. 53). In the painting Henry has changed the course of the road; it curves less than in the photograph. The vehicle is slightly different; boards across the rear axle seen in the photograph have been eliminated in the painting. Does this suggest that Henry used photographs or detailed drawings not to obtain a literal transcript but to simplify the manual labor of painting? The photograph of a railroad coach on the Boston and Providence Railroad (FIG. 73) may be a detail for a subject like Waiting for the New York boat at Stonington, Conn. (CAT. 329; FIG. 163). The transparency of a corn shock among Legrand W. Botsford's plates (FIG. 82) could well be a detail for the Autumn panel of The Four Seasons (CAT. 372: 3; FIG. 205), which shows corn shocks in a field.

There are many photographs in the Henry Collection of architectural subjects, including: Side view "Chew House"; St John's Chapel as Seen from Beach Street; Interior St John's Varick Street, N. Y. Built 1806–7. Taken in 1867. (Rockwood); Stairway City House Built 1803; Chase Sitting Room (with printed data on the back: H. Schaefer. Photo-Art Studio. 14 Main Str. Annapolis, Md.); Stenton, the seat of James Logan, 1730; Front view "Cliveden"; Hallway "Cliveden." Probably most of these could be identified from a complete record of Henry's paintings.

As a consequence of his method of work, it is often hard to distinguish a photographic copy of a Henry painting from a direct photograph of the same subject. Some examples are the paintings

recorded in the Henry Album (Henry 1864–68, p. 35, 68) [*Family Party*] (CAT. 216) and [*Southern Scene*] (CAT. 217). One should add here that in this practice Henry had the distinguished company of those two masters of realism, Eakins and Degas (Mayor, 1944).

Henry's Use of Prints and Books. Among the Henry Collection's study materials items which illuminate his approach to painting are chromos of the Brandenburg Gate, the Crystal Palace, the Vatican, Dresden and Vesuvius touched up (perhaps by his own hand?) in pencil and paint. Also among the prints is a photograph of Henry's painting *A Paris Diligence* (CAT. 129) treated the same way. On my field trip at Cragsmoor and Ellenville, in June, 1941, I frequently found touched-up photographs of Henry paintings and was often directed to a treasure cache of his work, only to find the pictures of this kind. A unique item is the print (CAT. 1001; FIG. 51) of Jacques Louis David's *Madame Récamier*, pasted on a wood panel and painted over in oils, David's original composition having been enlarged by the unidentified retoucher's painting beyond the edges of the print. Though the fact that this was done by Henry is not proved, yet the probabilities are that he was the retoucher; for Cragsmoor and Ellenville report on the practice well-known in the community of the two Henrys "water coloring" photographs or other prints of his paintings (p. 52-53, 59).

Henry used historical books, as well as prints, as sources of information. In Sketchbook 20 (CAT. 1204) he noted: "History of First Locomotive of America by Wm H. Brown. Appleton & Co. 1871. (551 Bdwy)." A more extensive note in Sketchbook 22 (CAT. 1206) reads: "Cuzzis Civilis, Or Genteel Designs for Coaches, Chariots, post chaises, etc., vis-a-vis, Whiskeys, single horse chaises, &sc, in the most fashionable taste, colored, engraved on 30 plates, price 10 s & 6, plain 18 s. 1788. Printed and sold by I. Taylor Holborn." In the Henry Album (Henry 1864–68, p. 19) a note in regard to "Lady Elizabeth Ferguson Sending a Letter to Gen. Joseph Reed" (CAT. 92) reads: "Vide Mrs Ellett's Houses of the Revolution, vol. 1, 1828." In his note on *The Floating Bridge* (CAT. 380; FIG. 213; see p. 228-29) Henry writes of using books of travel. The correspondence between Mrs Daly and Henry, quoted under *The Old Lydig House* (CAT. 197; FIG. 58; also FIG. 61) shows how carefully he verified factual visual detail.

The Post-Civil War Period

A Description. E. L. Henry matured as a painter after the Civil War. Thus his working life extended from 1859, the year he first exhibited in the National Academy of Design, to the year of his death, 1919. In time his work spans decades when the United States developed as an industrial nation, and copper, steel, coal and railroads' new rich became art's new patrons. In this span of 60 years, the United States passed from a rural to an urban way of life, and technology became its ruling principle. Modern transportation and communication—foreseen by Henry in primitive forms like *The Clermont* (CAT. 323; FIG. 242) and *The First Railway Train on the Mohawk and Hudson Road* (CAT. 257; FIG. 162)—bloomed into transcontinental limiteds. The Nation moved into full economic independence, world center of financial gravity shifting definitively after the first World War to Wall Street. In this period industrialism became the Nation's established productive system, and wealth concentrated in the hands of industrial entrepreneurs created a new order of patronage.

Henry's painting career, during which he exhibited almost every year in the National Academy of Design, outspanned the *Salon des Refusés* (1863) and the deaths of Cézanne (1906) and of Renoir (1917). In these 60 years the United States produced Ryder, Homer and Eakins (Goodrich '33, '44; Museum of Modern Art '30), as well as scores of painters equally integrated in the American tradition (Baur '40, '42, '42a; Metropolitan Museum of Art '39; Whitney Museum of American Art '35, '38, '42). In these years the battle of Impressionism and Cubism was fought. In these years, too, American artists created a body of work on which present-day opinion looks with justified pride. These years are the environment in which Henry evolved. To evaluate him as a painter, it is desirable to understand him as a part of his time. Thus the character of the period, the values which pervaded it and the general role of artists in the age need to be examined.

Looking back on the post-Civil War period, one may note the causes and effects summed up by Holger Cahill (Cahill '36, p. 11 seq.) partly as follows:

> *After the Civil War the picture changed completely The rapid expansion of industrialism made for the dominance of social groups which had no tradition of art patronage and little interest in art except as it might serve as the badge of a newly-acquired social distinction or as an object of conspicuous display After the Civil War the new generation of art patrons demanded the grandiose, the vulgar, the spectacular, the over-*

embellished and the over-genteel—this last as a means of obliterating their crude beginnings The serious result of this wasteful showiness was less the spread of vulgarity than the dislocation of art in this period from its social context. In a society with such aims there was little place for the creative artist whose concern was with the expression of human experience.

By implication, the artist who succeeded did so because he was content to express human experience not at all or on the level of shallow thinking and feeling.

Add to "insecurity of taste" (Cahill '36, p. 15) a parallel insecurity in the sources of income on which an American artist of the time might count. Eastman Johnson's abandonment of genre subjects for portrait commissions is explained by John I. H. Baur on the basis of financial necessity (Baur '40, p. 25, 27). The new patrons wanted portraits, but not paintings of everyday life. Thus the "genteel tradition," as Cahill has called it, operated as the aegis under which American painters of the time perforce worked.

The Period's Visual Aspect. The quality of the time may be gauged by its visual aspect. To 20th century eyes, it was elaborate, costly, ostentatious, making appeal by material show. Conspicuous display was, as Cahill writes, the hallmark of late 19th century taste. The period has been pictured by Isham (Isham '27, p. 260) as follows:

> *They gratified themselves with fast trotters, diamonds and champagne; they built themselves big and amazingly ugly houses and filled them with furniture whose only excuse was its cost. And with other things they bought pictures.*

For visual witness, see Mrs A. D. Jessup's rig and T. A. Vyse's four-in-hand (FIGS. 36, 38) in regard to "fast trotters"; for "big and amazingly ugly houses," see Vyse's and Jessup's Newport residences (FIGS. 35, 37); and for "furniture whose only excuse was its cost," see the crowded Victorian parlors (FIGS. 39, 40).

About this time, the Henrys gave a reception for Mr and Mrs Ernest Parton of London (Cl. undated), an occasion when their studio was reported to be hung with flags and its corners banked with palms 20 feet high. Wealthy folk had their horses photographed in front of painted backdrops showing balustered terraces, with barouche and liveried footmen; two such photographs are in the Henry collection (PH. undated). The look of the time may be studied in *In the National Academy*, (FIG. 42), a wood engraving by William St J. Harper, published in Harper's Weekly of April 29, 1882; in it bustles parallel walls crowded three rows deep with

ornately framed paintings. Henry's carved walnut frame, now on the portrait of Mrs Henry (CAT. 122; FIG. 41) in the New York State Museum, is typical. The frame was evidently a favorite of his; it is seen in numerous photographs of his studio building and Washington Square quarters.

The Period's Values. Inevitably the vast increase in wealth in the United States after the Civil War, the growing popularity of European travel, the importation by the new millionaires of foreign art—pointed out by Lloyd Goodrich in his essay on American genre (Whitney Museum of American Art '35)—affected American art and artists. From early American folk painters to Mount (Baur '42) genre had flourished in the United States, recording the development of the country in visual terms. Henry's early paintings of American subjects, such as *The 9.45 A.M. Accommodation* (CAT. 65; FIG. 109), were straightforward expressions in this tradition. The new patrons after the Civil War, however, did not seek realism in art. Goodrich (Whitney Museum of American Art '35, p. 7) has described the effect of their patronage as follows:

> Saloons, painted women and slums would have seemed positively indecent to the art public of the time. The urban burgher preferred his rural scenes, or at the most J. G. Brown's scrubbed newsboys or E. L. Henry's charming little idylls of an earlier New York Sex was sublimated into sentiment or confined within the range of family virtues.

The "family virtues" agreeable to "urban burghers" may be studied in the work of a score of academicians, all friends of Henry, among them Arthur Parton, S. J. Guy, Worthington Whittredge, J. W. Casilear, Sanford R. Gifford, Jervis McEntee, William H. Beard, E. Wood Perry, William Hart, William Page, Robert W. Weir, John F. Weir and Benjamin Franklin Reinhart.

Art books of the time record subjects in favor then—Parthenon, Venice canals, Adirondacks sunsets, "Lo, the Poor Indian," scenes along the Nile and the like. Illustrations in American Painters (Sheldon '79) suggest the caliber of the period. Values are implicit also in a statement made by Thomas Moran to Sheldon (Sheldon '79), which follows:

> Half the foreign stuff that is sold here I feel is a swindle on the public. The works of Jules Breton, L. Knaus, Oswald Achenbach, Meissonier and Gerome are admirable, to be sure; but I can't think anything of Corot.

The protest against support for foreign art which discriminated against American artists was justified. It is difficult, however, to

agree with Moran's judgment of "admirable" European painters. In the decade in which he uttered his opinion, Monet, Manet and Degas were at work. The heritage of French painting, from Géricault and Delacroix to Corot and the Impressionists, was available to the United States' art patrons. What they collected is therefore a measure of taste at that time.

An agreeable story in pictures was what was chiefly wanted. W. J. Lampton, writing to Henry (CORR. '00?), emphasizes "pictures that would paint well and pay well" and specifies the story element:

> I don't know anything about Art—with a big A—but I know what I like in pictures, and for a long time I have been scrapping with my artist friends because they persist in painting things that call for a plan and specifications when there are so many things that tell their own story, as soon as the artist gets them on canvas.

Art patrons also expected artists to agree with their political ideas. The letter to Henry from May A. Bookstaver (p. 195), headed Pembroke West, Bryn Mawr, October 22, 1896, suggests that Henry's connections were with people of conservative political opinion. This, too, would affect an artist's expression. Will Low's criticism, quoted at the end of the Biographical Sketch (p. 65), speaks of "a life which has all but disappeared since we have become the melting pot of other races than our own"; and Mrs Henry refers somewhat slightingly, in her Memorial Sketch (p. 325), to the Italian section of New York's lower West Side.

An occasional contemporary statement held out against prevailing standards. Art in America (Benjamin '80, p. 115–16) indorses a criticism of J. G. Brown because he washed his urchins' ears before he posed them. Benjamin criticizes Henry for hardness of outline, then refers approvingly to *Waiting for the Bathers* (possibly CAT. 140; FIG. 47), but gives first place to Winslow Homer and Eastman Johnson for painting truly American genre. Generally, artists found it easiest to conform.

The Period's Taste. The period expressed itself in ways often unacceptable to present-day criterions. Is it likely that the subject described by H. C. Henry of Minneapolis in the letter quoted above (p. 58) would be painted today? The idea of the husband, in nightshirt, shivering in the unheated bedroom etc., is not in our time-spirit. Typical, too, is a poem inscribed "with the compliments of Treadwell Cleveland of Newark Eve. News," a longhand

manuscript, dated at the Hotel Chelsea, March 12, 1918, pasted in Mrs Henry's manuscript Memorial Sketch. The text follows:

> *Midst fads and shibboleths, and freaky schools*
> *Whose creeds are folly, whose disciples fools,*
> *How gracious glows the brush whose touch sincere*
> *Depicts in truth the beauty all revere,*
> *As pigments from the palette of the skies*
> *Are purely seen through frank and faithful eyes,*
> *And forms, true traced with earnest, humble skill,*
> *Grow quick with art yet breathe of nature still!*
> *As vivid as Meissonier's master stroke,*
> *As fine as Vibert's pencil would evoke,*
> *But more alive, more intimate, more true,*
> *The world that Henry's hand unveils to view.*
> *When Futurist is buried by the Past,*
> *While Cubist molders with his shattered cast,*
> *And all the cults of psychopathic twist*
> *Are blown afar as winds dispel the mist;*
> *When honest sunlight clears the air of art,*
> *And honest craftsmen follow head and heart;*
> *Then homage will be paid to Henry's name*
> *And workmanship will seal his brow with fame.*

The tribute is characteristic. The effect of such standards was to enforce conformity. The quality of patronage is mirrored in Art Treasures of America (Strahan '79, II; *c.* 86, *c.* 98, *t.* 82, *t.* 126, III, *c.* 28, *t.* 28), which shows the kind of story-telling picture in vogue. Generally the story favored was an episode from history or mythology, a blurred image of the neoclassicism of David and Ingres, in the main lacking even the appeal of sentimental genre. Among the collectors recorded in this de luxe three-volume subscription set were W. H. Vanderbilt, Fairman Rogers, A. J. Drexel, W. W. Corcoran, T. H. Havemeyer, Mrs A. T. Stewart, J. Pierpont Morgan, who collected Bougereau, Gérôme, Meissonier and the like. Almost no American artists were represented, though some of those named had purchased paintings by Henry. The kind of painting in demand is suggested in an unidentified newspaper clipping (CL. April 3, 1879), which refers to *Old Folks at Home* [*The Old Paternal Home* (CAT. 110; FIG. 119)] as an "uncommonly fine and handsome canvas." The criticism continues:

> . . . *the refined nature of the artist has imparted, it seems to us, to this picture the very feeling of security and happy contentment which belongs to a well regulated household.*

Henry's taste in antiques has been mentioned in connection with the Ortgies sale (p. 46). His taste in literature is suggested by fragments of his library now in the Henry Collection. Among these are the magazines Character Sketches, edited by Marion Harland; Current Literature: A Magazine of Record and Review, The Art Amateur, Paris in the series King's Views, and (1870) Day's Doings: Illustrating Current Events of Romance, Police Reports, Important Trials and Sporting News, also Sporting Times and (1879) The Daily Graphic: An Illustrated Evening Newspaper.

The carved walnut frame in the Henry Collection has been mentioned (p.103). Possibly the painting From a Window, Newport (CAT. 62; FIG. 34) inspired its shape. More probably it represented an influence from the vogue for Romanesque which Richardson brought into architecture, to have it echoed in buildings as different as Post's New York Produce Exchange Building and a Brooklyn coffee warehouse (Abbott '39, p. 20–21, 200–1). Although today round and oval shapes are out of favor, this frame indicates an esthetic preference in Henry, as does the long, narrow horizontal he often used. About the only statement from him on a matter of taste has to do with a suitable frame for Spring (CAT. 315). A letter from Henry to Martin E. Albert, dated "On Mtn June 14th, 1904," reads in part:

> It is one of my strongest little pictures, I feel. I thought of framing it in a black ebonized frame with gilt flat next to canvass [sic], feeling that the dark wood helped to make the contrast greater like looking out of doors from a window. They are more durable and far more effective than gilt. If you don't want it, preferring a gilt frame, you can have your choice, as the frame is included in the price, of course; only if it were to be mine, I should have the heavy dark polished ebonized frame as the picture is sunny (springtime) and the effect would be bully.

In general, we may say that taste functioned on a low level, the period's "sensibility to the different degrees and kinds of excellence in the works of Art or Nature"—as Hazlitt wrote—being undeveloped and indiscriminate.

Esthetic Considerations

Alternatives for the Artist. In the United States after the Civil War, the artist had the alternatives of conforming and surviving or of making an upstream fight against prevailing standards, but at a price. Lack of support for American art made the latter course unattractive. The late Charles C. Curran N.A., Cragsmoor neighbor and friend of Henry, recalled to the writer (McCausland '41,

p. 149) that when he came to New York in 1881 as a student, there were few galleries and none gave assistance to American artists. The first gallery devoted exclusively to the exhibition and sale of work by Americans was founded only half a century ago (in 1892) by the late William Macbeth. Yet American painting and sculpture had had more than a century and a half of continuous production (Museum of Modern Art '32), not counting the fine anonymous portrait of Margaret Gibbs, painted in 1670. The general lack of support for American artists is witnessed by a newspaper clipping in the Henry Collection (CL. April 3, 1879) which urged that

> . . . it would be well for American art if such collectors of art as John Taylor Johnson, William H. Vanderbilt, Judge Hilton, Mr James H. Stebbins, Mrs A. T. Stewart, August Belmont and others that we could name, would buy more of it than they do, and they would, too, by so doing, possess much more interesting galleries than they now do.

The letter to Henry from Frank T. Robinson (CORR. July 25, 1895) quoted above (p. 66) proposed as a remedy that the Nation build a National Gallery of American Art and "that a minister of art for our cabinet" be created, nominating for the office Henry G. Marquand, Metropolitan Museum of Art president. A half century has not seen this proposal effectuated, though government programs for the support of art are an important step forward. Neglect of American art is stressed in the report of W. W. Story, one of the American commissioners for the Paris Exposition of 1878, in which Henry was represented by *Off for the Races* (CAT. 124; FIG. 122). Commissioner Story (Story '80, p. 3, 6, 7, 9) stated that the fine arts are an organic part of our educational system, writing in part as follows:

> . . . the small sum of $150,000 actually appropriated to cover all expenses of every kind was not only so insufficient in itself, but was so tardily given as to render it impossible for America to make an exhibition worthy of a great country
>
> The consequence has been an injury, not only to the reputation of the country, but even more to its material interests
>
> We wish to take among nations the high place to which we are justly entitled, but we grudge the necessary outlay. Our penurious grants of money for great public objects retards the development of the country.

Commissioner Story went on to list existing museums and academies in Boston, New York, Philadelphia and Washington, but added that these were supported by private gift, while he sought to have established the principle that the support of the arts is as much a public duty as the support of the sciences. He continued:

But these are private and local in their character and funds. They are not national institutions.

We have no national collections; no national museums, academies, or schools of art

As a nation, we do not profess to look down upon art; at least we utterly neglect it. It forms no portion of our education, and in the public representative bodies of our country a lamentable ignorance prevails. There is neither knowledge nor good taste in the patronage of the government

If we are a great country, as we justly claim to be, let us behave like a great country

As it is, art is heavily handicapped in America. The notion of our government is that it [art] *must manage for itself, without means and opportunities of study and culture, depend for its support upon private patronage solely, and develop itself as it may in the cold shadow of neglect. One might as well as expect the highest literary culture without libraries and schools.*

In such a situation, artists obviously had to function at the level of private patronage. Criterions were not high, and the effect was to sentimentalize, degrade and otherwise corrupt American art. Probably most post-Civil War American artists accepted the conditions without protest or rebellion, as Baur has pointed out in regard to Worthington Whittredge (p. 82). No evidence has come to light that Henry rebelled against prevailing criterions.

Patronage and the Artist. Henry's patrons have been listed in part in the Biographical Sketch (p. 30 f.). Complete data, as far as are known, are given in the catalog entries. Besides T. H. Havemeyer, William Astor, W. H. Vanderbilt, J. W. Drexel, E. T. Stotesbury, Sam Chew, Richard Hoe, John Taylor Johnson, Charles Peterson, T. A. Vyse, H. C. Dallett and others, the Henry Album Index (Henry 1864–68) lists the following: Mrs Mark Hopkins, John H. Hall, Emil Heineman, George Kemp, Harvey Kennedy, Leo I. Seney, William O'Brien, W. J. Raynor, John Sherwood, G. W. Stow. Their general scale of life may be judged from visual documents such as FIGS. 35–40. It is not an unfair assumption that in the main they mirrored the standards and taste above described. Henry seems to have accepted without question the support available. There is no testimony that he objected to the commission offered by the Minneapolis Henry (p. 58) or even to the shrewish letter of Mrs Moore (p. 31). Like his generation, he went with the stream.

The generalization may be particularized by describing the esthetic school to which Henry subscribed. Meissonier, not Manet, was his hero. Mrs Henry wrote in her Memorial Sketch (p.340):

He was very liberal, however, in his likes and dislikes of others who painted in a different school; and I have often seen him standing before a painting

*of Manet and finding many things in it to admire. Only it must have
some originality in it, for he had no patience with copyists.*

But, so that there may be no mistake, she adds:

Meissonier always stood to Mr. Henry as the greatest artist of his time.

Henry's time, it may be noted, was the time of Corot and Cour-
bet, the Impressionists including Monet, Manet, Degas and Renoir,
not to add Cézanne, Gauguin, Seurat and van Gogh.

Henry emulated Meissonier well, witness the judgment of the
National Academy of Design memorial quoted in the Biographical
Sketch (p. 66), which states "Surely he may be called the Meis-
sonier of America." Henry had won the designation before his
death, *vide* the Cleveland poem quoted above (p. 105). A news-
paper clipping pasted at the end of Mrs Henry's manuscript repeats:

*Mr Henry never failed to tell a story with his pigments and to tell it as
well as any one who painted in the same style. It was the style of Meis-
sonier and Knaus, and with them he was one of the great masters of the
style into which he never failed to put something that was his own.*

Remaining true to his ideal, Henry stood apart from the battle
of Impressionism. He continued to paint "with the Meissonierlike
technique, though his old friend J. G. Brown has been influenced
by the modern ideas caught in the currents of Impressionism"—
says an unidentified newspaper clipping (CL. '04 ?).

From such witness, as well as the internal evidence of his work,
it would seem that Henry set himself a lesser rather than a greater
objective. If it is argued that he followed the current of his time,
nevertheless another criterion existed at that time, as may be read
in what Commissioner Story wrote (Story '80, p. 18 *seq.*) of the
Meissoniers exhibited in the French section of the 1878 Paris
Exposition:

*He is an admirable draughtsman. His works are finished with exceeding
elaboration and pains. His attitudes and movements are correct, his
minuteness of finish and study of detail are surprising, his precision of
touch admirable, but all his works bear the mark of over-study and effort.
There is a want of freedom and happiness in it all. It is very well done,
but it leaves us cold. It is monotonous in tone, rigid and hard in feeling,
and not agreeable in color. His figures are as hard as tin. His dresses have
no texture or quality, his landscapes and skies no air. Everything has a
look of pre-determination and not of accident. It is what it is, because
the artist has chosen to have it so, and not because it happened to be so.
Nothing is like the real thing, though it is wonderfully copied in all its
details. The charm of a work that is finished more through happiness than
pains is entirely lost—one feels the labor.*

Is not this opinion curiously up-to-date?

The Visual Sentimental Image. The phrase "the visual senti-
mental image" is used here to describe a typical post-Civil War style
when the demand for "family virtues" (p.103) led artists to
"prettify" their work. The writer has the impression that the
phrase is not original; however, so far search of reference works and
consultation with authorities has failed to locate a source. Scholars
consulted agree that as a description the phrase is exact.

In the post-Civil War period, American painting founded itself
on literal representation of visual subject matter—an expression
which some critics today dismiss summarily as "representational"
or "naturalistic." It was not an esthetic statement concerned with
formal and plastic research, as were Impressionism, Post-Impres-
sionism and Cubism. The picture was made, not to be seen for
pure theoretical motives, but to tell a story in pictorial terms.
Further, the emotional intensity of the expression was at best
moderate; for the powerful dynamics of romanticism, as in Géri-
cault or Delacroix, middle class art of the time substituted ardors
of the parlor, for example, *Library of Jonathan Thorne* (CAT. 72;
FIG. 39) and *Parlor on Brooklyn Heights* (CAT. 98; FIG. 40).
Sentiment was the emotional channel for the genteel. In the
United States the visual sentimental image reached its apogee in
the rosy-cheeked smiling newsboys of J. G. Brown, scrubbed be-
hind the ears. The sentiments represented in visual terms in the
main did not strike deep chords of human experience. By com-
parison with the figure paintings of Corot, the portraits of Degas
and Manet, the superb formal statements of Gauguin and Seurat,
the realism of Courbet and the monumental creations of Cézanne;
this typical expression is a dilution. Measured, also, by our own
masters, Ryder, Homer and Eakins, the visual sentimental image
is a minor expression.

Not all of Henry's work can be so described; and it is likely
that in a kinder climate he would have escaped the "genteelizing"
process. His development in style and choice of subject matter
graphs the decline of American genre painting which Goodrich has
pointed out (Whitney Museum of American Art '35). Henry's
emphasis has been described (CL. '04 ?) as follows: "He calmly
continues to paint those delicate studies of a vanished epoch," the
"evocation of sweet, brave, old fashioned days." In 1906 the Art
News (Anon. '06) referred to the "quaintness of custom and
costume" in Henry's paintings. The *laudator temporis acti* motif
in itself gages the quality of the time: the tendency to admire
the past and to reject the present, which may be called cultural

recidivism, is typical of an esthetic which will not face existing reality. To such a point of view, the past offers a retreat as safe as the opposite tendency to retreat into experimentation and formalism. Yet while Henry and his generation were extolling the glories of time past, the young "New York Realists" (Whitney Museum of American Art '37) were going out into the city streets and portraying the facing of living humanity with zest and tenderness. The Will Low criticism referred to before (p. 65, 104) may be quoted, in part, again:

> There are few American artists who have better served their country in preserving for the future the quaint and provincial aspects of a life which has all but disappeared.

Does the statement imply that this life was of importance not by virtue of what it was or what it meant, but simply because it has *disappeared?* If so, an esthetic *status quo* is set up, as if what *was*, is venerable and deserving of the artist's brush, and what *is*, is of no account. In a clipping from the Ellenville Journal of February 14, 1918, pasted on the back of page 63 in Mrs Henry's manuscript, which quotes from a New York newspaper criticism of the painting *St Mark's in the Bowery* (CAT. 215; FIG. 381), the adjective *old* is used five times in eight sentences.

"Family virtues" were in demand, Goodrich wrote (p. 103). In choice of subject, this factor operated to produce such paintings as *The Widower* (CAT. 106; FIG. 117), *A Quiet Corner by the Door* (CAT. 107; FIG. 118), *The Old Paternal Home* (CAT. 110; FIG. 119), *Sunshine and Shadow* (CAT. 116), and *Out in the Storm* (CAT. 376; FIG. 199), which may be referred in the reproductions in this report. Other examples of the visual sentimental image in Henry's work are: *The Old Clock on the Stairs* (CAT. 70; see FIG. 214), *The Invalid* (CAT. 71), ["*A Cold Deceitful Thing Is The Snow*"] (CAT. 73), accompanied by a poem (Henry 1864–68, p. 30; see p. 160), apparently of Henry's own composition, [*Old Woman Reading*] (CAT. 81), *An Unexpected Attack* (CAT. 94), [*The Snowstorm*] (CAT. 95), [*Nurse and Two Children*] (CAT. 101), *The Young Heir* (CAT. 103), *Taking a Nightcap* (CAT. 112) and [*Children in a Graveyard*] (CAT. 121), photographs of which may be consulted in the Henry Album.

Effects on Henry's Work. Henry's working life, as said before, outspanned the *Salon des Refusés* and the deaths of Cézanne and Renoir. From 1859 to 1919, painting in the western world underwent drastic changes. In the United States, genre declined—

perhaps America's most characteristic expression, folk art excepted;
and the theories of Impressionism and Post-Impressionism were
tardily accepted by Weir, Twachtman, Hassam, Prendergast and
others. Yet, according to a clipping at the end of Mrs Henry's
manuscript,

> *The technical style of E. L. Henry underwent no changes or evolution in*
> *the full fifty years of his professional career.*

Is this true?

In the main, Henry's style and choice of subject matter typifies
the development of painting in the United States after the Civil
War. The golden day of genre culminated in Mount, Bingham
and Johnson. Thereafter, other values controlled painting. In
Henry's case, the early *Barnyard Scene* (CAT. 12; FIG. 92) and
Farm Scene in Pennsylvania (CAT. 13; FIG. 93), both painted in
1860, stylistically may be called the last glow of the golden day.
In these canvases, his style is relatively free and warm, not yet
frozen into his later hard, tight *Meissonierlike technique* (p. 67).
Years of study in Europe and the Civil War intervened, and Henry
began to be subjected to the academy, to the European vogue and
to the new patronage. In *The 9.45 A.M. Accommodation* (CAT.
65; FIG. 109), painted in 1867, he still derives, however, from
the American genre tradition, depicting realistically an event of
everyday life and at the same time expressing it with enthusiasm
and verve. A dozen years later Henry was continuing to paint
American railroad stations with crowds waiting for the oncoming
train; but by this time the subject has ceased to be a spur for his
imagination. In this interval there was a tightening of line and
a graying of color, evident but not crucially distracting in *City
Point, Va.* (CAT. 96; FIG. 107), painted in 1865–72, in which
Henry reached his goal of emulating Meissonier. One of the best
Henry's, if not his masterpiece, this canvas has the authentic virtue
of its fidelity to nature. Though it does not appeal on plastic or
sensuous grounds and though its color is subdued and certainly less
exciting than Blythe's *General Doubleday Crossing the Potomac*
or Bierstadt's *The Bombardment of Fort Sumter* (Metropolitan
Museum of Art '39, PL. 192, 184), to take comparable instances,
nevertheless *City Point* has the harmony of its own design and the
integrity of its own method. Tight gray waves of the Appomattox
are organized in a composition conscientiously observed and exe-
cuted by the painter, with copies natural detail (Fig. 107).

Hereafter, Henry's style evolved along the period's typical path.
He painted realistically, representationally or naturalistically—

whichever word is preferred—reproducing physical visual detail almost as minutely as in photography, with colors subdued, though not as dark as the bitumen which Düsseldorf foisted on American painters from Duveneck to Luks. In his Cragsmoor genre themes, beginning about 1880, Henry achieved a warmer palette. His historical reconstructions are not as strong in color as his genre paintings and have been described by present-day critics as "candy-box covers." According to his posthumous biographer, Mrs Henry, Henry remained untouched by Impressionism. But is this completely accurate? Brushwork may be noted in *A Virginia Wedding* (CAT. 231; FIG. 155), painted in 1890, which is somewhat akin to Impressionist divisionism. Does Henry's note on *The Four Seasons* (CAT. 372, 1–4; FIGS. 204–7) "Each in its season at the same place" (p.226) echo Monet's procedure in painting haystacks, Waterloo Bridge and Rouen Cathedral? Toward the end, Henry's painting relaxed its characteristic hard outline, which may be construed as, if not an actual concession to, at least an unconscious response to the influence of Impressionism.

This possibility may be supported by an episode related by the late Jerome Myers in his Artist in Manhattan (Myers '40, p. 37):

> It was at the Armory Show that I was introduced by friends to E. L. Henry, who was then in his eighties. [E. L. Henry, having been born in 1841, would have been 72 in 1913.. E.McC.] I had known his work, for which I had a great respect. Together we went around the huge show. Henry had an impairment of one eye, to such an extent that he had to hold the eyelid up with his finger to see. Yet he carefully looked at all the pictures, and when he had finished, he said, "Mr. Myers, they told me there was a lot of crazy wild art, here, but I really found it wonderfully interesting and I am very glad to have seen it." This was the unbiased tribute of an unpretentious American of a past generation.

The critic Forbes Watson adds his personal recollection that Henry was urged to exhibit in the Armory Show but refused.

The period's influence on Henry's painting may be observed particularly in his selection of and treatment of subject matter. The typical idealization of style had a parallel in the painter's attitude toward his material. Just as the J. G. Brown scrubbed newsboys purported to be "real life" but were not, so Henry's painting purported to be an exact realistic transcript of nature. Actually it was not, as he altered literal visual fact in many instances. Yet today his paintings appeal chiefly on the basis of historical value—their mirroring of American life in that time, their humor and especially their recording of the history of 19th

century transportation in the United States. About the accuracy
of his paintings of historical events, skepticism is permissible, in
view of the fact that they are mostly reconstructions. Skepticism
may also be allowed in regard to his genre subjects, because he
systematically altered details.

In regard to humor, changing times evolve changing standards,
and much that seemed funny in Henry's time does not seem funny
today. Again, the need for revaluation is evident. The subjects
described in the section on humor (p. 92) undoubtedly had a
vogue; they appeal to that superiority inherent in the phrase "coun-
try jake." To a degree, they recall aspects of American life not
far removed in time from the present. The most informed taste,
however, probably rejects the humor exemplified. Today it does
not seem funny that white children "picked on" a Negro girl,
upset her bucket of huckleberries and ran away in gales of mirth.
In general, the standard of humor of the second half of the 19th
century is well summed up when Henry uses Negro subjects. In
his paintings, the Negro almost always appears as a servant or a
social inferior, that is, a shabbily dressed, unkempt farmer or
loafer at the village crossroads. In this attitude, Henry simply
reflected his period. Eastman Johnson also echoed the prevailing
white superiority in some of his paintings on Negro themes (Baur
'40, PL. 16); and even Winslow Homer's A Happy Family in
Virginia (Whitney Museum of American Art '37, p. 21, no. 12)
might be so construed. The conception of the "pickaninny" as a
comic figure to be laughed at on the minstrel show stage was typical
of the time.

Why did Henry alter visual detail? The point is not of prime
importance; for an artist is surely free to rearrange nature as he
pleases, and when optical or emotional rather than so-called "real"
appearances are recreated, the liberty is valid. Henry has been
praised, however, especially for his "meticulous documentation"
(p. 64, 95). Plainly standards of documentary fidelity vary from
period to period; for there are many instances in which Henry
changed details without a corresponding esthetic gain. For ex-
ample, Sunday Morning (CAT. 283; FIG. 67) recreates a Sunday
morning scene in front of the old Dutch church at Bruynswick,
Ulster county. This 200-year-old edifice, known as "Shongum
Church," is a fine example of the region's colonial architecture.
Henry naturally has to reconstruct the churchgoers in colonial cos-
tume. He had the church at first hand to study, for visual accuracy.
Yet he eliminated one of its five columns (FIG. 68), saying that a

church could have only four. Myth is strong: today the caretaker tells visitors (McCausland '41, 30) that the fifth column was added after the picture was painted—this despite Miss Woodward's evidence (p. 202 *ff.*). Was Henry influenced in his standard of ideal church architecture by the fine church at Napanoch (FIG. 70; see McCausland '41, p. 40), almost next door to the Vernooy Place (p. 46 *f.*), which attracted him as an architectural specimen?

The example is not isolated. Consider the painting [*Maud Powell Plays the Violin*] (CAT. 319; FIG. 71). Major John W. Powell and his family, including his violinist daughter, summered in Ellenville in the 80's, and Maud Powell hired an empty Canal Street house·to practise in. So much for the story Henry tells. When he painted the picture, however, he altered the material of which the house was built. Ellenville never had *stone* houses, according to Florence T. Taylor, Ellenville librarian (McCausland '41, p. 220). The Canal Street house formerly occupied by the Otis family, whom the Powells visited, is a good example of wooden frame Victorian Gothic, in 1941 painted white. The point is not crucial, except that a future researcher trusting to the apparent visual accuracy of Henry's details could be led astray as to Ellenville architecture, if he had no other source of information. It would be a little hard to argue, on the esthetic side, that the painting gains anything by making the house of stone.

Bear Hill (CAT. 347; FIG. 79) was assembled from diverse elements, according to the specifications of its owner, Martin E. Albert, who commissioned the painting (p. 220). A further example of this habit of Henry's is *An October Day* (CAT. 308; FIG. 202), which may be compared with the Cragsmoor post office (FIG. 201) as it looked during my field trip in 1941. Henry's painting shows the rooftree at right angles to the position shown in the 1941 photograph. Has the building been rebuilt since Henry painted the canvas in 1903? Apparently not; an old photograph in the Henry Collection shows the rooftree at right angles to the front porch. Therefore Henry simply revised the building to suit his own taste. In so doing, he lessened to a degree the painting's historical value; for the building is no longer literally accurate and thus can not be accepted as typical of Cragsmoor architecture 40 years ago.

Another instance is *Village Post Office* (CAT. 248; FIG. 62), known to me only through a faded and crumpled photograph in the Henry Collection. The painting seems to be a good one,

related in quality to *The Country Store* (CAT. 181; FIG. 127),
and certainly less hard in line and brushwork than many of Henry's
canvases. *Village Post Office* shows the old Jesse Low store (FIG.
63) at the corner of Canal street and Cape road in Ellenville
(McCausland '41, p. 109), still standing little changed in 1941.
The painting is not a literal visual transcript of nature, however. In
the first place, the Low store never was the post office, according
to Mrs Taylor (McCausland '41, p. 109); the church is correctly
placed, but the houses are not; and so on. Similarly Sidney Ter-
williger of Cragsmoor recalls (McCausland '41, p. 172) that Henry
"wouldn't do us children as we were. He'd have us take off our
shoes and stockings and put our shoes back on without stockings."
In *Spring* (CAT. 315) Henry changed the position of the road in
relation to the Coddington cottage—formerly the George Mance
place. Mr Terwilliger found an old photograph of the cottage to
show how in the painting it had been turned at a right angle to
the road (McCausland '41, p. 171, 189).

Henry's Importance for Today

Contemporary Consensus. In his own time, Henry's rank as an
artist was secure, as the self-appointed historian of the manners and
customs of earlier days, as Isham wrote (Isham '27, p. 346–47):

> *No one else knows so well as he the manners and customs of an age which
> has become old-fashioned, but hardly as yet historic; the first half of the
> last century, when travel was by way of stagecoach or pack boats on the
> canal, when railroads were strange innovations of doubtful merit, when
> women wore hoops and carried reticules and bandboxes and the men were
> stately in swallow-tailed coats and hats of real beaver fur.*

Similar quotations throughout this chapter and in the Biograph-
ical Sketch indicate the place Henry won during his lifetime; and
more are set down here. The historical usefulness of his paintings
was the point stressed by contemporary critics. "He is really the
art historian of early American life and customs," wrote the Art
News in 1906 (Anon. '06). In 1919 Will Low (Low '19)
emphasized the service Henry had performed "in preserving for the
future the quaint and provincial aspects of a life which has all but
disappeared." He continued that Henry's "typical American
product . . . devoted to the perpetuation of truly national themes
[was] a life work of which an American artist may well be proud."

Pasted at the end of Mrs Henry's manuscript is a clipping headed *Pictures as History*, which reads in part:

> . . . *a phase of pictorial art too little understood or appreciated . . . pictures as historical records. . . . As an American social historian, Henry may have failed of recognition in his lifetime But there can be no doubt of the value of his pictures to the social student of future years. Now that St John's Church in Varick Street is gone forever, Henry's charming picture of it* [see CAT. 79, 324, 325; FIGS. 112, 247, 248] *preserves a social and architectural record that American art could ill spare.*

Henry's admirers, however, were not unaware of adverse judgments on his painting, as may be noted in the American Art News (Anon. '19) obituary:

> *Some critics have considered Henry more as an illustrator than as a painter, as he deals with minute details and carefully finishes his canvases to the end, like his early fellows of the old Hudson River School—but this estimate is hardly a fair one.*

Another clipping pasted at the end of Mrs Henry's manuscript may be quoted:

> *The tendency of the day is to slight the fact that every true picture tells a story. The apostles of "art for art's sake" are in the ascendency. They try to relegate the story-telling picture to the realm of illustration.*

As early as 1876, Professor Robert W. Weir wrote in his official report on the 1876 American Centennial Exhibition (U.S. Centennial Commission '76):

> *Mr Henry's style is often ragged and unskillful, but his aim is a compensation, and he attains happily the sentiment of olden times.*

Thus the dwindling popularity which overtook Henry toward the end of his life was the fate of a style rather than of a person. The process may be observed with many 19th century American artists, who went into eclipse and are but now emerging. At Henry's death it was stated, in a clipping pasted at the end of Mrs Henry's manuscript, that "His pictures today are miles out of fashion in manner and subject," this despite the fact that

> *In his own metier, Mr Henry had no superior. His simple, homespun genre paintings, too full of precision and detail to suit the tastes of the moment* [1919] *are the best of their kind.*

A little later—according to letters in the Henry Collection, dated 1925 and 1931—New York art dealers informed Mrs Henry and, after her death, her heirs that there was no market for Henry's work, his style being out of vogue. Moreover, Mrs Henry could

not place the manuscript of her Memorial Sketch, due probably not only to its commercial unavailability but also to the lack of audience for Henry's kind of painting.

Revival of Reputation. Today, a quarter of a century after his death, Henry is coming back into fashion, on a wave of American genre. The exhibition of his work at the Century Association in New York in May 1942 (Century Association '42) is an indication that painting of this kind is returning to favor. Royal Cortissoz's review in the April 26, 1942, issue of The New York Herald Tribune, headed "Edward L. Henry and Some Others," suggests how gladly the return is welcomed in quarters which always kept a soft spot for the old school. The review reads in part:

> *A particularly welcome development in the domain of exhibitions has been the growing revival of interest in certain of our older men. I do not forget the large historical exhibitions, in which they would be bound to appear, but what I especially have in mind is the one-man show. The Brooklyn Museum has played a conspicuous part in this movement, paying tribute to Eastman Johnson (whose brilliantly painted "Husking Bee" would alone justify renewed attention to him), to John Quidor and W. S. Mount. The first named of these has been well recalled, also, very recently at the John Levy Gallery. The Babcock Gallery has done honor to Winslow Homer and to Ralph Blakelock. And I might cite signs of an awakening to the fact that our seniors have a right to remembrance, even though they did not paint like, say, Manet. Another one of them is just now being commemorated at the Century Club. He is Edward Lamson Henry, who was born in Charleston, S. C., in 1841, and died in New York, in 1919. [E. L. Henry died in Ellenville. E. McC.] He was a member of the National Academy of Design, to which he was elected as a painter of genre, drawing his subjects from American life. His work has been unjustly neglected. It is that of a good craftsman who treated his simple material with a markedly sympathetic touch. The present exhibition is one of the most charming of the season.*

Cortissoz continues his tribute by describing Henry's subject matter as "Pictures of People" in a subhead:

> *It is charming because it contains exact pictures of our people, mostly in homespun, so to say, the people of what is called today the horse-and-buggy era. . . . The manner in which he was prepared to deal with his material is rather surprising to learn. His earliest training was received at the Pennsylvania Academy, but he was only nineteen when we find him a pupil of Charles Gleyre in Paris. What is surprising about the conjunction of his name with Henry's is that he was a painter of religious and mythological pictures, the last things in the world that the young American might have been expected to emulate. In fact, he did nothing of the sort, but, on the contrary, followed his own path, and though he subsequently visited Europe more than once, especially Paris, Rome and Florence, [not to mention England. E. McC.] he turned irresistibly to the stuff of the*

American scene, for his themes. In his twenties he found some of these in the Civil War. One of the pictures at the Century is a large, panoramic view of "City Point, Virginia, Headquarters of General Grant." It is a workmanlike affair, but not in his real characteristic vein. That is illustrated far more conclusively in the exhibition in the "Street Scene in Naples," done in 1864, and the better for being shadowy instead of registering the flood of sunlight conventionally associated with such studies. But it was at home that he did the work he was born to do.

He made his choice thoughtfully. The face that looks out at us from the portrait—admirably painted—of J. G. Brown, is eloquent of intelligence. The choice was directed, however, chiefly by instinct, by a deep inner feeling for American life. Despite his so different preoccupations, Gleyre had disciplined him in the fundamentals of his craft. Henry could draw. He had a sound sense of composition and a modest but excellent gamut of color. Also, as is shown again and again in this exhibition, he had a gift for the landscape background. Above all, he caught with its true sentiment the note of his selected field. Nothing could be more veracious than or more agreeable than the roadside episode entitled "News of the Nomination," in which the occupant of an old wheeled vehicle pauses to give his tidings to a pair of farmhands. It is a reconstruction, as it were, for it dates from as recently as 1896, but it remains absolutely spontaneous and convincing. I would note here, too, the merit in the landscape. Henry never fails to lend that factor the charm of which I have spoken. It is a fine part of the pictorial unity which he was wont to achieve. For he always saw his picture as a whole, not only the figures but their surroundings, welding them all together in a closely knit design. He could manage this even when he took a rather sprawling subject, as in the railway scene, "The 9.45 A.M. Accommodation." He put much into this composition but leaves it well balanced. Henry was a competent painter.

He was also varied. Sometimes he would do a "costume piece," as in the "Passing of the Outposts," or "The MacNett Tavern," or the festal "Virginia Wedding." More often he clung to later habiliments and painted pictures like the "Sharpening the Saw" or like the delectable one of "The Latest Village Scandal," in which country types stop their horses and exchange gossip. Somehow one can't help feeling that there is a kind of innocence about the "scandal." [Particularly as there is no evidence that the title is Henry's own. E. McC.] That is the ultimate impression that Henry leaves, one of the sweet sentiment, the neighborliness, the friendly domesticity, to which he was essentially dedicated. His pictures are as wholesome as bread and butter, and it is good to have them brought back into view. For they are, in the bargain, well painted.

Pros and Cons. Despite errors of fact—such as that Henry was elected to the Academy as a painter of American genre subjects; his presentation painting was an Italian street scene—the Cortissoz opinion reflects the most favorable judgment criticism today is likely to make on Henry's work. At the opposite extreme is the opinion of Neuhaus (Neuhaus '31, p. 145):

His pictures have little artistic merit, but today they are of interest as replicas of the customs and costumes of our ante-railroad days.

The most sensible present-day judgment lies between these two poles, the one uncritically embracing the academic and the other totally rejecting it. Felicitous and pertinent is an excellent middle-of-the-road statement from the late Charles C. Curran, N.A., the old friend and neighbor of Henry often referred to before (p. 106 ff., 254). In a personal letter to the Director, Dr C. C. Adams, dated August 1, 1942, he wrote, in part, as follows:

> Critically I think he [Henry] could be said to be about sixty per cent historic and forty per cent pictorial. When it comes to the question of pure artistic quality, I should not rate him very high. Artistic quality was, I think, second in his mind, the human subject first. I know he greatly admired the work of artists who are placed high in the scale of greatness, Henry's place in the annals of the past will, I think, be largely as a recorder of the ways and manners of his and of previous times.
>
> He drew sufficiently correctly; but he will not be classed as a great drafts-man. His color was accurate; but mere accuracy in coloration does not constitute a painter as a "colorist." His compositions were good regulation plans; but he could not be called a great designer such as artists like Thayer, Inness, Brush, Wyant, Dewing and their like.
>
> It would be as much of a disservice to Henry's memory to rate him too high as to rate him too low. I think Henry would agree to this.

Conclusion. By the above evidence, Henry was highly regarded in his own time as a pictorial historian of the American scene, his paintings being considered source books for students of the past. In the past quarter of a century, his reputation has waned and been rehabilitated. But current interest in his work derives from different motives than in his lifetime; in the past three quarters of a century, taste and critical opinion have traveled a considerable distance from the taste and criterions of his age. Today the more prevalent opinion is that Henry's genre paintings are his best work, because they are more representative of life in America in the late 19th century and because they are more esthetically expressive than his historical set pieces.

There is no need to evaluate Henry's painting by a documentary standard, even though his contemporaries thought they did so. In the sense of the past decade, documentary is a discipline of realism based on scientific observation and statement. In the inescapable truthfulness of such documents as photographs of real life, the modern soul finds a counterpart for modern technics. This is an esthetic in its essence almost antiseptic, certainly hygienic (Abbott '41, p. 163–69). As George Bernard Shaw wrote in 1910 (McCausland '42):

> Photography is so truthful—its subjects such obvious realities and not idle fancies—that dignity is imposed on it as effectively as it is on a church congregation.

The discipline, as a matter of fact, operates in all great realistic art. Of Caravaggio's *Boy Bitten by a Lizard* or Bernini's *Portrait of Costanza Buonarelli* (Museum of Modern Art '40, p. 52, 58), one feels that this thing happened, this person was; the esthetic impact is immediate and real. The esthetic of Henry's period, however, was not of such a character. Sentiment rather than realism ruled. If his method was one of "meticulous documentation" (p. 64, p. 95, p. 114), it was the meticulous documentation of details, not of essences. Delacroix in 1839 might paint *The Battle of Taillebourg*, which took place in 1242, or in 1831 paint *Boissy d' Anglas at the National Convention in 1795*, and, because profound human, historical and esthetic awareness informed him, make a significant and moving statement of historical themes. But the so-called historical paintings of Henry's generation were for the most part set pieces, mannequins posed and draped, properties in place. Henry's period accepted such reconstructions as historical, though by the standards of the second third of the 20th century they are not.

Henry's genre work, however, deservedly earns him the title of pictorial historian. Working from life, rather than from prints, costumes, vehicles and the like, he studied people, houses, landscape, clothing and accessories of the Cragsmoor scene, to give these back in his own dry, unemotional style. Lacking great warmth of feeling or plasticity of form, his paintings of everyday subjects nevertheless are expressive and even evocative. If the present-day beholder has no personal memory of the subjects represented, he may still obtain a fair knowledge from these paintings of the time's visual aspect. If the subject matter is familiar, the paintings arouse overtones of remembrance, of what was known and is remembered pleasurably. The current vogue for Americana must to a large degree be rooted in such understandable psychological factors; to the genuine rediscovery of the recent American past, sentimental motives have been added to the valid cultural objectives.

It has been stated above (p. 114 *ff.*) that in his paintings of genre subjects Henry mixed hybrid elements, borrowing a detail here and a detail there, and mingling costumes and architecture from different periods. With this caution in mind, it is possible to derive a quantity of information from his work. His paintings are especially informative in regard to details. The interior of *Sharpening the Saw* (CAT. 195; FIG. 136) appears to have been carefully observed. Scenes of farm and country life seem accurate, even when the visual facts have not been verified minutely. For

example, the buffalo robe of Peter P. Brown, seen in a number of
pictures (FIGS. 137, 139, 146), is an interesting bit of factual
information. Is Henry's painting then essentially miniature still
life? That the frozen image of *nature morte* was congenial to him
may be noted from his habit above mentioned (p. 92) of working
from plaster casts of horses' legs. His genre paintings record people
as well as appurtenances. The six small portraits owned by the
village of Ellenville tell a good deal about the men and women
portrayed. John Billings (CAT. 167; FIG. 133) is differentiated
from "Aunt Nelly" Bloomer (CAT. 230; FIG. 132), whom Henry
visited on her hundredth birthday, carrying her a bouquet. "Black
Fred" (CAT. 194; FIG. 131) is depicted in worn work clothes, no
doubt as he was customarily seen about Ellenville. Henry's exact-
ness of factual representation is attested by the painting (FIG. 128)
and the photograph (FIG. 134) of Carpenter "Joe" Mance. In
general, this is the kind of information which may be garnered
from a study of Henry's painting.

A "typical American product," Will Low (Low '19) called
Henry. Is such the respect in which his work is of most value
today? In the limitations of his art, is the period faithfully
mirrored? In technical matters, this seems true. Henry's painting
is meticulous, neat, carefully studied, industriously produced. He
was a carefully trained draughtsman and expert in his painting
craft, so that today his canvases are well preserved, showing no
signs of cracking or undue darkening. He was not a great colorist,
as Homer was in water color, nor did he possess a great plastic
gift, as Eakins did. He did not show forth the joy of living
expressed by Mount. Henry lived and worked in a period perhaps
best described by the adjective "circumscribed." The tiny, even
haggling quality of his brushstroke may thus be considered indica-
tive not of his individual talent but of the period's character.

Yet this is not the whole picture. The culture of Henry's time
has been inherited by Americans today. Despite lacks and evasions,
that culture speaks of historic American experience. Though senti-
mentalization of the Negro in art, as elsewhere, is regrettable,
nevertheless the fact that Henry frequently painted Negro subjects
shows him reacting to life around him, and in that life the Negro
appeared more and more. Though the period tended to vulgarize
genre, yet Henry revealed sensibility when he painted Cragsmoor
and Ellenville characters. Surely he used such subject matter be-
cause it appeared to his imagination? Further, his treatment of
country themes is significant. Through the early part of America's

history, the rural community was homogeneous; in Henry's time there began to be a division, evidenced at Cragsmoor by "summer people" and "natives." Even so, the democratic spirit of earlier days was not dead. This may be seen in the best of Henry's country life paintings. So analyzed, his work is indeed best described as typical.

Henry's paintings record a period which is gone. They arouse a nostalgia which Henry doubtless would have approved; and they visualize a time not far removed, re-creating scenes familiar not long ago. Henry's picture of the past spells security in the uncertain, changing today. Perhaps we attribute to that time virtues it never had? At any rate, the pleasure gained from work like Henry's is that it reminds us of the past. Because it does not question or criticize that past, we can endow memory with a glamor probably fictitious but nonetheless pleasurable. Take an example of how memory "glamorizes": Henry is often spoken of as the recorder of "horse-and-buggy" days; and surely he set down, with great attention to detail, the visual image of many kinds of horse-drawn vehicles. Those old enough to remember pre-automobile days are reminded, when they see such pictures, of their youth and savor that remembrance. However, probably none would wish to abandon the motor vehicle and return to the horse and buggy—even in gas rationing days (1943).

The appeal of Henry's painting, then, is that it speaks on a level of experience shared by many. It makes no exorbitant demand on emotion, nor does it force the spectator into fantasy. It deals recognizably with the known. Accepting the familiar as its base, it postulates a common denominator of great scope. Despite lacks and limitations, Henry's painting is another reminder that a popular art in the United States today would best be based on general human experience, stated in intelligible terms. By his implications, perhaps even more than by his absolute esthetic achievements, Henry may be said to be integrated in the native tradition and therefore well to deserve his place in the history of painting in the United States.

More than this should be set down on the importance of artists of Henry's rank for the American tradition. In the accelerating rediscovery of that totality loosely called "America"—the whole complex sum of American history, experience, culture and aspiration —men like Henry are seen to stand higher than formerly they were thought to do. This is due not alone to the impact of world events on the Nation but also to an esthetic process which is now,

as it were, completing its cycle and returning upon itself. I refer, of course, to the return to an interest in and a concern with realism or naturalism as a convention capable of expressing broad democratic meanings.

Those who say that America (meaning the United States) is too young to have a history fail to see that already by the 19th century an American stamp had been thrust deep into the yielding substance of native subject matter. Nevertheless sincerely scientific study of this period, of which Henry is a characteristic product, reveals that a prime object of the painters of the time was that rendering function of art, which has been lost in the furious theoretical battle of 20th century artistic theory. The visual artists of that too often scorned academic age were given at least two arrows for their quiver—sound training in draftsmanship and orientation to the outer world. If they had a philosophic point of view as well is another question. However that may be, having been trained to useful tasks in art, they succeeded in creating a better and more expressive portrait than they knew of the America of their time and place. To this increasingly valuable and significant visual chronicle Henry contributed his full share.

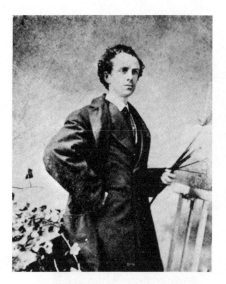

Figure 33 E. L. Henry, *circa* 1867. (Photograph by Sarony, 680 Broadway, New York City)

Figure 34 *From a Window, Newport*, 1866: CAT. 62

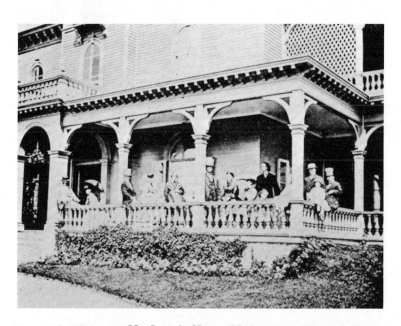

Figure 35 "Taken at Mr Jessup's House, Marine Ave., Newport, R. I., Aug. 1866." Henry is third from the left, perched on the rail

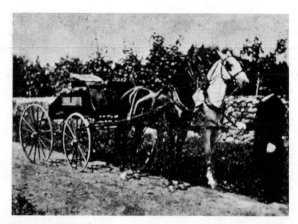

Figure 36 "Mrs A. D. Jessup's Rig with Seat Behind for Footman. Used at Newport, 1866"

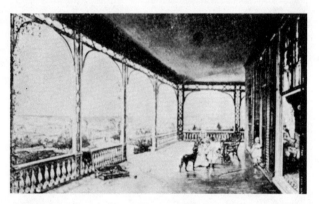

Figure 37 *Porch Scene, Newport, R. I.,* 1866: CAT. 61

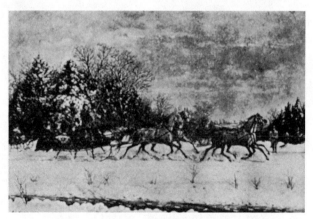

Figure 38 *Four-in-Hand, Central Park,* 1867: CAT. 64

[126]

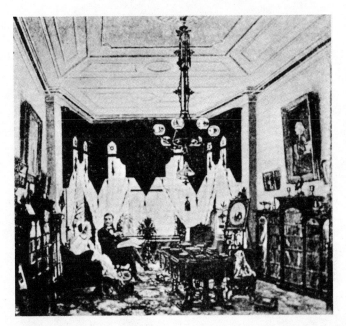

Figure 39 *The Library of Jonathan Thorne, 526 Fifth Avenue, New York,* 1868: CAT. 72. "Just after they were married"

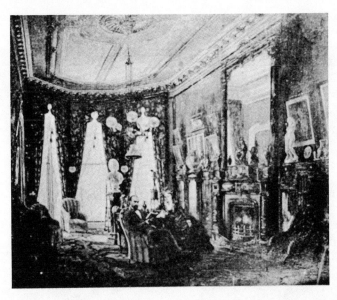

Figure 40 *A Parlor on Brooklyn Heights,* 1872: CAT. 98. This was painted "from Nature" for Mr and Mrs John Bullard

[127]

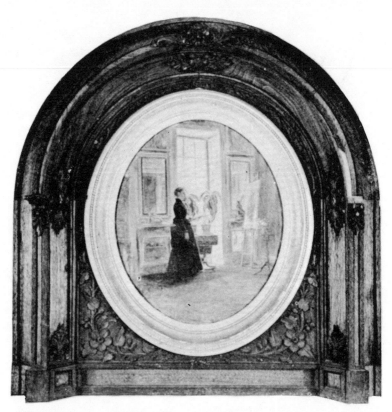

Figure 41 *Portrait of Mrs Henry, London, 1876:* CAT. 122. Note the Victorian frame. Collection, New York State Museum

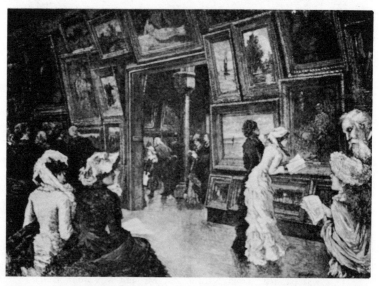

Figure 42 *In the National Academy of Design,* a wood engraving by William St J. Harper, published in Harper's Weekly, April 29, 1882.

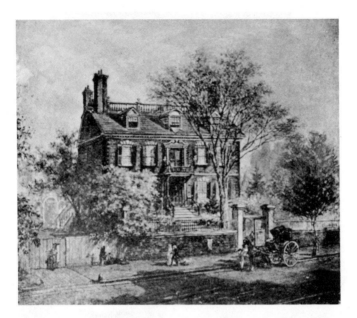

Figure 43 *The John Hancock House,* 1865: CAT. 54. Collection, Estate of Francis P. Garvan.

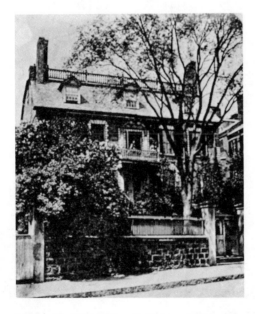

Figure 44 "The Hancock House. Taken down for common modern houses about 1865"

Figure 45 *Beach Wagon:* CAT. 1010. Collection, New York State Museum

Figure 46 *On the Beach:* CAT. 1068. Collection, New York State Museum

Figure 47. *On the Beach: Waiting for the Bathers:* 1879: CAT. 140

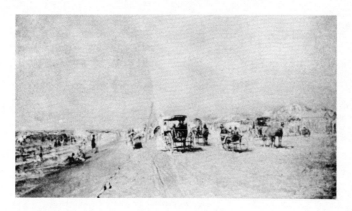

Figure 48 *East Hampton Beach*, 1881, earlier version of figure 49

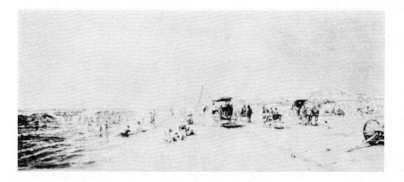

Figure 49 *East Hampton Beach*, 1881: CAT. 154

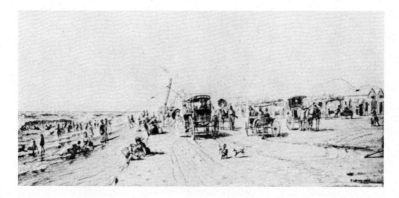

Figure 50 *Bathing Hour, East Hampton Beach*, 1889: CAT. 154-a

[131]

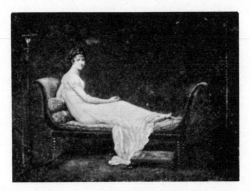

Figure 51 *After David, circa* 1875: CAT. 1001.
Collection, New York State Museum

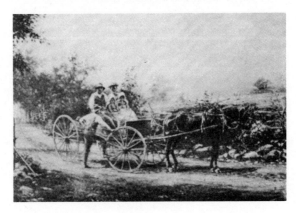

Figure 52 *Taking Life Easy,* 1911: CAT. 359.

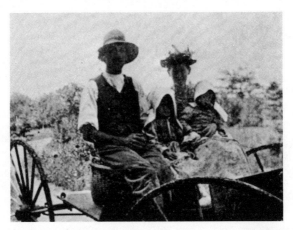

Figure 53 A photograph used as a detail for figure 52

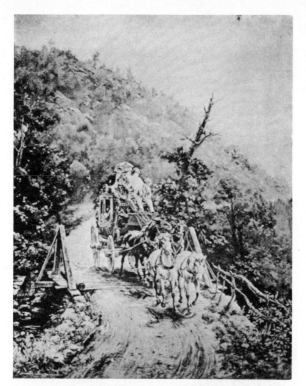

Figure 54 *The Mountain Stage*, 1881: CAT. 155

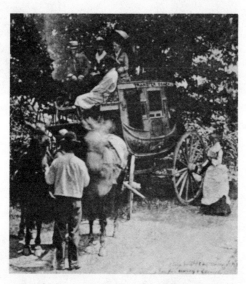

Figure 55 "Stage built 1845 Concord, N. H. Ran from Newburg to Ellenville. Photographed in Otis yard 1881." On the box are Henry, Harriet Otis (?), Mrs Henry and the driver, Dick Elting of the old Elting House in Ellenville. This photograph was used for figure 54

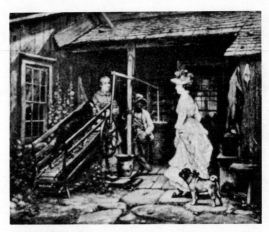

Figure 56 *Capital and Labor*, 1881: CAT. 150.
Collection, New York Historical Society.

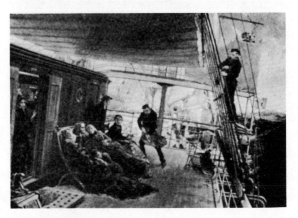

Figure 57 *In the Roaring Forties*, 1884: CAT. 175. Collection, Mrs Seabury C. Mastick.

Figure 58 *The Old Lydig House on the Bronx, Near Fordham*, 1887: CAT. 197

Figure 59 A pencil drawing in Sketchbook 3: CAT. 1187, used as a detail for figure 56. The page is signed, lower right: *Sparta, N. J., 1862*

Figure 60 A pencil drawing in Sketchbook 2: CAT. 1186, used as a note for figure 57

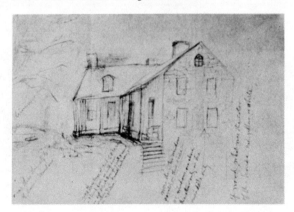

Figure 61 A sketch in a letter from Mrs Charles P. Daly to Henry, to document figure 58

Figure 62 *Village Post Office*, 1891: CAT. 248, a "lost" painting

Figure 63 The old Jesse Low store, at the corner of Canal street and Cape road, Ellenville, as it looked in 1941

[136]

Figure 64 "Winter Scene, Jan. 6, 1880. Copy of
Pencil Sketch, Milton W. Wright Place, LWB." A draw-
ing by the "hermit of Cragsmoor," Legrand W. Botsford

Figure 65 Cragsmoor landscape. "This is with the stone wall
you spoke of I will sell the negative. Will be up in the morn-
ing with camera if the wind don't blow. LWB"

Figure 66 *Country Scene, circa* 1890: CAT. 233. Collection,
Estate of Francis P. Garvan.

[137]

Figure 67 *Sunday Morning (Old Church at Bruynswick)*, 1898: CAT. 283. Collection, J. G. Myers Hilton. Note the four columns

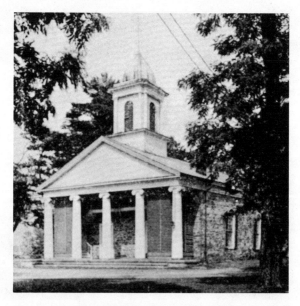

Figure 68 The church at Bruynswick, N. Y., in 1941

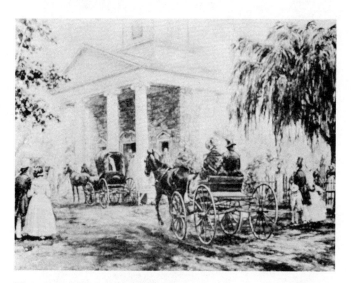

Figure 69 [*Bruynswick Church*] : CAT. 283-*a*

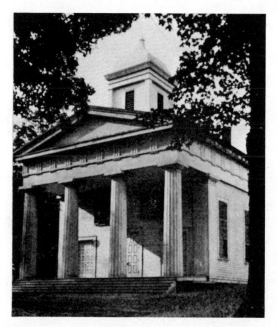

Figure 70 The Dutch Reformed Church, Napa-
noch, N. Y., in 1941

Figure 71 [*Maud Powell Plays the Violin*], 1904: CAT. 319

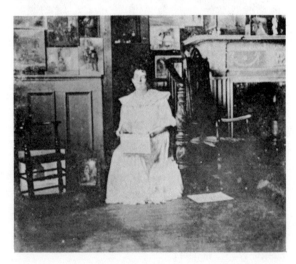

Figure 72 Maud Powell in Henry's studio at Cragsmoor

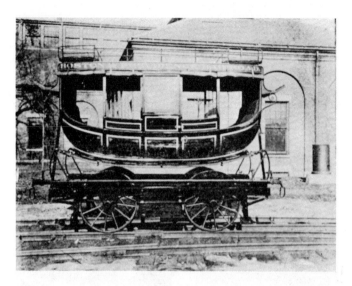

Figure 73 "R. R. Coach. From Boston and Providence Rail-
road"

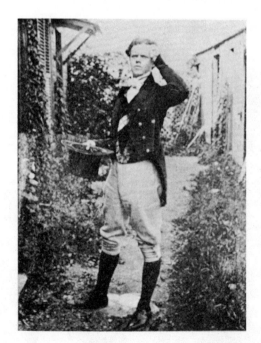

Figure 74 "Mr Armstrong (Beth Chappell's
husband) in one of my old fashioned coats and
vest. July 1900"

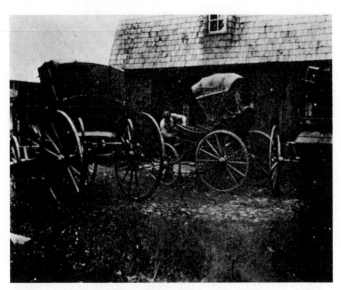

Figure 75 Carriages collected by Henry. These went to the Johns-
town Historical Society in 1922

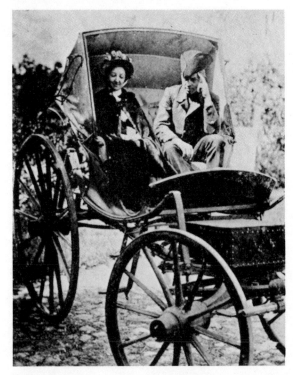

Figure 76 Mrs Lawrence Stetson and Mr Martin E.
Albert in Governor Gansevoort's coach.

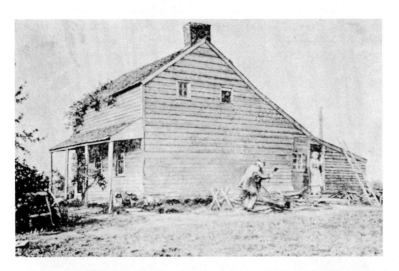

Figure 77 "Old Brown House (as it was in the old days.)" Photographed by Henry in 1880 and copied by Botsford in 1904. "The figures by the woodpile being playfully painted in, as he talked of the old days. LWB"

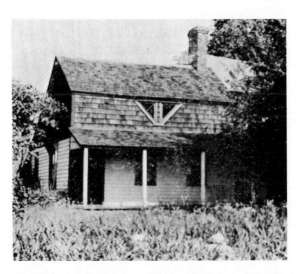

Figure 78 The Peter P. Brown house, 1941, owned at that time by Frederick Baker

Figure 79 *Bear Hill*, 1908: CAT. 347. Collection, Martin E. Albert. (Photograph courtesy, Martin E. Albert)

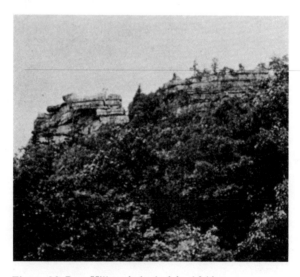

Figure 80 Bear Hill as it looked in 1941

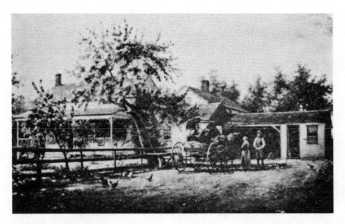

Figure 81 *A Mountain Post Office*, 1900: CAT. 298

Figure 82 Transparency of a corn shock,
possibly a detail for figure 205

[145]

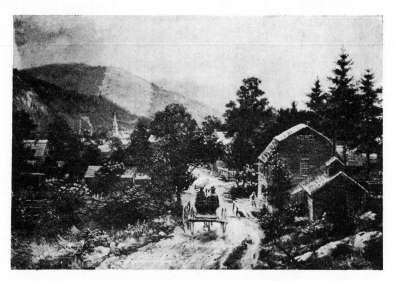

Figure 83 *In the Valley:* CAT. 929, another "lost" canvas

Figure 84 Dutch Reformed Church, Ellenville,
1941. The spire of this church may be seen in
the painting above

A Catalog of the Work of E. L. Henry, 1858–1919

THIS CATALOG lists original works, including those of whose existence the only document is a reproduction (as photograph, platinotype or photogravure) or a reference in correspondence or printed material. Chronological order has been followed, rather than an elaborate system of cross reference, and in the first section of the catalog, drawings and sketches have been collated with oils and water colors for the ease of the reader in studying Henry's development. Measurements are given in inches, height first.

Abbreviations used are:

AL. Photographs of Paintings by E. L. Henry: An Album (see bibliography)

FIG. Figures in this catalog

KL. Reproductions of the Works of E. L. Henry N.A., Klackner, 1906 (see bibliography)

MS. A Memorial Sketch: "E. L. Henry N.A. His Life and His Life Work." A manuscript by his wife, Frances L. Henry, published in this report (p. 311–461).

NAD Annual exhibitions of the National Academy of Design

NO. Numbers used in this catalog

Italics are used to show the artist's signature or other identifying data in his hand. Identifying data from other sources are italicized, with source given. Brackets [] indicate attributed dates and titles.

The catalog is divided into the following sections:

Oils, Water Colors and Sketches: Dated

Oils and Water Colors: Undated

Sketches in Oil and Water Color on Wood, Canvas and Paper, in the Henry Collection

Sketches in Pencil and Pen and Ink on Paper, in the Henry Collection

Henry's Sketchbooks

Miscellaneous Works by Henry

Works Related to the Henry Collection

Oils, Water Colors and Sketches: Dated

This section comprises completed works and preliminary drawings for them, which can be dated with reasonable certainty.

1858

1 GREAT BEND, SUSQUEHANNA
> Pencil on paper, 7x10 in.
> Lower center: *Great Bend, Susquehanna*
> Lower right: *Sept/58*
> Collection: New York State Museum
> Figure 85
> The earliest known work of Henry. *Cf.* NO. 16

2 WEST POINT FROM PROF. WEIR'S
> Pencil on paper, 5x8½ in.
> Inscribed on mount as above
> Collection: New York State Museum

Henry's acquaintanceship with influential people began early. Professor Weir taught drawing at West Point, having been Whistler's teacher. One of his sons, J. F. Weir, was director of the Yale School of Fine Arts for many years. A letter from him to Henry, dated April 19, 1897, indicates that the family friendship continued in later life. In the Henry papers there is no indication that Henry was particularly friendly with the better known son, J. Alden Weir, a leader among the early American Impressionists.

J. F. Weir's letter (on stationery of the School of Fine Arts) follows:

I am sending you by express a little souvenir of Dordrecht, where I spent a summer some years since. It is a sketch taken from Popindrecht, looking over the meadows toward Dordrecht. The black frame is Dutch in color at least, and seems to suit the sketch. This is for a "sweet remembrance," as I am often reminded of you as I go up our staircase, and I hope it will remind you of

<div align="right">

Very truly your friend

Jno. F. Weir

</div>

Give my kindest regards to Mrs Henry

1859

3 BETHLEHEM, PA., 1859
> Pencil on paper, 5¾ x10 in.
> Lower left as above
> Collection: New York State Museum

On the back are two drawings: *Freight Engine* in pencil and *Express Locomotive about 1858* in water color.

4 ON THE LEHIGH, PENN., 1859
> Oil on board, 9x13¼
> Inscribed on back: *On the Lehigh, Penn., 1859, one of the first sketches from Nature of E. L. Henry*
> Collection: New York State Museum

1859

5 MAUCH CHUNK, PA., SEPT. 1859
Pencil on paper, 7x10 in.
Lower center as above
Collection: New York State Museum
Figure 86
Cf. NO. 10

6 [BARNYARD: 1]
Pencil on paper, 6¼ x8⅞ in.
Collection: New York State Museum
Figure 88

7 [BARNYARD: 2]
Pencil on paper, ruled off to 3⅝₆x6¹⁄₁₆ in.
Collection: New York State Museum
Figure 89

This drawing shows the barn, corn crib, hay wagon and house seen in NOS. 9, 12, 13 and 14. Proportions have been changed, the paintings including more sky than the drawing.
Cf. also Sketchbook 1: NO. 1185

8 [BARN INTERIOR]
Pencil on paper, ruled off to 4x6⅛ in.
Collection: New York State Museum
Figure 90

The same architecture, vehicles and chickens may be seen in this drawing as in the other barnyard subjects. On the back is a sketch for NO. 13.

9 BARNYARD SCENE NEAR PHILADELPHIA
Lower right: *E. L. Henry '59*
Cf. NOS. 12, 13 and 14

This may be *Barnyard Scene*, NAD 1859, NO. 781. Of that painting, the Daily News (FIG. 228) wrote on Wednesday morning, June 8, 1859, as follows:

ACADEMY OF FINE ARTS—NO. VII

Northeast Gallery

No. 187, Barn-Yard Scene—Ed. L. Henry, Philadelphia. A very natural, conscientious, and well painted picture, beautiful in composition, by a young and most talented artist. We do not feel like seeking for its fault, being satisfied that Mr Henry only requires experience, combined with that judgment which we think he possesses, to enable him to repair and improve effectually any deficiencies which may be in this picture. We are much mistaken if there is not a foreshadowing of great excellence in this "Barn-Yard Scene."

"187" seems to be a transposition of "781"
AL. p. 43

10 BELOW MAUCH CHUNK ON THE LEHIGH RIVER
Exhibitions: NAD 1859, NO. 586
Cf. NO. 5

1860

11 [BARNYARD]
Figure 91

The photograph in the New York State Museum Henry Collection shows the same barn and house as are seen in NO. 14; but the house is turned so that its gable end faces out. *Cf.* NO. 9. Inscribed on the back of the photograph is the following: *Painted about 1863–4. Originally purchased by G. W. Stow of New York in the sixties. Afterwards taken for a debt by J. H. Brown of New York. After his death in 1880, held by his widow for a few years. Then sold at auction to a Philadelphia dealer, Hugh McCann. And afterwards turned up at a sale in Washington, D. C., in 1908 and* [was] *purchased by a Mr William T. Clerk of that city, who made this little photo copy of it. 1896–7.* It seems more correct to ascribe the earlier date to this work, as Henry was sometimes inaccurate in dating his pictures and as the other barnyard paintings (FIGS. 92 and 93) fall in the years 1859–60.

12 BARNYARD SCENE
Oil on board, 10x14 in.
Lower right: *E L HENRY* (capitals in red)
Exhibitions: NAD 1860, NO. 478; Century Association, 1942, NO. 2
Collection: Estate of Francis P. Garvan
Figure 92

This painting was formerly listed as *The Old Home in Dixie.* Pasted on the back of the stretcher is the Art News obituary of E. L. Henry.

13 FARM SCENE IN PENNSYLVANIA
Oil on board, 10x14 in.
Lower right: *E L Henry '60*
Exhibitions: NAD 1860, NO. 647; Century Association, 1942, No. 11
Collection: Estate of Francis P. Garvan
Figure 93

This painting was formerly listed as *Farmyard.*

14 [BARNYARD SCENE]
AL. p. 44
Cf. NOS. 12 and 13

15 WOODPILE
AL. p. 6

16 ON THE SUSQUEHANNA
AL. p. 8
Cf. No. 1

Cf. also the photograph in the New York State Museum Henry Collection, described in a printed label on the back as follows: *The Gap, from the East Side of the River. Evening. No. — Scenery in the Region of the Delaware Water Gap, Pennsylvania. Photographed by Moran & Storey, Philadelphia.*
Figure 87

1860

17 OFF TO EUROPE
Pen and ink on paper, 5^{11}⁄$_{16}$x7^{13}⁄$_{16}$ in.
Lower right: *E. L. Henry, N. Y., Sept. 22, 1860* (with the date added
 in pencil, apparently later)
Lower left: *Off to Europe*
Collection: New York State Museum
Figure 229

1861

18 UNA VIA IN NAPOLI /61
Pencil on paper, 12x8⅞ in.
Lower right: *una via in Napoli /61; Naples Feby 1861*
Collection: New York State Museum
Figure 94
Cf. NO. 42

19 THE CAMPAGNA FROM FRASCATI
Pencil on paper, 5⅞x12 in.
Lower left: *Frascati*
Collection: New York State Museum
Inscribed on mount as above

20 IN BELLA FIRENZE
Pencil on paper, 5¼x8⅞ in.
Lower right as above
Collection: New York State Museum
Figure 233
Inscribed on mount: *Fort Belvidere, Florence, from the Arno*
Cf. NO. 33

21 AU FOND DU LAC, COLICO, LAC DU COMO
Pencil on paper, 6¼x8⅞ in.
Lower left as above
Collection: New York State Museum

22 COLICO, LAKE OF COMO
Pencil on paper, 7½x12 in.
Collection: New York State Museum
Figure 234
Inscribed on mount as above

23 LUINO, LAKE MAGGIORE
Pencil on paper, 7½x17½ in.
Collection: New York State Museum
Inscribed on mount as above

24 LIVORNO, LAKE MAGGIORE
Pencil on paper, 7⅛x11¾ in.
Collection: New York State Museum
Inscribed on mount: *Livorno, Lake Maggiore, St Maria del Sasso*
Cf. NO. 37

1861

25 CANNSTADT IN WURTEMBURG, JUNI 1861
Pencil on paper, 6½ x11 in.
Lower left as above
Collection: New York State Museum
Figure 235
Inscribed on mount: *Die Rosenstein near Stuttgart and Palace of the King
of Wurtemburg*

26 IN STUTTGART
Pencil on paper, 10½ x8⅞ in.
Lower left as above
Collection: New York State Museum
Figure 236
Inscribed on mount: *Street View in Stuttgart, Wurtemburg*

27 A BERLIN OMNIBUS
Pencil on paper, 4½ x6 in.
Lower right: *nach Berlin*
Collection: New York State Museum
Figure 237
Inscribed on mount as above

28 PRUSSIAN CANAL BOAT
Pencil on paper, 3⁵⁄₁₆x6 in.
Lower right: *nach Berlin*
Collection: New York State Museum
Figure 238
Inscribed on mount as above

29 ITALIAN SCENE
Exhibitions: NAD 1861, NO. 270
Collection: Isaac H. Brown, 1861–
NAD catalog note: *Now in Rome, Italy*

1862

30 IN AMSTERDAM
Pencil on paper, 11⅝ x8 in.
Lower right as above
Collection: New York State Museum
Figure 239

31 ROTTERDAM, APRIL '62
Pencil on paper, 8¼ x12 in.
Lower right as above
Collection: New York State Museum
Figure 240

32 ICEBERGS OFF BANKS OF NEWFOUNDLAND
Pencil on paper, 5⅝ x12 in.
Lower left: *ELH '62*
Collection: New York State Museum
Figure 241

1863

33 THE ARNO, FLORENCE

Oil on canvas, mounted on board, 10x11⅞ in.
Lower left: *E L Henry '63* (in red)
Bibliography: Our Heritage, 1942, p. 32, NO. 207
Exhibitions: Our Heritage, National Academy Galleries, 1942, NO. 207
Collection: National Academy of Design; NAD Catalog NO. 729
Henry's "diploma" picture on election to the Academy.

34 AN ITALIAN VETTURA

AL. Index and p. 7
Collection: James Thomson, 1864–?
Figure 232
Cf. Figures 230 and 231

35 VIA PALLOMETTE, NAPLES, AFTER A MODEL FROM NATURE

Exhibitions: NAD 1863, NO. 166

36 VIA SAN LUCIA

AL. p. 44
Cf. Figure 95

37 ST MARIA DEL SASSO, LAGO MAGGIORE

Exhibitions: NAD 1863, NO. 397
Cf. AL. p. 17; also NO. 24

38 RUSSIAN FLEET AT ANCHOR IN THE NORTH RIVER

A letter from Henry (from which the signature has been torn off and to which the Date *Nov. 1863* has been added later in pencil) refers to this painting. It reads:

To the Russian Consul General

I understand by the papers that the Russian Fleet will leave Boston next week. As I wish to present to the Admiral a painting of the Russian fleet at anchor in the North River, I would like to know how or in what manner I can forward the painting to him ere he leaves this country.

With respect, I am, dear sir,

Your obedient servant

On the back is the following:

To Admiral Lisoffsky, 1863, commander of the Russian Fleet for several weeks anchored off the Battery, New York City. The painting of the Russian Fleet by E. L. Henry was presented to the Russian Government and fully acknowledged by the Russian minister and consul at New York at the time—early in 1864.

1864

39 CANAL IN VENICE
AL. Index and p. 5
Exhibitions: NAD 1865, NO. 552, as *A Canal Scene, Venice*
Collection: James Thomson, 1865–?
 A photogravure in the Henry Collection shows the subject reversed from the photograph in the Album.

40 THE ITALIAN MAN-OF-WAR, IL RE GALANTUOMO
Exhibitions: NAD 1864, NO. 83

41 NEAR PALESTRINA, ITALY
Exhibitions: NAD 1864, NO. 71

42 STREET SCENE IN NAPLES
Oil on canvas, 24x17 in.
Exhibitions: NAD 1865, NO. 568, as *Via. St Catarina, Naples;* Century Association, 1942, NO. 54
Collection: B. H. Moore, 1864—?; Century Association, 1942, gift of Mrs. J. H. Gibbons of Washington, D. C., in memory of her father, Richard S. Ely
Figure 95
Cf. NO. 18, 1078

 A letter to Henry gives the following information:

Phila Jan 23/64

Dear Sir

Your picture has arrived & is much admired.
We heard that you were coming to the "Fair" in a day or two. Is this the case? We shall be pleased to see you, and also in relation to the picture, I had the pleasure of dining with Mr Bierstadt and other artists yesterday.

Respectfully

B. H. Moore

 A note added at the top of the paper continues:

Your picture on exhibition has been sent to my house as those in charge did not know what to do with it, the exhibition having closed (Acad. Fine Arts)

43 SOUVENIR DE LAC MAGGIORE
AL. p. 39

44 STATION ON "MORRIS AND ESSEX RAILROAD"
AL. Index and p. 9
Exhibitions: Probably NAD 1864, NO. 56, *The Railroad Depot*
Collections: James Thomson, 1864—?
Figure 108
 The photograph in the Album is inscribed *Old Station at South Orange, N. J., 1864,* though the printed index gives the title as above. The painting shows a station of the period. A coach, a wagon, a surrey, with people, are waiting for the train, while a Negro boy chases sheep across the track **before the approaching train.**

1864

45 CITY POINT, OCT. 1864

 Pencil and pastel on paper, 8½ x18½ in.

 Lower left: *ELH, Oct. 1864*

 Collection: New York State Museum

 Figure 105

 Inscribed on mount as above: also: (from left to right) *Sketch taken from Pilot House on a U. S. Transport. Down James River. Anchored vessels with stores waiting to discharge cargoes. "Double ender" (guard ship). Stores dock. Monitor. U. S. Mail Dock. Adams Exp. Barge. (Ltnt Grant's Hd Qurts) (Commander in Chief). Sutler's schooner. Gen Ingall's Hd Quarters. Mouth of Appomottax River.*

 Cf. Figures 106 and 107

46 THE MARKET PLACE, WASHINGTON

 Pencil and white chalk on paper, 6⅜ x12½ in.

 Lower left: *ELH, Oct. 1864, Washington*

 Collection: New York State Museum

 Figure 96

 Inscribed: *The Market Place, Washington, sketched from the window of a hotel, Oct. 1864. Showing fortifications on the Virginia side of the Potomac, protecting the Capitol*

47 THE GREAT HORSE DEPOT AT GIESBORO ON THE POTOMAC BELOW WASHINGTON

 Pencil and water color on paper, 11½ x18½ in.

 Lower left: *E. L. Henry Nov. 1864*

 Collection: New York State Museum

 Figure 97

 Inscribed: *The great horse depot at Giesboro on the Potomac below Washington where horses were broken in & drilled for the two branches of the Service and where they were brought back to recuperate. Horses ready to be shipped on a Transport. Where the incurable & condemned Horses were shot. Dead animals loaded on barges & carried across the Potomac.*

48 NEAR HARRISON'S LANDING, LOWER JAMES RIVER

 Pencil and pastel on paper, 11½ x19½ in.

 Lower left: *Near Wilson's Landing, Lower James River, sketched from the Pilot House on a Transport, Nov. 1864*

 Collection: New York State Museum

 Figure 98

 The inscription is over writing which has been erased. A drawing in Sketchbook 4, called *Harrison's Landing*, shows the same subject. The gazetteer gives Harrison's Landing as the scene of important actions in this Civil War campaign.

1864

49 CITY POINT, VA., NOV. 1864
Black and white wash, 9x20 in.
Lower left: *E. L. Henry, City Point, Va., Nov. 1864*
Exhibitions: Century Association, 1942, NO. 4-a
Collection: Harry M. Bland
Figure 106
Inscribed further: *View from James River. From sketch taken from the pilot house of a transport, Nov. 1864*
Cf. Figures 105 and 107

50 U. S. TRANSPORT ON THE POTOMAC BELOW WASHINGTON: DURING THE WAR, 1861–1865
Water color on paper, 10x16 in.
Lower right: *E. L. Henry, Nov. 1864*
Collection: Bernard H. Cone
Inscribed: *Drawing made from a small boat on the river*
The name *John Brooks* is plainly lettered on the paddle wheel.
Data on the back: *Side-wheel Steam-boat JOHN BROOKS. Length 239.8, beam 31.4, depth of hold 10.8. Ran from Bridgeport, Conn., in 1859. At start of Civil War in the call for Steamboats was chartered for $600 a day and served in Virginia and Carolina waters. At the end of the war, returned to Bridgeport and ran for many years in New Hampshire and Maine waters. From 1890 to 1894, ran from Boston to Portsmouth*
Cf. NO. 90

51 WESTOVER, JAMES RIVER
Pencil and pastel on paper, 12¼ x19⅛ in.
Lower left: *Grant's Campaign, Nov. 1864. Old "Westover," James River, a Division Hd Qtrs, Army of the James*
Lower right: *Sketch Made from the Deck of a Transport. E L Henry, Nov. 1864*
Collection: New York State Museum
Figure 102
Cf. Figure 103

52 ON THE JAMES RIVER, VA.
Oil on canvas, 6x12 in.
Lower left: *E L Henry Nov. 1864*
Lower right: *On the James River, Va. Campaign of 1864*
Exhibitions: Century Association, 1942, NO. 39
Collection: Guy Mayer Gallery
Inscribed on back of canvas in pencil: *Study from Nature. Sunset effects through the smoke of the campfire of the Confederate armies from the James River below Richmond Landing. 1864. E L Henry*

53 THE RACES AT FLORENCE, ITALY
AL. Index and p. 11
Collections: J. P. G. Foster, 1865–?
This painting is titled as above in the index of the Album, but inscribed under the photograph: *Spring Races at Florence, Italy.*
Cf. also a photograph in the Henry Collection inscribed: *The Race Course at Florence, Italy. From pencil sketches made at the time. Dated: 1864*

1865

54 THE JOHN HANCOCK HOUSE
Oil on wood, 7x8¼ in.
Lower center: *E L Henry '65*
Exhibitions: Century Association, 1942, NO. 21
Collection: Estate of Francis P. Garvan
Figure 43
Cf. Figure 44

55 RESIDENCE AT POUGHKEEPSIE
AL. p. 39
Inscribed: *Owned by the late Robt Sanford*

56 ST ERASME, GAETA, ITALY
AL. index and p. 13
Exhibitions: NAD 1866, NO. 438
Collection: William E. Dodge, 1865–?

57 WESTOVER, VA., 1863
Oil on wood, 12x14 in.
Lower right: *E L Henry*
Exhibitions: NAD 1867, NO. 294, as *Westover, James River, Campaign of 1863;* Century Association, 1942, NO. 60
Collection: Century Association
Figure 103
Cf. NO. 51; also MS. p. 319; also AL. Index and p. 15
 This painting is titled as above on the card fastened to the frame. The date *1863* is an obvious error, probably the artist's, as the James River campaign was fought in 1864, the year in which Henry served with the commissary of the Union Army.

1866

58 AN AMERICAN RAILROAD STATION
AL. Index, No. 9
Collection: John Taylor Johnson, 1866–?
 At the sale of his collection in 1876, a painting was sold, No. 41, *Railway Station, Westchester,* 16x30 in. It may be the same painting.

59 THE GRAND HALL, LEVENS, WESTMORELAND
AL. Index and p. 23
Exhibitions: NAD 1867, NO. 494, as above.
Collection: C. J. Peterson–?
 The printed index of the Album gives the title as follows: *Drawing Room of Levens Hall, Westmoreland, England,* though Henry has given the above title under the photograph on p. 23 of the Album. The notation dates the picture as *1868.* But this is obviously incorrect, from the NAD entry, as well as from a letter from Peterson to Henry, dated February 2, 1865: *Mrs Peterson is looking for something very fine. "Levens" will be her pet picture, if it equals what she expects.*

1866

60 [THE MAIL CARRIER]
AL. p. 58

A photograph in the Henry Collection is inscribed: *The mother of our old housekeeper, Mrs Jane Morgan of North Wales. She carried the mail. Painted from this little photograph sent over by the Countess of Vane to the old woman's daughter here in New York City.*

61 PORCH SCENE, NEWPORT, R. I.
AL. Index and p. 21
Lower right: *E L Henry, 1866*
Collection: T. A. Vyse, 1866–?
Figure 37
Cf. Figure 35

62 FROM A WINDOW, NEWPORT
AL. p. 39
Figure 34

Another photograph in the Henry Collection is inscribed: *From a Sketch after Nature, July 1866, Jessup's, Newport, R. I.* This painting may be the inspiration for the heavily carved walnut frame, now in the Henry Collection. Cf. Figure 41

63 SOUVENIR OF A TRIP TO NANTUCKET
AL. p. 3

1867

64 FOUR-IN-HAND, CENTRAL PARK, NEW YORK
AL. Index and p. 16
Lower left: *E L Henry, 1867*
Collections: T. A. Vyse, 1867–?
Figure 38

Photograph in Album is inscribed: *1867. Mrs. Vyse, her sister, Miss Power, & E. L. Henry. Thos. A. Vyse driving. The Four-in-Hand of the late Thos. A. Vyse in Central Park.*

65 THE 9.45 A.M. ACCOMMODATION, STRATFORD, CONNECTICUT
Oil on canvas, 16x30⅝ in.
Lower right: *E. L. Henry P. 1867*
Bibliography: Life in America, pl. 212; Metropolitan Museum of Art Bulletin, June 1939, Vol. 34, No. 6, p. 137–38, "The Moses Tanenbaum Bequest"; Magazine of Art, June 1939, p. 332; Life, June 19, 1939, p. 30; "Our Heritage," 1942, p. 29, NO. 179
Exhibitions: Life in America, Metropolitan Museum of Art, 1939; Our Heritage, National Academy Galleries, 1942, NO. 179; Century Association, 1942, NO. 32
Collections: Moses Tanenbaum; Metropolitan Museum of Art
Figure 109

A photograph in the Henry Collection shows what seems to be another version of the subject, with minor changes. The architecture of the houses

1867

at the right is different. The man in the wagon at the extreme right is whipping his horses. At the extreme left, the woman running wears a different costume and does not lead a child. Details throughout show such alterations.

Of the above painting, the Metropolitan Bulletin writes: *Henry's picture . . . is all human activity, all bustle and confusion. Here is the fine puffing engine that frightens horses and little children, here are the houses and station that man has made for his comfort and convenience, here are his wagons, his trunks, his horses, his dogs, and here is man himself, a very bee for busyness. And how this scene has changed since the artist's time! The wood-burning locomotive may have been the iron monster of its day— it seems but a toy to us, its antlered lamp, its bell and all, charming us with their quaintness. And did the owners of the pretty houses realize that this pleasant little train would soon grow up and drive them from their once gracious and quiet homes and turn the neighborhood topsy-turvy? Perhaps they did, but here in 1867 it is still all very fine, all very gay—a veritable feast for the eyes. Louise Burroughs*

66 A NEW YORK REGIMENT LEAVING FOR THE FRONT TO REENFORCE THE ARMY OF GEN. GRANT. SCENE, NEW JERSEY RAILROAD TERMINAL, 1864–5

Black and white wash drawing on paper, 11¾ x 19½ in.
Lower right: *E L Henry, 1864–7*
Collection: Albert Duveen
Figure 101
Cf. NO. 85

67 THE WARNING

Lower left: *E L Henry*
A photograph in the Henry Collection is inscribed on the back: *The Warning: An Episode in the Valley of Virginia during Campaign of 1864. Owned by Dr Sternberg, N. Y.*

67-a. THE WARNING

Oil on paper, 14½ x 20¼ in.
Lower left: *E L Henry*
Exhibitions: Century Association, 1942, NO. 58
Collection: Albert Duveen
Figure 104

68 THE MONASTERY OF ST MARIA DEL SASSO

AL. Index and p. 17
Collection: A. D. Jessup, 1867–?

69 SANTA SPIRITO, FLORENCE, ITALY

Exhibitions: NAD 1867, NO. 363
Collection: Henry Dallett, 1867–?

1868

70 THE OLD CLOCK ON THE STAIRS
AL. p. 33

Lower right: *E L Henry*

Exhibitions: NAD 1869, NO. 406, as *The Clock on the Stairs;* International Exhibition, Philadelphia, 1876, NO. 258

Collection: Robert Gordon, London, 1869–1918

Cf. MS. p. 320; also NO. 379; also Sketchbook 7, which notes: *20 stairs, 6 panels* etc. for this painting; also NO. 81

In the Henry Collection there are several photographs of the subject, one inscribed: *To Miss Frances M. Wells, 1874, Compts of E. L. Henry.*

The most informative inscription is: *A Study after Nature in lower Spruce Street, Philadelphia, in 1866. Purchased by Robert Gordon, a banker of London. His residence was at Sydenham, near London, where this picture is. He died there early this year, 1918.*

Cf. Figure 214

Cf. CORR. December 24, 1894

71 THE INVALID
AL. Index and p. 27

Exhibitions: NAD 1870, NO. 233

Collection: Dr J. D. Haren White, 1868–?

The photograph in the Album is inscribed: *Portrait of Miss Kate White, Philadelphia, died February, 1868*

In the Henry Collection there is photograph, colored by hand, on the back of which a visiting card has been pasted. There is a further notation by Henry: *Born 1846. Died 1868*

72 THE LIBRARY OF JONATHAN THORNE, 526 FIFTH AVENUE
AL. p. 43

Figure 39

A photograph in the Henry Collection is inscribed: *Mr and Mrs Jonathan Thorne in their parlor, Fifth Avenue near 44th Street. 1868. Just after they were married.*

73 ["A COLD DECEITFUL THING IS THE SNOW"]
AL. p. 30

Lower left: *E L H '68*

This seems to fit the arch-shaped frame shown in Figure 41

Under the photograph in the Album the following verse is written:

> *A cold deceitful thing is the snow*
> *Though it come on dovelike wing*
> > *the false snow*
> *'Tis but rain disguised,*
> > *appears*
> *And our hopes are frozen*
> > *tears*
> > *like the snow.*

1868

74 GEN. FITZJOHN PORTER'S HEADQUARTERS, JAMES RIVER
AL. p. 43

This seems to be a second version of *Westover*. A letter to Henry from C. J. Peterson, dated February 2, 1865, may bear on the question. It reads, in part, as follows:

I did not answer your last letter . . . because I expected, before this, to have had the James River picture, and, with it, an occasion for writing.

I fear, now, that you have not had time to paint the picture, for the exhibition where you were to show it came off, I believe, more than a week ago. If you have painted it, I should like to have it, as soon as is convenient to yourself. How shall I remit? By my check?

75 AFTER THE BATTLE
AL. p. 45
Inscribed: *Souvenir of the Peninsular, 1864*

76 THE TERRACE AT HADDON
Exhibitions: NAD 1868, NO. 335

77 A CHAT AFTER MEETING
AL. p. 43
Collection: J. W. Pinchot, 1868–?
Figure 114

78 FACADE OF CATHEDRAL PIACENZA, LOMBARDY
AL. Index and p. 25
Collection: Robert Hoe, 1868–?

A note from R. Hoe, dated June 15, 1868, reads:

Please send the picture by bearer. I intended to come & see you today but am much engaged & I may be absent on business for several days.

Cf. the photograph in the Henry Collection, which seems to be reversed, to judge by the signature. This reads in mirror image: *E L Henry Pxt*

79 ST JOHN'S CHURCH, VARICK STREET, NEW YORK: 1866
Oil on board, 6½ x 4½ in.
Lower left: *E L Henry '68*
Exhibitions: Collections in Hartford, Wadsworth Atheneum, 1936; Century Association, 1942, NO. 49
Collections: Misses Welcher, Hartford; Macbeth Galleries
Figure 112
Cf. NOS. 324 and 325; also clippings in Henry files.

A large photograph (15½ x 21¾ in.) of this subject in the Henry Collection is inscribed on the back as follows: *Old Dry Plate Negative. Taken by Rockwood by order of E. L. Henry. Winter of 1866–7, as the City Government had to or was about to commence to cut down the trees & destroy the old park to make way for a freight depot for the N. Y. Central R. R. through the efforts, &, &, of William H. Vanderbilt.*

The unidentified newspaper clipping quoted under NO. 89 writes: *St. John's Chapel, before the old trees surrounding it were cut down, and the fine park in front was not covered with a mass of brick and mortar, has also an existence on his canvas.*

1868

80 ST PAUL'S CHURCH: 1766
Oil on board, 8x5¾ in.
Lower left: *E L H '68*
Exhibitions: Collections in Hartford, Wadsworth Atheneum, 1936; Century Association, 1942, NO. 50
Collections: Misses Welcher, Hartford; Macbeth Galleries
Figure 113

81 [OLD WOMAN READING]
AL. p. 42
The model seems to be the aunt of William Kulp, Philadelphia antiquarian; she posed for NO. 70.

Mortimer E. Barnes, Westbury, L. I., has a small oil on cardboard, 5¾ x9 in., signed, lower left: *E L Henry '70*, which seems to be related. It is inscribed on the back: *The old back sitting room. Souvenir of Phila Quaker families. E L Henry*

1869

82 A PRESENTATION OF COLORS TO THE FIRST COLORED REGIMENT OF NEW YORK BY THE LADIES OF THE CITY IN FRONT OF THE OLD UNION LEAGUE CLUB, UNION SQUARE, NEW YORK CITY IN 1864
Oil on canvas, 17x26½ in.
Lower right: *E L Henry 1869*
Collection: Union League Club
Figure 100

82-a PRESENTATION OF COLORS
Pen and ink on paper, 3⅜ x4¾ in.
Unsigned and undated
Collection: New York State Museum
Figure 99
Inscribed on back: *To be painted by Mr Henry, 17x26 for*
the Union League Club for 500$
Presentation of Colours
by the Ladies of NY
to the 1st NY Coloured Reg.

83 OLD DUTCH CHURCH, NEW YORK
Oil on canvas, 18x14 in.
Lower right: *E L Henry 1869*
Bibliography: *Life in America*, pl. 213; Valentine's Manual of New York, 1916
Exhibitions: NAD 1869, NO. 383, as *Middle Dutch Church, Fulton Street;* Life in America, Metropolitan Museum of Art, 1939; Century Association, 1942, NO. 37
Collections: S. P. Avery; Metropolitan Museum of Art
Figure 110

1869

The unidentified newspaper clipping quoted under NOS. 79 and 89 reads: *New York can thank him for preserving in this manner several old landmarks fast disappearing before the march of improvement. Among these are the New York Hospital . . .; also, the old North Dutch Church in William street before its curtailment by the vandal hands of workmen, or fire had toppled over its spire and destroyed the carved memorial above its doorway.*

84 THE OLD WESTOVER MANSION
Oil on canvas, 11x13 in.
Lower right: *E L Henry '69*
Collection: Corcoran Gallery of Art
Cf. NOS. 51 and 57

85 DEPARTURE FOR THE SEAT OF WAR FROM JERSEY CITY
AL. p. 41
Exhibitions: NAD 1869, NO. 398, as *Departing for the Seat of War*
Collection: Charles E. Gregory, 1869–?
Cf. NO. 66; also two photographs in the Henry Collection, one an albumen print, the other colored in oils, the first called *A New York Regiment Leaving Jersey City for the Front, March 1864*, the second *Embarkation of Troops, Weehawken.*

86 GRAEME PARK, NEAR PHILADELPHIA
AL. p. 46
The photograph in the Album shows a colonial interior, with a man and a woman in period costume sitting before the fireplace. A second woman opens the door at the right as a man enters, lifting his tricorne.
Two photographs in the Henry Collection show exterior views of Graeme Park. One is inscribed on the back: *End View, Graeme Park, at Horsham. Built by Sir William Keith, 1720–22, near Philadelphia. Gov. of Penn. 1720 to 1727. Full of Historical Associations. The Home of Lady Elizabeth Ferguson of Revolutionary Memory.* The other photograph is inscribed on the back: *"Graeme Park." Built 1722 by Sir Wm. Keith. Gov. of Penna. 1720 to 1727. At Horsham near Philadelphia*

87 INTERIOR OF HOPE LODGE
AL. p. 27

88 [REVOLUTIONARY INTERIOR]
AL. p. 38
An interior with a couple in period costume

1870

89 THE LIBRARY OF A. H. WARD
AL. p. 32
Lower right: *E L Henry*
Exhibitions: NAD 1870, NO. 340, as *Interior of a Library*
Collection: Miss Ward, 1870–?
The photograph in the Album is inscribed: *Old Mr Ward in his Library, Waverly Place. Painted from life.*

1870

An unidentified newspaper clipping, probably of 1869, adds: *At present Mr Henry is engaged in painting the interior of the library of the late A. H. Ward, Esq., in Washington Place, with a portrait of the deceased therein. The room is a copy of Sir Walter Scott's library at Abbotsford, with oak ceiling and panelling. The coats of arms and heraldic devices belonging to the family of Mr Ward, together with portraits on glass of English and Scottish poets, also adorn its walls.*
Cf. Sketchbook 7 for a notation: *Ward's Room, 22 feet long. 15 Do wide. 16 feet high.*

90 [U. S. TRANSPORT ON THE POTOMAC]
AL. p. 62
Cf. NO. 50

1871

91 INDEPENDENCE HALL
AL. p. 49
Lower right: *E L Henry '71*
Exhibitions: NAD 1872, NO. 159
Collection: James W. Drexel, 1872–?
The photograph in the Album is inscribed: *Independence Hall, July 8, 1776; after signing the Declaration of Independence, July 4, 1776*

92 LADY ELIZABETH FERGUSON SENDING A LETTER TO GEN. JOSEPH REED OF REVOLUTIONARY MEMORY, JULY 28, 1778, AT GRAEME PARK NEAR PHILADELPHIA
AL. p. 19
Lower left: *E L Henry '71*
A further note in the Album reads: *Vide Mrs Ellett's Houses of the Revolution, vol. 1, 1828*

93 NORTH PORCH, CATHEDRAL OF BERGAMO
AL. p. 47
Exhibitions: NAD 1871, NO. 333
Collection: G. F. Tyler, 1871–?

94 AN UNEXPECTED ATTACK
AL. p. 61
Exhibitions: NAD 1872, NO. 192
Collection: A. Bierstadt, 1872–?

95 [THE SNOWSTORM]
AL. p. 17
Lower left: *E L H '71* (reversed, a mirror image)

1872

96 CITY POINT, VIRGINIA, HEADQUARTERS OF GENERAL GRANT (1822–1885)
Oil on canvas, 29¾ x 61 in.
Lower right: *E L Henry, 1865–1872*
Bibliography: *Life in America*, pl. 191; *American Battle Painting: 1776–1918*, p. 57 and pl. 26
Exhibitions: Life in America, Metropolitan Museum of Art, 1939; Century Association, 1942, NO. 4; American Battle Painting, National Gallery of Art, 1944, Museum of Modern Art, 1944

1872

Collections: Union League Club; Stephen C. Clark; Addison Gallery of American Art, Andover, Mass.
Figure 107
Cf. Figures 105 and 106
The photograph in the Henry Album (p. 29) is comprehensively documented. From left to right the inscriptions read:
Transport disembarking troops, horses
Mail dock
Adams Exp. Barge. Embalmed bodies being sent north. Andy Hepburn's barge. Head sutler. Captain's gig
Grant's Hd Qts
Gen. Ingal's Hd. Qts
15-inch Mortar & 2 Hundred Pound parrots on platform cars. Mouth of Appomattox
Schooners with stores, forage, & lumber swinging to the current
Monitor in the distance, Bermuda Hundreds

97 NO. 217 E. 10TH, N. Y.
Oil on paper, 21x14 in.
Lower left: *E L H '72*
Lower right as above
Collection: Albert Duveen
About an inch of paper has been added at the bottom of the painting, which shows a snow scene. A cutter with one bay horse is hitched in front of a three-story red brick house. Henry lived across the street from this subject.
Cf. Figure 19

98 A PARLOR ON BROOKLYN HEIGHTS
AL. p. 50
Figure 40
Another photograph in the Henry Collection is inscribed: *The parlor on Brooklyn Heights of Mr and Mrs John Bullard overlooking East River and New York City. Painted from Nature for them.*

99 THE PASSION PLAY, OBERAMMERGAU
Ortgies catalog, 1887, NO. 60
An unidentified clipping (pasted on an unnumbered page of the MS. following MS. p. 58) reads as follows: *There is now on exhibition in the west window of Messrs. Bailey, Banks and Biddle, Twelfth and Chestnut Streets, a large painting by Edward L. Henry, representing The Passion Play as given at Oberammergau. The picture contains a large number of figures and is a fine piece of descriptive work, showing one of the closing tableaux of the play—the crucifixion. In the foreground is the large audience showing respectful attention to the grand scene being carried out, and the artist has grouped the figures in an attractive manner. In coloring and other respects the painting is well-executed, and is viewed daily by hundreds of admirers.*
Cf. MS. p. 327f; also NO. 100
The painting listed in the Ortgies catalog sold, according to Henry's annotated copy, for $165.

1872

100 ALT KIRCHE, OBERAMMERGAU
AL. p. 52
Figure 115
 Another photograph in the Henry Collection is inscribed: *Alt Kirche,
Oberammergau, where mass is held before the play. Collection, Hon. H. W.
Bookstaver.*
Cf. NOS. 99 and 1080

101 [NURSE AND TWO CHILDREN]
AL. p. 48
Lower left: *E L Henry, 1872*
Cf. NO. 61

102 THE HICKSITE QUAKERESS
AL. p. 40
Lower left: *E L Henry '72*

103 THE YOUNG HEIR
AL. p. 40
Lower right: *E L Henry '72*

104 A COURTSHIP: TIME, 1817
AL. p. 61

1873

105 THE DOCTOR
Oil on cardboard, 9x12⅞ in.
Lower left: *E L Henry '73*
Exhibitions: Century Association, 1942, NO. 9
Collection: Estate of Francis P. Garvan
Figure 116
 The doctor's name, *Dr H. P. Farnham,* is painted on the side of the
horse block from which one mounts to the doctor's gig.
Cf. Sketchbook 8 for a detailed drawing, inscribed: *Dr H. P. Farnum's
 Visiting Buggy. W. 23d St. April 1874*

106 THE WIDOWER
Oil on wood, 8x5⅝ in.
No signature
Exhibitions: Century Association, 1942, NO. 62
Collection: Estate of Francis P. Garvan
Figure 117

107 A QUIET CORNER BY THE DOOR
AL. p. 36
Lower left: *E L H '73*
Figure 118
 In the Henry Collection there is a print of this subject, colored by hand
in oils and framed.

1873

108 A SUMMER MORNING
Oil on canvas, 9½ x 13½ in.
Lower left: *E L Henry '73*
Exhibitions: Century Association, 1942, NO. 55
Collection: James Graham and Sons
A slip pasted on the back reads: *A Summer Morning. Artist, E. L. Henry. Price $100. 51 West 10th Street.* The painting shows a country landscape. A man in a red shirt and a woman in a white sunbonnet are driving along in a wagon drawn by a white and a bay horse.

109 THE MEETING OF GENERAL WASHINGTON AND ROCHAMBEAU
AL. Index and p. 51, p. 53
Lower right center: *E L Henry, 1873*
Exhibitions: NAD 1874, NO. 217
Collection: W. H. Raynor, 1874–?
Cf. NO. 1020; Figure 222

1874

110 THE OLD PATERNAL HOME
Oil on cardboard, 9x8 in.
Lower left: *E L Henry, 1874*
Exhibitions: Century Association, 1942, NO. 38
Collection: Mabel Brady Garvan Collection, Yale University Art Gallery
Figure 119
This painting was formerly called *Group in a Colonial Doorway*

111 [THE DOCTOR'S CALL]
Oil on canvas, 13x12 in.
Lower left: *E L Henry '74*
Collection: Albert Duveen
The painting shows an old woman in cap and plaid shawl, watching the doctor make up powders, which he pours from a bottle into papers. Through the window his gig and horse may be seen outside.

112 TAKING A NIGHT CAP
AL. p. 14
Lower right: *E L Henry, 1874*
Exhibitions: NAD 1875, NO. 450; International Exhibition, 1876, Philadelphia, NO. 429
Collection: W. O'Brien, 1876–?
An old woman in a nightcap is heating water on a coal stove in her bedroom. A glass with a spoon in it stands on her bedside table, while a wicker-covered jug of rum may be seen underneath the table.
An unidentified clipping in the Henry Collection reads: *"Taking a Night Cap" is . . . elaborate and faithful in execution, representing an old lady in an old fashioned room sitting by the fire and brewing for herself a*

1874

hot whiskey toddy before retiring. The old-fashioned furniture, mantle ornaments, dress of the lady, who sits with a comfortable pet terrier in her lap, blinking his eyes at the fire, are admirably worked up. The artist, E. L. Henry, makes old American subjects a specialty, and has now on his easel an American battle scene, which promises well, and has recently completed an interview of American and British officers in Revolutionary times, which was much admired.
Cf. NO. 1085

113 [COLONIAL COUPLE]
AL. p. 28
A man and woman in period costume have just come down a flight of stairs and are going out a colonial doorway with a fanlight. A dog is running beside them.

114 RECEPTION GIVEN TO LAFAYETTE (AT THE CHEW HOUSE, GERMANTOWN, THE CONTESTED POINT AT THE BATTLE OF GERMANTOWN, OCT. 4th, 1778) BY HIS BRETHREN OF THE MASONIC FRATERNITY, MILITARY AND OTHER OR- GANIZATIONS, AND BY THE TOWNSPEOPLE, JULY 20th, 1825
AL. p. 26
Exhibitions: NAD 1874, NO. 246
Collection: Samuel Chew, 1874–

115 GOING OUT TO RIDE: NEW YORK, ABOUT 1796
AL. p. 20
Lower left: *E L Henry*
 L X X I V

116 SUNSHINE AND SHADOW
AL. p. 20

1875

117 FRANCES LIVINGSTON WELLS (HENRY)
Oil on board, 6x5 in.
Lower left: [name illegible], *1875*
Collection: Alida Wells Stetson, Edward C. Wells, Margaret L. Wells and
 William C. Wells; Albany Institute of History and Art
Figure 227
The painting is apparently in its original condition. It is in a gold frame, set in a deep black walnut shadow box, lined with plush now faded to ashes of roses.
Pasted on the back is a slip, reading: *Loaned to Mrs M. C. Murray during her lifetime. Then to be returned to E. L. Henry, New York City.* The date *May, 1905* has been added, possibly the date of the picture's return.
Probably the portrait was painted before the Henrys' marriage.

1875

118 LIBRARY AT THE HOME OF W^M LORING ANDREWS, 16 E. 38

Oil on wood panel, 9x7 in.

Lower left: *E L Henry 1875*

Exhibitions: Century Association, 1942, NO. 26

Collection: Century Association

There are two labels pasted on the back. The upper reads: *Painted by E. L. Henry. The old man is a fancy sketch. A daughter of E. L. Henry posed for the young girl.*

The unidentified writer was in error, for the Henrys had no children.

The lower label reads: *The above painting brought $200 at a sale at the American Art Galleries on April 10, 1931. But is incorrectly catalogued as The Grandfather: Interior of a Phila Living Room. J. E. Turkas. Ms. of Wm Loring Andrews.*

AL. p. 52

Cf. note pasted on manuscript p. 37, MS. (February 29, 1904) regarding possible purchase by Metropolitan Museum of Henry's railroad painting.

119 ST GEORGE'S CHAPEL, BEEKMAN AND CLIFF STREET, NEW YORK

Oil on wood, 10x8½ in.

Lower left: *E. L. Henry '75*

Exhibitions: Century Association, 1942, NO. 48

Collection: Metropolitan Museum of Art

Figure 111

This church was torn down in 1868 (McCausland '41, p. 180).

120 THE LITTLE CHICKS

Exhibitions: NAD 1875, NO. 438

121 [CHILDREN IN A GRAVEYARD]

AL. p. 53

Lower left: *E L Henry '75*

1876

122 PORTRAIT OF MRS HENRY

Oil on canvas, oval, 13¼ x 11¼ in.

Lower right: *London 1876*

Collection: New York State Museum

Figure 41

Mrs Henry is shown standing at an easel, palette and mahlstick in left hand, brush in right, painting a flower subject. This painting evidently was designed for a rectangular frame, as it has been pieced out to fill the oval frame, itself a piece of Henryiana. It shows up in numerous photographs of his studio at 51 West 10th street, New York, with various pictures in it. It is made of walnut, 24½ x 24½ in., and is heavily carved with flowers and leaves. The inset oval frame, 17x15 in. outside, is gilded, and measures 13¼ x 11¼ inside.

A letter written 28 years later to Martin Albert (*Cf.* NO. 315) gives a clue to Henry's taste in presentation. He writes of *feeling that the dark wood helped make the contrast greater like looking out of doors from a window.*

Cf. also Figure 34, actually the view through a window at Newport.

1876

123 ALL HALLOWS, GREAT AND LESS: THOMAS STREET, LONDON
4 water color sketches on paper
Exhibitions: Architectural League, New York, 13th annual, 1915
Collection: New York State Museum
1 *Interior of the Church . . . and the Noted Rood Screen*
 Water color on paper, 21½ x 26¼ in.
 Lower left: *London, 1876*
2 *Arms of the Hatters' Guild*
 Water color on paper, 7¾ x 4½ in.
3 *The Noted Wood Carved Pulpit and Clerk's Desk*
 Water color on paper, 9 x 6¾ in.
4 *Wood Carving on Rear Pews*
 Water color on paper, 5¼ x 5¾ in.
NOS. 2, 3 and 4 are on one mount.

124 OFF FOR THE RACES
Oil on canvas, 10⅛ x 18⅝ in.
Lower right: *E L Henry 1876*
Exhibitions: NAD 1877, NO. 271, $500, illustrated, 12x20; Century
 Association, 1942, NO. 33
Collection: Fairman Rogers, Philadelphia, 1878–?; Estate of Francis P.
 Garvan
Figure 122
On the stretcher is written: *Fairman Rogers. West Rittenhouse Square,
Philadelphia, U. S.*
 In the Henry Collection, there is a framed photograph (11¼ x 20 in.)
of this subject. The photograph has been touched up with black and white
and is signed lower right *E L Henry, Warwickshire, 1882.* A slip pasted
on the backing reads: *"Off For the Races" a study from Nature of old St
John's, Warwick, England, belonging to Lord Brooke. Painted July 1876.
The painting from this study was purchased by the late Fairman Rogers,
Philadelphia, in 1878. E. L. Henry*

125 [FEEDING THE DUCKS]
Oil on canvas, 24x16 in.
Collection: New York State Museum
Figure 123
Gift of Wilfred Thomas

126 WARWICK, ENGLAND
AL. p. 14
Lower right: *E L Henry, Warwick, 1876*
 This may be *A View of Warwick, England, from the Commons,* sold
for $100 at the Ortgies sale, 1887, NO. 66.

127 INTERIOR OF AN OLD ENGLISH MANSION
Exhibitions: NAD 1876 (50th annual) NO. 77, $150
 Cf. AL. p. 57. The photograph there shows the interior of an English
castle, which may be the above painting.

1876

128 LES FOSSES COMMUNES, CIMITIERE DE ST OWEN, PARIS
Oil on canvas, 19x32 in.
Lower left: *E L Henry, Paris 1876*
Exhibitions: NAD 1877, NO. 159, $500
Collection: New York State Museum
Figure 121

128-*a* LES FOSSES COMMUNES
Pencil and pen and ink on paper, 5¾ x 10⅛ in.
Lower right: *E L H*
Collection: New York State Museum
Figure 120

129 A PARIS DILIGENCE
Exhibitions: NAD 1876 (50th annual) NO. 85, $150

130 WILLIAM FLOYD
A photograph in the Henry Collection is inscribed: *Original copied by E. L. Henry for Independence Hall, Philadelphia, Nov. 1874. Presented by David Floyd, Greenport, L. I., Nov. 1874.*

A letter from Henry printed in the American Art News in 1917 gives a little history connected with this painting. It reads:

Those Philadelphia Portraits

Editor AMERICAN ART NEWS

Dear Sir:

In reading the editorials in your paper and your quotations from others in connection with the supposed "Fake" pictures in Independence Hall, Phila., I would like to add a word as in 1875 I served on a committee for restoration of the building having the "expert" advice of the late Daniel Cotier and the late James Renwick, also early in 1876 I was given a commission to copy a portrait of one of the "Signers," Wm Floyd—the original being at the ancestral home, at Greenpoint, L. I.

I can still feel the deathly chill of the parlor where I had to work from the original, almost at the risk of pneumonia. Several other artists were also given commissions to copy other originals, there being no known copies or portraits of the few that were left. They closed up the list with what they had and so the controversy over the supposed "Fakes" is to me a very mistaken conclusion, and partly one of a new committee which does not seem to have made much of an investigation whether they are originals, copies or so-called "Fakes" and want to throw them all "out." Perhaps to be able to get "new jobs" for some of their artist friends.

While in Paris in 1875, I made an oil study of the Tomb of La Fayette at the Cimitiere Picpus.

I presented it to the City of Phila. to hang in Independence Hall. Two years later, on visiting the city, I found the work covered with dust and dirt. They promised to "clean it off." Evidently the "job" was given to some poor char woman who used probably sand soap, for in visiting the hall again later, I found most of the iron railing around the tomb nearly

1876

all erased and all of the lettering on the tomb, as well as the Mural Tablets rubbed off entirely. Also the tablet reading "Tomb of La Fayette, Cimitiere Picpus," was all gone and a new tablet in its place reading "Tomb of La Fayette—Pere le Chaise" the latter not being known as a cemetery until many years later, but what a hard lesson to learn to whom to give it to.

Yours very truly

E. L. Henry

N. Y. Mar. 12, 1917

1877

131 THE ANCESTRAL HOME
AL. p. 55
Lower right: *E L Henry*
Exhibitions: NAD 1877, NO. 195, $1500, illustrated, 39x29; Gill 1879, *The Ancestral Home (An Elizabethan Manor, property of Earl of Warwick)*

131-*a* [THE ANCESTRAL HOME]
Pen and ink on paper, 8x6⅝ in.
Lower right: *E L Henry '76*
Collection: New York State Museum
Cf. Sketchbook 6

132 TENTH STREET STUDIO BUILDING
Oil on canvas mounted on board 11x8 in.
Lower left: *E L Henry Feb. 1877*
Lower right: *E L Ḥ*
Bibliography: "Our Heritage," 1942, p. 31, NO. 203
Exhibitions: Our Heritage, National Academy Galleries, 1942, NO. 203
Collection: National Academy of Design; NAD Catalog NO. 725.
Figure 258

The painting was acquired by the Academy in 1911, the gift of the artist as a memento of the old Studio Building at 51 West 10th street. A letter and note attached to the back of the painting tell the story:

Cragsmoor, N. Y., Oct. 8th, 1911

My Dear Maynard:

Thank you so much for your letter in relation to the sketch of the "cor. of 10th St. and 5th Ave." made in 1877. I remember writing the letter offering it, but I do not recall ever having an answer, whether the Academy cared for it. However! I have it still and when I return early Nov. will get it Framed & send it or take it up. It isn't very much after all. Yet as so many of the older men lived & painted in that old "51" I thought it might help to recall the corner. The old sign on that corner as far back as I remember it, was nailed on that old forlorn tree and when I made the sketch of it had a Kite tail and the remnants of an old kite tangled in the branches, the end of the tail hanging down like a noose. A rainy dismal day,

1877

*a little wet snow, & the prison van going down 10th St. to the courthouse,
made a picture suited to that very dull season when few if any were paying
Expenses. We have had so far the most cold cheerless Autumn for many
years. Last night was a killing black frost, froze ice. The weather has
driven nearly everyone away, except Inness, & he and his wife (who I don't
think wishes to) are to remain up here on this mountain plateau all
Winter. It is awfully lonely now. What will it be like in the depth of
winter? Hope you & Mrs Maynard have had a pleasant summer & with
very best wishes.*

<div align="right">

Most sincerely yours

Edw. L. Henry

</div>

The note by Henry on the painting reads: "*The old tree with the sign
that stood on the corner of 5th Ave. & W. 10th St. N. Y., for over forty
years." Painted in 1877 from a lead pencil sketch from nature. Wm
Beard & Wm De Haas were passing at the time. The bad winter of '77,
when there was very little business done & "the prison van & funerals were
most of the traffic through the street," as was said by the Artists in the
building at the time.*

133 A STUDY IN BLACK AND TANS
AL. p. 22
Lower right: *E L Henry '77*

The photograph in the Album is inscribed: *Exhibited in Royal Academy,
1878.* Another photograph in the Henry Collection is inscribed: *This
little painting called a "Study in Black and Tans" was exhibited in the Royal
Academy, London, in 1881 and hung on the line. It was painted after
Nature at Concord, Pa., close to the Delaware line. The little Nigger was
cutting off pieces of red flannel to decorate the collars of two "Black and
Tans"*

A sketch in water color on paper, 4¼ x 6¼ in., signed lower right, *E L
Henry '77*, is in the collection of the Guy Mayer Gallery.

134 A QUAKER VISIT
AL. p. 26
Lower right: *E L Henry '77*
Bibliography: KL. NO. 51

1878

135 SARAH AKINS WELLS
Oil on board, 10¼ x 13¼ in.
Lower right: *E L Henry, 1878*
Collection: Miss Margaret L. Wells

A portrait of Mrs Henry's grandmother. On the back it is inscribed:
*Painted from life at her home in William Street, Johnstown, N. Y., summer
1878. Sarah Akin was born May 9, 1788. She was married at Sir William
Johnson Hall to Nathan P. Wells Ap. 22, 1813. She died in Johnstown,
Jan. 25, 1881, aged 92 years and 8 months.*

1878

136 THE DEPARTURE OF THE BRIGHTON COACH
AL. p. 12
Lower left: *E L Henry, 1878*
Exhibitions: NAD 1878, NO. 339, $600
Figure 125

137 REVERIE
AL. p. 27
Lower right: *E L Henry '78*
 This painting was stolen from the gallery of the Union League Club, early in 1879, according to a newspaper clipping pasted in the Album.

138 AN AWKWARD THROW
Exhibitions: Gill, 1878

1879

139 THE PEDLER
Oil on canvas, 13⅝ x19½ in.
Lower right: *E L Henry '79*
Bibliography: KL. NO. 47; illustrated in earlier edition of Klackner.
Collections: James Kirkham; James W. Kirkham; William B. Kirkham
Figure 189

140 ON THE BEACH: WAITING FOR THE BATHERS
AL. p. 17
Exhibitions: NAD 1879, NO. 198, *Waiting for the Bathers?*
Figure 47

141 A PORTRAIT OF MRS E. L. HENRY AND THE TWO BLACK AND
 TANS: ON THE UPPER HUDSON NEAR FORT MILLER,
 SUMMER OF 1879
Lower left: *E L Henry '79*
 The photograph in the Henry Collection is inscribed: *This painting was stolen from the picture frame shop of late Geo. F. Of, Clinton Place, 1886.*
 An inscription on the back reads: *This painting was left all summer at the frame shop of Geo. F. Of in Clinton Place and the following autumn was gone. Stolen from there during the summer. Never been able to trace it. Fortunately this photograph was taken of the painting before it was left at Mr Of's.*

141-*a* "ON THE LOOKOUT"
Pen and ink on paper, pasted on canvas, 7½ x9 in.
Lower left: *E L Henry 1879*
Lower right: *E L H*
Collection: New York State Museum

142 SOUVENIRS OF LONG AGO
Bibliography: KL. NO. 60, not illustrated
Exhibitions: NAD 1879, NO. 434

1880

143 CHANGING HORSES
Oil on canvas, 16½ x31 in.
Lower left: *E L Henry, 1880*
Collections: James Ben Ali Haggin sr; Louis Terah Haggin; Eila Haggin McKee; Haggin Memorial Art Galleries, Stockton, Calif., NO. 65

144 THE BATTLE OF GERMANTOWN, PA., OCT. 4, 1777
AL. Index and p. 18
Collection: Samuel Chew, 1880–?
In 1881, Henry painted this subject for William Astor. *Cf.* NO. 161. Was it an exact copy of Chew's painting?
Cf. also reproduction, MS., pasted on back of manuscript p. 23, called *The Attack on Chew's House during the Battle of Germantown, 1777.*
An unidentified newspaper clipping in the Henry Collection writes of one of these canvases as follows:
. . . the most important he has on hand. This is the "Battle of German-town," which, it will be remembered, was fought on the part of the British from the old Chew House, one of the most interesting of Revolutionary relics which is still standing, carefully preserved with all the marks of the dangers it passed through. As the work is historical, the artist has endeavored to make it as accurate as study of the house and grounds will permit. It is represented with windows filled with red coats, whose posi-tion has enabled them to scatter the grounds with the bodies of American soldiers who are trying to gain the house by assault. The cannon in the road has done some execution on the house, and the statuary of the grounds and the house is on fire in several places.

145 READING THE STORY OF BLUEBEARD
A photograph in the Henry Collection is inscribed on the back: *Water color. "Reading the Story of Blue Beard." E L Henry*
Figure 140
Can this be *Fairy Story,* exhibited NAD 1880, NO. 332, $125?

146 THE APPROACHING TRAIN
Bibliography: KL. NO. 12, as *The Coming Train*
Cf. MS., back of manuscript p. 16, for another reproduction.
A photograph in the Henry Collection shows the signature and date as *E L Henry, N. Y., 1880,* painted on a fence at the lower right.

147 THE WAY STATION
Bibliography: KL. NO. 80
Exhibitions: NAD 1880, NO. 182, $650

148 THE HALT AT THE FERRY
Exhibitions: NAD 1880, NO. 145
Collection: G. H. Blanchard, 1880–?

149 THE OLD TRIMBLE HOUSE, CHESTER CO., PENN: BUILT IN 1741
Exhibitions: Gill, 1880

1881

150 CAPITAL AND LABOR
Oil on canvas, 12½ x 15¼ in.
Lower left: *E. L. Henry '81*
Collection: New York Historical Society
Figure 56
Cf. Sketchbook 3 for drawings of a dog on a "dog churn" (Figure 59)
and of a cow on a treadmill.

151 OLD HOOK MILL, EAST HAMPTON
Oil on canvas, 14x22 in.
Lower left: *E L Henry, East Hampton '81*
Collection: Mrs Francis P. Garvan sr
Figure 126
The Garvan estate owns a painting by Childe Hassam with the same
title and subject.

152 THE SUMMER BOARDERS
Oil on canvas, 15x19 in.
Lower right: *E L Henry '81*
Bibliography: KL. NO. 9, as *City Boarders*
Collection: Martin E. Albert
Figure 146
The driver was a neighbor of the Henrys, Peter P. Brown. Mrs Henry
is on the right and Mrs Eliza Hartshorn on the left. The buggy is com-
ing down the old "Gully Road" from Cragsmoor to Ellenville.

153 A MOUNTAIN ROAD
AL. p. 24
Bibliography: KL. NO. 61, as *A Stony Road*, not illustrated in 1906 edition,
but in earlier edition
Figure 137
The photograph in the Album is inscribed: *A Mountain Road.
Shawangunk Mountains Above Ellenville*, N. Y.
The subject was identified by Sidney Terwilliger of Cragsmoor as Peter P.
Brown on the old gully road. The same man and vehicle are seen in
Figure 139.
The original Botsford negative envelope is inscribed: *Old Peter P. Brown
on the old Gulley Road. LWB*

154 EAST HAMPTON BEACH
AL. p. 34
Lower right: *E L Henry 1881*
Exhibitions: NAD 1881, NO. 547, $1000, illustrated, 21x51.
Figure 49
A photograph in the Henry Collection, AL. p. 17 (Figure 48) shows the
same subject, with slight differences. It may represent the canvas in an
earlier state.
This painting or NO. 140 may be *Study at East Hampton*, sold at
Ortgies sale in 1887 for $127.50, NO. 64.

1881

154-a BATHING HOUR, EAST HAMPTON BEACH
Pen and ink with white on bleached photograph, 4⅜ x 9½ in.
Lower right: *E L Henry, 1889*
Collection: New York State Museum
Figure 50
 This item was prepared for magazine reproduction and illustrates Henry's method of work. It is interesting that he altered the date of the original painting, which shows in other photographs plainly as *1881*.

155 THE MOUNTAIN STAGE
AL. p. 38
Lower right: *E L Henry '81*
Bibliography: KL. NO. 34
Figure 54
 Mrs Frederick Dellenbaugh is said to be one of the passengers in the stage. *Cf.* Figure 55

156 THE RELAY
Bibliography: KL. NO. 53
Exhibitions: NAD 1881, NO. 10, $850
Figure 157

157 [REVOLUTIONARY SCENE]
AL. p. 60
 A man in the costume of a Revolutionary general, an Indian chief, soldiers, sentries, are seen grouped in the doorway of a colonial house. *Cf.* NO. 251

158 A WAY STATION ON A SMALL PENNSYLVANIA RAILROAD
 The photograph in the Henry Collection is inscribed: *In possn of Lady Northcote, London.*

159 CHINA WAS THE PASSION OF HIS SOUL
Exhibitions: NAD 1881, NO. 445, $600

160 THE PETS
Exhibitions: Gill, 1881, "sold"

161 THE BATTLE OF GERMANTOWN
AL. p. 24
Collection: William Astor, 1881–?
Cf. NO. 144

1882

162 A HARD ROAD TO TRAVEL
Oil on canvas, 17x14 in.
Lower left: *E L Henry '82*
Collections: Dr Lawton S. Brooks; Mrs Harcourt W. Bull
Figure 139
 A letter from Harcourt W. Bull jr, states that the painting was purchased by his grandfather from James D. Gill in 1884, for $205. He

1882

adds the following description: *On a partially overcast day in autumn when some colored leaves are still left, some branches are bare, on a country road running along a hillside and bordered by a split-rail fence, an old farmer drives home in an ancient topless buggy. He is moving directly away from the observer, giving a detailed view of the back of the old character seated on his buffalo robe, a red handkerchief showing from his pocket between his coat-tails, the head of a pig protruding by the dashboard at his feet. The weather-worn buggy is painted with particular care. Of especial and humorous interest are the large wheels which are just passing over a stony outcropping in the road and are each turned at a different angle.*

163 MAIN STREET, EASTHAMPTON, L. I.
AL. p. 58
Lower left center: *E L Henry '82*

164 MEETING'S OUT, ABOUT 1849
Exhibitions: NAD 1882, NO. 88, $450

165 PREPARING DINNER
Exhibitions: Gill, 1882, $225

166 A COUNTRY ROMANCE
Exhibitions: NAD 1882, NO. 454, $200

1883

167 JOHN S. BILLINGS
Oil on cardboard, 13½ x9½ in.
Lower left: *E. L. Henry*
 1883
Exhibitions: Art Exhibition for the Benefit of the Red Cross, Hunt
 Memorial Hall, Ellenville, August 6–7, 1918
Collection: Village of Ellenville
Figure · 133
A card tacked on the back is inscribed: *The late John S. Billings. An esteemed citizen of Ellenville. A lover of roses.*
"Josh" Billings lived on Center street, had a garden, loved roses, loved dramatics, used to go to New York for first nights, according to the village clerk, Miss Alice I. Moffit. Henry painted him sitting in a chair, in a dark blue suit, holding a rose in his hand. The picture is dark in key, the two notes of color being the rose and the purple velvet facing on his coat collar.

168 BRACING UP
Lower right: *E L Henry '83*
Exhibitions: NAD 1884, NO. 131, $450
Figure 138
When Mrs Thomas Wade of Cragsmoor gave the New York State Museum a sepia photograph of the subject, she spoke it as *A Quiet Nip.*
In the Henry Collection there is a sepia photogravure (plate, 8¼ x6¾ in.; paper, 17½ x13½ in.) published by the Woodbury E. Hunt Co.

1883

This is called *Going Through the Rye* and shows a different background than the above. The accompanying poem is printed on a separate, gold-edged slip of paper and tipped on to the mount.

A painting called *Bracing Up* brought $155 at the Ortgies Sale, 1887, NO. 55.

168-a PETER BROWN TAKING A DRINK
Pen and ink on paper, 15⅜ x11 in.
Lower right: *E L Henry '83*
Collection: Edward C. Wells, Johnstown, N. Y.

169 UNINVITED GUESTS
Lower right: *E L Henry '83*
Bibliography: KL. NO. 1, as *An Afterdinner Nap*
Exhibitions: NAD 1884, NO. 203, $650
Figure 143
A photograph in the Henry Collection is inscribed: *Large negative 18x22. Owned by C. Lambert, Patterson, (sic) N. J.*

170 TRAVELING SOUTH IN THE THIRTIES
Water color
Lower left: *E L Henry, 1883*
Bibliography: KL. NO. 68; Ortgies sale catalog, 1887, NO. 62, as *Traveling South Fifty Years Ago* (not sold)
In the Henry Collection there is a large photograph, 14⅞ x13⅝ in.

171 A HARD SCRAPE
Exhibitions: NAD 1883, NO. 13
Collection: Hugh Auchincloss, 1883–?

172 A LADIES RECEPTION AT THE OLD UNION LEAGUE, MADISON SQUARE
Exhibitions: NAD 1883, NO. 376, $200

173 NOVEMBER DAYS
Exhibitions: NAD 1883, NO. 215, $375

174 IN SIGHT OF HOME
Exhibitions: NAD 1883, NO. 151, $500

1884

175 IN THE ROARING FORTIES
Oil on mahogany panel, 14x21 in.
Upper left: *E L Henry '84*
Bibliography: The Story of My Life by Lucien Calvin Warner, 1914, p. 133–34
Exhibitions: NAD 1884, NO. 215, $650
Collections: Dr Lucien Calvin Warner; Mrs Seabury C. (Agnes Warner) Mastick
Figure 57

1884

There is considerable documentary material about this picture. The account book kept by Mrs Mastick's mother shows it to have been bought before January 1885, for $650. At that time, it was listed as *In The Roaring Forties*. A recapitulation, dated 1904, gives it as *In The Rolling Forties*. And by this title Doctor Warner refers to it in his autobiography.

At this time, apparently the Warners had a winnowing of their collection; for written on the back of the panel is: *L. C. Warner, Waldorf-Astoria, 2/27/04—new frame.*

A large photograph (13⅜ x19¼) in the Henry Collection is inscribed on the back: *Painted by E. L. Henry about 1885. On the deck of the old White Star liner the Celtic. Four masts, three ship rig and jigger, one screw, about 13 knots.*

Cf. Sketchbook 2, NO. 1186, for two sketches related to the painting; also Figure 60.

Mrs Mastick gives the following information about the picture: *The scene is on the open deck of an Atlantic steamship of the time. The phrase "roaring forties" was used for the stormy waters off the Newfoundland Banks in the latitude of the forties. I have heard my father say that Mr Henry told him that he made the sketch on shipboard and that the members of the party sent the rugs and wraps that they wore to his studio later for him to finish the painting. Dr Warner took a fancy to this picture because it reminded him of his own first trip abroad.* [This in 1880.] *I quote from his autobiography, The Story of My Life, privately published in 1914: "We took passage on the steamer 'City of Chester' which was at that time one of the best steamers crossing the Atlantic. It was a single-screw steamer of about five thousand tons. The ventilating shafts from the kitchen and engine-room opened on the main deck, where the passengers walked and sat, so that the vile smells of the ship were constantly in evidence The only covering for the deck was canvas awnings, and these were usually removed when it rained or when the wind was high, so that in case of storm or rough weather the passengers must either endure the storm or remain in their cabins below. The painting by E. L. Henry entitled 'In The Rolling Forties' is an excellent representation of the ships of this period, and might have been taken from the decks of the 'City of Chester.' "*

Henry painted the costumes with a different color scheme than that indicated in his sketch. The first woman at the left, sitting, wears a red cloak, the second is covered with a blue, green and red plaid steamer rug, and beyond her a woman is covered with a roman striped blanket. The color is quite strong, with the seaman's red neckerchief, the blue-green water and the brown wood tones.

The color notes in the sketch are: *Scarlet hood. White border, Astrahkan. Muff, white. Gray shawl. Black skirt.*

176 MISS X AND SISTER
Oil on canvas, 20x13 in.
Lower right: *E L Henry '84*
Collection: Mrs Warren Van Kleeck

1884

177 TAKING HIS MORNING EYE-OPENER
Oil on wood, 11x7¾ in.
Signed on back: *Painted by E L Henry from life in 1884. Old Peter Paul
Brown above Ellenville, N. Y., at the age of 83. Taking His Morning
Eye-Opener.*
Collection: Miss Margaret L. Wells
 In this version, Brown has his coat off. The two top buttons of his vest
are open. He is wearing a white shirt, with a short lavender tie, untied.
He is pouring something (?) from a bottle into a glass, his firm grip on
bottle and glass indicating the need for an eye opener. His lips are parted
(in anticipation?) and his hair is mussed. The painting shows a three-
quarter length figure.

178 THE LATEST VILLAGE SCANDAL
Oil on canvas, 18x28 in.
Lower left: *E L Henry*
Exhibitions: NAD 1886, NO. 434, $500; Century Association, 1942,
NO. 24
Collection: William H. Thompson

179 THE WATERING TROUGH
Lower left: *E L Henry*
Exhibitions: NAD 1884, NO. 622, $500
Figure 151

180 THE WANING OF THE YEAR
Exhibitions: Gill, 1884, $200

1885

181 THE COUNTRY STORE
Oil on canvas, 11⅝x20⅜ in.
Lower left: *E L Henry, '85*
Exhibitions: Century Association, 1942, NO. 7
Collection: Estate of Francis P. Garvan
Figure 127

182 WHAT AM DAT?
Oil on wood, 12x10 in.
Lower right: *E L Henry '85*
Collection: Gimbel's
 A Negro girl in a red dress leans on her broom while she stops to talk to a
Negro boy carrying a basket.
Could this be *What Dat For?*, NAD 1886, NO. 590, $225?

183 THE MAIN STREET
Exhibitions: NAD 1885, NO. 511, $350

184 FOUR O'CLOCK TEA
Exhibitions: NAD 1885, NO. 367, $375

1885

185 AMONG THE FLOWERS
 Exhibitions: NAD 1885, NO. 355, $325

186 THE HOME OF THE SQUIRE
 Exhibitions: NAD 1885, NO. 38, $425

1886

187 PETER BROWN
 Oil on cardboard, 17½ x 14¼ in.
 Lower right: *E L Henry*
 1886
 Exhibitions: Art Exhibition for the Benefit of the Red Cross, Hunt
 Memorial Hall, Ellenville, N. Y., August 6–7, 1918
 Collection: Village of Ellenville
 Figure 129
 Peter P. Brown, the celebrated "drunk" of Cragsmoor, is shown shaving.
 According to Miss Alice I. Moffit, the Colgate Company asked permission
 from the village of Ellenville to use the picture in an advertisement. The
 trustees wrote Mrs Henry, then alive. She refused, saying that Mr Henry
 had never commercialized his art.

187-*a* PETER BROWN SHAVING
 Pen and ink on paper, 7¾ x 6 in.
 Lower right: *E L Henry*
 Collection: Edward C. Wells
 Inscribed on margin of paper, lower right: *Pen & Ink Drawing of old
 Peter Brown Shaving, 1885.*

188 MARTIN TERWILLIGER
 Oil on cardboard, 13¼ x 9¾ in.
 Lower right: *E L Henry*
 Lower left: *Martin Terwilliger at the age of 95*
 Exhibitions: Art Exhibition for the Benefit of the Red Cross, Hunt
 Memorial Hall, Ellenville, N. Y., August 6–7, 1918
 Collection: Village of Ellenville
 Figure 130

189 A COUNTRY DOCTOR
 Lower right: *E L Henry '86*
 Bibliography: KL. NO. 13
 Figure 148

190 A VILLAGE STREET
 AL. p. 38
 Lower right: *E L H '86*
 Bibliography: KL. NO. 72
 Exhibitions: NAD 1889, NO. 341; Gill, 1890, $175?

1886

191 THANKSGIVING SLEIGH RIDE
Oil on canvas, —
Lower left: *E L Henry '86*
Figure 152
 A painting of this title brought $172.50 at the Ortgies sale, 1887, NO. 67.

192 WHAT DAT FOR?
Exhibitions: NAD 1886, NO. 590, $225

1887

193 JOSEPH E. MANCE
Oil on canvas, 18x14 in.
Lower left: *E L Henry*
Exhibitions: Art Exhibition for the Benefit of the Red Cross, Hunt
 Memorial Hall, Ellenville, N. Y., August 6–7, 1918
Collection: Village of Ellenville
Figure 128
Cf. Figure 134
 Joe Mance, the Cragsmoor carpenter, is shown standing, holding an
L-square in his hand.
 Cf. correspondence, 1884, for a letter to Henry from Mance, dated
Ellenville, May 5, quoted in full in the Biographical Sketch, p. 38

194 FRED THOMAS *ALIAS* BLACK FRED
Oil on wood, 14x10 in.
Lower right: *1887, E L Henry*
Lower left: *A sketch on the Del & Hudson Canal*
Exhibitions: Art Exhibition for the Benefit of the Red Cross, Hunt
 Memorial Hall, Ellenville, N. Y., August 6–7, 1918
Collection: Village of Ellenville
Figure 131
 Inscription on a card tacked on the back: *Fred Thomas alias "Black
Fred." A Hunchback, Canal Boatman and Guide to the Trout Streams.
Was murdered by another Negro some years ago.*
 The back of the panel is inscribed similarly.

195 SHARPENING THE SAW
Oil on canvas, 16⅜x12 in.
Lower left: *E L Henry*
Exhibitions: American Genre, 1935, Whitney Museum of American Art;
 Century Association, 1942, NO. 51
Collection: Estate of Francis P. Garvan; New York State Historical Asso-
 ciation
Figure 136
 Is this *Learning The Trade,* sold for $115 at the Ortgies sale, 1887,
NO. 53?

1887

196 STAGE COACH
Oil on canvas, 27x21 in.
Lower right: *E L Henry, 1887*
Collections: James Ben Ali Haggin sr; Louis Terah Haggin; Eila Haggin
McKee; Haggin Memorial Art Galleries, Stockton, Calif., NO. 68

197 THE OLD LYDIG HOUSE ON THE BRONX, NEAR FORDHAM
A photograph in the Henry Collection is inscribed as above, with the
following: *Painted from an old painting dated 1790 for the late Maria
Lydig Daly.*
Figure 58
A letter from Henry to Mrs Daly gives the history of the painting, as
well as throwing light on his careful method of work. It follows:

Ellenville, N. Y., July 19th '87

I would like to have a few points on the old home on the Bronx.

*I was up there & made a number of drawings & studied the place & am
working it out (the problem) of how it must have been 30 to 40 years
ago, as numbers of the trees that I saw & have had to omit were evidently
at that time not planted or very little saplings.*

*I wish more particulars (as it is the most prominent object) to be
correct on the house. I was unable to tell from that old picture of yours
whether the house was of wood, stone or stucco. If wood, was it clap-
boarded or boards perpendicular with battens? Also, if the end of house
seen in picture had two windows side by side or but one in the middle?
I have made drawing so you can mark it & return. I hope to have the
picture finished by end of the month, & hope it will meet your expecta-
tions. Mrs Henry joins me in sending our love & best wishes & hope you
are both having a very pleasant summer.*

Very sincerely yours

EDW. L. HENRY

Cf. Figure 61 for the above-mentioned drawing, which is on the back
of Henry's letter and is carried over onto a second sheet of paper. It is
annotated as follows:

Was the base of the big tree on this line or line of this piazza?
Were chimneys red brick or white?
Was this the style of dormer window?
Wing from here to end?
*Was this door at end of piazza a blind door or half door or did it look
through a hall & window at other end? It would look very pretty in a
picture.*
*Were there two windows parallel on this side? Or windows one above the
other, only in the middle only?*
If wood, what was the color of the house, red, yellow or white?

Mrs Daly replied on the back of Henry's letter, as follows: *The side of
the house was common mason work, like good stone fencing of sand stone
or granite grey stone and white plaster. The roof was wood shingle
rounded, the rest wood boards lapping over each other, across, not up and*

1887

down. *There was a small ledge forming a bench-seat about 2 feet high so that the piazza was sunken and the turf seemed to come up to the house. The old tree had pendant branches and was on a slight rise. You could see but 2 sides of house.*

A letter from Mrs Daly to Henry, dated Sag Harbor, July 20th adds a few details: *I have tried to alter your drawing. There were two doors on the first side by the steps, which opened inwards and with two steps down from the piazza which made them look short. All that side was stone and white-washed. The projection was wood and as I mention boarded, laterally, not upright. The chimneys I think were stone. I have changed the dormer windows. The steps came down quite steep. I have no doubt but that you will make a success. Bring the picture to us and stay a few days. With kindest regards to Mrs Henry.*

198 **ONE HUNDRED YEARS AGO**
Bibliography: KL. NO. 44
Exhibitions: NAD 1888, NO. 386, $2000; Gill, 1891, $1000, with a
 note that the painting was exhibited at the Paris Salon, where it received
 honorable mention
Figure 153
Cf. AL. p. 35, that photograph being inscribed: *Near Philadelphia. Old house, 1747*

A letter on The Art Club of Philadelphia stationery from Henry Bentley, dated November 30, 1891, reads as follows:

Friend Henry:

I am very glad we shall be able to keep your "One Hundred Years Ago" in our city and I am also pleased to know that one of my neighbors in Germantown was the purchaser. Let me hope too that you got a satisfactory price for it. It was the picture—take it all around, on exhibition. It has been much admired and it was sure to have [sold] over here had not Mr. S. bought it.

A letter from "Mr S." [E. T. Stotesbury] continued the story. It reads:

<div align="right">

124 Tulpohocken Street

Germantown

April 9/92
</div>

Mr. E. L. Henry

 Dear Sir

 Some time ago I purchased at the Art Club a picture painted by you called "One Hundred Years Ago," which has been much admired as I have it in my colonial house. I want to thank you for a beautiful photograph sent me by your friend Henry Bentley, which you forwarded to him to be given the purchaser of the "One Hundred Years Ago." Should you ever visit Germantown I would be glad to have you call on me & see what an addition your picture has made to my home.

1887

199 "SCHOOL'S OUT:" BELOW CRAGSMOOR, N. Y.
Figure 147
After School, sold for $67.50 at Ortgies sale, 1887, NO. 50, may be this picture.

200 THE OLD FORGE
Bibliography: KL. 41; illustrated in earlier edition
Figure 144
Cf. NO. 234

201 GOING TO MARKET
AL. p. 47
Lower left: *E L Henry '87*
Bibliography: KL. NO. 26
 A subject Henry painted with many variations. The rutted road curves from left to right over a plank bridge. At the left is a farm building, and in the distance at the right another. A man and a woman are driving away from the spectator in a single-seated spring wagon, drawn by a white and a dark horse. The woman is holding an umbrella.
 Is this *On the Way to Market*, Gill, 1891, $300?

202 THE OLD TOLL GATE
Bibliography: KL. NO. 66
Exhibitions: NAD 1887, NO. 324

1888

203 COMING FROM CHURCH
Oil on canvas, 22x16 in.
Lower left: *E L Henry '88*
Bibliography: KL. NO. 10
Collections: Daniel Graham; Mrs Charles B. Knox
 The man driving is Mr Graham's great-grandfather, James C. Kennedy. With him are his wife, Lucinda Grinnell Kennedy, and a friend. They are on their way home from the West Galway, N. Y., church.

203-a COMING HOME FROM CHURCH
Oil on academy board, 14x11 in.
Lower left: *E L Henry*
Exhibitions: Art Exhibition for the Benefit of the Red Cross, Hunt
 Memorial Hall, Ellenville, N. Y., August 6–7, 1918
Collections: Mrs George Deyo; Mrs Barbara Deyo Bealer
 A letter from Mrs Lilah Deyo Johnson of Ellenville, Mrs Bealer's aunt, states: *The scene depicts people leaving a country church. The time is autumn. In far background are horses and carriage, and man and woman on ground. Then coming down road a team of bay horses; four in wagon, man driving and three women. In foreground a single rig with white horse, elderly man having gray beard, driving, two older women in bonnets and shawls, one on either side of driver. This rig is passing a little girl and boy, walking on road. My niece states she has been told this girl was named*

1888

*Grace Keir, who lived at Cragsmoor. This painting was one of many
exhibited in Ellenville, as a benefit for Red Cross, during the World War.
Many Cragsmoor artists loaned and had for sale some of their work. Mr
George Inness jr, stated this picture differed from some of Mr Henry's work
in that it showed greater distance, and the lighting raised from some of his
others.*

In a second letter, Mrs Johnson adds the information that the picture
was purchased by her brother, George Deyo, as a present for his wife, and
that at her death it went to their daughter, Mrs Bealer.

Cf. McCausland, '41, p. 54–55, 57, 95–96, for further information on
the Red Cross benefit exhibition.

204 [TAKING A REST]
Oil on canvas, 17x12½ in.
Collection: New York State Museum
Figure 124

205 KEPT IN: A STUDY IN A COUNTRY SCHOOL
AL. p. 38
Figure 141

206 THE MAIL STAGE ON THE MOUNTAIN
AL. p. 60
A photograph in the Henry Collection is inscribed: *Painted about 1888.
Owned by Mrs Willis A. Barnes, 446 Central Park West, N. Y.*

207 COMING FROM THE TRAIN
AL. p. 62
Lower right: *E L Henry*
Bibliography: KL. NO. 11
A man and a woman are driving toward the spectator, with a child seated
between them. The woman holds an umbrella. The buckboard is drawn
by two dark horses and is about to cross a plank bridge over a rivulet. The
road is lined on either side with rail fences. At the left in the distance is a
farmhouse.

208 FORGOTTEN
AL. p. 27
Lower left: *E L Henry '88*
Figure 253
From the photograph in the Henry Collection this seems to be a water
color. It is inscribed on the back: "*Forgotten.*" *Owned in St. Paul, Minn.*

209 [MRS HENRY IN A BUCKBOARD]
AL. p. 32

210 VACATION TIME
AL. p. 62

211 [A PAUSE]
AL. p. 19
A couple on horseback have stopped to talk to a clergyman in a carriage.

1888

212 A TEMPERANCE PREACHER
Lower left: *E L Henry '88*
Bibliography: KL. NO. 64
Exhibitions: Possibly NAD 1888, NO. 78, $375, as *Layin' Down De Law*
Figure 154
Cf. AL. p. 47, inscribed *Scene in Georgia;* also manuscript p. 22 MS., for pencil sketch and reproduction

213 A VENDER OF SIMPLES
AL. p. 58
Exhibitions: Gill, 1890, $175
　　An unidentified newspaper clipping refers to this picture as follows: *Among the figure pieces one of especial merit is Edward L. Henry's "Vender of Simples," which is not only a delightful character picture, and one of the best things Mr Henry has ever painted, but preserves for history a characteristic southern scene. The original village square which forms the scene and background of the picture must be in Virginia, and all its rustic traits are attractive; while the old chap in the front who at his board awaits customers for garden sauce is a quaint and original person, whom one would like to meet and chat with.*
　　It is more likely that the scene of the painting is Tennessee; for the Henrys traveled there in 1888.

214 SMOKY MOUNTAINS, N. C.
Bibliography: KL. NO. 59
　　A photograph in the Henry Collection is inscribed on the back: *"On the Way to Market" A Study in the great Smoky Mts. of North Carolina on the border of East Tennessee. Owned in N. Y.*

215 STREET SCENE, KNOXVILLE, TENN.
Bibliography: KL. NO. 62

216 [FAMILY PARTY]
AL. p. 46
　　A Negro family is sitting in the yard behind a Southern mansion. The younger man is playing a guitar. Through a rustic covered gate a woman in white may be seen in a garden. In the foreground there is a square wooden pump.

217 [SOUTHERN SCENE]
AL. p. 35
　　Three men in shirt sleeves and slouch hats are sitting in front of a building which cannot be identified, though there is a sign which reads *House* in front of it. An ox cart and oxen are standing in the street, and a dog looks on. The types are related to other Southern subjects, and the ox cart is like that in NOS. 212 and 214

218 [A CLEAN SWEEP]
AL. p. 35
Lower right: *E L Henry*
　　A Negro maid sweeping the porch has been interrupted by some comic incident not clear in the picture and leans on her broom to laugh. She is wearing a white apron and a hat. A drove of hogs may be seen coming down the street.

1889

219 ON THE RONDOUT
Oil on canvas, 11½ x 15½ in.
Lower right: *E L Henry 1889*
Exhibitions: Century Association, 1942, NO. 40
Collection: James Graham and Sons
 Inscribed on back: *A sketch from nature on the Rondout above
Napanoch, N. Y., the Shawangunk Mountains in the distance. This is just
below the celebrated "Yama Nouchi Farm." E L Henry 1889*

220 THE VILLAGE STREET
Lower right: *E L Henry '89*
Bibliography: KL. NO. 72
Exhibitions: NAD 1889, NO. 341, $175

221 [BACKDOOR CONVERSATION]
AL. p. 62
Lower left: *E L Henry*
 Two women are talking at a farmhouse back door. The architecture is
faintly southern. But the women are reminiscent of those Henry painted
around Cragsmoor.

222 A LOVER.OF OLD CHINA
Lower right: *E L Henry '89*
 A photograph in the Henry Collection is inscribed on the back: *Finding
rare examples in the old lady's cupboard. The gentleman in this picture
was Mr Richard Ely, cor. 5th Ave & 35th St, and who was attache of
Legation at court of Louis Phillipe, 1839–40 & 41. The old lady was
Mrs Livingston Murray (Mrs Henry's aunt) & who lived to nearly 101
years of age. Painted by E. L. Henry, in 1886–8.*

223 BOUND TO CUT A SHINE
AL. p. 57, 60
Exhibitions: NAD 1889, NO. 316, $375; Gill, 1890, as *Bound to Shine,*
 $300
 The unidentified newspaper clipping quoted under *A Vendor of Simples,*
No 213, refers to this painting also, as follows: *Mr Henry also illustrates
Negro life in "Bound to Shine," with the belle posing before the glass, the
little sister admiringly grinning, and outside the expectant beau leaning
against the fence with his hands in his pockets, waiting for the appearance
of his charmer.*

224 IN DOUBT
AL. p. 57
Exhibitions: NAD 1889, NO. 43, $300

225 [YOUNG MERCHANTS]
AL. p. 58
Lower left: *E L Henry*

226 [NEGRO GIRL RINGING DOORBELL]
AL. p. 62

1889

227 A QUIET LITTLE COUNTRY WEDDING
A photograph in the Henry Collection gives the title as above.

228 A CALL ON THE BRIDE
Exhibitions: Gill, First Annual Water Color Exhibition, 1889, $250

229 THE COUNTRY STAGE
Exhibitions: Gill, 1889, $450

1890

230 NELLY BLOOMER
Oil on wood, 18½ x15 in.
Upper right: *E L H, Sept. 1890*
Lower left: *Aunt Nelly Bloomer*
Exhibitions: Art Exhibition for the Benefit of the Red Cross, Hunt
Memorial Hall, Ellenville, N. Y., August 6–7, 1918
Collection: Village of Ellenville
Figure 132

A card tacked on the frame reads: *Aunt Nelly Bloomer. Painted from life on her 100th birthday. She lived to the great age of 103.*

Tacked on the back of the panel is a card, reading: *Mrs Nelly Bloomer of Ellenville. Painted from life on her 100th birthday. She lived to 103 years. E. L. Henry, 1890.* The story goes that Henry read in the local papers that she was to celebrate her hundredth birthday. He went to call, with a bouquet of flowers, and began then and there to paint the portrait. She is shown wearing a gray dress, with lace cap and fichu and old steel spectacles. She sits in a rocking chair with an antimacassar.

Aunt Nelly Bloomer's home was at the corner of Canal and Bloomer Streets, the latter named for her family.

Cf. Loose Notes (CAT. 1213) for sketch inscribed *Aunt Nelly Bloomer at 95. 1885. Sept. 10.*

231 A VIRGINIA WEDDING
Oil on canvas, 21¼ x36 in.
Lower right: *E L Henry, N.A. '90*
Bibliography: KL. NO. 74
Exhibitions: Century Association, 1942, NO. 56
Collection: Estate of Francis P. Garvan
Figure 155

The occasion of this painting was the marriage of Elizabeth Otis Woodruff to Edward Carroll of Charleston in the '80s. The horses were painted from the gray team of Doctor Woodruff of Pine Bush, N. Y., Jennie being on the left and Major on the right.

Robert McIntyre of Macbeth Galleries bought the painting from James D. Gill of Springfield and sold it to the Garvan Estate. An unidentified newspaper clipping pasted on manuscript p. 41, MS., reads as follows:

Perhaps Mr Henry is best known by his pictures of the period following the Revolution, during the latter part of the 18th and the early part of

1890

the 19th centuries. He has made a special study of the costumes, the architecture, the decoration, the carriages, the manner of life of the well-to-do classes in this country, both North and South, during that time, and he loves the picturesqueness, the color, the vivacity by which it is characterized. His Virginia Wedding, with its gay crowd on the veranda of a colonial mansion, the carriage at the door, and all the happy excitement so well indicated in faces and gestures, is a good example of this phase of Mr Henry's art.

232 A COUNTRY SCHOOL
Oil on board, 11⅞ x 16⅞ in.
Lower left: *E L Henry, N.A. '90*
Bibliography: KL. NO. 15; *Life in America*, 1939, pl. 147
Exhibitions: NAD 1891, NO. 264, as *The Class in Second Reader;* Life in America, Metropolitan Museum of Art, 1939; Century Association, 1942, NO. 7
Collection: Estate of Francis P. Garvan
Figure 149
Cf. NO. 241

233 COUNTRY SCENE
Oil on canvas, 12x22 in.
Lower left: *E L Henry*
Collection: Estate of Francis P. Garvan
Figure 66
The scene shows barns and a house, apple trees and in the distance the familiar mountains of the Cragsmoor country.
Cf. Figures 64 and 65

234 THE COUNTRY CARPENTER
Lower left: *E L Henry 1890*
Figure 145
The photograph in the Henry Collection is inscribed: *Painted after nature in the early "eighties" at Cragsmoor, N. Y.*
Cf. Figures 128, 134 and 144

235 A SITTING ROOM IN HOLLAND
One photograph in the Henry Collection is inscribed on the front of the mount: *E L Henry, 1889,* and on the back: *Mrs Judge Bookstaver, posed for this figure and it was a fine likeness and Judge Bookstaver bought the picture.*
Another photograph is inscribed on the back: *Mrs Bookstaver, widow of Judge Bookstaver, in early Dutch dress. Painted for the Judge. Painted in 1890. An old Holland Dutch interior.*

236 THE DEPARTURE OF THE BRIDE
AL. p. 57
Bibliography: KL. NO. 21
A photograph in the Henry Collection is inscribed: *Left by Mrs Wilcox of Brooklyn. Now at Westerly Memorial Hall, R. I.*

1890

237 ON THE WAY TO TOWN
AL. p. 52
Exhibitions: Probably NAD 1891, NO. 149
The same man and woman and wagon as are seen in NO. 201 appear in this painting. The horses are both dark now, however. A farm girl in sunbonnet is walking beside the road, barefooted. The woman still holds her umbrella, and the equipage is still driving away from the spectator.

238 [STOPPING TO TALK]
AL. p. 58
A couple in a buckboard drawn by two dark horses has stopped to talk to a farm girl in sunbonnet leaning over the fence. This subject differs from NOS. 201 and 237 in that the two have a child on the seat between them, and the woman does not hold an umbrella.

239 [SWAPPING NEWS]
AL. p. 58
A man in a buckboard with a robe draped over the seat has stopped to talk to a neighbor. He has his back turned to the spectator but has pivoted around to talk to the other man who faces out of the picture. The scene is a typical one on the "mountain" at Cragsmoor, N. Y.

240 STUDYING HER SUNDAY SCHOOL LESSON
The photograph in the Henry Collection is inscribed: *Studying her Sunday School lesson and fell asleep. A study from life by E L Henry.*

241 THE NEW SCHOLAR
AL. p. 17, p. 27
A photograph in the Henry Collection is inscribed: *Owned by Wm Alker.*
Cf. NO. 232

242 AT THE TOLL GATE
AL. p. 46
The painting shows the Evanses in a buckboard at the toll gate, in a view from the opposite side shown in KL. NO. 66.

243 A SUMMER DAY
Exhibitions: NAD 1890, NO. 263

244 A MOMENT OF PERIL
Exhibitions: NAD 1890, NO. 479
Is this *A Moment of Terror*, KL. NO. 32?

245 TOWARD EVENING
AL. p. 58

1891

246 THE COUNTY FAIR
AL. p. 60
Bibliography: KL. NO. 17; Sun and Shade, 1891–2, v. 4
Exhibitions: World's Columbian Exposition, Chicago, 1893, Fine Arts
 Building, NO. 550, as *The Country Fair*
Collection: W. F. Havemeyer, 1893–
Figure 182

 The photograph in the Album is inscribed: *From the picture in the possession of W. F. Havemeyer* and is dated *April, 1891*. The scene is at the Ulster County Fair, and Nancy Evans of Walker Valley, N. Y., was the model for the woman.

247 ON THE OLD GULLY ROAD ABOVE ELLENVILLE
AL. p. 60
Figure 245

 A photograph in the Henry Collection is inscribed on the back: *The painting was purchased by Andrew Carnegie & is now in Skibbo Castle in Scotland. He purchased it to show some of the awful roads in the Eastern States.*
Cf. Figures 137 and 139

248 VILLAGE POST OFFICE
AL. p. 54
Bibliography: KL. NO. 71
Figure 62

 A photograph in the Henry Collection is inscribed on the back: *Collection of Shepard Knapp.* Another photograph is inscribed: *The Main Street*

 Florence T. Taylor, Ellenville librarian, states that there is no reason to believe the old Low store was ever the post office. This store is still standing at the corner of Canal street and Cape road. Formerly owned by Jesse Low, it is now owned by David Harkavy.
Cf. Figure 63

249 THE TOW PATH
AL. p. 52
Bibliography: KL. NO. 67
Exhibitions: Gill, 1893, as *The Delaware Canal*, $400
Figure 170

 A photograph in the Henry Collection is inscribed on the back: *Now in possession of G. G. Stow, White Plains.*

 Leon Sciaky in New York History, July 1941, gives a good account of the Delaware and Hudson canal, which appears in many of Henry's paintings of this period. The canal, to be a tidewater route from mine to city, was begun in July 1825, and opened for business in October 1828. It was 28 feet wide at the top, 20 at the bottom, with a maximum depth of 4 feet. At first it accommodated only barges up to 30 T. The distance from Eddyville (on the Hudson near Kingston) to Honesdale, Pa., was 108 miles, with another 16 miles by rail to Carbondale.

1891

The first barge to navigate the canal was the Orange Packet. By 1832, there was a traffic of 4000 tons a month. In 1836 a flagstone industry developed in this region, due to the cheap transportation. Twice the canal was enlarged, till it reached a maximum capacity of 136 T. per boat. By 1872, a million tons of cargo were being carried by canal to tidewater. The flood of December 1878 caused serious damage. But the greatest harm was caused by the rise of rail transport. On November 5, 1898, Boat No. 1107 cleared Honesdale with the last load of anthracite. A transportation era had ended. (*Cf.* also McCausland, '41, p. 4–5, 46, 59–61, 155.) Henry did not seem to concern himself with this aspect of the D & H canal. It was its picturesque quality he put down on canvas. Rarely a subject like Fred Thomas (NO. 194 and FIG. 131) portrayed the realistic side of canal life. Usually it was the visual sentimental image Henry set forth.

An unidentified newspaper clipping, probably from the Ellenville Journal or Press, adds further data. It reads:

Last Trip on Old Canal

Edward Murtha of New York was last week visiting friends in Honesdale, and talking about bygones he said that he drove the horses that drew the last load of pea coal out of Honesdale. That was on Saturday, November 5, 1898; the name of the boat was "Sunshine," and her number 1107. Frank Hinzenbecker, of 49, German street, Kingston, captained the barge on this farewell trip.

That was thirteen years ago. A glance at the line of the old canal along the valley suggests that it must have been much longer ago. The Honesdale Citizen, which contains this note, recalls that the canal was built in 1828, eighty-three years ago; cost more than six millions of dollars, and was in operation almost 71 years, then in 1899 sold to the Erie R. R. Company.

More information is supplied by an unidentified newspaper clipping, probably from one of the Ellenville papers, inscribed by Henry: *The last of the "breaks" in the old Del & Hudson Canal—Now in use for a few weeks only, prior to its being filled up for the R. R.* It reads:

A bad break occurred in the canal on the level below Kerhonkson, Thursday afternoon, the fourth, occasioning much inconvenience to Cox Bros., and other shippers of wood, &c., whose time for boating is now very short. The leak started near the aqueduct, the origin being unknown—very possibly the work of a muskrat, or something of the sort.

The break took away some thirty or forty feet of the canal bank, and tore out the bottom for a good stretch to the depth of ten or a dozen feet below the canal bottom. Sup't Rose at once organized a force for repair, and fifty or more men, with teams, piled in stonewall and earth from a neighboring field into the gap, and it was a scene of genuine hustling up to Tuesday, when water was put in, but a leak necessitated further work. Thursday afternoon the water was let in, and the waiting boats were started down.

1891

250 [AT THE LOCKS]
AL. p. 19

Another scene on the Delaware and Hudson canal. It shows a packet boat towed by two horses, approaching the locks. Men and women in gay costumes of the early part of the 19th century sit on the flat top of the packet boat and observe the country landscape.

251 [CONFERENCE]
AL. p. 19

Another revolutionary scene. (Cf. NO. 157) Sentries stand outside a mansion, through whose open door uniformed men may be seen sitting at a table in earnest discussion.

252 THE GOLDEN HOUR
Exhibitions: NAD 1891, NO. 392

1892

253 THE NEW WOMAN
Bibliography: KL. NO. 37
Figure 179

A photograph in the Henry Collection is inscribed on the back: *The Bicycle Girl. Quite common, 15 to 20 years ago. From a sketch from nature above Ellenville, 1892.*
Cf. McCausland, '41, p. 193–94

A letter from May A. Bookstaver, dated October 22, 1896, refers to this painting. It reads as follows:

<div style="text-align:right">

Pembroke West,
Bryn Mawr,
Pennsylvania.

</div>

Dear Mr Henry:

If it were not for that demon of procrastination which possesses me, you would have known long ago how much I enjoyed your letter and the newspaper clippings you so kindly sent me.

Judge McLean should I think be greatly complimented on having had the courage of his convictions. I hope the women will prove themselves capable for that would encourage me more than anything else to take steps toward accomplishing what is still my ambition.

I am glad that you have so few Bryanites in your part of the country. I wish we could say the same here. This is the only part of Pennsylvania, I believe, which is not solid for McKinley, but here we have numerous expressions of free silver ideas. I am going to a political meeting tonight in the Town Hall, where both sides of the question are to be discussed. What do you think the upshot of such an arrangement will be, a free fight?

It is certainly very kind of Mrs Henry to think of sending us apples. I am sure they will be greatly appreciated at home. Things edible always are.

Mrs Henry and yourself will not forget to come and see me, will you when you come to Philadelphia? I can promise you material for numberless caricatures, for women when they go all to brain do very strange things. I saw a long article about that bicycle picture of yours the other day. It seems to have been fully appreciated.

This sounds like another new woman.

1892

254 TESTING HIS AGE
Bibliography: KL. NO. 65
Exhibitions: NAD 1892, NO. 418, as *Proving His Age*
Figure 192
A photograph in the Henry Collection is inscribed on the back as above
and on the front as: *Holding him uncomfortably by the under lip.*

Charles Peters of Cragsmoor has a letter from Oliver H. Durrell of
Boston, Mass., dated March 16, 1899, to Henry, at 111 East 25th street,
New York, to the effect that he was sorry the painting had been sold and
wanted to know what Henry would paint a similar subject for in oil.
The painting would be only for his private collection and would never go
on the market. He referred to the painting as *Making a Trade*, a water color.

The scene is in front of the old Mance house on the mountain at Crags-
moor. Later the house was owned by the Coddingtons. The Evanses of
Walker Valley serve as models again.
Cf. McCausland '41, p. 224

254-*a* TESTING HIS AGE
Pencil on paper, 14⅞ x 10⅞ in.
Collection: New York State Museum
Figure 195

255 MEDITATING REVENGE
AL. p. 56
Exhibitions: NAD 1893, NO. 296, $200
Figure 142

256 AFTER THE SHOWER
Exhibitions: NAD 1892, NO. 236
Could this be KL. NO. 2, *After the Rain?*
A water color of this title was sold at the sale of the Frederick Halsey
Collection at the Anderson Art Galleries in 1916 for $62.50. The catalog
describes it as follows: *Stage coach leaving the Tavern. Signed with initials.*

1893

257 THE FIRST RAILWAY TRAIN ON THE MOHAWK AND HUDSON
ROAD
Oil on canvas, 42¾ x 110 in.
Lower left: *Copyrighted*
E L Henry 1892–3
Bibliography: KL. NO. 23, as *The First Railway Train*
Exhibitions: World's Columbian Exposition, Chicago, 1893, Transporta-
tion Building; Corcoran, 1894; NAD 1894, NO. 377, as *The Opening
of the First Railroad in New York State, August, 1831, between Albany
and Schenectady;* Universal Exposition, St Louis, 1904, special medal
Collection: Albany Institute of History and Art, Albany, N. Y.
Figure 162
Note that the signpost in the painting reads: *To Schenectady 15 miles
To Albany 2 miles.* The locomotive is inscribed: *Mohawk & Hudson
R.R. Co.*

1893

Cf. MS. p. 330ff.

Martin E. Albert, himself the owner of a number of Henrys, reports that Mrs Henry told him Henry received $15,000 for the painting. Mr Albert posed for some of the figures, namely, the man running and a man sitting in a coach.

There is considerable correspondence about the painting in the files of the Henry Collection, including a note from the Quaker William Kite of Germantown about the first locomotive; letters between Henry and J. C. Pangborn of the Baltimore and Ohio about shipping the canvas to Chicago etc.; a request from F. E. Stebbins of the U. S. Patent Office for a photograph of the picture; a letter to Henry from Tiffany's regarding using the railroad painting on a "Transportation Vase," and letters from John S. Kennedy and W. F. Havemeyer about the possible purchase of the painting by the Metropolitan Museum of Art.

The Mohawk and Hudson Rail Road Company was chartered April 17, 1826, but took four years to raise capital of $300,000. Construction began August 1, 1830. *For thirteen years* (writes the New York Times of April 11, 1926) *horses drew the cars from the tollhouse in Albany to the first incline, up which the trains were drawn by ropes. Then the locomotive hauled the cars over twelve miles of level and straight road to the Schenectady incline, from whose foot horses pulled the train to the Schenectady tollhouse.*

The railroad's official opening was on September 24, 1831. But a trial trip for passengers was made on August 9—free for those who dared attempt it. The DeWitt Clinton engine, built at the West Point Foundry, supplied power. Concord coaches with special wheels to fit the rails were hitched on. The locomotive belched forth smoke and fire, and the passengers had to put out the flames. Frightened horses ran away. All in all, an historic occasion, and a good theme for Henry's anecdotal gift.

A loose, unnumbered sheet in the MS. gives more information:

THE OPENING OF THE FIRST RAILROAD TRAIN IN N. Y. STATE AND THE SECOND IN AMERICA AS A PASSENGER ROAD SEPT. 1831

The start was made at the two mile level, at the junction of Lydias Street and the Western Turnpike, and ran from Albany to the top of the hill at Schenectady. The train consisted of three cars, stage coach bodies, supported on trucks, and were drawn by the "little" De Witt Clinton, built at the West Point Iron Foundry, and were followed by several platform cars drawn by horses driven tandem.

Large crowds collected from the surrounding country, attracted by this novel sight, or event.

The roadbed was supported on square stone blocks, on which were laid pine timbers, with half-inch iron bars nailed on as rails. No brakes were used on these experimental trips, and the sudden jerk in starting, and violent bumping in stopping was so serious, that at the first water station, fence rails were strapped on between each car, thus keeping them apart.

On this trial trip, those seated on top, particularly the two back coaches, **suffered from the sparks from the engine pipe, burning holes in their**

1893

umbrellas and clothes. The conductor sat on a small "gig seat" at the end of the tender and gave the signal for starting and stopping by blowing through a tin horn.

The engine was built on the idea of a coach horse, lightness with strength and of course failed in traction, particularly in wet weather, when, according to their advertisements, horse power was substituted.

This was the first R R built and equipped for passenger service in America, with the exception perhaps of an experimental one, between Charleston and Hamburg in South Carolina the year previous.

A note added on the back reads:

The first train run as a passenger train in America was from Charleston to Hamburg, S. C., built in 1830. The engine was built at West Point Foundry, where the DeWitt Clinton was built. It blew up after running for three months. After that horses were used. The engine was called the Best Friend.

257-a THE FIRST RAILWAY TRAIN

An entry under the heading, *Water Colors by E. L. Henry,* in the catalog for the sale of the Frederick Halsey Collection at the Anderson Art Galleries in 1916 gives the above title as having sold for $125. The description reads: [*Hudson and Mohawk R.R.*] *Sept. 9th 1831. From the painting by E. L. Henry. Colored. 14x38.8 in.*

The photogravure, advertised in Klackner as $13\frac{3}{4} \times 34\frac{3}{4}$, sold for $10 plain and $15 colored. The difference in dimensions suggests, however, that the picture sold was not necessarily a colored print, in spite of the catalog's description, but a smaller version of the large painting.

258 THE COACHING PARTY
Oil on canvas, 18x14 in.
Lower left: *E L Henry, 1893*
Collection: Albany Institute of History and Art

259 IN THE RONDOUT VALLEY
Exhibitions: NAD 1893, NO. 322, $200; Gill, 1894, $150

May this be one of the Henry paintings, of the same title, shown at the Red Cross benefit exhibition in Ellenville, in 1918? *Cf.* McCausland, '41, p. 54–55, 95

260 NOON TIME
Exhibitions: NAD 1893, NO. 238, $85

1894

261 LATE AFTERNOON ON THE OLD DELAWARE AND HUDSON CANAL, AT PORT BEN, N. Y.
Oil on board, $7\frac{1}{2}$ x$9\frac{1}{2}$ in.
Exhibitions: Century Association, 1942, NO. 23
Collections: Thomas B. Clarke; Mabel Brady Garvan Collection, Yale University Art Gallery
Figure 171

1894

A slip of paper pasted on the back of the painting reads:

A study of a late afternoon effect at a canal lock on the old Del & Hud Canal at "Port Ben," Ulster Co., N. Y., The spire of a church in the distance is at Ellenville, a few miles back.

The characters in the picture were residents of that locality and posed for me. The painting was sold at a private exhibition at the Century Club to Mr Thomas B. Clarke and was afterwards in the sale of his noted collection.

<div align="right">

E L HENRY, N.A.

</div>

262 ENTRANCE TO HENRY HOUSE, CRAGSMOOR, N. Y.
Oil on board, 7¾ x 9¼ in.
Lower left: *E L Henry 1894*
Collection: Miss Margaret L. Wells
 The painting is inscribed on the back: *To F L H, for her birthday June 25, 1894, with love of E L H—pinxit.* The painting shows the rustic gateway leading into the Henry grounds, now renamed The Hemlocks by the present owners, Mr and Mrs R. L. Foster.

262-a E. L. HENRY'S HOME AT CRAGSMOOR, N. Y.
Oil on board, 7¾ x 9¼ in.
Lower left: *— June 25, 1914*
Collection: Edward C. Wells, Johnstown, N. Y.
 Inscribed: *A Present to Frankie on her Birthday, June 25th, 1914, painted for her by her husband, E. L. Henry, N.A.*

263 [NEWS OFFICE]
Oil on canvas, 4¼ x 6¼ in.
Lower left: *E L Henry*
Collection: James Graham and Sons
Figure 183
Cf. NO. 343
 The mat is inscribed: *To Hon^{bl} Henry W. Bookstaver with comp^{ts} of E. L. Henry. April 1894.*

1895

264 A COUNTRY LAWYER
Lower left: *E L Henry '95*
Bibliography: KL. NO. 14
Exhibitions: NAD 1895, NO. 200, $450, as *Asking Legal Advice*, illustrated
 18x23
Figure 150
 The country lawyer is George Keeler of Ellenville and his client is Peter P. Brown, ubiquitous in Henry's paintings of this period.

265 [AN INFORMAL CALL]
Lower right: *E L Henry 1895*
 The photograph in the Henry Collection shows an old man and woman in a buggy drawn by a single dark horse, talking to a couple outside their

1895

farmhouse. The man is seated on a sawhorse, and the woman wearing a sunbonnet stands, her back to the spectator, with her hands on her hips. In the distance the familiar Cragsmoor mountains may be seen, with the characteristic rail fence also in view. May this be *On the Way Home,* exhibited NAD 1896, NO. 95, $500, illustrated 19x30?

266 [RALPH MANCE AS MESSENGER]
AL. p. 48
Ralph Mance of Cragsmoor is carrying a basket. He is five years old. Mrs Bertha Mance Peters of Cragsmoor, his sister, has a photograph of the subject taken by Henry, evidently as a model for the painting.

267 GETTING READY FOR MARKET
Lower right: *E L Henry '95*
Bibliography: KL. NO. 25

268 THE VILLAGE STREET
Exhibitions: NAD 1895, NO. 183, $200

269 THE VILLAGE SQUIRE ENTERTAINING THE NEW DOMINIE
Exhibitions: NAD 1895, NO. 195, $500

1896

270 MRS NANCY EVANS
Oil on panel, 8x6 in.
Exhibitions: Century Association, 1942, NO. 30
Collection: Harry MacNeill Bland
Figure 135
The panel is inscribed on the back: *Painted from life, Walker Valley, Ulster County, N. Y., 1896.*

271 THE SWEETEST FRUIT
Oil on canvas, 11½ x15½ in.
Lower left: *E L Henry '96*
Collection: Bernard H. Cone
Two white boys and two Negro boys are stealing water melons and running for it. An old Negro and his dog are coming out of the corn-field in pursuit of the marauders.

272 NEWS OF THE NOMINATION
Oil on canvas, 17x28½ in.
Lower left: *E L Henry*
Bibliography: KL. NO. 36
Exhibitions: NAD 1897, NO. 143; *Century Association,* 1942, NO. 31
Collection: Milch Galleries
The painting shows a man in a buggy which sags under his weight as he leans to the right to talk to two farmers. One of them is sitting on the rail fence, the other leans on it. Both wear work clothes and seem glad of a breathing spell. A scythe is hooked over the top rail of the fence.

1896

273 MORNING PRAYERS: A STUDY AT A POOR FARMER'S HOME IN ULSTER CO., N. Y.
Lower right: *E L Henry '96*
Another photograph in the Henry Collection is inscribed: *Reading the Bible before breakfast. Old Oliver Evans and wife, Walker Valley, N. Y.*

274 A VIRGINIA POST OFFICE
Bibliography: KL. NO. 73

275 BIDDING GOOD BYE
Lower left: *E L Henry '96*

276 "GOOD-BYE"
Exhibitions: NAD 1896, NO. 346, $180; Gill, 1897, $175

277 WAITING FOR THE FERRYMAN: TIME, ABOUT 1844
Exhibitions: NAD 1896, NO. 230, $275

278 WAITING FOR THE FERRY
Lower left: *E L Henry*
Bibliography: KL. NO. 76

279 ON THE WAY HOME
Exhibitions: NAD 1896, NO. 95, $500, illustrated 19x30; possibly, Gill, 1907, $450
Could this be KL. NO. 55, *Returning Home?*

1897

280 [NEAPOLITAN SCENE]
A photograph in the Henry Collection is inscribed on the back: *Painted for Peter Doelger, 1897.*
The painting shows a scene along the waterfront with Vesuvius in the background, smoking. A two-wheeled vehicle drawn by a horse with a plume in its harness is filled to overflowing with driver, a woman holding a baby, a priest, three men sitting at their feet and three other men hanging on behind. Typical architecture is seen at the left, and to the right there is a flirtation going on.

281 THE CHILDHOOD OF RAPID TRANSIT
Lower left: *E L Henry '97*
Bibliography: KL. NO. 8
Exhibitions: NAD 1897, NO. 309, illustrated 16x33, as *In 1837— The Childhood of Rapid Transit;* Gill, 1913, $1200

282 THE PILLORY AND WHIPPING POST, NEW CASTLE, DELAWARE
Bibliography: KL. NO. 20, as *A Delaware Whipping Post*
Exhibitions: NAD 1897, NO. 140
Collection: Fred G. Kraft

1898

283 SUNDAY MORNING (OLD CHURCH AT BRUYNSWICK)

Oil on canvas, 34x62 in.

Lower left: *E L Henry, 1898*

Bibliography: NAD catalog, 1898, NO. 205, illustrated 34x62; KL. NO. 39, as *The Old Dutch Church, Bruynswick, N. Y.*

Exhibitions: NAD 1898, NO. 205

Collections: John G. Myers; Mrs George P. Hilton; J. G. Myers Hilton. Figure 67

Cf. MS. p. 331, 333*ff.*; also McCausland, 41, p. 29–31, 68; also Figures 68, 69 and 70

The story of this painting is interesting. It was originally purchased by John G. Myers of Albany from the artist; he was the grandfather of the present owner. The painting was inherited by his daughter, Mrs George P. Hilton (Jessie Kenyon Myers) and bequeathed by her to her son, J. G. Myers Hilton. On her death, Mr Hilton lent the painting to his aunt, Mrs H. King Sturdee, Taunton Manor, England, for her lifetime. The painting came back to the United States about a dozen years ago. There was considerable difficulty in getting it out of England without paying death duties. In the course of all these travels, the key to the identity of the people in the painting was lost. The painting was cleaned by David C. Lithgow of Albany and is now under glass. (McCausland, '41, p. 196–201.) Mrs Hilton, in giving the above facts, added that the yellow house in the background was taken from an old house in Johnstown, N. Y. Mrs Lawrence Stetson of Johnstown states that the house was the Gilbert house on South William street, built by Judge Morrell, no longer in existence.

Miss Mary Hartshorn Woodruff of Nyack, N. Y., a cousin of Mrs Henry, added another chapter to the history. (McCausland, '41, p. 232–36.) The Henrys were staying with the Woodruffs in Pine Bush. Miss Woodruff could drive a horse, so the three of them went in a double-seated carriage on the five-mile drive to Bruynswick. Henry painted all day, just stopping while they ate their picnic lunch in the carriage house.

In regard to the fact that the church actually has five columns, though Henry painted it with but four, Miss Woodruff contributed a footnote. Henry said he knew antiques. All the time he was painting, he fussed, blustered and flustered, saying no church could be built that way; this, in spite of the fact that the Bruynswick Church obviously *was* built that way. So the church appeared in the painting edited and censored.

The final anecdote from Miss Woodruff tells of the sale of the picture. Walter L. Palmer, son of the Albany sculptor, was in Henry's studio, in New York, and saw the painting. John G. Myers, the Albany merchant, was hunting for a painting to celebrate his wife's return from a trip. He had built a new house and there was a large space in the hall for which he wanted a picture. Palmer told him of the large Henry canvas he had seen, and Myers bought it forthright. When his wife came home and entered the hall, she exclaimed "Where did you get that picture of that church?" As a little girl, she had visited cousins nearby and had attended it every Sunday.

1898

An unidentified clipping in the Henry Collection reads:

ACADEMY OF DESIGN
The Spring Exhibition

Academy exhibitions generally contain a good proportion of subject pictures, and the present display is no exception to the rule. These pictures interest visitors who do not care much about technical questions in portrait painting nor about subtle points concerning atmosphere and compositions in landscapes, and often, too, they interest the painters themselves, for it is not unusual to find men of good equipment telling stories in their pictures, and others find in figures doing something more than standing up to be painted a congenial theme for the exercise of tried abilities. In this latter class, for example, is Mr Henry with his large picture in the south gallery, "Sunday Morning," No. 205. The scene shows an ancient stone church in a country town in New Jersey, or in Virginia, probably, with four great round pillars supporting the roof of the porch, and a gallery staircase built under it leading up to the second story. Weeping willow trees on the one side and tall shade trees on the other, a broad stretch of green grass and a summer sky form the setting for this architectural feature. This is the mise en scene, and the personages appear in the foreground, walking away at the close of services from the church to the carriages and gigs or standing about in groups to chat. The people are in the costumes of the early part of the century, and the stuffs are of many brilliant hues. Yellow, green, red, blue, pink, and white appear in the gowns, shawls and parasols of the women, and only slightly less sober tints in the coats and breeches of the men. The reconstruction of this scene of life and manners is so well done as to give an air of naturalness to the picture, and the individual types are all closely studied. The whole picture is carefully and competently painted. It ought to be engraved, or well printed in colors, so that when the original is in the possession of some private owner, or placed in some public gallery, people who will never have an opportunity to look at it may have a copy to hang in their homes. It is a very pleasing picture, and an American document of genuine value.

A letter to Henry from Dr John Deyo of Newburgh, dated August 30, 1918, adds another chapter to the saga of this painting. It reads in part:

I am very much pleased to learn that through your efforts, and through you and Judge Clearwater, the consistory and others at the Shawangunk Church have been induced to see a light and will refrain from despoiling the unique and historical church which you have made so well known through your art.

I am very much interested in historical matters, being the President of Board of Trustees at Washington's Headquarters and State Museum at Newburgh, also President of Temple Hill Association and a Director of Knox Headquarters Association, all in and near Newburgh. I would be delighted to have you call to see me when I am at home, and I would take pleasure in showing you all these places. You might think one or more of them would be worth while to reproduce in canvas or otherwise.

I thank you very much for your thought in offering me a photo reproduction of one of your recent works. I know I will enjoy it.

1898

283-*a* [BRUYNSWICK CHURCH]

A photograph in the Henry Collection shows another version of this subject. Though the photograph is faded and hard to read, the medium seems to be water color.

This arouses conjecture. It is more probable than the painting on which Henry worked during the famous trip with his wife and Miss Woodruff would be a smaller work and in a medium easier to work than oils. A further point is that the trip took place when Miss Woodruff was a child or a young girl, and in 1898 she would have been a young woman. What has happened to this version?

Figure 69

Can this be KL. NO. 57, *A Sabbath Morn, Bruynswick, N. Y.*, not illustrated?

284 A CHIP OFF THE OLD BLOCK

Oil on canvas,

Lower left: *E L Henry '98*

Collection: Bernard H. Cone

A Negro boy has just crawled under the fence and is eying the roosting fowl. The scene is night, and pale moonlight illuminates an otherwise dark picture.

285 ONE-SIDED BARGAIN

Water color

This sold for $50 at the sale of the Frederick Halsey Collection at the Anderson Art Galleries in 1916. The catalog gives the information: *E. L. Henry '98*

Cf. NO. 305 and Figure 190

286 THE COUNTRY STORE

Oil on wood, 7½ x10 in.

Lower right: *To my friend G. Inness, Jr., from E. L. Henry, 1911*

Collection: Winfield Scott Clime

Cf AL. p. 28

According to a letter from Mr Clime, a piece of paper pasted on the back of the panel is inscribed: *E. L. Henry, June, 1911. Cut down old sketch made in 1898 and repainted to fit frame.*

This agrees with the photograph in the Album, in which *E L Henry '98* may be seen very faintly in the lower right. Mr Clime's letter gave so good a description of the painting that it was possible to identify its verbal details by the above-mentioned photograph. The painting was given to him by Mrs George Inness jr, after her husband's death.

Mr Cline's description of the painting reads as follows: *The picture is a typical E. L. Henry. To the right, occupying slightly more than one-third of the canvas, is a country store with a porch supported by four columns, and under the porch a display of vegetables in boxes and baskets. There is a large dog lying on the floor of the porch. There is a figure of a man in the store, visible through the door. In approximately the center of the canvas is a white horse hitched to a single-seated rig, the top of which is folded halfway back. This horse is looking at the dog. In the middle*

1898

distance the road crosses a bridge, apparently over a very small stream. One man is leaning against the railing of this bridge and apparently talking to another man. On the same plane back of the horse is the side of a country house. In the extreme distance is part of a small country house, picket gate in front,' and small covered porch. At the extreme right of the canvas is a tree which bends over to the left and hides the part of the store that is above the porch. The horse is tied to a hitching post. . . . I almost forgot to say that our picture is a bright sunny one, with a blue sky and fluffy clouds.

Mr. Clime adds:

Mr. Henry died before we went to Cragsmoor, N. Y., but we knew Mrs Henry very well and often called on her, and many times she took us through the house and Mr Henry's studio, showing us his pictures and his historical collection of costumes etc., which we understand were sent to Johnstown, Pa. We are glad to know that our dear friend Charles C. Curran painted a portrait of Mr Henry. (Figure 32) *Mr Henry occupied a unique place among American painters, and it is good to know that a record is being made of his work.*

The Henry estate went to Johnstown, N. Y. The costumes are now in the Brooklyn Museum.

1899

287 WAITING FOR THE FERRYMAN
Oil on canvas, 28x50 in.
Lower left: *E L Henry 1899*
Exhibitions: NAD 1900, NO. 8, as *Waiting at the Ferry;* Century Association 1942, NO. 57
Collection: Albany Institute of History and Art
Figure 165
A photograph in the Henry Collection is inscribed on the back: *The Return from the First Congress. This carriage was imported from France in 1788 by Genl Peter Gansevoort of Albany (the Hero of Fort Stanwix) and was given to me by his granddaughter, Mrs Gansevoort Lansing. This vehicle is now in my collection at Cragsmoor, Ulster Co., N. Y. Washington rode in it with Gen. Gansevoort while on a visit to Albany in 1792. It was driven by a postillion as seen in the picture.*
Cf. Figures 166 and 169

287-a WAITING AT THE FERRY
Pencil on paper, 10x11⅞ in.
Lower right: *E L H Oct. 8 '99*
Collection: New York State Museum
Figure 166
Cf. NO. 1088 and Figure 169: another detail for the painting, showing a man in greatcoat, purplish-plum in color, wearing a top hat and leaning on a cane

1899

288 A BROOKLYN FERRYBOAT
Water color
Lower left: *E L Henry, 1899*
Bibliography: KL. NO. 40, as *An Old Ferry Boat (Fulton Ferry, 1832)*

288-a CROSSING THE FERRY
Water color on paper, 11¼ x20 in.
Lower right: *E L Henry, 1893*
Collection: Mrs Frank E. Miller
Figure 167

289 ENTERING THE LOCK
Water color on cardboard backed, 18¾ x26¼ in.
Lower left: *E L Henry '99*
Exhibitions: A History of American Water Color Painting, Whitney
Museum of American Art, 1942, NO. 109; Century Association, 1942,
NO. 10
Collection: Albany Institute of History and Art
Figure 255
The canal boat is inscribed: *Buffalo Express Packet*

290 INDIAN QUEEN INN, BLADENSBURG, MD., IN 1795
Lower left: *E L Henry, 1899*
Bibliography: KL. NO. 29
Figure 159
Cf. NOS. 143, 327 and 333

291 PASSING THE OUTPOSTS
Water color
Lower left: *E L Henry, 1899*
Bibliography: KL. NO. 46 seems to be another version
Exhibitions: Philadelphia Art Club, water color exhibition, 1900; Water
Color Society, 1901
Cf. Figure 185

292 A MORNING CALL ON NARRAGANSETT BAY
Lower right: *E L Henry '99*
A photograph in the Henry Collection is inscribed on the mount, lower
right, as above and, lower left: *Painted by E L Henry 1899*

293 A VILLAGE STREET
AL. p. 46.
Lower right: *E L Henry '99*
Exhibitions: Possibly NAD 1901, NO. 240, as *A Village Street, in the Old
Stage Days*

294 AT THE WATERING TROUGH
Lower right: *E L Henry '99*
A photograph in the Henry Collection is inscribed on the back: *A party
of city men. Been out hunting. In the Shawangunk Mtns.*

1899

295 "HOME AGAIN"
Exhibitions: NAD 1899, NO. 54

296 A SEPTEMBER AFTERNOON
Bibliography: KL. NO. 58
Exhibitions: NAD 1899, NO. 161

297 "A STORMY AFTERNOON"
Exhibitions: NAD 1899, NO. 194

1900

298 A MOUNTAIN POST OFFICE
Lower left: *E L Henry 1900*
Exhibitions: NAD 1904, NO. 117
Figure 81

299 TALKING POLITICS
Lower right: *E L Henry, Oct. 1900*
Bibliography: KL. NO. 63
Figure 219

300 GOOD-BY. SWEETHEART
Water color,
Lower left: *E L Henry, 1900*
Bibliography: KL. NO. 27
Figure 187
A photograph in the Henry Collection (touched up with black and white) is inscribed on the back: *Old Houses, Kingston, R. I. This was before the road was cut down or graded some years ago.*
A water color of this title sold for $65 at the sale of the Frederick Halsey Collection at the Anderson Art Galleries in 1916. The catalog gives the signature as *E. L. Henry, 1900* and describes the picture as *Trooper; Revolutionary period.*

301 CROSSING THE LOG-BRIDGE IN A FRESHET
Wash drawing
This picture brought $52.50 at the sale of the Frederick Halsey Collection at the Anderson Art Galleries in 1916. The catalog gives the signature as *E. L. Henry 1900.*
Cf. NO. 380

302 THE BATTERY AT NEW YORK IN 1660
A photograph in the Henry Collection is inscribed: *The Battery at New York in 1660* and *"The Church in the Fort." Governor's Island in the distance. Painted by E. L. Henry for the Guarantee Title and Trust Co., N. Y.*

303 HOME FROM THE PHILIPPINES
Exhibitions: NAD 1900, NO. 145
Is this *Return from the Wars? Cf.* Figure 220

1901

304 FULTON'S FIRST STEAM FERRYBOAT, RUNNING FROM CORT-
 LANDT STREET TO PAULUS HOOK, JERSEY CITY, 1813–14
 Reproduced as a calendar in 1901 by Theo. Gubelman, Jersey City
 Figure 168

1902

305 A ONE-SIDED BARGAIN
 Oil on canvas, 12½ x21 in.
 Lower left: *E L Henry, 1902*
 Bibliography: KL. NO. 48, as *The Peddler, No. 2*
 Exhibitions: Probably NAD 1903, NO. 97, as *The Peddler;* American
 Genre, Carnegie Institute, 1936; American Genre, Whitney Museum of
 American Art, 1935; Century Association, 1942, NO. 41
 Collection: Estate of Francis P. Garvan
 Figure 190
 Cf. NO. 285; also Figure 195

306 BURGOYNE'S ARMY ON THE MARCH TO SARATOGA, SEPTEM-
 BER 1777
 Bibliography: KL. NO. 7, as *Burgoyne's March down the Hudson*
 Exhibitions: NAD 1902, NO. 60
 Figure 186
 There are two copies of the subject in the Henry Collection: 1) a
 photograph mounted on a stretcher 15¼ x29 and colored by hand in oils;
 2) the same photograph in black and white, similarly mounted.
 The Albany Institute of History and Art can not locate a water color,
 12x18½, signed not dated, called *The Army of General Burgoyne.* Are
 these paintings the same?

307 TIME IS NO OBJECT
 Exhibitions: NAD 1902, NO. 367

1903

308 AN OCTOBER DAY
 Oil on canvas, 12x22 in.
 Lower left: *E. L. Henry, 1903*
 Exhibitions: NAD 1904, NO. 313
 Collection: Martin E. Albert
 Figure 202
 The subject is the post office in the center of Cragsmoor. Just down the
 road, though not visible, is the Cragsmoor Inn. Mrs Henry, wearing a
 blue sunbonnet and a red skirt and carrying a market basket, is reading
 a letter as she comes away from getting the mail. With her are the two
 Henry dogs. Driving away in a buggy are Tom Boyce and his daughter,
 while other members of the community sit on the porch of the building
 which serves also as general store. George Inness jr's coachman has just
 come up, riding a horse, to collect their mail. On this plateau, 2000 feet
 above sea level, autumn has already turned the leaves orange and red.
 Cf. Figure 201

1903

309 PASSING THE OUTPOSTS
Oil on canvas, 17½ x 28½ in.
Lower left: *E L Henry 1903*
Exhibitions: Century Association, 1942, NO. 42
Collection: Babcock Galleries
Figure 185
Cf. NO. 291

A photograph of this picture at Fraunces Tavern is inscribed: *Passing the Outposts on the old Kingsbridge Road. British Occupation of New York. To the Society of the "Sons of the Revolution." Complts of E. L. Henry, N.A.*

A letter in the Henry Collection refers to this photograph, among others, as follows:

*Sons of the Revolution
in the State of New York
Fraunces Tavern
Corner Broad & Pearl Streets
New York City*

Sept. 17, 1910

E. L. Henry, Esq., N.A.,
 c/o Rev. George S. Baker, D.D.,
 205 West 107th St.,
 New York.

My dear Sir:

Your very generous donation of five photographs of your own paintings representing Colonial and Revolutionary scenes is received and I beg to express to you the earnest thanks of the Society and our apprciation of the spirit which prompted the gift. The pictures are most appropriate for this building and will add greatly to our collection.

Under separate cover I am sending you one of our acknowledgment certificates.

Yours very truly

Henry Russell Drowne (signed)

Secretary

310 SIR WM JOHNSON PRESENTING MEDALS TO THE INDIAN CHIEFS OF THE SIX NATIONS AT JOHNSTOWN, N. Y., 1772
Oil on canvas, 22x36 in.
Lower right: *E L Henry, 1903*
Collection: Mrs Charles B. Knox

Painted as a commission for the Knoxes. Henry, according to Mrs Knox, "considered it his very finest painting." No copies were made, until the Knoxes realized that the artist felt badly not to be able to duplicate the work. Today there are copies in eight or ten libraries throughout the State. A copy was presented by Henry to the Johnstown Historical Society. It now hangs in Johnson Hall, Johnstown. A water color, *Johnson Hall, Johnstown,* (27½ x18, signed and dated 1907,) is listed as belonging to the Albany Institute of History and Art but can not be located.

1903

When Johnstown held an historical celebration in 1922, the painting was acted out as a charade at the Colonial Club. The picture has been reproduced as a postcard. Today the blockhouse at the left of Johnson Hall is gone, but the fort and other blockhouse still stand.
Cf. correspondence, 1910; clippings, 1922

310-*a* A PRESENTATION OF MEDALS BY SIR WILLIAM JOHNSON TO THE TRIBESMEN OF THE SIX NATIONS HELD AT JOHNSON HALL A.D. 1770

Pen and ink on cardboard, 11x16 in.
Lower left: *E L Henry*
Lower right: *E L Henry*
Collection: Johnstown Historical Society; presented by the artist May 1910

A letter from Brigadier General Edgar S. Dudley, U. S. Army, (retired), to Henry, dated May 11, 1910, reads:

I had the pleasure last evening at the meeting of the Johnstown Historical Society to present to them, in your name, the copy of your painting of "The Presentation of Medals by Sir William Johnson to the Tribesmen of the Six Nations at Johnson Hall, 1770." It was much admired and its historic value appreciated.

The society not only gave you a vote of thanks, but also elected you an honorary member of the body, of all of which you will probably be soon notified officially by the corresponding secretary, Mr Carroll. (Cf. correspondence, May 19, 1910) We hope you will visit Johnstown during the summer, and I am sure any suggestions made by you will be thankfully received. Trusting that your health is restored and with kindest regards to Mrs. Henry and yourself, I remain,

Yours sincerely

Edgar S. Dudley

P.S. It may be well to say also that it was directed that the picture be suitably framed with an inscribed plate showing the name of the donor and hung in the Hall. I would be glad of a suggestion as to the "most suitable" frame. Apparently a flat frame on which the plate can be placed will be appropriate, but I am not the best kind of a judge in such matters.

E.S.D.

311 SPRINGTIME
Lower right: *E L Henry, 1903*
Exhibitions: NAD 1903, NO. 160

312 [WATERING THE HORSES]
Lower right: *E L Henry, 1903*

313 THE SURRENDER OF NEW YORK TO THE ENGLISH BY STUYVESANT, 1664
Lower right: *E L Henry, 1903*
Reproduced as a calendar for Title Guarantee and Trust Company, 146 Broadway, New York

1903

314 "OUR LANE"
Water color,
Lower right: *E L Henry '03*
A photograph in the Henry Collection is inscribed on the back: *Water color. Our Lane, Mtn. Sold up there to Mr. Edgar N. Sidman, married Arthur Keller's sister. Sherman Sqr. Hotel.*

1904

315 SPRING
Oil on canvas, 11x20 in.
Lower left: *E L Henry, May 1904*
Collection: Martin E. Albert
Cf. KL. NO. 79, A Wayside Well
The Coddington cottage was the first house up the gully road from Ellenville. The subject is characteristic—rustic cottage, apple trees in bloom, pump. Mrs Coddington is churning while she talks to Harry Cook, a farmer whose rig is hitched by the road.
A letter from Henry to Martin Albert, dated *On Mtn June 14th, 1904,* reads:

I am taking the picture of the horse and wagon, man at well, girl churning etc., which you have wanted so long, and it is at last finished. I worked all the time I have been here since early June and having few interruptions and nature to work from, I have it completed. It is one of my strongest little pictures, I feel. I thought of framing it in a black ebonized frame with gilt flat next to canvass, feeling that the dark wood helped make the contrast greater like looking out of doors from a window. They are more durable and far more effective than gilt. If you don't want it, preferring a gilt frame, you can have your choice, as the frame was included in the price, of course; only if it were to be mine, I should have the heavy dark polished ebonized frame as the picture is very sunny (springtime) and the effect would be bully
P.S. I had a letter from that firm in Phila. who are making a small replica of part of your picture "An October Day."

316 THE ARRIVAL OF THE STAGE
Oil on canvas, 12⅛ x21¼ in.
Lower right: *E L Henry 1904*
Exhibitions: NAD 1905, NO. 38; Century Association, 1942, NO. 1
Collection: Estate of Francis P. Garvan
Figure 158

317 THE MacNETT TAVERN
Water color on paper, 14x21½ in.
Lower right: *E L Henry 1904*
Bibliography: KL. NO 31, as *McNetts Tavern, Germantown, Pa.,* (Headquarters of Gen. Howe)
Exhibitions: A History of American Water Color Painting, Whitney Museum of American Art, 1942, NO. 110, as *McNett's Tavern, 1909;* Century Association, 1942, NO. 27.

1904

Collection: Albany Institute of History and Art
Figure 256
Cf. Figure 257

An entry label of the American Water Color Society pasted on the back reads: *General Howe's Headquarters after the Battle of Germantown.*

A photograph of the tavern (still standing in 1868) in the Henry Collection is inscribed on the front of the mount: *The Macnett Tavern, Germantown road, Used by Lord Howe as Hd Qtrs during the and after Battle Oct. 4, 1777. Still Standing.* Another notation reads: *E L Henry from Wm Kulp, Antiquary, 1868.* There is correspondence with Kulp in the Henry files, and it was his old aunt who posed for The Old Clock on the Stairs, NO. 70.

318 GOODBYE, SWEETHEART
Water color on cardboard, 11x16½ in.
Lower left: *E L Henry, 1904*
Collection: Albany Institute of History and Art

Penciled on the backing is the following note: *Original study in black-and-white by E. L. Henry for a water color in possn of A. Lewiston, N. Y. (the "Copper King")*
Cf. NO. 300

319 [MAUD POWELL PLAYS THE VIOLIN]
Lower right: *E L Henry, 1904*
Figure 71

In the Henry Collection there are several photographs and photogravures of this painting. One, the gift of Miss Annette Mason Ham of Providence and Cragsmoor, is inscribed: *To Miss Annette M. Ham. With the best wishes of E L Henry.* Inscriptions on other examples give further information: *A little Negro selling berries is entranced at front door listening to Maud Powell on the violin. She had never before heard such "fiddle playing."* Also: *A Study from nature at Ellenville, N. Y., where the incident happened in 1883.* And: *Photo from painting by E L H in possn of Mrs. Cord Meyer, Great Neck, L. I.*

Major Powell and his family (including Maud, the famous violinist) used to come to Ellenville for the summers, no doubt through Frederick Dellenbaugh, who had been with Powell on his second expedition down the Colorado river in 1871 (*Cf.* Taft, 1939, p. 288–89) and who had become interested in and later married Harriet Otis, who lived on Canal street in Ellenville. Maud Powell used to rent an empty house to practice in. At various times, all boarded at a village boarding house run by Mrs John A. Morse. (McCausland, '41, p. 6–7)

Henry and Maud Powell kept up the friendship, witness the correspondence of December 4, 1891, March 29 and April 21, 1894, which suggests a fairly steady exchange of tickets for concerts and *vernissages*. The first mentioned letter is endorsed by Henry: *Maud Powell, aged 24 years, the great Violin Virtuosa.* She was thus only 16 years old in the picture, if Henry's inscribed date of *1883* is correct.

A photograph (also the gift of Miss Ham) shows her in Henry's studio at Cragsmoor. *Cf.* Figure 72.

1904

All these documents show the foundation in real life for the painting. Henry's incurable habit of "dressing up" his subjects would out, however. Florence T. Taylor, Ellenville librarian, states that there were no stone houses in Ellenville like the one depicted!

320 [STOPPING TO WATER HIS HORSES]
Lower right: *E L Henry, 1904*
At the left is a farm cottage, with an old woman sitting on the porch knitting. In the center is a well, from which the farmer is drawing water for the team of horses, stopped on the road at the right.

321 ARREST OF MAJOR WILLIAM DYRE FOR TREASON IN WRONG-FULLY TAXING THE PEOPLE OF NEW YORK
Lower right: *E L Henry, 1904*
Reproduced as a calendar for Title Guarantee and Trust Company, 146 Broadway, New York

322 [THE MAIL STAGE WAITING FOR THE FERRY]
Lower left: *E L Henry*
A photograph in the Henry Collection is inscribed on the back: *A single team mail stage in use from 1830 to 1865. From a drawing made from the old Stage in Concord, N. H., 1904. The picture represents the mail stage waiting for the ferryboat to carry it over. Photod from the painting by E. L. Henry.*

323 THE CLERMONT, FULTON'S FIRST STEAMBOAT
Lower left: *E L Henry, 1904*
Figure 242
A letter, dated February 3, 1911, to Henry from G. B. Schley refers to the Henry painting he bought at the last N.A.D. exhibition. This is pasted on the back of manuscript p. 30, MS. A photograph in the Henry Collection is inscribed: *Purchased by Mr. Schley, who died Nov. 1917*
An undated letter to Henry from F. D. Millet (pasted on the back of manuscript p. 51, MS.) requests data about the Clermont.
Reproduced, apparently as a calendar, by Theo. Gubelman, Jersey City. There is a discrepancy in the date, the copy of this reproduction in the Henry files being dated *1901.*

323-a THE "CLERMONT" MAKING A LANDING AT CORNWALL ON THE HUDSON, 1810
Platinum photograph worked up in gouache by the artist, 9⅛ x 19 in.
Bibliography: American Historic Prints, Early Views of American Cities etc. p. 53.

The above reference adds:
Date depicted: 1810.
Artist: E. L. Henry, whose penciled signature appears in the lower left corner, and a pencilled presentation inscription in the lower right corner: "To Mr Henry Havemeyer. Complts of E. L. Henry.
We are indebted to this artist for many carefully studied and charmingly drawn "reconstructions" of old time buildings, costumes and events.

Taking a photograph of this touched-up photograph and having it colored, the West Virginia Pulp and Paper Company used this Henry subject for its 1942 calendar, printing an edition of 30,000 copies.

1905

324 ST JOHN'S PARK AND CHAPEL, NEW YORK
Lower left: *E L Henry 1905*
Bibliography: KL. NO. 56
Figure 247
Cf. NO. 79, 325; Figures 112, 248

A photograph in the Henry Collection is inscribed: *As it appeared about 1839–40.*

The literature about this painting reveals Henry's interest in preserving relics of the past. St John's was tenacious in its hold on life; for a half century passed before it was finally demolished. (*Cf.* NO. 79) Till the end Henry struggled to save what he called one of the best examples in America of Sir Christopher Wren architecture. A letter from the secretary of the Borough President of Manhattan, dated June 6, 1913, begins the story:

George McAneny
 President

 Leo Arnstein
 Secretary of the Borough
 Louis Graves
 Secretary to the President

 City of New York
 Office of
 The President of the Borough of Manhattan
 City Hall

 June 6, 1913

E. L. Henry, Esq.
 Cragsmoor, Ulster County
 New York
Dear Sir:

President McAneny has received your note about St. John's Chapel. He has been giving the matter his very careful personal attention, and is now having plans prepared that may very possibly offer a solution. If the engineering difficulties that have been encountered can be overcome, and the old church saved from demolition, he will be very much gratified; and he is doing all that he can to this end.

 Yours very truly

 Louis Graves
 Secretary to the President

An unidentified newspaper clipping, probably 1914, continues

 ST JOHN'S CHAPEL UP TO-DAY
 Future of Old Episcopal Structure to
 Be Settled by the Board of
 Estimate

Old St. John's Episcopal Church, Trinity Parish, in Varick Street, seems sure to go at last. Consideration of the future of the ancient landmark is on the calendar of the Board of Estimate for to-day. It is recommended to

1905

the Board that the Commissioners in the proceedings be asked by the Corporation Counsel either to agree to the removal of the portion of the building encroaching upon the street or to the moving of the building to a position wholly on property belonging to Trinity Corporation.

The report of the city engineers to the President of the Borough of Manhattan shows that an agreement between the city and Trinity Corporation stipulated that the building, part of which was taken in the Varick street widening and title to which has been vested in the city, was to remain undisturbed for two years from July 1, 1914.

A second unidentified newspaper clipping, probably 1916, reads:

MUST ST JOHN'S BE WRECKED?

It is the preservation of such edifices as old St John's chapel in Varick street, a link between the New York of the present and the New York of the past of which there are too few landmarks remaining, which gives a city personality as well as individuality. The metropolis is too prone to forget that it is the sum of all it has been in the past plus what it is today and to take note only of the piles of brick and stone that are new is to lose much of its heritage.

We are told once again that old St John's must go unless public spirited citizens donate the funds necessary to its preservation. Trinity Corporation owns the body of the church; the city had to take title to the front, including the columns and the bell tower which they support, in widening Varick street. In London they would have bent the street into a curve to save them as was done in the cases of St Clement's Danes and St Mary's-le-Strand.

But now the building is falling into decay; if the facade, which should be maintained in spite of the obstruction to the sidewalk, is removed, scarcely a ruin will remain. The congregation has disappeared and Trinity is not willing to provide the upkeep; neither is the city.

Considering the great wealth that Trinity Corporation has accumulated through appreciation in the value of metropolitan real estate, keeping old St John's in repair should not fall as an unbearable hardship upon it. In the two years during which the matter has been in abeyance there have been no public subscriptions toward that end.

A letter to the editor of the New York Times, pasted on the back of manuscript p. 26, MS., reads:

Old Saint John's in Varick Street

An article in your Sunday edition signed H.K.R., has verified what I feared would happen, i.e., the demolition of old St John's in Varick Street. I wrote a few years ago to Mr McAneny of the Board of Aldermen and he generously responded in regard to preserving the portico by allowing the sidewalk to extend out into the street, passing around the bases of the columns and then returning to the new sidewalk line, doing all within his power to preserve the magnificent edifice. But it appears it was all of no use. Trinity Corporation was eager for what the site would bring. So it is being destroyed. Very fortunately, I painted two large pictures of it a few years ago from sketches made in 1867–8. But they give a very poor

1905

*idea of the splendid church edifice itself and the wonderful detail in it all.
St John's was without doubt the most magnificent example of the Sir
Christopher Wren type of church in America—the exterior and the interior
particularly. And it is a shame that it was not allowed to stand as a rare
example of the early nineteenth century church architecture. Too bad.*

 E. L. Henry, N.A.

Ellenville, N. Y., Sept. 24, 1918
Cf. MS. p. 324

325 **ST JOHN'S CHAPEL**
 A photograph in the Henry Collection is inscribed: *View taken from
the park as it looked about 1840.* Another photograph is inscribed on the
back: *Old St John's Chapel from the Park. Park taken away 1867.*
Figure 248
Cf. NO. 79, 324; Figures 112, 247

326 **A DISTURBER OF THE PEACE**
Lower left: *E L Henry 1905*
Bibliography: Broadway Magazine, August 1908, p. 221
Figure 177
 A tear sheet for this article (which is called "A Painter of the Good
Old Times" and was by Page Dunbar) is annotated by Henry: *Stone Ridge,
N. Y.,* though the church steeple in the picture looks more like the Ellenville
church as he represented it.

327 **CHANGING HORSES**
Lower right: *E L Henry 1905*
Figure 160
Cf. NO. 143, 290 and 333
 General Jackson adorns the inn sign in this painting, whereas in Indian
Queen Inn, Bladensburg, Md., the sign shows the presentment of an Indian
maiden.

328 **[WHAT'S THAT YOU SAY?]**
Lower right: *E L Henry 1905*
 . The photograph in the Henry Collection shows a single-seated spring
wagon. A woman and a man, the latter apparently the Negro of *Taking
Life Easy* (Cf. NO. 359) have stopped to talk to an elderly farmer, who
is having difficulty in understanding what they say, to judge from his hand
cupped behind his ear and the inquiring cock of his head. The small Negro
boy perched on the rear seems to be related to the boy in *Returning Home,*
KL. NO. 55.

329 **WAITING FOR THE NEW YORK BOAT AT STONINGTON,
CONN., THE FIRST RAILROAD FROM STONINGTON TO
BOSTON**
Lower left: *E L Henry 1905*
Figure 163

1905

330 A MORNING CALL
Lower right: *E L Henry 1905*
Lower left: *Copyright 1906 by E L Henry*
Exhibitions: Possibly NAD 1906, NO. 89
The photograph in the Henry Collection is inscribed on the back: *At old Stone Ridge near Kingston, N. Y.*

331 RESIDENCE OF CAPT. WILLIAM KIDD, 1691
A photogravure in the Henry Collection (4⅝ x 6¾ in.) is from the same Title Guarantee and Trust Co. series as NOS. 302, 304 and 321.

1906

332 KNOX HOMESTEAD
Oil on canvas, 18x24 in.
Lower left: *E L Henry 1906*
Collection: Mrs Charles B. Knox
This painting was a commission for the Knoxes, painted from a photograph of the old family homestead, about 12 miles from Canajoharie. It shows three generations of Knoxes.

333 THE INN AT BLADENSBURG
Wash drawing on paper, 10x15 in.
Lower left: *E L Henry, Bladensburg, Md.*
Exhibitions: Century Association, 1942, NO. 19
Collection: Century Association
A label in Henry's handwriting on the back reads: *The Main Street, Bladensburg, and the Indian Queen Tavern. Presented to the Century Club for the new private dining room, 1906.* The price $50 is marked on an exhibition label of the Boston Art Club, undated.
Cf. NOS. 143, 290 and 327

334 A PRIVATE VIEW: A.D. 1905-1906
Lower left: *E L Henry*
Lower center as above
Lower right: *How we three, a Tumbler Pigeon, a Top Knot Hen, and a Goose, suggested the present Styles of 1905-1906*
Figure 208
A photograph, lent the New York State Museum by Mrs Charles B. Knox of Johnstown, N. Y., is inscribed on the back: *A caricature Exhibition held at the Century Club This caricature picture was on the style of dress & hats of 1905-6. Title, "private view of the Natnl Academy Exhbtn" showing the Absurdities in Dress.*

335 THE FLOWER SELLER
Lower right: *E L Henry '06*
Exhibitions: NAD 1907, NO. 164
Figure 194
A photograph in the Henry Collection is inscribed on the back: *A study from nature at Cragsmoor, N. Y.*

1906

The setting is front of the cottage now owned by Miss Julie M. Husson and Miss Mary D. Buxton, which they purchased from the Henrys about this time. (*Cf.* Figure 197) The setting has been used in at least one other Henry painting, *Unexpected Visitors*, NO. 355.

336 ON THEIR VACATION

Water color and chalk drawing on paper, 13x20 in.
Lower left: *E L Henry 1906*
Collection: Bernard H. Cone

Two horses are being watered at a trough. They are drawing a carriage containing a man and a woman and a young boy and a dog. A boy and his dog are passing at the extreme right. The picture is inscribed: *Upper part of Ellenville, N. Y., Shawangunk Mts. in the distance.*

337 IN EAST TENNESSEE

Lower right: *E L Henry 1906*

A white girl in a sunbonnet is riding a horse. She has paused to talk with a white woman and man. A Negro woman is leaning out of the window of a shack to watch. There is a house at the right rear.

Can this be NAD 1915, NO. 64, *In the Mountains of East Tennessee?* And Gill, 1917, $250?

Figure 209

338 EARLY AUTUMN

Lower right: *E L Henry 1906*
Figure 180

339 THE CALL BY THE WAY

A reproduction from the Broadway Magazine, August 1908 issue, shows this picture, with the above title and date. A buggy has drawn up at the side of the street and its occupants are stopping to talk to a woman who stands on the hitching block. A man in a tall hat is driving the vehicle, while two women sit behind him.

340 COUNTRY FOLKS

Exhibitions: NAD 1906, NO. 66

1907

341 IN THE OLD STAGE COACH DAYS

Oil on canvas, 24x28 in.
Lower left: *E L Henry 1907*
Collection: Martin E. Albert
Figure 249

The old Terwilliger House stood on the site of the present Ellenville post office. The scene shows muddy street, slabs of stone for sidewalks, cobblestone gutters, hitching posts and all, with the coach leaving the inn. The artist made an addition, however, putting in the church. The oxcart is of the period.

1907

A letter from Henry to J. H. Smith, the original owner of the painting, dated January 12, 1908, reads:

I cleaned it, retouched it in places and varnished it the day before it was called for by the Century Club. It made quite a "hit" there last night and was considered the best work in general "tone" that I had ever yet produced. Out of decency I cannot write you of the comments I heard on the work, but judging from it you have one of my best examples.

A second letter from Henry to Smith is dated August 15, 1915:

That stage picture I considered one of by best works At present, no one seems to have any money for pictures just now. I haven't sold anything except one small work since last Christmas and all the other artists' complaint is the same except a few portrait painters and in Europe it is deplorable." He advises therefore against attempting to sell the picture until the season begins.

342 SCENE ALONG THE DELAWARE AND HUDSON CANAL
Oil on board, 8x11 in.
Lower right: *E L Henry 1907*
Bibliography: Check list of exhibition, Our Own—Our Native Art, John Levy Galleries, May 10–June 15, 1941, NO. 11
Exhibitions: possibly NAD 1908, NO. 149, On the Banks of the Canal (Miss Anna Riker Spring); Our Own—Our Native Art, John Levy Galleries, May 10–June 15, 1941; Century Association, 1942, NO. 52
Collection: John Levy Galleries
Figure 172

The check list has this to say: *The Delaware-Hudson Canal ran from Harrisburg to Albany and the water right-of-way was later used by the Delaware and Hudson Railroad. This scene is evidently painted in back of Kingston, near Henry's home.*

Here is a scene that might well have illustrated the recent book, "Chad Hanna." E. L. Henry had the clearest eye for catching the spirit of American life at the close of the 19th century. We owe much of our knowledge of the Civil War to his sketches and studies, and his keen eye for character and quaint humor give us a clear picture of our neighbors in the country.

The above suggests the need for documentation of our artists of even the recent past; for several errors of fact creep into the statement about the canal. It did not run from Harrisburg to Albany, but from Honesdale, Pa., to Kingston, etc.

343 FOOD FOR SCANDAL
Lower right: *E L H 1907*
Figure 184

A photograph in the Henry Collection is inscribed on the back: *"Food for Scandal." A village girl has picked up a "Drummer" & invited him out for a Ride in her Buggy.*

A photograph, lent to the New York State Museum by Mrs Charles B. Knox of Johnstown, N. Y., amplifies: *Food for Scandal. A sketch of a village News Depot. The old women watching a village girl who has picked*

1907

up a "Drummer" and taking him for a "Buggy Ride." The oldest saying—
"I wouldn't have believed it if I hadn't seed it with mine own eyes." The
Hussy!
Cf. NO. 263

344 JOHNSON HALL, JOHNSTOWN, N. Y.
Water color, 18x27½ in.
Signed and dated 1907
Collection: Albany Institute of History· and Art
This painting can not be located.

345 ON THE WAY TO TOWN
Exhibitions: NAD 1907, NO. 228

346 WAYSIDE REST
Exhibitions: NAD 1907, NO. 257

1908

347 BEAR HILL
Oil on canvas, 22x26 in.
Lower right: *E L Henry 1908*
Collection: Martin E. Albert
Figure 79
A photograph in the Henry Collection is inscribed on the back: *Bear's
Hill on the Shawangunk Mountains. The old Ellenville and Newburg Stage
crossing the Mountains on the way to Newburg through Orange Co.
Where steamboat was taken for New York City or Albany passengers.
Painted for Martin Albert.*
The painting is a sunset subject which combines details of reality and
imagination. The present owner, for whom the artist painted the picture,
wanted a bridge, cattle, a farmhouse, a stage coach with four horses and the
setting sun. So Henry obligingly altered his angle of view. Tired from
the pull up from Walker valley, with a full coach, the horses are in a slow
walk. The formation of the cliff which gives the pictures its name is true
to nature. (Cf. Figure 80) Bear Hill is on the top of Cragsmoor and
gets its name from the wild life which once abounded on this high ridge.

348 STENTON
Oil on canvas, 14½ x23 in.
Lower right: *E L Henry, 1908*
Exhibitions: NAD 1909, NO. 189, as *An Afternoon Reception at "Sten-
ton," the Seat of James Logan, Philadelphia: Time, about 1760*
Collections: James Ben Ali Haggin sr; Louis Terah Haggin; Eila Haggin
McKee; Haggin Memorial Art Galleries, Stockton, Calif., NO. 66

349 THE GOSSIPS
Water color, 6⅞ x8¾ in.
Lower left: *To cousin Edith with best wishes of E. L. Henry, 1908*
Exhibitions: Century Association, 1942, NO. 13
Collection: Estate of Francis P. Garvan; now in private collection
Figure 181

1908

350 TERWILLIGER TAVERN
Lower right: *E L Henry 1908*
Inscribed on the back of the photograph in the Henry Collection is:
After a black and white by E L Henry. Taken early July 1908.

351 [A SERIOUS TALK]
Lower left: *E L Henry 1908*
The two photographs in the Henry Collection show a buckboard with two horses. The scene is somewhat different than usual, a road leading up from a bay. There is no evidence to identify it as Rhode Island coast or Long Island. The elderly man driving looks like a reformed Peter Brown and seems to be sitting on the buffalo robe which figures as a property in Figures 137 and 139.

352 "HOME AGAIN"
Exhibitions: NAD 1908, NO. 17

353 [ALONE]
A photograph in the Henry Collection is mounted on a sheet of paper in which corners have been cut. It is inscribed: *Old Gray standing alone in the pasture.* A horse stands by a rail fence and looks lonesomely at the horses in the pasture beyond.

1909

354 [MISS INNESS AND FRIEND]
Lower left: *E L Henry 1909*
A photograph in the Henry Collection is inscribed on the back: *Miss Inness and friend calling on us, Cragsmoor, N. Y.*

355 UNEXPECTED VISITORS
Exhibitions: NAD 1909, NO. 5

1910

356 A STOP AT THE CARPENTER'S
Exhibitions: NAD 1910, NO. 236
Cf. NOS. 200 and 234

357 WHAT LUCK
Lower left: *E L Henry 1910*
Exhibitions: NAD 1911, NO. 221
Figure 261

358 THE ROAD BY THE RIVER
Exhibitions: NAD 1910, NO 17

1911

359 TAKING LIFE EASY
Oil on canvas, 14x22 in.
Lower left: *E L Henry 1911*
Exhibitions: NAD 1912, NO. 100; Century Association, 1942, NO. 59, as *Wayside Greeting*
Collection: James Graham and Sons
Figure 52
Cf. Figure 53

360 [DOING HER CHORES]
Lower left: *E L Henry 1911*
A photograph in the Henry Collection is inscribed on the back: *Sent to Gill exhbtn, Springfield, Mass., & sold there $100—Jany 1917.* The annual Gill catalogs do not list any title which fits the picture. It shows a pasture with a log cabin in the background. A farm girl in sunbonnet and apron is walking down the path toward a pool, from which she apparently is about to dip up water in the pails she carries in each hand. A dog follows her, and horses graze at the left.

361 A MORNING IN JUNE
Exhibitions: NAD 1911, NO. 46

1912

362 A CANAL BOAT ENTERING A LOCK
Water color
Lower left: *E L Henry 1912*
Bibliography: Scribner's, August 1920, p. 253.

363 HAVE YOU HEARD THE NEWS?
Exhibitions: NAD 1912, NO. 99

364 THE TRAMP
Lower left: *E L Henry 1912*
A photograph in the Henry Collection is inscribed on the back: *Photo copy of painting sold at National Academy of Design Dec. 1912, called "The Tramp," by E. L. Henry.*

1913

365 THE BILL COLLECTOR
Oil on canvas, 14x21 in.
Lower left: *E L Henry 1913*
Collection: Dr and Mrs H. M. Sassaman
Figure 203
The painting shows a scene in front of a familiar barn on the "Mountain." (*Cf.* Figures 144 and 145) A Cragsmoor farmer leans against a spring wagon, mopping his forehead, while the bill collector (clad in a frock coat) shakes his finger at the farmer. The farmer's wife watches proceedings through the open barn door, and a horse stretches his head out of the barn window.

1913

366 NEWS OF THE WAR OF 1812
Oil on canvas, 26x42 in.
Lower left: *E L Henry 1913*
Collection: Martin E. Albert
Figure 250

 In the distance may be seen Sam's Point, a mile as the crow flies from Cragsmoor, Henry's summer home. An old stone house stands on the country road leading from Kingston. Two women sit in a buckboard, with the driver in the costume of the period. A man in uniform, ready to join his regiment, stands by the side of the road with his bride and her parents. The Negro cook is coming from the servants' quarters to learn the news: that war has been declared on Great Britain. A photograph in the Henry Collection, an enlargement of the center part of the painting, is inscribed on the back: *The Vehicle. From a sketch made in Albany at the Bicentennial. One of the earliest vehicles in America, the body hung on a frame by leather straps. It dated back to just before the middle of the eighteenth century, about 1743 to 5.*
Cf. NO. 1157

367 THE VILLAGE HUCKSTER
Lower left: *E L Henry 1913*
Figure 191

368 [GETTING OUT THE VOTE]
Lower left: *E L Henry 1913*
Figure 251
Cf. Figure 252

1914

369 THE UPLANDS AT BOW
Oil on canvas, 20x33½ in.
Lower left: *E L Henry 1914*
Collection: The First Church of Christ, Scientist, in Boston, Massachusetts
Figure 210

 A photograph in the Henry Collection is inscribed on the back: *The Birthplace of Mrs Eddy, Christian Scientist, at "Bow," N. H. Painted for Woodbury Hunt, Concord, N. H.* The New York State Museum has received from the First Church of Christ, Scientist, in Boston, Mass., a copy of the brochure for which this picture was painted. It is: *The Birthplace of Mary Baker Eddy. Bow. New Hampshire, copyrighted 1914 by the Woodbury E. Hunt Company, Concord, New Hampshire.* The title page reads: *Concerning a Painting by Edward L. Henry, entitled The Uplands at Bow portraying the Birthplace of Mary Baker Eddy.* A loose sheet is inserted in the brochure, with prices for reproductions of the painting, as follows:

Popular Edition, Size 12x20 inches

Style A. Platinum prints, gray tones	**$5.00**
Style B. Platinum prints, sepia tones	**5.00**
Style C. Platinum prints, hand colored	**10.00**

Limited Edition, Size 16½ x27½ inches
Style D. Hand colored platinum prints only. Price for the first 200 copies $30.00 each

1914

Regarding the painting, the brochure reads in part:

In recent years, much has been done to preserve and restore the birthplaces of illustrious persons and what could be more fitting and proper, than that a study should be made of this homestead, the birthplace of Mary Baker Eddy, the beloved leader and founder of Christian Science and the best known and most illustrious woman that America has ever known. Many months ago it occurred to the writer, [name not given. E.McC.] an old neighbor of Mrs Eddy, that it would be of great interest and importance, to produce a better picture of this historic birthplace, than had hitherto been issued. . . . To produce an ideal picture, required a vast amount of study and research, also an artist, qualified by experience, to paint it. Mr Edward L. Henry, the eminent New York artist, was selected as the best and only man in the United States for such a composition. Mr Henry has spent a lifetime in painting pictures of this nature and he was a happy selection, as demonstrated by the completed picture. The commission was given him in January, 1914, and the painting was completed in September.

The greatest credit should be given Mr Henry for his painstaking and conscientious work. Acknowledgment is also made to Mr John Brown Baker, Mrs Eddy's second cousin, and to his son, Mr Rufus Baker, for their uniform courtesies and great helpfulness. . . . It was possible to secure detailed information concerning the house shed and the feeding shed and with a part of the old foundation of the barn still in sight, Mr Henry was enabled to execute his conception of the original.

The painting is an oil 20x33¼ inches in size. It is rich in color and delightful in atmosphere. The small cut shown herewith can give but a faint conception of the beauty of the original. The details of the picture Mr Henry has executed in the most charming and idealistic way conceivable and in harmony with the times. The grass-grown road; the old stone walls; the apple orchard in full bloom; the lilac bushes (in Mrs Eddy's favorite color); the flowering almonds; the well-sweep and old oaken bucket; the old carriage in the shed and wagon in the farmyard; the dog in the doorway; the little blue pitcher in a window; the cat, emerging from the house by the way of the "cat-hole" (a common thing in those days); the two-seated vehicle in the front yard, with occupants dressed appropriately for the period; the milk pans by the south door; the farm fowls about the place; the cow in the barn, all lend an indescribable charm. The general atmosphere of the picture is distinctly that of the period about 1831–32, when Mary Baker was about 10 or 11 years old. Mr Henry has put in the foreground the figure of a little girl, which might well have been Mary Baker, watching with interest the people who have just arrived at the front of the house.

In producing the picture the chief aim was historical accuracy and it is believed a valuable service has been rendered to American history. The eminence of the artist guarantees a valuable and artistic painting; as there could be but one Mary Baker Eddy, so there could never be another E. L. Henry. The original painting is priceless and not at present for sale, but it is hoped that, some day, it will find its home in some important place, where it may be viewed by coming generations. For the present, the painting

1914

has been reproduced for circulation in two sizes, particulars of which may be had on application to the publisher.

On the Baker farm, not far from the house, there has been standing for 150 years or more, an apple tree, blossoming and bearing fruit during all the years of Mrs Eddy's life. It was, indeed, fortunate that this tree could be secured and from the wood thereof a quaint and beautiful frame has been constructed, as a most appropriate setting for this original painting by Edward L. Henry, of Mary Baker's birthplace.

The brochure ends with a page of biographical data, called *Concerning the Artist,* and with a photograph of Henry at work in his Cragsmoor studio on the painting, *The Uplands at Bow.* The biographical sketch reads as follows:

Mr Edward Lamson Henry is a member of the National Academy of Design and the American Water Color Society. He is a painter of genre and historical subjects, having always shown a decided preference for pictures of American country life and for country vehicles and other means of transportation and for pictures of American history. He was born in Charleston, South Carolina, in 1841, came north before the war, studied art in Philadelphia and afterwards in Europe, with Suisse. He occupies a unique place in American art and is one of the best known and most highly respected of American artists. He has a winter studio in New York City, but his summers are spent at his charming home at Cragsmoor, New York, among the Catskills, where, amid the grandeur of the scenery and the superb views, he does much of his painting. He has a rare and unusual personality and those of his friends who have been entertained in his Cragsmoor home, presided over by Mrs Henry, a lady of equal charm and a most delightful hostess, are fortunate indeed. He was on the James River in the latter part of the Civil War, where he made many studies. One of his Southern sketches was "Old Westover," one of the most celebrated colonial houses in America, then the headquarters of Fitz John Porter. "The Headquarters of General Grant at City Point," now in the Union League Club, New York, was his first important work and his large picture, "The First Railway in New York State, 1831," from Albany to Schenectady, is another of his noted compositions. His latest important work is "The Uplands at Bow," portraying the birthplace of Mary Baker Eddy.

370 **THE HUCKSTER**
Oil on canvas, 13½ x 23¼ in.
Lower right: *E L Henry 1914*
Exhibitions: NAD 1914, NO. 319, as *The Huckster's Wagon;* Century
 Association, 1942, NO. 16
Collection: I. Snyderman
Figure 193
Cf. Figure 196

A photograph in the Henry Collection is inscribed on the back: *On Mountain at Cragsmoor, N. Y.*

The peddler was probably John Howe. The summer house is gone now. (McCausland '41, p. 164, 224.)

1914

371 CONTRASTS

Oil on canvas, 15½ x25 in.

Lower left: *E L Henry 1914*

Exhibitions: NAD 1915, NO. 18

Collection: Alida Wells Stetson, Edward C. Wells, Margaret L. Wells and William C. Wells; Albert Dureen

Figure 178

Cf. Figure 177; also Sketchbook 25: CAT. 1209 and Sketchbook 27: CAT. 1211

372 THE FOUR SEASONS

Four small oils originally framed in one large gold frame, each small panel being framed in a narrow molding and sunk into gilt matboard. (*Cf.* McCausland, '41, p. 119, on inventory of Henry estate.)

Exhibitions: Gill, 1917, $500

Collection: Alida Wells Stetson, Edward C. Wells, Margaret L. Wells and William C. Wells; Albert Dureen

Pasted on the back is a slip: *The Four Seasons. Painted from Nature. In the Shawangunk Mountains, New York. Each in its season at the same place. E. L. Henry.*

1 Spring

Oil on board, 5¾ x9⅜ in.

Lower right: *E L Henry*
1914

Figure 204

2 Summer

Oil on board, 5¾ x9⅜ in.

Lower right: *E L Henry 1914*

Figure 206

3 Autumn

Oil on board, 5¾ x9⅜ in.

Lower right: *E L Henry*
1914

Figure 205

4 Winter

Oil on board, 5¾ x9⅜ in.

Lower right: *E L Henry*
1914

Figure 207

373 ELECTION DAY

Lower left: *E L Henry*

Exhibitions: NAD 1914, NO. 12

Figure 252

Cf. Figure 251; also the photograph pasted on manuscript p. 48, MS. A photograph in the Henry Collection is inscribed on the back: *Nov. 5, 1844, between Henry Clay and James K. Polk*

Cf. MS. p. 336f.

1916

374 MAIN STREET IN JOHNSTOWN, N. Y., IN 1862
Oil on canvas, 20x30 in.
Lower left: *E L Henry 1916*
Johnstown in 1862
Collection: Mrs. Charles B. Knox
Figure 211

The painting shows the main street of Johnstown in the days when the railroad stopped at Fonda. John Dunn's coach completed the trip to Johnstown. On the route between Buffalo and Albany, along which cattle were driven, Johnstown had a famous inn, the Cayadutta House. Another item of local interest was the annual arrival from New York City of the Livingston coach. This family had a summer home in Johnstown, and the whole community turned out to see their coach drive up. Elizabeth Cady Stanton's home stood on the corner where the People's Bank stands now, beside the inn. The Livingston coach, incidentally, is the smaller of the two seen in the painting.
Cf. Figure 212

375 OLD PETER BROWN OF CRAGSMOOR, N. Y.: TAKING, AS HE
CALLED IT "AN EYE-OPENER"
Oil on board, 6x4 in.
Lower left: *E L Henry*
Collection: Mrs Charles B. Knox
Inscribed: *To Mrs Chas. B. Knox. From her friend, E. L. Henry, July 1916*
Cf. NOS. 168, 177 and 187

376 OUT IN THE STORM
Lower right: *E L Henry 1916*
Bibliography: NAD 1917 catalog, illustrated
Exhibitions: NAD 1917, NO. 146
Figure 199
Cf. Figure 198

376-a "FORGOTTEN"
Pencil on paper, 2⅜ x3⅝ in.
Lower left: *A sketch in the rain, E L H 1894, "Forgotten"*
Collection: New York State Museum
Figure 198
(This drawing is pasted on manuscript p. 23, MS.)
Cf. Figure 199

377 ON THE PORCH
Exhibitions: NAD 1916, NO. 155
This may be the picture, a photograph of which in the Henry Collection is inscribed on the back: *My Back Porch, Cragsmoor, N. Y. Maid Shelling Peas.* It signed, lower left: *E L Henry 1915*

378 A VILLAGE STREET
Lower left: *E L Henry 1916*
Figure 200

1917

379 THE OLD CLOCK ON THE STAIRS

Oil on canvas, 20x16 in.

Lower right: *E L Henry 1917*

Collections: Emil B. Meyrowitz; Ernest du Pont Meyrowitz

Figure 214

A letter from Henry to the elder Mr. Meyrowitz, dated July 12, 1917, reads:

I send you by Adams Express today the picture you purchased while calling here some days ago. I hope you will like it. I found after looking it over carefully that I could improve it greatly by painting it over, so I painted it in oil, getting a much stronger, better effect than was possible in water color, particularly as I had not the white water color paper to work on. It was a sort of "labor of love" as they say, for I was over three days on it; but as I felt you have given me the honor of such a long ride up here to see me and my place that I could return the courtesy by giving you a fairly good example of my work in return.

With the picture Henry sent the following statement:

The original of this painting was made from nature in an old Philadelphia house built in the latter part of eighteenth century on Spruce Street. It was the residence of the noted antiquary, William Kulp, and was exactly as it appeared then. His old aunt, sitting in her back private room, reading the morning paper, her cat on a stool close to her.

It struck me at the time as so picturesque that I painted the work from life and it was afterwards sold to a Mr Robert Gordon of London, where the painting is now. The title was the "Old Clock on the Stairs."

<div align="right">E. L. Henry, N.A.</div>

Cf. NO. 70; also MS. p. 320

380 THE FLOATING BRIDGE

Oil on canvas, 22¾ x 39¾ in.

Lower left: *E L Henry 1917*

Bibliography: KL. NO. 24

Exhibitions: NAD 1901, NO. 185, as *The Floating Bridge Across the Schuykill, and the "Stage Waggon" of the Latter Part of the 18th Century*

Collection: Mr and Mrs Arthur V. Hoornbeek

Figure 213

Cf. Sketchbook 24: CAT. 1208 and NO. 301.

From Knoedler's library came the following document: *"THE FLOATING BRIDGE ACROSS THE SCHUYLKILL RIVER AT GRAY'S FERRY, PHILADELPHIA, AND THE 'STAGE WAGON' OF 1795." These Stage Wagons ran from Paulus Hook (Jersey City) via Trenton and Burlington to Philadelphia. From there, via Chester, Wilmington, to Baltimore. There were no side doors, the only way of entering being by the front steps and climbing over the seats, which had no backs. The stage was copied from a scale drawing in a work issued at the time—"Mellish's Travels in the U. S., 1795 to 1800." The "Floating Bridge" was, from a description of it, in a work issued a few years ago called, "Twinings Diary" of a trip to America in 1795. I was also aided in some of the details by a*

1917

very old Quaker gentleman of Philadelphia, a Mr William Kite, who rode over the bridge as late as 1816 (when a boy) in a heavy wagon, and his father driving the horses. His account of how the heavy vehicle settled the bridge down so that the water ran in over the bottom of the wheels, and gave me many details which I would have been ignorant of otherwise. This painting was commenced about 1898, and taken up and completed in 1908, and last year it was taken off the old stretcher, was "relined" and entirely repainted, and is as nearly an accurate representation of the hard primitive traveling of those days as it is possible to represent at this present day.

The "Draw" in this bridge can be seen just beyond the leading horses, and was opened and allowed to float down stream, enabling a vessel to pass through, and was then hauled back and fastened, as shown in the painting. The whole bridge was held in place by chains and anchored in the river.

<div align="right">

E. Henry, N.A.

</div>

A photograph given the New York State Museum by Knoedler's was apparently taken before the painting "was entirely repainted," for it does not show the Georgian mansion in the upper right background on the rise beyond the river. It is the one reproduced in this report.

The Hoornbeeks have a note from Henry, framed with a 4-column cut from the New York Sunday Sun, Sept. 30, 1917, under the heading "In the World of Art." The note (Field Journal p. 32–41) reads as follows:

"The Floating Bridge Across the Schuylkill, Philadelphia, and the 'Stage Wagon' of 1795"

This bridge was made of logs and planked over and floated on the river, being anchored to prevent it from moving with the current. Generally, it sank a little when a heavy weight passed over it, causing the water to run over the bridge and the rims of the wheels. If vessels wished to pass up or down, the bridge was unfastened at one end, and allowed to drift downstream with the current and afterwards hauled back and secured at the shore end. This picture of the stage was made from a drawing in a book of the time, "Mellish's Travels in North America" and shows what a heavy cumbersome affair it was. It had four cross seats with no backs except the rear one and no way of entering it except by a step over the front wheels, and then climbing over the front seats. The "stage wagon" was drawn by four horses, and often carried the mail. And whatever luggage the passengers carried was generally in small parcels and placed under the seats. It was hard riding, roads very rough, and traveling in those days, unless by private conveyance, very wearisome. This route south "by land" was from New York across the "Jerseys" by stage to Philadelphia, then by this route from Philadelphia to Baltimore via Chester and Wilmington, Delaware, and was the only route south, except by sea in "sailing packets." An excellent account of the above can be found in "Twining's Diary in America, 1795 to 1800," published a few years ago in New York.

<div align="right">

E. L. Henry

</div>

The photographs in the Henry Collection, including one pasted on the back of manuscript p. 30, MS., all show the picture in its first state, as it was reproduced in Klackner.

1917

381 **ST MARK'S IN THE BOWERY IN THE EARLY FORTIES**
Oil on canvas, 20x30 in.
Lower left: *E L Henry 1917*
Lower right: *St Mark's in the Early Forties*
Bibliography: Scribner's, August, 1920, p. 252, as *Old St Mark's-in-the-Bouwerie*
Exhibitions: NAD 1918, NO. 34; NAD Centennial Exhibition, 1925, NO. 100, illustrated NO. 26
Collection: Martin E. Albert
Figure 215
Cf. Loose Notes, CAT. 1213

This is a typical Henry subject. Coaches and gigs are waiting outside the church for the wedding party. There are pigs in the unpaved street, just as James Fenimore Cooper had written a little earlier of New York. Gas lamps, a dog team pulling a ragpicker's cart, signposts reading *Boston Road* and *Bowery Lane*, all set the stage for a century ago. Today the old church is covered with stucco, to remove which a campaign is being initiated.

Pasted on the back of manuscript p. 63, MS., there is a photograph of the painting, also a clipping from the Ellenville Journal of February 14, 1918. The item is in quotation marks in the clipping. It reads:
"*E. L. Henry, of the Chelsea, 222 W. 23d St., New York, is now at work on one of his interesting canvases of old New York, a picture of old St Mark's in the Bouwerie as it appeared in 1842. A wedding is taking place at the church, and in front are coaches and gigs of the period. A coach on the way to New Haven is in the foreground. Mr Henry is an authority on the costumes and life of the early days in this country. He owns many old vehicles and has made interesting sketches and careful studies of them. For many years the Henry home was directly across the street from old St Mark's, so that Mr Henry knows his neighborhood and subject well. He has at his studio numerous sketches of the vicinity and of other parts of old New York. He is preparing this picture for the coming Spring Academy exhibition.*"

A large photograph in the Henry Collection (13¼ x15¼) is inscribed on the back of the mount: *A. T. Stewart Died April 10th, 1876. April 10, 1818. Died 42 years ago today. Was buried in a vault, St Mark's Churchyard under the willow tree to the right. His body was stolen from there later in the year.* This bit of information is typical of Henry's interest in necrology, evidenced by quantities of clippings of obituaries in the Henry files.

Another photograph in the Henry Collection has two slips of paper pasted on the back of its mount, one reading: *To. Mr Rawson W. Haddon, Complts of E L Henry, March 16th, 1918,* and the other reading: "*Old St Mark's in the Bowery" as it appeared about 1842. Second Ave. was the old "Boston Road." Stuyvesant Street was then called "Bowery Lane." In the distance can be seen the spire of old St Ann's, Formerly "Father Preston's Church." The present St Ann's was finished 1847, 12th St. below 4th Ave., the original St Ann's was taken down some years ago for*

1917

the subway & the large Wanamaker's new building. Pigs were everywhere
in the streets at that time as scavengers, two of which are seen in the gutter
at the extreme left. The New Haven stage (seen at the left) started at
Park Row and via the Boston Road went via Bridgeport to New Haven,
thence via Hartford & Springfield to Boston. The N. Y. & New Haven
R. R. was opened for traffic end of 1848. The old willow tree at the right
marks the vault where A. T. Stewart's body was stolen from, many years
ago.

<div align="right">

E. L. Henry

</div>

An inscription on a third photograph adds another tidbit: *Old St Ann's,*
taken down for the subway & Wanamaker's big building.

None of the photographs in the Henry Collection show the signature
and inscription as they appear on the canvas now.

382 MAIN STREET, JOHNSTOWN
Lower right: *E L Henry 1917*
Figure 212
Cf. Figure 211

383 [A DOG'S LIFE]
Lower right: *E L Henry 1917*
The Henry porch and Henry dog provide setting and actors for this
story-telling picture of teaching a dog tricks.

384 THE PEDDLER
Exhibitions: NAD 1917, NO. 145

385 [THE TRAMP: 2]
Lower left: *E L Henry 1917*

386 THE OLD GRIST MILL AT NAPANOCH
Oil on paper, 7x10 in.
Lower left: *E L Henry*
Collection: Mr and Mrs Arthur V. Hoornbeek
A photograph in the Henry Collection is inscribed: *Old Mill, Napanoch,*
N. Y. Taken from oil study from Nature in 1917, the original painted in
1895. This painting is of the old grist mill in Napanoch, owned by the
Hoornbeek family and now used to make pulp (McCausland '41, p. 4).
The small oil is possibly painted over a photograph. It was given to the
Hoornbeeks by Henry, and a card on the back is inscribed: *The Old Grist*
Mill at Napanoch. Built in 1709. (Date on it.) Early in the Eighteenth
Century During the Reign of Queen Anne. Rebuilt in 1887. From a
Study from Nature by E. L. Henry. 1887. A note has been added by Mrs
Hoornbeek: *Old Stone House Opposite, 1741.*
The John C. Hoornbeek Sons Pulp Mill (which makes "wood flour"
for linoleum, dynamite, plastics) was rebuilt about 15 years ago after a fire.
It is now a corrugated iron building on a steel frame. The old house is
falling down for lack of repairs.

1917

387 WAITING FOR THE STAGE
Lower left: *E L Henry*
Exhibitions: NAD 1918, NO. 216
Figure 216
Cf. Figure 217

1918

388 LEAVING IN THE EARLY MORN IN A NOR'EASTER
Oil on canvas, 12x20½ in.
Lower right: *E L Henry 1918*
Exhibitions: NAD 1919, NO. 209; Century Association, 1942, NO. 25
Collection: Estate of Francis P. Garvan, formerly recorded as *Early Morning Stage*
Figure 161
 Inscribed on the back: *Study for large painting for man in Chicago, 1899; taken up to finish in 1918. Lined by Beers, West 30th Street.*

1919

389 A RIVER LANDING
Exhibitions: NAD 1919, NO. 25

390 [STAGECOACH DAYS]
Lower right: *E L Henry 1919*

391 [FLORIDA LANDSCAPE]
Oil on board, 10x14 in.
Unsigned and unfinished at the artist's death
Collection: Alida Wells Stetson, Edward C. Wells, Margaret L. Wells, and
 William C. Wells; New York State Museum
Figure 218

Oils, Water Colors, Prints, Undated

Frequently the only proof of the existence of the work listed is a photograph in the Henry Collection. It is difficult to date Henry's work by internal evidence because of his practice of painting a second version of a popular subject many years after the first was painted. Stylistic variations are relatively slight, therefore. Ascribed titles are enclosed in brackets [] and listed in alphabetical order.

900 AFTER THE RAIN
Bibliography: KL NO. 2

901 [AT DUSK]
AL. p. 54
 A scene on the "Mountain" at Cragsmoor. The landscape stretches out, not dramatic or spectacular. Cows are going down the road to be milked. An old man sits beside the road, resting, contemplating the evening calm.

902 AT NAPANOCH

Lower left: *E L Henry*

A photograph in the Henry Collection is inscribed on the back: *The Original was sold out of the Nat. Academy Exptn cor. 23d st & 4th Ave many years ago to old Mr Wilson (firm of Earl & Wilson, collar makers, Troy, N. Y.) & is in his attempt at the "Chelsea" West 23d St. Was painted at Napanoch, close to the mills.*

The subject is typical—a country road, a two seated surrey, the driver stopping to talk to the country folk on foot. The reference to the National Academy can not be traced.

903 AT THE FERRY

Bibliography: KL. NO. 3

The photograph in the Henry Collection is in too bad condition to be reproduced, the emulsion peeling away at the edges. It shows a two-seated vehicle covered, with rear wheels larger than front, and three dangling steps. A woman sits in the rear seat, a boy in the front, while a man holds the horses' heads and a second woman has descended to break the monotony of the wait for the ferry, to be seen crossing the river.

904 AT THE OPERA

Water color

This brought $37.50 at the Ortgies Sale, 1887, NO. 54

905 AN AUTUMN MORNING IN VIRGINIA

Bibliography: KL. NO. 4

906 AN AUTUMN STUDY

This brought $35 at the Ortgies Sale, 1887, NO. 58

907 BEFORE THE DAYS OF RAPID TRANSIT

Bibliography: KL. NO. 6; Pageant of America, IV, Figure 167; U. P. Hedrick's History of Agriculture, opp. 252.

In the collections of the Springfield (Mass.) Museum of Fine Arts there is a painting in oils of this subject, 8x19 in. It seems to have been painted over a photograph on a support and is signed lower left: *E L Henry.* It is inscribed on the back: *Original owned by Shepard Knapp.*

908 [A BUGGY RIDE]

Lower right: *E L Henry*

The photograph in the Henry Collection shows a courting couple out for a ride in his fashionable stanhope. They have stopped to talk with two women and a man standing on the sidewalk. The man in the buggy wears a derby and sits with his hand on his thigh; the woman holds a parasol. The man on the sidewalk has one foot up on the buggy's wheel. The couple in the buggy faces out of the picture.

909 [BUYING A FOWL]

The photograph in the Henry Collection shows a buxom housewife in cap and apron dickering with a Negro huckster who holds a scale in his hand to weigh the dangling bird. His jaded nag looks around at the pro-

ceedings, while a woman with a child in her arms stands in the gateway looking on. Across the street is the southern colonial facade of a house where a Negro maid is sweeping the sidewalk. Beside it is a house with a Dutch gabled roof. Approaching from down the street may be seen a white horse.

910 [CALLING THE CHICKENS]
A girl in a sunbonnet and full skirt has come down some steps from a yard and is throwing grain to the chickens which answer her call.

911 A COUNTRY LANE
NO. 68 in the Ortgies Sale, 1887, not sold

912 A COUNTRY TEA PARTY
Bibliography: KL. NO. 16

913 CROSSING THE BRIDGE
This brought $42.50 at the Ortgies Sale, 1887, NO. 56.

914 CROSSING THE LINES
Bibliography: KL. NO. 18

915 [DAY DREAMS]
A man is sitting on the steps of his little shack, while a woman waters the flowers with a watering-pot. The subject well might "Be it ever so humble, there's no place like home."
The photograph in the Henry Collection shows the signature, lower left: *E L Henry*

916 THE DOCTOR'S VISIT
Water color
This picture brought $72.50 at the sale of the Frederick Halsey Collection at the Anderson Art Galleries in 1916.

917 [THE ERIE CANAL COMPLETED]
The clue to this painting is a reproduction in an unidentified clipping in the Henry Collection. Pretty certainly, the title is not as above.

918 [A FAMILY AT TABLE]
Lower right: *E L Henry*
The photograph shows two women, a man and a child seated at the table. The baby is leaning from his highchair to feed the family dog.
Cf. NO. 1136

919 [THE FAMILY WASH]
AL. p. 58
A woman is bent over the washtub, while her husband sits (one charitably interprets) tired out by his own proper "man's work."

920 GARDEN IN WARWICK
Exhibitions: Gill, 1919, $225

921 [GATHERING BERRIES]
AL. p. 35
Lower right: *E L Henry*
This seems to be a water color to judge from photographs in the Henry Collection.

922 [GOING HUNTING]
A photograph in the Henry Collection shows two men with shotguns over the shoulders and gamebags at their backs, who have stopped to talk with an old farmer standing beside his ox team and wagon in front of his barn. The usual rail fence and country landscape complete the picture.

923 GOING TO TOWN
Exhibitions: Gill, 1919, $375

924 GOSSIPING
Collection: Mabel Brady Garvan Collection, Yale University Art Gallery
This painting can not be located.

925 GOSSIPS
Bibliography: KL. NO. 28

926 INTERIOR
Oil on wood, 5½ x 7¾ in.
Exhibitions: NAD 1939
Collection: Mabel Brady Garvan Collection, Yale University Art Gallery
This is inscribed on the back: *E L Henry.*
A man and a woman are sitting at a table in an interior of the early republic.

927 INTERIOR OF ST JOHN'S, WARWICK, ENGLAND
Ortgies Sale, 1887, NO. 65; not sold

928 [IN THE GARDEN]
A woman in a sunbonnet, seen through an opening in a vine-covered porch, is picking flowers in the garden. A photograph in the Henry Collection is inscribed on the back: *From Back Door, Mtn., sold 1911 Fall Exhtn.* Could this be *A Morning in June,* NAD 1911, NO. 46?

929 [IN THE VALLEY]
Figure 83
The photograph shows a landscape, somewhat different than Henry's usual style, though the subject matter is familiar. A buckboard is coming down the mountain and driving toward a village, where the characteristic white church steeple is seen. At the right is a gambrel-roofed farmhouse. The quality of design is more formal, more classic, than is usual in Henry's paintings.

930 JACK'S RETURN
Bibliography: KL. NO. 30

931 [JOHNSON HALL]

AL. p. 35

An old woman is sitting on the stoop of a colonial house. A note in Henry's hand reads: *Owned by the Late Mrs Murray of Johnstown, N. Y. Aged 100 years, 1910.* This would seem to refer to Mrs Murray. She sold Sir William Johnson Hall to the Johnstown Historical Society. *Cf.* NO. 310

932 JUDGE DALY

Bibliography: KL. NO. 19

933 LEARNING THE TRADE

This brought $115 at the Ortgies Sale, 1887, NO. 53. Can it be *Sharpening the Saw,* NO. 195?

934 THE LONG GOOD-BYE

This brought $110 at the Ortgies Sale, 1887, NO. 61

935 THE MARAUDERS: SKETCHED FROM A WINDOW IN WARWICK

This brought $125 at the Ortgies Sale, 1887, NO. 48. Apparently this was bought by Dr Lucien Calvin Warner (*Cf.* NO 175); for Mrs Warner's account book has an entry, under March, 1887, of the purchase of a picture of this name for $125. Nothing further is known of it.

936 MARKETING SATURDAY MORNING

Lower left: *E L Henry*

Figure 259

A photograph pasted on the back of manuscript p. 52, MS., is inscribed on the back: *From the painting by E L Henry, N.A., in the possn of Mr and Mrs Lang of Montclair, N. J.* It shows a companion piece of NO. 367, the woman shopper having gotten down from her equipage and begun to look through the comestibles displayed on the sidewalk outside the store.

937 [A MORNING CALL]

Cf. New York State Museum photograph to differentiate from other similar subjects. (Baldwin 667.)

938 MORNING CALL IN 1800

Exhibitions: International Exhibition, Philadelphia, 1876, NO. 130, p. 20, Official Catalogue, U. S. Centennial Commission
Collection: C. S. Smith, 1876–?

939 NEAR THE BRANDYWINE

Etching, $16\frac{1}{2}$ x $26\frac{1}{2}$ in.
Bibliography: KL. NO. 35
Collection: New York State Museum
Figure 243

940 [NEIGHBORS' MEETING]

A buggy has drawn up beside a single-seated buckboard, the two vehicles facing in opposite directions. Two women are in the buckboard, a man and a woman in the buggy. This scene is a familiar theme of Henry.

941 OFF THE MAIN ROAD

Lower left: *E L Henry*
Figure 254

A photograph in the Henry Collection is given this title by an inscription on the back. It shows the back of a farmhouse with two-storied back porch. The daughter of the family is scrubbing away at a tub and washboard, the mother talks to a man who is drawing up a bucket of water from a well, and the man's wife sits dourly in a buggy holding the reins.

942 OLD ENEMIES

This brought $200 at the Ortgies Sale, 1887, NO. 70.

943 OLD GRANDFATHER

Bibliography: Klackner, (earlier edition), illustrated, no number, platinotype 8x6½, $1

944 OLD WARWICK

Bibliography: KL. NO. 43

945 ON GUARD

Water color
Ortgies Sale, 1887, NO. 52; not sold

946 [ON THE CANAL]

Oil on canvas, 14¼ x22¼ in.
No signature or date.
Collection: Albert Duveen

This painting, probably unfinished, shows a scene on the Delaware and Hudson canal, with the Shawangunk mountains in the background.

947 ON THE WAY HOME

Water color
This brought $22 at the Ortgies Sale, 1887, NO. 47.

948 A PASSING SHOWER

This brought $185 at the Ortgies Sale, 1887, NO. 69.

949 THE PHAETON

Oil on cardboard, 14½ x20¾ in.
Lower left: *E L Henry*
Exhibitions: Century Association, 1942, NO. 43
Collection: Albany Institute of History and Art

950 THE PLANET (CAMDEN & AMBOY R. R.)

Bibliography: KL. NO. 49

951 PLEASANT MEMORIES

This brought $62.50 at the Ortgies Sale, 1887, NO. 59.

238

952 PRINCE OF THE MOHAWK

Bibliography: KL. NO. 50

Can this be *King of the Montauks,* an oil 12x16 in., dated 1880, lent anonymously to the Century Association exhibition of 1942, NO. 22? The Klackner entry is not illustrated, so the point can not be checked.

953 READY FOR THE POST

Bibliography: KL. NO. 52

954 THE REPAST

This brought $37.50 at the Ortgies Sale, 1887, KO. 73.

955 THE RETURN FROM JOURNEY

Bibliography: KL. NO. 54

956 RETURN FROM THE WARS

Water color and crayon on paper, 15x23½ in.
Lower left: *E L Henry*
Collection: Albert Duveen
Figure 220
Is this *Home from the Philippines?* Cf. NO. 303

957 RETURNING HOME

Bibliography: KL. NO. 55
Cf. [*What That's You Say?*] NO. 328

958 ROADSIDE CHAT

Oil on canvas, 5x7 in.
Lower right: *E L Henry*
Collection: F. Newlin Price

959 SOLITUDE, COAST SCENE

This brought $50 at the Ortgies Sale, 1887, NO. 71.

960 STUDY FROM DOOR AT FULHAM, LONDON

This brought $50 at the Ortgies Sale, 1887, NO. 72.

961 THE SURPRISE

This brought $42.50 at the Ortgies Sale, 1887, NO. 51.

962 THRASHING MACHINE

This brought $35 at the Ortgies Sale, 1887, NO. 49.

963 [TOLL GATE]

The painting shown in the photograph in the Henry Collection is related to NO. 242, in so far as the general subject matter is the same, the buckboard, the Evanses, the old woman coming out of the tollhouse to collect the toll etc. This picture differs, however, to the extent that the Evanses have with them in the buckboard a child in a very fancy cap and holding tenaciously to a basket.

964 UNION LEAGUE CLUB, 26th STREET AND MADISON AVENUE,
 IN THE OLD GEROME MANSION

Oil on canvas, backed with wood,
Lower right: *E L Henry*
Collection: Union League Club, presented by William E. Benjamin, 1925

965 VACATION DAYS

Bibliography: KL. NO. 69

966 VILLAGE GOSSIPS

Bibliography: KL. NO. 70, not illustrated
 Is this NO. 263 or NO. 343?

967 A VILLAGE STREET

Oil on canvas, 12x10 in.
Lower right: *E L Henry*
Collections: James Ben Ali Haggin sr; Louis Terah Haggin; Eila Haggin
 McKee; Haggin Memorial Art Galleries, Stockton, Calif., NO. 67

968 WAITING FOR THE FERRY

Bibliography: KL. NO. 76

969 WAITING FOR THE STAGE

Bibliography: KL. NO. 77, not illustrated

970 WAITING UP FOR HIM

This brought $135 at the Ortgies Sale, 1887, NO. 63.

971 THE WATERING TROUGH

Oil on canvas, 12x16 in.
Lower right: *E L Henry, 1900*
Exhibitions: American Genre, Whitney Museum of American Art, 1935;
 Century Association, 1942, NO. 34, as *The Old Caleche*
Collection: Salmagundi Club

972 THE WATERING TROUGH

This brought $45 at the Ortgies Sale, 1887, NO. 57.

973 WAYSIDE GOSSIP

Bibliography: KL. NO. 78, not illustrated

974 A WAYSIDE WELL

Bibliography: KL. NO. 79

975 WEARY WAITING

Water color, 11x18 in.
Unsigned
Collections: James Ben Ali Haggin sr; Louis Terah Haggin; Eila Haggin
 McKee; Haggin Memorial Art Galleries, Stockton, Calif., NO. 181

976 A WEDDING IN THE EARLY FORTIES

The only direct evidence of the existence of this painting is a photograph seen at the home of R. T. Cookingham, 163 South Main street, Ellenville, inscribed as above and: (*Painted from a study of the old Vernooy House at Napanoch, N. Y.*). The photograph shows bride and groom departing from a house of southern colonial type, the old "Vernooy Place." Negro servants are speeding the newly wed couple, a man servant putting luggage on the back of a coupe with the top down, while a Negro driver sits on the box ready to crack his whip and drive off in style.

There is considerable myth about the picture, however. A cousin of Mrs Henry, a Wells from "out West," made a lot of money (rumor is vague as to how) and came back east. He saw Henry's painting of the "Vernooy Place" and bought it, then liked the house so well he bought it also. On his death, his widow married again, according to legend her sons' tutor, and seems to have vanished from the scene. Perhaps the picture went with her?

(Was this Wells, N. W. Wells, who wrote Henry January 23, 1894, on the letterhead of Wells & Nieman, Millers and Grain Merchants, Platte Valley Roller Mills, Schuyler, Neb.? He had seen the large railroad picture in the Transportation Building at the 1893 Chicago World's Fair and wrote to express admiration, adding: *Give my love to my dear Cousin and tell her I often think of her.*)

The "Vernooy Place" was built in the 30's of the last century by the Southwick family. Later the Vernooys lived there. After Mr Wells' death, the place was purchased by Raymond G. Cox, an Ellenville lawyer, who was the executor of the estates of Mr and Mrs Henry. Today it houses a hospital for mental diseases and is sadly grown up with trees and shrubbery.

The Henrys stayed at Napanoch, three miles from Ellenville, at various times. Sometimes they boarded with Miss Grace Denman, who lived on the hill up behind the Vernooy house. Mrs Richard Hayden of Ellenville has two Henry platinotypes, *The Old Toll Gate* and *The First Railway Train*, which Miss Denman had given to Mrs Hayden's mother.

Miss M. J. DuBois, now of Kingston, whose father was president of the bank in Ellenville, and who lived with her family in Napanoch at that time, relates that Henry used to come to their house a great deal when he came to sketch in Napanoch. She adds that Mr Wells paid $300 for a painting he bought from Henry.

For the above data *Cf.* McCausland, '41, p. 40, 50–1, 67, 97–8, 123–24, 245–46.

Napanoch: A Wedding in the Thirties (a water color which sold for $65 at the sale of the Frederick Halsey Collection at the Anderson Art Galleries in 1916) may be the same work.

There are four photographs of the "Vernooy Place" in the Henry Collection, showing different views. An inscription on the back of one notes: "*Southwick," Napanoch, built 1830. Bought by Mr Wells of Omaha in 1904. He died in 1910 & it is now owned by Mr Seamen of Yama Nouchi Farm, Napanoch. E. L. Henry 1917.*

977 [WOODLAND COURTSHIP]

Lower right: *E L Henry*

A photograph in the Henry Collection shows this scene—a young woman has been interrupted at reading a letter, perhaps from a rival of the young man who comes around a tree to intrude on her shady nook.

Sketches in Oil and Water Color on Wood, Canvas and Paper in the Henry Collection

1001 AFTER DAVID [*circa* 1875]
Oil over paper pasted on wood, 9x12 in.
Figure 51

1002 APPLE TREES
Oil on cardboard, 15x20 in.

1003 APPLE TREES IN BLOOM
Oil on wood, 8½ x10⅝ in.

1004 THE ARBOR
Oil on paper, 8x10¾ in.

1005 ASLEEP
Oil on canvas, 7¾ x10¾ in.

1006 THE BACK FENCE
Oil on paper, 10x14 in.

1007 BACK YARD AT CRAGSMOOR
Oil on paper, 10x14 in.

1008 BANQUET HALL, BANBURY
Oil on canvas, 14⅝ x19½ in.

1009 BANQUET HALL, BANBURY: ENTRANCE DOOR FROM ALLEY WAY
Oil on canvas, 13¾ x10¾ in.

1010 BEACH WAGON
Oil on paper, 7⅜ x9⅝ in.
Figure 45
This may be related to the Easthampton scenes. *Cf.* Figures 46–50.

1011 BY THE LAKE
Oil on canvas, 12½ x21 in.

1012 BY THE OCEAN
Oil on paper, 9¾ x13¾ in.

1013 CHOPPING WOOD
Oil on wood, 11x7½ in.
This is obviously a Cragsmoor character; but *who?* A white-haired man, clad in brownish coat and greenish cap, holds an ax in his right and a branch in his left, as he chops wood.

1014 CITY POINT, VA., NOV. 1864
Oil on paper, 7⅜ x14 in.
Lower right as above
Cf. NOS. 45, 49, 96

1015 COLONIAL DOORWAY
Oil on canvas, 16¾ x 11½ in.
Figure 221
Cf. NOS. 110 and 116

1016 CORNER CUPBOARD
Oil on wood, 5 5/16x3⅞ in.

1017 COUNTRY BACK YARD
Oil on canvas, 12x18 in.

1018 A COUNTRY ROAD
Oil on canvas, 7x14 in.

1019 CRAGSMOOR SCENE
Oil on paper, 10x14 in.

1020 DOORWAY
Pen and ink with water color wash on paper, 10x14 in.
Figure 222
Detail for *The Meeting of Gen. Washington and Rochambeau*, NO. 109

1021 EARLY NOVEMBER, ELLENVILLE, N. Y., 1905
Oil on wood, 6½ x10 in.
Lower left: *Nov. 1905*

1022 FLOWER STUDY
Oil on canvas, 8x7 in.

1023 FROM AN OBSERVATION CAR
Oil on paper, 14x10 in.
This shows the shape of a frame, as in *From a Window, Newport*, 1866,
NO. 62

1024 FROM SAM'S POINT
Oil on cardboard, 7⅜ x9⅝ in.

1025 A GARDEN
Oil on wood, 5½ x8 in.

1026 GARDEN AT HENRY'S HOME
Oil on paper, 10x14 in.

1027 GARDEN FENCE
Oil on canvas, 9x14½ in.

1028 GARDEN SCENE
Oil on canvas, 14x11 in.

1029 THE GHOST ROOM, ST. JOHN'S
Oil on paper, 10x14 in.
This sketch is inscribed on the back: *The Ghost room, St John's.*
This sketch painted from Nature, August 1876. A Lady dressing for a
ball in this room in 1626 was burned to death by her dress catching fire.
Her father had the family arms and her initials placed over the door to
commemorate the event. A. S. (Ann Stoughton) 1626.

1030 THE HENRY HOME AT CRAGSMOOR
 Oil on wood, 4½ x5¼ in.
 The sketch shows the garden with a pitchfork stuck in the earth and a
 basket lying beside it. The house is in profile against the sky.
 The date, *June 25, 1892*, is carved on the wood panel.

1031 HOLLYHOCKS
 Oil on canvas, 14½ x9 in.

1032 HORSE
 Oil on paper, 7x10 in.
 Lower left: *E L H*

1033 HORSE
 Oil on paper, 14x10 in.

1034 HORSE
 Oil on cardboard, 9¾ x4¼ in.

1035 HORSE
 Oil on cardboard, 7x3 in.

1036 HORSE FACING LEFT
 Oil on wood, 7x10 in.

1037 HORSE FACING RIGHT
 Oil on wood, 4x7½ in.
 On the back, vertically, are the forelegs of a bay horse.

1038 HORSE IN HARNESS FACING LEFT
 Oil on canvas, 14½ x16 in.

1039 HORSE IN HARNESS FACING LEFT
 Oil on canvas, 13x15 in.

1040 HORSE IN HARNESS FACING LEFT
 Oil on wood, 7x10 in.

1041 HORSE GRAZING
 Oil on wood, 7¼ x4⅛ in.

1042 HORSE LOOKING OVER FENCE
 Oil on board, 8x10¼ in.

1043 HORSE ON TOW PATH
 Oil on wood, 7½ x4⅛ in.
 Collar and tow line are plainly shown.

1044 HORSE'S HEAD
 Oil on canvas, 17x11½ in.

1045 HORSE'S HEAD
 Oil on wood, 8⅛ x4⅞ in

1046 HORSES
 Oil on paper, 10x14 in.

1047 HORSES
Oil on wood, 7x13 in.
On the back, vertically, there is a man on a horse. He wears a blue coat and tall hat.

1048 HORSES
Oil on wood, 7½ x4⅛ in.
On the back, in pencil, there is a horse harnessed to the shaft of a buggy, shown in a head-on view.

1049 HORSES STANDING
Oil on paper, 7½ x3½ in.

1050 HORSES WITH BUGGY
Oil on canvas, 7½ x9 in.

1051 THE LAFAYETTE COACH
Oil on canvas, 15x19 in.
Lower right: *This sketch after nature, made at Chittenango, N. Y., Sept. 1882. E. L. Henry*
Lower left: *The So-called Lafayette Coach. It was built for President Monroe. And Lafayette on his visit in 1824 rode in it with the President through the City of Baltimore and Back to Washington. It was in the early thirties purchased by the Hon. Abraham Yates and inherited by his daughter, Mrs. Brinkerhof. This carriage was afterwards purchased by the U. S. Government and presented to France where it is now.*
Figure 224

1052 MAIN STAIRWAY, ST JOHN'S; WARWICK
Oil on canvas, 18½ x15½ in.
Lower right: *E L H '76*
Lower left: *Warwick, Eng. '76*

1053 MRS. FRANCES L. HENRY
Oil on canvas, 16¼ x13 in.

1054 MOUNTAIN RAINBOW
Oil on paper, 7x10 in.

1055 NEGRO BOYS
Oil on canvas, 11x9 in.

1055-a NEGRO BOY AND GIRL ON OXCART
Oil on wood, 9¾ x14 in.
Lower right: *Aug. 1930, found in the Studio of E. L. Henry, N.A., by Chas. C. Curran, N.A., removed by permission of executor*
Collection: New York State Museum. Presented by Charles C. Curran, 1941
Figure 226

1056 NEGRO GIRL HOLDING CAT
Oil on canvas, 11x6 in.

1057 NEGRO STABLEBOY
Oil on paper, 10x14 in.
Figure 156
Detail for *The Relay*, Figure 157

1058 NEGRO WOMAN AND CHILD
Oil on wood, 7x3½ in.
The woman is shown as a full length figure facing right. She wears blue with a white apron. High shoes, a hat with red roses, and gold earrings complete her costume. The child wears a pink dress and blue bonnet.

1059 NEGRO WOMAN WITH HANDS ON HIPS
Oil on wood, 11½ x5⅝ in.
The woman, a standing figure, is in white with a red belt. Her hands are on her hips.

1060 NEGRO WOMAN IN WHITE
Oil on cardboard, 7¾ x4¼ in.

1061 OLD CLOCK ON THE STAIRS
Oil on wood, 10½ x8 in.

1062 OLD MAN ASLEEP IN A ROCKING CHAIR
Oil on paper, 5x7 in.
Lower left: *Goshen, Sept. 1872*

1063 OLD MAN AT A TABLE
Oil on paper, 4¼ x4¼ in.
Lower right: *E L H 1872*

1064 OLD WOMAN IN A ROCKING CHAIR
Oil on canvas, 11x10 in.

1065 OLD WOMAN READING
Oil on paper, 10x14 in.
Cf. painting of the same title, NO. 81

1066 OLD WOMAN WRITING
Oil on paper, 9¾ x13¾ in.

1067 ONE OF THE BEDROOMS, ST JOHN'S
Oil on canvas, 14x22 in.
Lower right as above

1068 ON THE BEACH
Oil on wood, 5⅞ x11⅞ in.
Figure 46
Related to Easthampton scenes, Figures 45, 47–50

1069 ON THE "MOUNTAIN"
Oil on paper, 10x14 in.

1070 ORCHARD AND HOUSE
Oil on canvas, 10½ x16 in.

1071 ORCHARD AND HOUSE
Oil on wood, 6x8 in.

1072 OXCART AND OXEN
Oil on paper, 6x8 in.

1073 THE PORCH
Oil on canvas, 10¾ x13½ in.

1074 ROSES AT CRAGSMOOR
Oil on canvas, 10½ x15 in.
Lower left: *June 22 '94*

1075 SAG HARBOR (?)
Oil on canvas, 7x12½ in.

1076 STONINGTON
Oil on paper, 10x14 in.
Figure 244

1077 STOVE
Oil on paper, 12x8 in.

1078 STREET IN NAPLES
Oil on canvas, 4½ x3½ in.
Lower right: *H*
Lower left: *1861*
A sketch for the painting of the same title, NO. 42

1079 STUDY OF A CHURCH, NEW YORK
Oil on card, 11½ x9½ in.

1080 STUDY FOR *ALT KIRCHE*
Oil on paper, 10x14 in.
Figure 246
Cf. NO. 100

1081 SUNFLOWERS
Oil on canvas, 7x12 in.

1082 SUNSET
Oil on paper, 7½ x14 in.

1083 SUNSET
Oil on paper, 8½ x10 in.

1084 SUNSET AT CRAGSMOOR
Oil on wood, 6x8 in.

1085 TAKING A NIGHT CAP
Oil on paper, 10x14 in.
Detail for painting of the same name, NO. 112

1086 TREE IN PASTURE
Oil on paper, 14x10¼ in.

1087 TWO TREES
Oil on wood, 10x6¼ in.

1088 WAITING AT THE FERRY
Oil on wood, 10x6¼ in.
Figure 169
Detail for painting of same name, NO. 287

1089 WAITING FOR THE STAGE
Oil on paper, 11½ x10 in.
Lower left: *Posed by Miss M. E. Powel, Newport, R. I., 1872*
Lower right as above
Figure 217
 This sketch was used for the painting of this title, NO. 387

1090 THE WELL
Oil on paper, 10x14 in.

1091 WHITE FRIARS, COVENTRY
Oil on paper, 11½ x9 in.
Inscribed on the back: *Sketched by E L Henry July 1876*

1092 WILD AZALEA BUSH
Oil on paper, 10x14 in.
Lower right as above

1093 WOMAN AT A TABLE
Oil on paper, 10x8 in.

1094 WOMAN IN A CITY INTERIOR
Oil on wood, 4½ x6⅛ in.
 A woman is sitting, at the left, on a sofa, facing right. In the center of the composition there are four casement windows, framed in curtains looped back.

1095 WOMAN IN A COUNTRY INTERIOR
Oil on wood, 8x11¾ in.
 A woman is standing center rear at a table. Two lanterns hang on the wall above her. At the left, a white door opens out. At the right, through another, a second open door may be seen. At the left under a window, a second table is set. The effect of the interior is rustic, but the furniture is of period style.

1096 WOMAN IN A VICTORIAN INTERIOR
Oil on wood, 6¼ x5⅞ in.
 A woman, facing right, is sitting at the left. Above and behind her is a window with curtains looped back. In the center rear there is a tall mahogany colored commode, with a full length mirror, showing the woman's figure reflected. A corner of a fireplace and overmantel mirror may be seen.

1097 WOMAN IN BLUE
Oil on canvas, 6x4½ in.

1098 WOMAN IN WHITE

Oil on wood, 9x7¼ in.

The sketch shows a full length figure, wearing a blue sunbonnet and with a basket over her right arm, coming down a path. A pink belt is an accent of color. The woman is reading a letter.

Is this Mrs. Henry?

1099 WOMAN IN WHITE WITH A RED SCARF

Oil on canvas, 10x5½ in.

Lower left: *Aug 1877*

This seems to be Mrs Henry

1099-a WOMAN WITH A BASKET

Oil on wood, 9⅝ x7½ in.

Lower right: *Found in the studio of Edw. L. Henry, N.A.; removed by permission of the executor by Charles C. Curran, N.A., Aug. 9, 1930*

Collection: New York State Museum. Presented by Charles C. Curran, 1941

Figure 225

1100 WOODLAND SCENE

Oil on wood, 9¾ x12¾ in.

On the back there are three military dress uniforms pictured in blue and buff.

1101–07 MISCELLANEOUS SKETCHES IN OIL ON CANVAS

1108–33 MISCELLANEOUS SKETCHES IN OIL ON PAPER

Sketches in Pencil and Pen and Ink on Paper in the Henry Collection

1134 AT THE WASHTUB

Pencil on paper, 9⅝ x7 in., mounted on paper 12⅛ x9⅞ in.

Lower left: *E L H*

Lower right: *F L H*

Upper right: *Nov. 18 1873*

1135 BEEKMAN COACH, ABOUT 1772

Pencil and water color on paper, 5x8¾ in.

Lower left: *Beekman Coach, about 1772. Sketched from Nature. Oyster Bay.*

On the back, there are quick sketches (vertical) of a Negro boy in standing poses.

1136 BESSIE AND PETER

Pencil on paper, 9½ x5⅞ in.

Lower right: *Bessie & Peter. 218 E. 10. 1871.*

1137 EASTHAMPTON, L. I.

Pen and ink on paper, 4x6 in.

Lower right: *1830 to 60. Easthampton, L. I., 1879.*

On the back there is a sketch of a man with whiskers sitting in a spring wagon, inscribed *Montauk Express.* This is signed, lower right: *E H 4th Oct. 80*

1138 FAMILY CARRIAGE, 1830 TO 45

Pencil on paper, 6¾ x 8 in.

Lower left: *Sketched at Darby, Pa., 1867*

Lower center as above.

1139 IN ELEVATED TRAIN, 10 P.M., MAY 23, 1910

Pencil on paper, 7x4 in.

Inscribed across bottom as above

1140 KNOXVILLE, TENN.

Pencil on paper, 9⅞ x 13⅝ in.

Lower right as above

On the back are quick sketches of two old men.

1141 NEGRO GIRL

Pencil on paper, 11x8 in.

Cf. [*Taking a Rest,*] NO. 204

1142 "NEWLY MARRIED"

Pen and ink on paper, 11x7¾ in.

Lower right: *E L Henry*

The title, as above, is written on the back.

1143 OLD CONESTOGA WAGON

Pen and ink on paper, 5¼ x 7⅛ in., (evidently the back of an Eastman booklet, as a printed rectangle may be seen with the slogan: *There is no Kodak but the Eastman Kodak.*)

Inscribed across the bottom: *From Phila to Pittsburg. Old Conestoga Wagon.*

On the back are details of the wagon's construction and the inscription: *Very rare specimen*

1144 OLD "ROCKAWAY" 1845 TO 60

Pencil on paper, 4⅜ x 6⅜ in.

Inscribed across top: *Old "Rockaway" 1845 to 60. Sketched at Johnstown, N. Y. Belonged to Wm Livingston.*

On the back in, water color, is a sketch of a cottage.

1145 OLD STAGE SLEIGH

Pencil on paper, ruled off to 4½ x 6¼ in.

Lower left *E L H*

Across the bottom, the sketch is inscribed: *Old Stage Sleigh. The Body Put on Double Runners.*

Lower right: *Quick sketch from Nature, 1871*

1146 ON THE TOW PATH: 1

Pencil on paper, 15x10⅝ in.

Figure 173

Two horses are carefully drawn.

On the back are quick rough horizontal sketches of two horses pulling a barge.

1147 ON THE TOW PATH: 2
Pencil on paper, 10¼ x15 in.
Figure 175
Two horses are feeding from nosebags.
On the back, two horses are pulling a barge with a boy walking beside them.

1148 ON THE TOW PATH: 3
Pencil on paper, 16½ x11½ in.
Figure 174
Two horses are shown with nosebags, feeding.
Figure 196
On the back, is a sketch of a horse and pedler's wagon.

1149 ON THE TOW PATH: 4
Pencil on paper, 8¾ x11½ in.
Figure 176
A man is walking at the left, and two horses are pulling a barge.

1150 OXCART
Pencil on paper, 5x8½ in.

1151 "ROCKAWAY" 1850 TO 60
Pencil on paper, 4x6 in.
Lower left as above
Lower right: *3-seated wagon 1850 to 60*
On the back are details of construction of another type.

1152 RUNABOUT 1835 TO 1845
Pencil on paper, with water color, 7⅛ x8⅞ in.
Lower left: *Light Runabout formerly in possn of Hon. Abram Yates. Sketched from Nature, 1882.*
Lower right as above

1153 STAGE FROM BROOKLYN TO EAST HAMPTON
Pen and ink and pencil on paper, 4 1/16x5⅞ in.
Lower left: *Sketched from Nature 1880.*
Lower right: *This Stage ran from South Ferry, Brooklyn, to East Hampton in the thirties and forties, 19th century*
A newspaper paragraph pasted on the top center reads: *Charles Ketcham, the last of the drivers of the old mail coach line from Fulton Ferry to Montauk Point, died yesterday at his home near Babylon, aged 92.*
On the back, there are quick sketches of two men's heads and a dog, inscribed: *At Judge Daly's, Sept. 21st '80*

1154 STAGE WAGON: END VIEW
Pencil on paper, with water color, 7x5 in.
Lower left: *E L H*
Lower center: *End View, Stage Wagon, 1820 to 1830*
Lower right: *Sketched at Sag Harbor, end of L. I., 1880*
On the back, horizontal, is the stage wagon's side view. It is signed, lower left: *E L H,* and lower right: *Running from Sag Harbor to the Hamptons in connection with the first Steamboat, 1821.*

1155 "STAGE WAGGON" OF 1821
Pencil and water color on bluish-green paper, 5x7 in.
Lower left: *Used to meet the Steamboat*
Lower center as above
Lower right: *Sketched at Sag Harbor, L. I.*
 On the back are sketch of "stage waggon" at wharf and at railroad station with locomotive puffing away.

1156 STUDY FOR "THE FIRST RAILWAY TRAIN"
Pencil on paper, ruled off to 5x2½ in.
Cf. the painting, NO. 257

1157 [VEHICLE] ABOUT 1775
Pencil on paper, 5x8 in.
Inscribed across the bottom: *About 1775. Bicentennial at Albany, 1886*

1158 [VEHICLE] 1830 TO 40
Pen and ink with blue water color, on paper, 7½ x4¾ in.
Inscribed across bottom: *1830 to 40. Sketched, Chittenango, N. Y. 1882*

1159 [VEHICLE] 1830 TO 40
Pen and ink with water color on paper, 7½ x4¾ in.
Lower right: *1830 to 40. Sketched at Chittenango, N. Y., 1882*

1160–84 MISCELLANEOUS SKETCHES IN PENCIL ON PAPER

Henry's Sketchbooks

Numbered chronologically by earliest dates

1185 SKETCHBOOK 1: 1859–61

1186 SKETCHBOOK 2: 1862–90

1187 SKETCHBOOK 3: 1862–64

1188 SKETCHBOOK 4: "War Sketches, Oct. and Nov. 1864"

1189 SKETCHBOOK 5: 1867–1919

1190 SKETCHBOOK 6: 1868–1912

1191 SKETCHBOOK 7: 1869–?

1192 SKETCHBOOK 8: 1871–1902 (?)

1193 SKETCHBOOK 9: (1873–1900s)

1194 SKETCHBOOK 10: 1874

1195 SKETCHBOOK 11: 1874

1196 SKETCHBOOK 12: 1874–80

1197 SKETCHBOOK 13: 1875–79

1198 SKETCHBOOK 14: 1875–76

1199 SKETCHBOOK 15: 1875–76

1200 SKETCHBOOK 16: 1876–79

1201 SKETCHBOOK 17: 1876–79

1202 SKETCHBOOK 18: 1877–80

1203 SKETCHBOOK 19: 1882

1204 SKETCHBOOK 20: 1883–?

1205 SKETCHBOOK 21: 1888–?

1206 SKETCHBOOK 22: 1888–98

1207 SKETCHBOOK 23: (1890–1918)

1208 SKETCHBOOK 24: 1899–1906

1209 SKETCHBOOK 25: 1903–12

1210 SKETCHBOOK 26: 1906

1211 SKETCHBOOK 27: 1908–19

1212 SKETCHBOOK 28 (no dates)

1213 LOOSE NOTES: 1871–1904; 1884–1917

1214 HENRY'S DIARIES FOR 1898 and 1899

Miscellaneous Works by Henry

1215 E. L. HENRY
 Silhouette, mat opening 4¾ x3¼ in.
 Lower right: *E L Henry 1888*
 Collection: Bernard H. Cone
 Figure 29

1216 F. L. HENRY
 Silhouette, mat opening 4¾ x3¼ in.
 Lower right: *F L Henry 1888*
 Collection: Bernard H. Cone
 Figure 30

1217 STATUE OF GENERAL GANSEVOORT
 Bronze, 7 feet 2 inches; with pedestal, about 16 feet in height.
 Designer: E. L. Henry
 Sculptor: E. F. Piatti
 Architect: D. N. B. Sturgis
 Presented to the City of Rome by Catherine Gansevoort Lansing, 1906
 Figure 188
 There is considerable information about the statue which Henry "designed." It was, according to his notation on the photograph in the Henry Collection, *unveiled at Rome, N. Y., Nov. 8, 1906, and erected on the site of Fort Stanwix which he* [Gen. Gansevoort] *so successfully defended against the British general, St Leger, in 1777.*

A letter from Mrs Lansing to Henry, dated October 2, 1906, tells of arrangements for the trip to the dedication:

Your letter of the 30th ult. has been received. How you must have enjoyed your visit with your cousin at the beautiful old home I remember so well in your wedding pictures! I sincerely regret that we were unable to get over to Cragsmoor from Mohonk. If I had been alone, I might have attempted the journey.

I am glad that the bronze tablets have at last been settled upon. I only wish I had been able to express to the architect long ago the reasons for preferring the bronze—as you so well expressed them to me in your letter of two or three weeks ago.

The delay was caused by the non-receipt of the die for the pedestal, which no one seems to be able to account for. Mrs Henry has made a mistake in thinking Nov. 8th falls on Monday. If she looks again in the calendar, she will see that is Thursday.

The plans for the day are this: A special train will leave the Albany Station at 11.15 a.m., reaching Rome at 1.45 p.m. On the train going up a luncheon will be served. The exercises will be at 2 p.m., and at 4 p.m. the special train is to leave Rome for Albany, so as to connect here with the Empire and allow the New York guests, who so desire, to go home that evening, either by boat or train.

I want you and Mrs Henry to come up to Albany the day before, so that Mrs Henry can have a good night's rest and start out feeling fresh. I am hoping that some of your Johnstown friends will be able to go up with us. Mrs Henry can stay here the night of the 8th, and get another good rest, and then, if you choose, you can go on to Johnstown the next day.

I want you and Mrs Henry to come for my pleasure as well as your own benefit. I am hoping that some of our prominent citizens will meet you both on that day, and in this way get a greater interest in you and your work,—especially the Railroad Picture, which I am still hoping the Historical Society will buy.

I will send you twenty-five invitations, as I before suggested, which you can send to your artist friends, enclosing your own card. It will be a compliment to them, even if some of them are not able to attend the exercises. I hope Mr Havemeyer will certainly come. Do write him and express my desire to meet him and have him come.

A full page spread in the Utica Saturday Globe, November 10th, gives a long account of the ceremony, with illustrations, one halftone showing Mrs Lansing (the granddaughter of General Gansevoort,) standing with her arms full of flowers, and Henry also in the group.

Works Related to the Henry Collection

1218 PORTRAIT OF E. L. HENRY, N.A. by J. G. Brown, N.A.
Oil on canvas, 35x30 in.
Unsigned
Bibliography: "Our Heritage," 1942, p. 16, NO. 46
Exhibitions: Our Heritage, National Academy Galleries, 1942, NO. 46
Collection: National Academy of Design; NAD Catalog NO. 90
Figure 1
 The date *1868* is written on the back of the stretcher in blue pencil. The portrait was presented to the Academy by Henry when he became an associate. *Cf.* Figure 3

1219 E. L. HENRY by Sarah E. Cowan
Silhouette, 10x7 in.
Signed: *E. L. Henry 1917*
 by Sarah E. Cowan
Collection: Bernard H. Cone
 Henry is sitting, brush in hand, palette on his knee.

1220 PORTRAIT OF E. L. HENRY, N.A. by Charles C. Curran, N.A.
Oil on canvas, 20x12 in.
Lower right: *Chas. C. Curran, 1909*
Collections: Frances L. Henry; New York State Museum
Figure 32
 A letter from Mr Curran, dated August 8, 1941, reads in part:
 I painted the portrait of Mr Henry in his studio while he was actually at work on one of his pictures, as I wanted to get a characteristic pose. His eyes made me think always of an eagle's. Wide open and birdlike. He was very slim and I think he very often sat at his easel with his legs apparently twisted around each other!
 I gave the portrait to Mrs Henry
 I am glad to know that my little portrait is in the Museum at Albany. . . .
 What would Mr Henry have said if he had known what care would be taken to memorialize him!
 Cf. McCausland, '41, p. 147, for Mr Curran's first acquaintance with Henry

1221 RHODODENDRON by Frances L. Henry
Exhibitions: NAD 1885, NO. 229, $60
 Cf. the painted glass doors in the Henry home at Cragsmoor; also the rhododendron bank beside the Sarine's brook (McCausland, '41, p. 9-b)

1222 IN THE VILLAGE OF BRUNNEN by Worthington Whittredge
Oil on canvas, 12¼ x15 in.
Lower left: *W. Whittredge, 1853*
Collection: New York State Museum
On the back of the canvas: *In the Village of Brunnen, Switzerland. Painted in 1853. W. W.*

Figure 85 *Great Bend, Susquehanna*, 1858: CAT. 1.
Collection, New York State Museum

Figure 86 *Mauch Chunk, Pa.*, 1859: CAT. 5. Collection, New York State Museum

Fiure 87 *On the Susquehanna*, 1860: CAT. 16

[255]

Figure 88 [*Barnyard: 1*], [1859]: CAT. 6. Collection, New York State Museum

Figure 89 [*Bardyard: 2*], [1859]: CAT. 7. Collection, New York State Museum

Figure 90 [*Barn Interior*], [1859]: CAT. 8. Collection, New York State Museum

Figure 91 [*Barnyard*], [1860]: CAT. 11

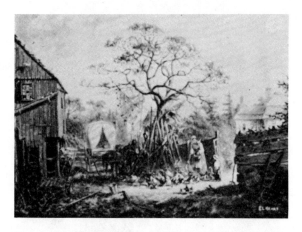

Figure 92 *Barnyard Scene*, 1860: CAT. 12. Collection, Estate of Francis P. Garvan

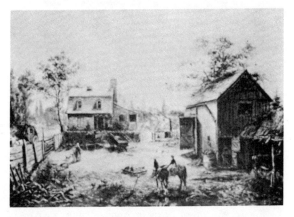

Figure 93 *Farm Scene in Pennsylvania*, 1860: CAT. 13. Collection, Estate of Francis P. Garvan

Figure 94 *Una Via in Napoli*, 1861:
CAT. 18. Collection, New York State
Museum

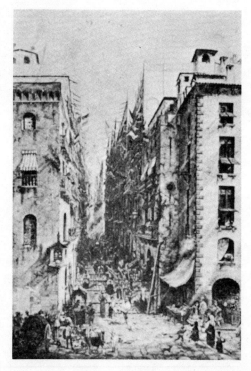

Figure 95 *Street Scene in Naples*, 1864: CAT.
42. Collection, Century Association

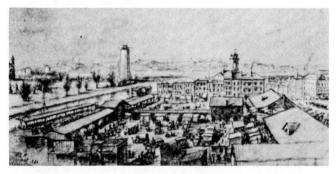

Figure 96 *The Market Place, Washington*, October 1864: CAT. 46. Collection, New York State Museum

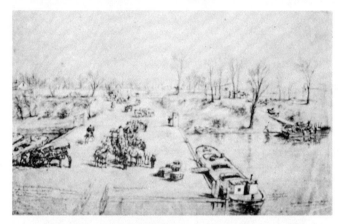

Figure 97 *The Great Horse Depot at Giesboro on the Potomac below Washington*, 1864: CAT. 47. Collection, New York State Museum

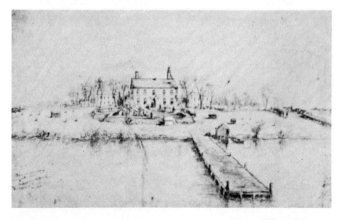

Figure 98 *Near Harrison's Landing, Lower James River*, November 1864: CAT. 48. Collection, New York State Museum

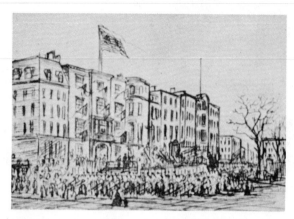

Figure 99 *Presentation of Colors,* [1869 ?]: CAT.
82-*a*. Pen-and-ink. Collection, New York State Museum

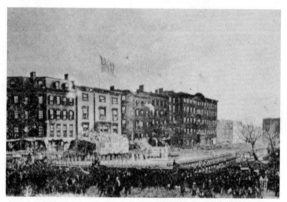

Figure 100 *A Presentation of Colors to the First Colored Regiment of New York by the Ladies of the City in front of the old Union League Club, Union Square, . . . in 1864,* 1869: CAT. 82. Collection, Union League Club

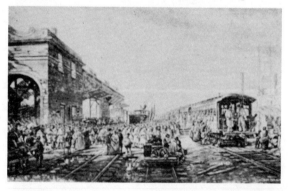

Figure 101 *A New York Regiment Leaving for the Front to Reenforce the Army of Gen. Grant. Scene, New Jersey Railroad Terminal, 1864–5,* 1864–67: CAT. 66.

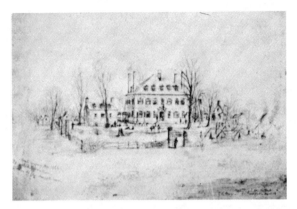

Figure 102 *Westover, James River*, 1864: CAT. 51.
Collection, New York State Museum

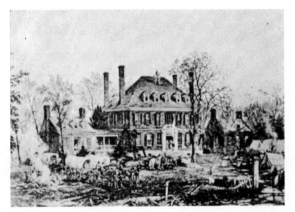

Figure 103 *Westover*, 1865: CAT. 57. Collection,
Century Association

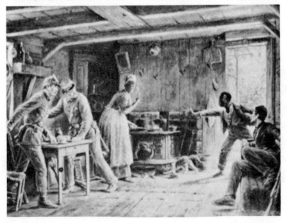

Figure 104 *The Warning*, [1864–67 ?]: CAT. 67-*a*.

[261]

Figure 105 *City Point,* October 1864: CAT. 45. Sketch made from a Union transport. Collection, New York State Museum

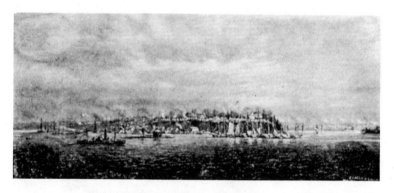

Figure 106 *City Point, Va.,* 1864: CAT. 49. Collection, Harry M. Bland

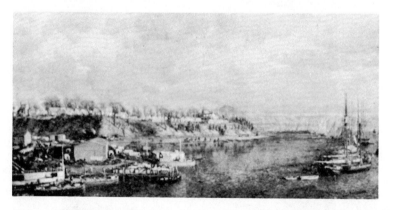

Figure 107 *City Point, Va.,* 1865–72: CAT. 96. Addison Gallery of American Art, Andover, Mass.

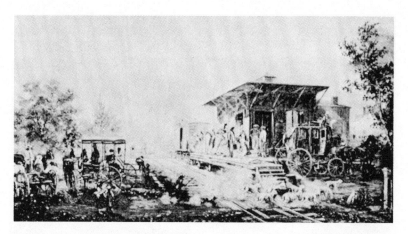

Figure 108 *Station on "Morris and Essex Railroad,"* 1864: CAT. 44

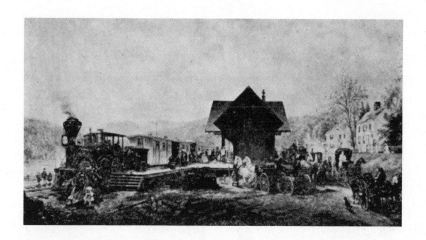

Figure 109 *The 9.45 A.M. Accommodation, Stratford, Connecticut,* 1867: CAT. 65. Collection, Metropolitan Museum of Art. (Photograph courtesy Metropolitan Museum of Art)

Figure 110 *Old Dutch Church, New York,* 1869: CAT. 83. Collection, Metropolitan Museum of Art. (Photograph courtesy, Metropolitan Museum of Art)

Figure 111 *St George's Chapel, Beekman and Cliff Street, New York,* 1875: CAT. 119. Collection, Metropolitan Museum of Art. (Photograph courtesy, Metropolitan Museum of Art)

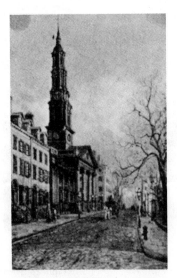

Figure 112 *St John's Church, Varick Street, New York, 1866,* 1868: CAT. 79. Collection, Macbeth Galleries

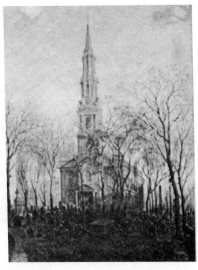

Figure 113 *St Paul's Church, 1766;* 1868: CAT. 80. Collection, Macbeth Galleries

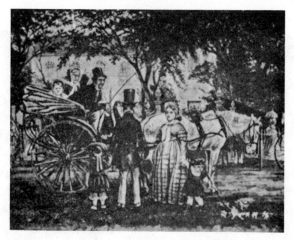

Figure 114 *A Chat After Meeting*, 1868: CAT. 77

Figure 115 *Alt Kirche, Oberammergau*, 1872: CAT. 100

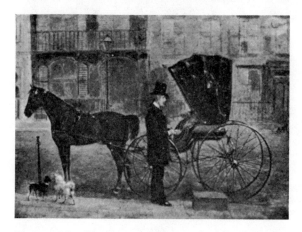

Figure 116 *The Doctor*, 1873: CAT. 105. Collection, Estate of Francis P. Garvan

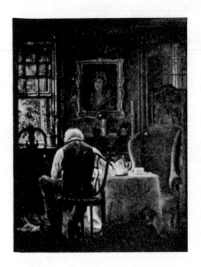

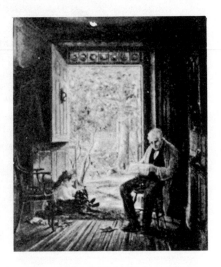

Figure 117 *The Widower,* (1873 ?): CAT. 106. Collection, Estate of Francis P. Garvan

Figure 118 *A Quiet Corner by the Door,* 1873: CAT. 107. A photograph, colored, is in the Henry Collection, New York State Museum

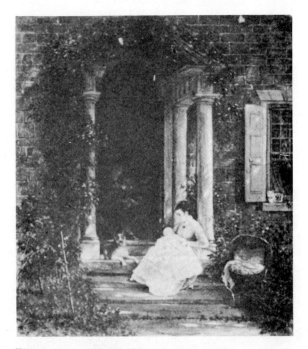

Figure 119 *The Old Paternal Home,* 1874: CAT. 110. Mabel Brady Garvan Collection, Yale University Art Gallery

Figure 120 *Les Fosses Communes,* 1876: CAT. 128-*a.*
Collection, New York State Museum

Figure 121 *Les Fosses Communes, Cimitiere de St Owen, Paris,*
1876: CAT. 128. Collection, New York State Museum

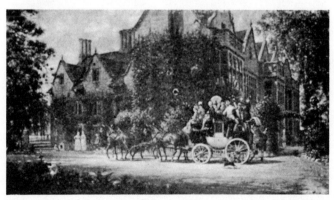

Figure 122 *Off for the Races,* 1876: CAT. 124. Collection,
Estate of Francis P. Garvan

[267]

Figure 123 [*Feeding the Ducks*], [1876]: CAT. 125. Collection, New York State Museum

Figure 124 [*Taking a Rest*], [1888]: CAT. 204. Collection, New York State Museum

Figure 125 *Departure of the Brighton Coach*, 1878: CAT. 136

Figure 126 *Old Hook Mill, East Hampton*, 1881: CAT. 151. Collection, Mrs Francis P. Garvan sr.

Figure 127 *The Country Store*, 1885: CAT. 181. Collection, Estate of Francis P. Garvan

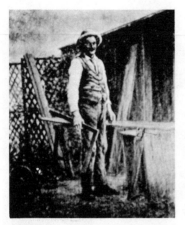

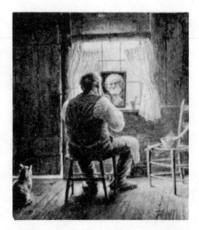

Figure 128 *Joseph E. Mance,* [1887 ?]: CAT. 193. Collection, Village of Ellenville. (Photograph copyright, Village of Ellenville)

Figure 129 *Peter Brown,* 1886: CAT. 187. Collection, Village of Ellenville. (Photograph copyright, Village of Ellenville)

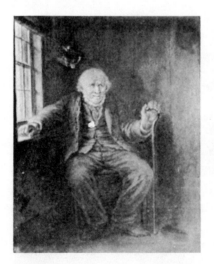

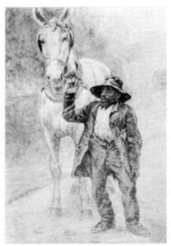

Figure 130 *Martin Terwilliger,* [1886]: CAT. 188. Collection, Village of Ellenville. (Photograph copyright, Village of Ellenville)

Figure 131 *Fred Thomas alias Black Fred,* 1887: CAT. 194. Collection, village of Ellenville. (Photograph copyright, Village of Ellenville)

Figure 132 *Nelly Bloomer*, 1890: CAT. 230. Collection, Village of Ellenville. (Photograph copyright, Village of Ellenville)

Figure 133 *John S. Billings*, 1883: CAT. 167. Collection, Village of Ellenville. (Photograph copyright, Village of Ellenville)

Figure 134 A snapshot of Joseph E. Mance, the gift of his son, S. D. Mance of Ellenville

Figure 135 *Mrs Nancy Evans*, 1896: CAT. 270. Collection, Harry M. Bland

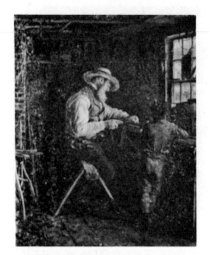

Figure 136 *Sharpening the Saw*, [1887 ?]: CAT. 195. Collection, New York State Historical Association

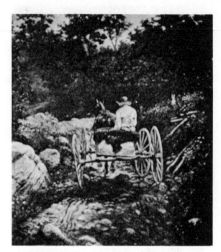

Figure 137 *A Mountain Road*, 1881: CAT. 153

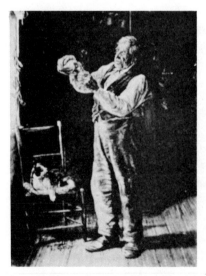

Figure 138 *Bracing Up*, 1883: CAT. 168

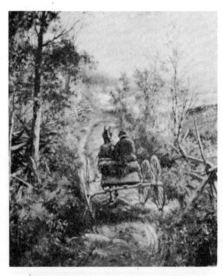

Figure 139 *A Hard Road to Travel*, 1882: CAT. 162. Collection, Mrs Harcourt Wesson Bull

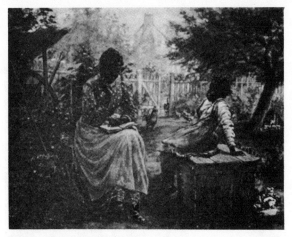

Figure 140 *Reading the Story of Bluebeard*, [1880 ?]: CAT. 145

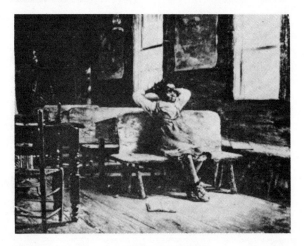

Figure 141 *Kept In*, 1888: CAT. 205

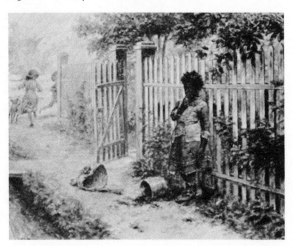

Figure 142 *Meditating Revenge*, 1892: CAT. 255

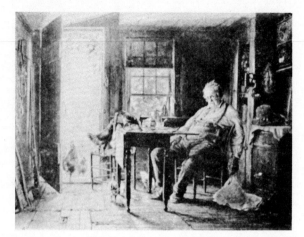

Figure 143 *Uninvited Guests*, 1883: CAT. 169

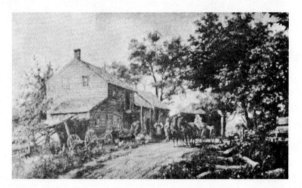

Figure 144 *The Old Forge*, [1887 ?]: CAT. 200

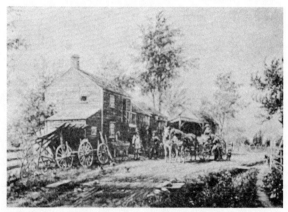

Figure 145 *The Country Carpenter*, 1890: CAT. 234

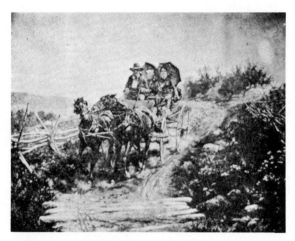

Figure 146 *The Summer Boarders*, 1881: CAT. 152.
Collection, Martin E. Albert

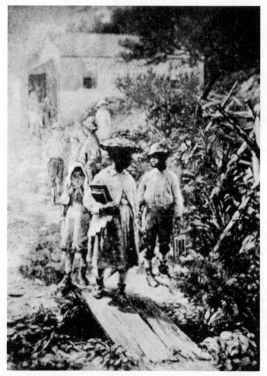

Figure 147 *"School's Out,"* *Below Cragsmoor,*
N. Y., 1887: CAT. 199. Compare with figure 20.
in which this painting may be seen on the wall

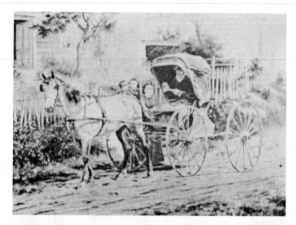

Figure 148 *A Country Doctor*, 1886: CAT. 189

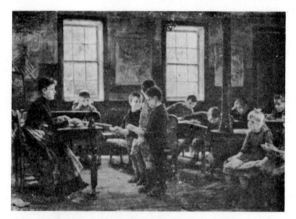

Figure 149 *A Country School*, 1890: CAT. 232. Collection, Estate of Francis P. Garvan

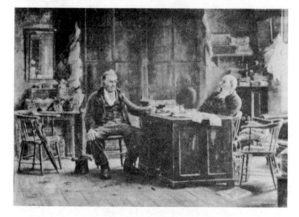

Figure 150 *A Country Lawyer*, 1895: CAT. 264

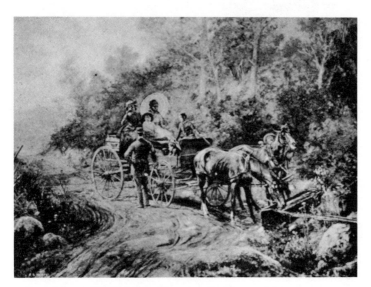

Figure 151 *The Watering Trough*, 1884: CAT. 179

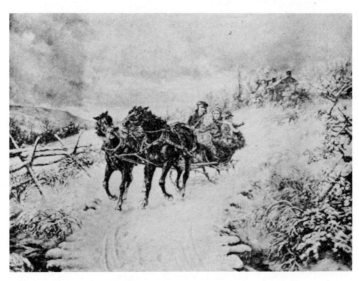

Figure 152 *Thanksgiving Sleigh Ride*, 1886: CAT. 191

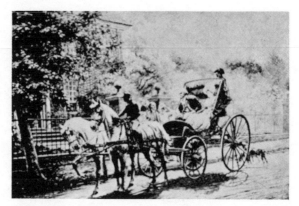

Figure 153 *One Hundred Years Ago,* 1887: CAT. 198

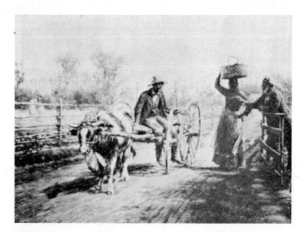

Figure 154 *A Temperance Preacher,* 1888: CAT. 212

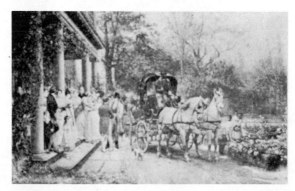

Figure 155 *A Virginia Wedding,* 1890: CAT. 231.
Collection, Estate of Francis P. Garvan

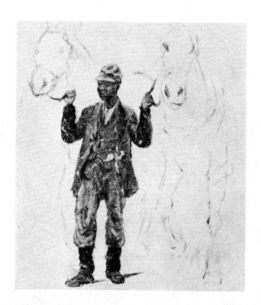

Figure 156 *Negro Stableboy*: CAT. 1057. Used as a detail for figure 157. Collection, New York State Museum

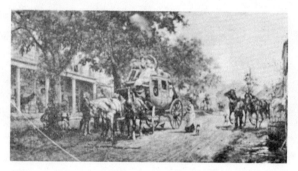

Figure 157 *The Relay*, 1881: CAT. 156

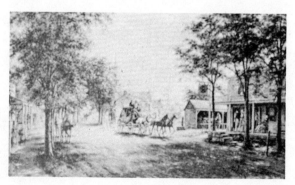

Figure 158 *The Arrival of the Stage*, 1904: CAT. 316. Collection, Estate of Francis P. Garvan

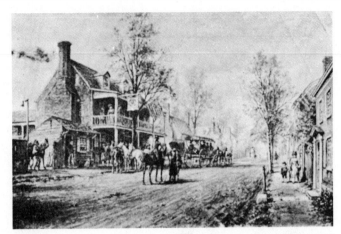

Figure 159 *Indian Queen Inn, Bladensburg, Md.* 1899: CAT. 290

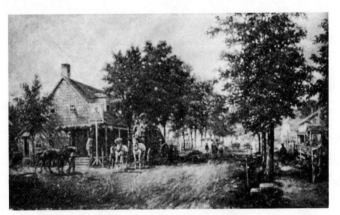

Figure 160 *Changing Horses*, 1905: CAT. 327

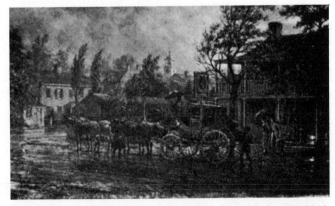

Figure 161 *Leaving in the Early Morn in a Nor'easter*, 1918: CAT. 388. Collection, Estate of Francis P. Garvan

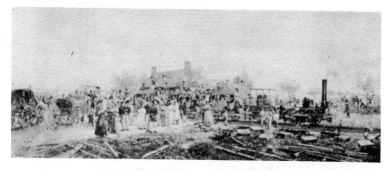

Figure 162 *The First Railway Train on the Mohawk and Hudson Road,* 1892–93: CAT. 257. This photograph is a copy of the Klackner print, copyrighted in 1894. Collection, Albany Institute of History and Art

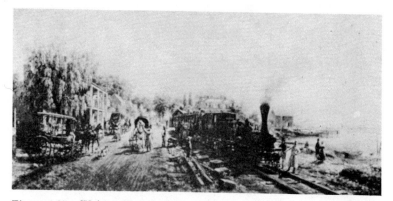

Figure 163 *Waiting for the New York Boat, Stonington, Conn., the First Railroad from Stonington to Boston,* 1905: CAT. 329

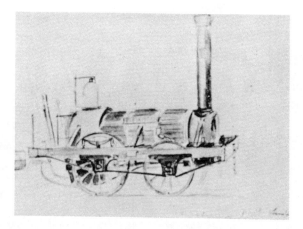

Figure 164 "Built in England by Stevenson." A drawing in Sketchbook 24: CAT. 1208. Collection, New York State Museum

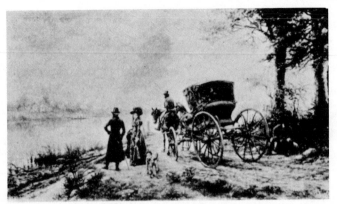

Figure 165 *Waiting at the Ferry*, 1899: CAT. 287

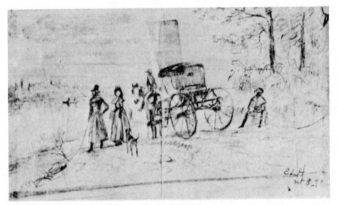

Figure 166 *Waiting at the Ferry*, 1899: CAT. 287-*a*. A drawing
used as a detail for figure 165. Collection, New York State Museum

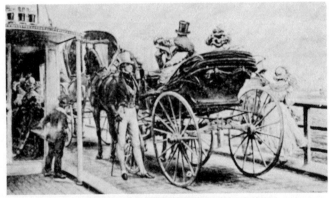

Figure 167 *Crossing the Ferry*, 1893: CAT. 288-*a*. Compare
also with CAT. 288. Collection, Mrs Frank E. Miller

Figure 168 *Fulton's First Steam Ferryboat, Running from Cortlandt Street to Paulus Hook, Jersey City, 1813–14*, [1901]: CAT. 304

Figure 169 *Waiting at the Ferry*, (1899): CAT. 1088. A sketch in oil on wood used as a detail for figure 165. Collection, New York State Museum

Figure 170 *The Tow Path*, 1891: CAT. 249

Figure 171 *Late Afternoon on the Old Delaware and Hudson Canal at Port Ben, N. Y.*, 1894: CAT. 261. Mabel Brady Garvan Collection, Yale University Art Gallery

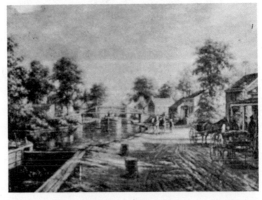

Figure 172 *Scene Along the Delaware and Hudson Canal*, 1907: CAT. 342

Figure 173 *On the Tow Path, 1:* CAT. 1146. Collection, New York State Museum

Figure 174 *On the Tow Path, 3:* CAT. 1148. Collection, New York State Museum

Figure 175 *On The Tow Path, 2:* CAT. 1147. Collection, New York State Museum

Figure 176 *On the Tow Path, 4:* CAT. 1149. Collection, New York State Museum

Figure 177 *A Disturber of the Peace*, 1905: CAT. 326

Figure 178 *Contrasts*, 1914: CAT. 371. Collection. Albert Duveen

Figure 179 *The New Woman,* [1892 ?]: CAT. 253

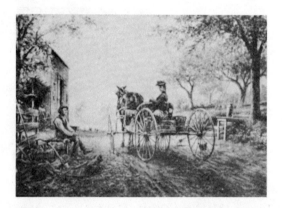

Figure 180 *Early Autumn,* 1906: CAT. 338

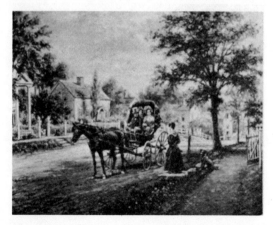

Figure 181 *The Gossips,* 1908: CAT. 349

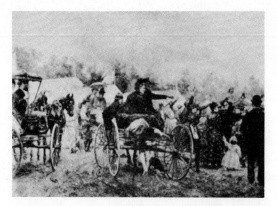

Figure 182　*The County Fair*, 1891: CAT. 246

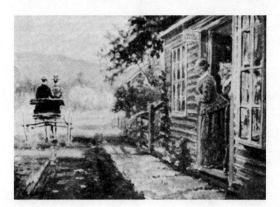

Figure 183　[*News Office*], [1894 ?]: CAT. 263.

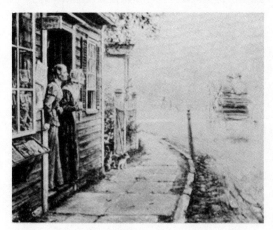

Figure 184　*Food for Scandal*, 1907: CAT. 343

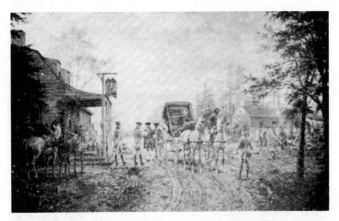

Figure 185 *Passing the Outposts, 1903:* CAT. 309

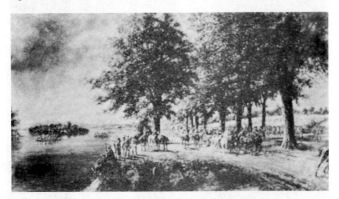

Figure 186 *Burgoyne's Army on the March to Saratoga, September, 1777, [1902 ?]:* CAT. 306

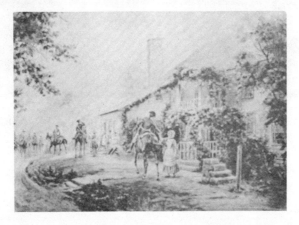

Figure 187 *Good-Bye, Sweetheart, 1900:* CAT. 300

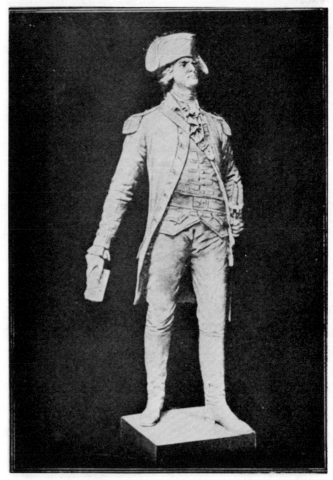

Figure 188 Statue of General Gansevoort, 1906: CAT. 1217.
Designed by Henry and presented to the City of Rome by Catherine
Gansevoort Lansing of Albany

Appendix to the Catalog

Titles which have been located since the completion of the catalog in 1942 are entered in this appendix, being designated by *A* followed by the number of the catalog entry they should succeed (as *A-57*), to distinguish them from catalog entries of collateral items already designated by *a* which follow the catalog number (as *244-a*).

A-57 THE RAINBOW 1865
Oil on canvas, 8x12 in.
Lower right: *E L H '65*
Exhibitions: Century Association, 1942, NO. 44

A-64 CANAL STREET, NEW YORK, 1830 1867
Oil on cardboard, 11x10½ in.
Lower right: *E L Henry '67*
Collection: E. Mortimer Barnes

A-105 STATION AT ORANGE, N. J. 1873
Oil on academy board, 11x19 in.
Lower left: *E L Henry '73*
Collection: E. Mortimer Barnes

A-106 THE GOVERNOR GOES TO THE FARM c. 1873
Oil on canvas, 8x7½ in.
Lower right: *E L Henry*
Exhibitions: Century Association, 1942, NO. 14
Collection: Mrs Frederic Frazier

A-108 OLD CHURCH
Oil on board, 5½ x3¾ in. 1873
Lower right: *E L H '73*
Exhibitions: Century Association, 1942, NO. 35
Collection: Macbeth Gallery

A-110 SKETCH AFTER NATURE, SEPTEMBER 30 1874
Oil on canvas, 10x14½ in.
Lower right: *E L Henry 1874*
Exhibitions: Century Association, 1942, NO. 53
Collection: Douthitt Galleries

A-119 RESIDENCE OF DUDLEY S. GREGORY 1875
Oil on canvas, 16x28 in.
Lower right: *E L Henry 1875*
Exhibitions: Century Association, 1942, NO. 45
Collection: Mrs Ernest Tyler

A-126 WARWICK FROM ST. JOHN'S PRIORY 1876
——, 11¾ x19¾ in. (inside mat)
Lower right: *Warwick from St. John's Priory*
 E. L. Henry 1876
Collection: Juanita A. Almirall
Miss Almirall has supplied the above information and gives the following text of an inscription, location not stated:
A study from nature of Warwick, England from the Gate House of St. John's. St. Mary's is seen at the right, at the left in the distance is the Norman Tower of Warwick Castle. Made in July 1876.

A-143 KING OF THE MONTAUKS 1880
Oil on canvas, 12x16 in.
Lower right: *E L Henry '80*
 East Hampton, L. I.
Exhibitions: Century Association, 1942, NO. 22
Cf. Prince of the Mohawk CAT. 952

A-197 A STUDY NEAR PETERSBURG, VA. *c.* 1887
Oil on canvas, 12½ x21 in.
Lower left: *E L Henry*, and as above
Collection: E. Mortimer Barnes

A-222 MARRIAGE IN THE OLDEN TIME *c.* 1889
The only datum is a reference in a letter dated December 27, 1889.

A-229 IN THE GARDEN *c.* 1889
Water color on paper, 6⅞ x4⅞ in.
Lower left: *E L Henry*
Exhibitions: Century Association, 1942, NO. 18
Collection: Macbeth Gallery

A-238 THE DOCTOR'S BUGGY *c.* 1890
Oil on canvas, 12½ x17 in.
Lower left: *E L Henry*
Collection: E. Mortimer Barnes

A-240 COUNTRY POST OFFICE, EAST TENNESSEE *c.* 1890
Water color on paper, 5½ x8¼ in.
Lower left: *E L Henry*
Exhibitions: Century Association, 1942, NO. 6
Collection: Arthur Lasslow

A-241 HAPPY-GO-LUCKY *c.* 1890
Oil on wood panel, 10½ x7⅜ in.
Lower left: *E L Henry*
Collection: Guy Mayer Gallery
Figure 260

A-244 A MOMENT OF TERROR
KL. NO. 32

A-258 THE MESSAGE 1893
Oil on board, 10x14 in.
Lower right: *E L Henry '93*
Exhibitions: Century Association, 1942, NO. 28
Collection: Gilbert Gabriel
 This painting was given to its present owner by William Beers Crowell.
whose mother was a daughter of one of the Beers brothers who did framing
for Henry.
 The painting seems to be related to [*Mrs Henry in a Buckboard*] CAT.
209.

A-293 A RAINY DAY *c.* 1899
The only datum is a reference in Henry's 1899 diary.

A-294 SATURDAY MORNING *c.* 1899
The only datum is a reference in Henry's 1899 diary.

A-303 HOME FROM THE WAR *c.* 1900
 The only datum is the copyright application, dated February 12, 1903.
For date attributed here, see NOS. 295 and 303.
 Included in the Century Association exhibition, April 7 to May 9, 1942,
was a water color and crayon drawing on paper, 15 by 23½ inches, NO. 46,
entitled *Return from the Wars*. Could this be the above unidentified
picture?

A-304 OLD NEW YORK 1901

Water color on paper, 13x21 in.
Lower right: *E L Henry 1901*
Exhibitions: Century Association, 1942, NO. 36
Collection: Douthitt Galleries
Inscribed on back: *The first brick house built in America*

A-354 ST. JOHN'S CHAPEL, VARICK STREET, NEW YORK CITY 1909

Oil on ———, 21 15/16x20 12/16 in. (inside frame)
Lower left: *E. L. Henry — 1909*
Collection: Juanita A. Almirall
Miss Almirall has supplied the above data.

A-355 A SUNSET PAINTED FROM NATURE AT CRAGSMOOR 1909

Oil on ———, 15⅞ x19⅝ in. (inside frame)
Lower right: *E. L. Henry — 1909*
Collection: Juanita A. Almirall
Miss Almirall has supplied the above information and gives the following
text of an inscription, location not stated:

*A sunset painted from nature at Cragsmoor on the Shawangunk moun-
tains overlooking the Roundout Valley and the distant Alleghanies* [sic!]
*in Eastern Pennsylvania. Painted from studies made of the sunset the
next morning by*

E. L. Henry
Summer of 1909

Miss Almirall's letter adds that this painting received honorable mention
at the 1909 winter exhibition of the National Academy of Design.

A-372 COUNTRY LANDSCAPE c. 1914

Oil on canvas, 18x30 in.
Lower right: *E L Henry*
Exhibitions: Century Association, 1942, NO. 5
Collection: Joseph A. Muller

A-388 [THE OLD LOCK BELOW ELLENVILLE] 1918

———, 9⅜ x12⅝ in. (inside frame)
Lower right: *E. L. Henry — 1918*
Collection: Juanita A. Almirall
Miss Almirall has supplied the above information and gives the following
text of an inscription, location not stated:

*This picture was made from a study from nature at this old lock just
below Ellenville in the nineties at the old "Delaware and Hudson Canal"
which ran from Honesdale, Pennsylvania, in the coal mining district to
Rhinebeck-on-the-Hudson. It supplied coal all along the whole route
plentifully and cheap and brought up freight even from New York City.
J. P. Morgan came up from New York City and seeing that the canal inter-
fered with the revenue of the new Ellenville and Kingston Railroad, pur-
chased it and had it destroyed, to the regret of the whole valley.*

Miss Almirall's letter adds that this is Henry's last completed picture.
Cf. NO. 249

A-907 THE BROOKS POST OFFICE, STRATFORD, CONN.

Oil on canvas, 11x13 in.
Exhibitions: Century Association, 1942, NO. 3
Collection: Charles Wellington Walker

A-910 COLONIAL WEDDING
The only datum is a reference in the MS., p. 331, 335

A-911 COUNTRY LANE
Bibliography: Parke-Bernet catalog, February 10–11, 1939, NO. 91

A-912 COUNTRY WEDDING
The only datum is a reference in the MS., p. 331

A-919 FOOT OF EAST BROAD STREET, STRATFORD, CONN.
Oil on canvas, 14x20 in.
Exhibitions: Century Association, 1942, NO. 12
Collection: Charles Wellington Walker

A-925 INDIAN ENCAMPMENT
Oil on canvas, 7x10½ in.
Exhibitions: Century Association, 1942, NO. 17

A-932 KITCHEN OF FRAU JUDAS
Oil on paper, 10x8¾ in.
Lower right: *E L H* (enry), [the latter added in another hand]
　　　　　　Sept. 11
Collection: Joseph P. Hartert

A-976 THE WEDDING DAY
Exhibitions: World's Columbian Exposition, Chicago, 1893, NO. 551
Collection: "Mr. Dickinson, Holyoke, Mass."

A-1101–07 The Gift of Mr and Mrs Charles H. Peters, of Cragsmoor, includes two sketches in oil on canvas not listed in the catalog proper.

A-1108–33 The gift of Mr and Mrs Charles H. Peters, of Cragsmoor, includes several sketches in oil on paper not listed in the catalog proper.

A-1160–84 The gift of Mr and Mrs Charles H. Peters, of Cragsmoor, includes a number of pencil drawings on paper not listed in the catalog proper. Among these may be noted the following:

(1) St. Erasme, Gaeta. 9¾ x7¼ in. Apparently a drawing for NO. 56, an unlocated painting.

(2) A sketch for *The 9.45 A.M. Accommodation*, NO. 65, measuring 5¼ x9 in. There are in the Peters gift two other drawings of railroad station scenes, which seem related.

(3) Sketch, 8¼ x10 in., for *The Temperance Preacher*, NO. 212.

(4) Sketch, 10x14 in., for *A Virginia Wedding*, NO. 231.

(5) Sketch, 7½ x11 in., of Gen Gansevoort's gig, with the initial "G" in a circle.

(6) Several sketches of horses, related to details reproduced in report. *Cf.* Figs. 173–76.

(7) Sketch, 9½ x6 in., of Negro girl standing in listening pose: a detail for [*Maud Powell Plays the Violin*], NO. 319, Fig. 71.

(8) Sketch, 13⅞ x9⅞ in., pencil with colored crayon. This drawing shows a woman sitting in a window alcove, reading. It is interesting because it documents Henry's attention to detail and shows how carefully he worked.

(9) Sketch, 7¼ x5¾ in., showing a religious procession in a French church led by the *bedeau* with halberd and mace. Was this a note for a French subject which has not come to light? *Cf.* NOS. 128 and 128-*a*, Figs. 120 and 121.

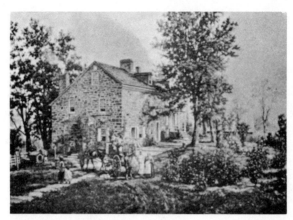

Figure 189 *The Pedler*, 1879: CAT. 139. Collection,
William B. Kirkham

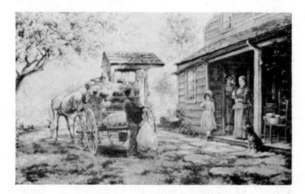

Figure 190 *A One-Sided Bargain*, 1902: CAT. 305.
Collection, Estate of Francis P. Garvan

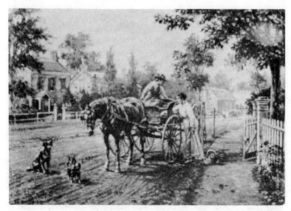

Figure 191 *The Village Huckster*, 1913: CAT. 367

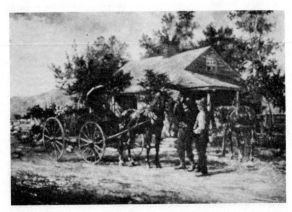

Figure 192 *Testing His Age,* [1892 ?]: CAT. 254

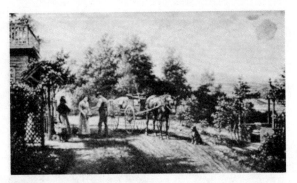

Figure 193 *The Huckster,* 1914: CAT. 370. Collection, I. Snyderman

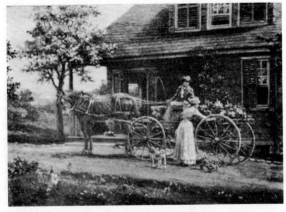

Figure 194 *The Flower Seller,* 1906: CAT. 335

Figure 195 *Testing His Age*, [1892 ?]: CAT. 254-a. A detail for figure 192. Collection, New York State Museum

Figure 196 *Horse and Pedler's Wagon*: CAT. 1148. A detail for figure 193. Collection, New York State Museum

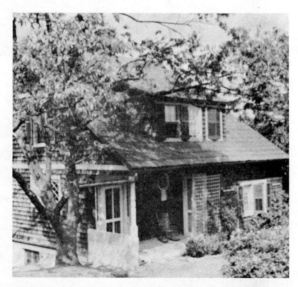

Figure 197 The Husson-Buxton Cottage at Cragsmoor, formerly owned by the Henrys, seen in figure 194, as it looked in 1941

Figure 198 *Forgotten*, 1894: CAT. 376-*a*. A detail for figure 199. Collection, New York State Museum

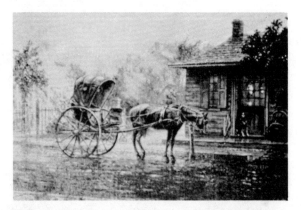

Figure 199 *Out in the Storm*, 1916: CAT. 376

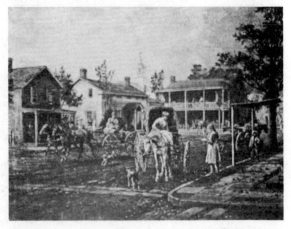

Figure 200 *A Village Street*, 1916: CAT. 378

Figure 201 The Cragsmoor Post Office, 1941.
Seen in figure 202

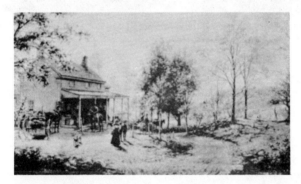

Figure 202 *An October Day*, 1903: CAT. 308. Collection, Martin E. Albert

Figure 203 *The Bill Collector*, 1913: CAT. 365. Collection, Dr and Mrs H. M. Sassaman

Figure 204 *The Four Seasons—Spring,* 1914: .CAT. 372-1. Collection, Albert Duveen

Figure 205 *The Four Seasons—Autumn,* 1914: CAT. 372-3. Collection, Albert Duveen

Figure 206 *The Four Seasons—Summer*, 1914: CAT. 372-2. Collection,
Albert Duveen

Figure 207 *The Four Seasons—Winter*, 1914: CAT. 372–4. Collection,
Albert Duveen

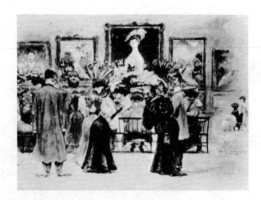

Figure 208 *A Private View*, 1906: CAT. 334

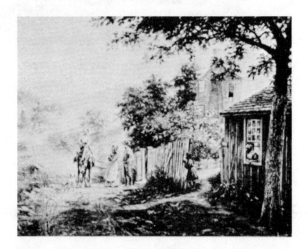

Figure 209 *In East Tennessee*, 1906: CAT. 337

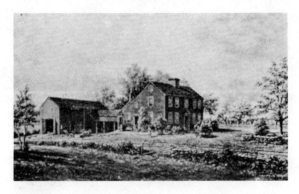

Figure 210 *The Uplands at Bow*, 1914: CAT. 369.
Collection, The First Church of Christ, Scientist, in Boston, Massachusetts

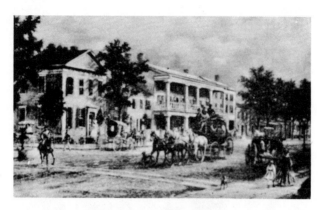

Figure 211 *Main Street in Johnstown, N. Y., in 1862,*
1916: CAT. 374. Collection, Mrs Charles B. Knox

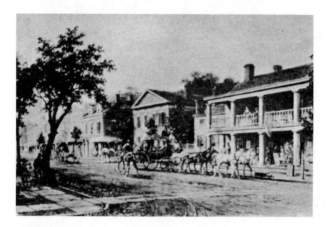

Figure 212 *Main Street, Johnstown, 1917*: CAT. 382

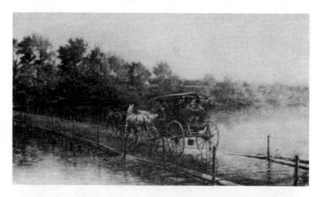

Figure 213 *The Floating Bridge,* 1917: CAT. 380. Col-
lection, Mr and Mrs Arthur V. Hoornbeek. (Photograph
courtesy, M. Knoedler and Company)

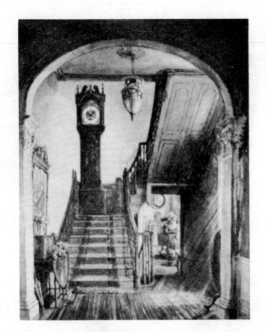

Figure 214 *The Old Clock on the Stairs,*
1917: CAT. 379. Collection, Ernest du Pont
Meyrowitz. (Photograph courtesy, Ernest du
Pont Meyrowitz)

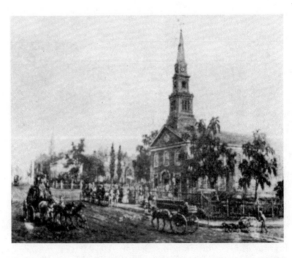

Figure 215 *St Mark's in the Bowery,* 1917: CAT. 381.
Collection, Martin E. Albert

Figure 216 *Waiting for the Stage*, [1918]: CAT. 387

Figure 217 *Waiting for the Stage*, 1872: CAT. 1089. A note for figure 216. Collection, New York State Museum

Figure 218 *Florida Landscape*, 1919: CAT. 391. A canvas left unfinished at Henry's death. Collection, New York State Museum

Figure 219 *Talking Politics,* 1900: CAT. 299

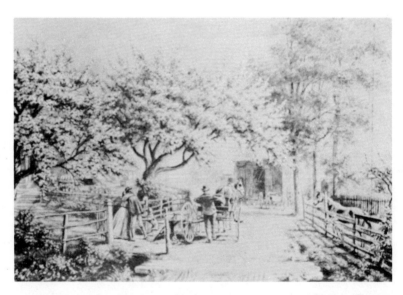

Figure 220 *Return from the Wars:* CAT. 956. Collection, Albert Duveen

Figure 221 *Colonial Doorway:* CAT. 1015. A detail for Nos. 110 and 116. Collection, New York State Museum. See figure 119

Figure 222 *Doorway:* CAT. 1020. A detail for No. 109. Collection, New York State Museum

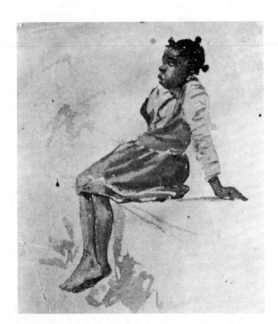

Figure 223 *Negro Girl:* CAT. 1141. Compare
with figure 124. Collection, New York State
Museum

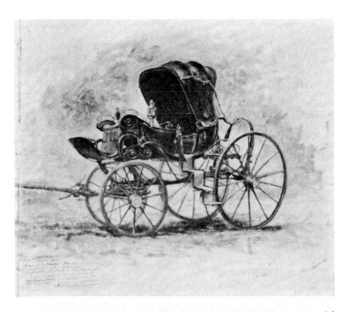

Figure 224 *The Lafayette Coach:* CAT. 1051. Compare with
figure 75. Collection, New York State Museum

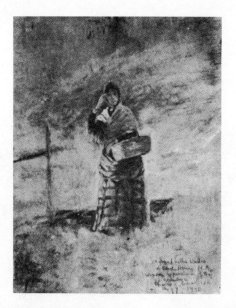

Figure 225 *Woman with a Basket:* CAT. 1099-a. Collection, New York State Museum, the gift of Charles C. Curran, N.A.

Figure 226 *Negro Boy and Girl on Oxcart:* CAT. 1055-a. Collection, New York State Museum, the gift of Charles C. Curran, N.A.

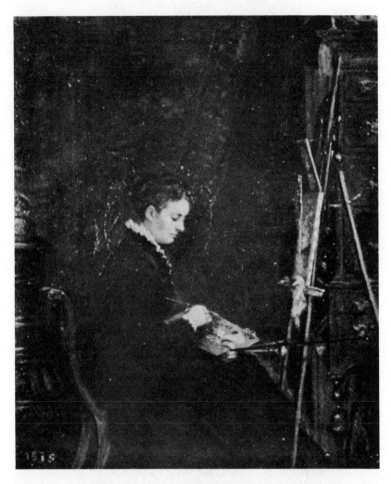

Figure 227 *Frances Livingston Wells (Henry)*, 1875: CAT. 117. The original is 6 x 5 inches, in a handsome shadow box. Collection, Albany Institute of History and Art.

A Memorial Sketch:

E. L. HENRY, N. A., His Life and His Life Work

BY FRANCES L. HENRY*

Dedication

I dedicate this sketch, written in loving memory of him, to all those patrons who cared for his paintings and all the dear friends who knew and loved him and who still care enough for him to read the simple and imperfectly written memoirs of his life and work. Although he has laid down brushes and paints, his lifework finished and well done, I hope he still lives in the hearts of these his friends. [1920–28]

F. L. H.

Childhood

People as a general thing seem to have a desire to know something of the private life of those whose work has brought them before the public, as it is often the inner life of one that counts as well as the more open, and I have been asked if I could not write some details of the life of my husband, Mr E. L. Henry, as nearly half a century of our life was spent together.

I have been asked, would I not tell something about the way he painted? How and where he found so many varied subjects of American life? Did he get his ideas from books? If so, what books? What he considered his most important work? These

* The late Mrs Henry left her manuscript unfinished at her death in 1928. It has been edited for publication with a minimum of revision to keep the color of her style. Spelling and punctuation have been partially corrected for clarity, and the material has been arranged chronologically. Brackets [] indicate my additions to her text. Parentheses () enclose references to this report.

Frances L. Henry died at Cragsmoor July 23, 1928, of angina pectoris, and was buried in the Johnstown cemetery with her husband. The Cragsmoor Echo of August 6, 1928, printed a memorial by Frederick S. Dellenbaugh, which states that she was born in Johnstown in 1845, of one of the oldest families in New York State. Dellenbaugh states that she went to New York to study art, which is erroneous, according to her niece, Mrs Stetson (McCausland '41). He adds, what is obviously true by Henry's portrait of her (CAT. 117; FIG. 227) that a prominent Academician, meeting the Henrys in Paris soon after their marriage, said Mrs Henry was one of the most beautiful women he had ever seen.

E. McC.

questions are constantly asked me, not only by friends, but also people have written me about paintings which they own, [asking] where and how they are painted?

I have portfolios of reproductions of his paintings and in trying to answer these questions by looking over them, I realize more and more what his life work was, and how everything centered in it. His large library of books, mostly Americana, travels, costumes and customs of the early American habits and life that our forefathers led, [was one evidence of his interest. Then he was always] searching through the country for their homes, sparing no pains or expense in getting all and everything that could help him make his work as perfect as possible; for he always felt and others often said, his paintings would live and be used as references long after he had gone. So, he wanted to make them as perfect and as true to the time they represented as was possible.

He had little if any care for foreign subjects although he has painted some. His great interest was historical as well as the simple country life of America. An article entitled "A Painter of the Good Old Times," (CL. '08) found in the Broadway Magazine of August, 1908, (Dunbar, '08) is so true of him that I am quoting from it.

> "But each for the joy of working and each, in his separate star,
> Shall draw the Thing as he sees it for the God of
> Things as They Are!"
>
> . . . For "the Thing as he sees it" is the thing that he straight-forwardly paints, regardless of changing fads and fashions in art. All outdoors is full of beauty and of interest for him, and although he has chosen certain portions of it as his special province, he could set his canvas anywhere and be quite sure that either the face of nature or the life of man, or both together, would offer him a scene worth painting. Nor would he think it necessary to make changes in it in order to intensify its beauty or sentimental appeal. He sees the thing, exactly as it is, so full of beauty and of meaning and sentiment that to paint it with exact truth seems to be the full duty and the quite sufficient task of the artist. Nor does the question, "It's clever, but is it Art?" ever trouble him. Through all the years of a long and busy life he has been so occupied in transferring to canvas as much as he could of the everlasting beauty of the world that he has scarcely had time to consider whether this, that, or the other way of seeing or working is or is not art.

[This quotation was edited by Mrs Henry. In the original, the second sentence from the end reads: "Nor does Kipling's Devil of the Workshop, the Mephistopheles of Art, with his age-old, deadening conundrum. 'It's clever, but is it Art!' ever whisper his paralyzing question in Mr Henry's ear." E. McC.]

He collected vehicles of all kinds, guns, dueling pistols, harnesses or a worn oxcart wheel, costumes of men, costumes of women, shoes, hats, children's dresses, everything can be found in his collection, and all were used in his paintings. Very often he was asked where he got them and people would hardly believe him when he said he owned them all.

I have his diaries from 1860 when he was sent alone to Paris to study art, because from babyhood he was an artist. When other children were given children's playthings, he would sit quiet and happy if he could only have paper and pencil trying to make some mark or little drawing that would look like something real. And when fame came to him he said he could still often feel the thrill of ecstasy that came over him, baby as he was, when something that looked like a figure was on the paper. He was only a very little child, but he had created something. A little older, when children ask for toys and playthings, he asked for brushes and paint. In church, to keep him quiet during the long sermons of that day, he was given a pencil and Bibles, hymn books and prayer book were filled with battles, boats, horses and wagons. And if the minister happened to be preaching about the warriors and heroes of old, they too were generally to be found among the drawings— [as like as not] David, a very fierce man, and not at all as the sweet singer of Israel, but as a boy fighting Goliath. When only five years old, he was watching with deep interest a string of boats on the Connecticut shore, and was seized with a desire to make a picture of them, so with pencil and bit of paper he did his baby best to make them look as he saw them, with recognizable result.

In that day when a boy left school, it was thought that he must be put in some business, mercantile or otherwise, and he was sent down as a messenger in Wall Street for a beginning. One day's trial was sufficient. He was given some bonds to deliver in a great hurry. Reaching the bank, he was attracted by an engraving of early American history hanging on the wall and stood so long looking at it that the president of the bank, noticing the young boy's interest [to be] so great, became interested in him, asking his name. The engraving which heretofore was merely a piece of furnishing for the bank wall, gained great interest through the boy's eyes, and time flew.

Suddenly awaking to the great need for hurry as it was nearly time for closing, he was charged to run all the way back. But again seeing pictures in a window in the street [he] forgot hurry, time, bonds, and returned to the office long after closing hours,

interest on bonds for that day lost. Then his family gave up all thought of a business career for the boy and allowed him to follow his own inclination and study the one profession he loved.

Student Years

Mr Henry was only 19 years old when he went to Paris to study art. He had been studying some time already in Philadelphia, as schools were considered more advanced there at that time than in New York, but showed such ability that his family was advised to send him abroad, where in the ateliers of various masters he would have greater advantages than at home. I think he studied with F. Weber, Courbet, also Gleyre, as well as copying in the Louvre. A large copy of Vibert which he made at that time is still in existence and brilliant with color.

Art at that time was almost purely classic, pupils being drilled in drawing before they were allowed to use color, first from casts, then the life class, which is still done, of course. But it was drawing, drawing, drawing, and I think that early drilling is shown in his paintings; for I am quite sure every one will concede that his drawing is quite perfect and hardly ever to be criticized. In later life when students often came to him for criticism on what they were doing, bringing their work with them, he would beg them to, before learning to paint in colors, learn to draw, then study perspective, composition etc.

Once, in passing a class of students who were sitting in the road trying to paint from nature, they asked him to help them or at least tell them why the road would go up hill on their canvases [in spite of] all they could do, when in nature it went down. In a few moments with the brush in his hand, it was all right. Then he gave them a lesson on drawing and the importance of even *drawing in color*. Color itself was easy enough if one only knew first how to draw and the rules of perspective. A foreign artist who was looking at one of his paintings said, "Henry is truly a master of drawing and perspective."

In looking through his diaries which commence from his student days, I find how much he had to study from models classically draped, but his eyes were always open to everyday passing events. Even in those early days of hard study, his great interest was centered in life around him; but the greatest interest was American history. In school days the lesson in history was always read so far beyond the given lesson that the teacher would be compelled

to stop him at recitation. The lesson was given for a certain chap
ter perhaps, but there was hardly need to study or memorize for
him, for his memory was almost abnormal and he would read
on and on until the book was finished. In other studies he might
be quite defective, but never in history. He never forgot dates:
ask him at any time when such or such an event happened, instead
of mentioning a number of years he would tell the exact date of
the event.

When the students in the class in Paris were told to bring in
a sketch, the subject their own choosing, he brought in a little
picture of the French *Voiture de Chemin*, people inside and out,
the conductor standing on the steps behind, people passing in the
street and the street stretching far off in the distance. It was con-
demned as very commonplace, uninteresting and not "art." It was
what had appealed to him, however, although he had to continue
drawing and painting from the classic.

Mr Henry was always very fond of traveling. Even in those
early days of 1860, when only 19 years old, he took advantage of
intervals of study to visit the noted places of Europe. Writing
again from his diary of that date:

He sailed from New York Saturday, September 22d, (CAT. 17;
FIG. 229) going directly to London, where he stayed until Oct.
29th, visiting all places of interest. Oct. 29th, he left London
for Paris where he began his studies in art and copying in the
Louvre, taking lessons in French, going to a gymnasium, taking
lessons in fencing, in which he became very proficient. He went
to Lyons, Marseilles, Napoli (Naples), (CAT. 18; FIG. 94)
Genoa, Livorno, Civita Vecchia, Parsleppo, Pompeii, Vesuvius,
Rome. Of course, in Rome he went to the ateliers of Rogers,
Buchanan Reed. Saw the Pope at St Peters, blessing the people:
went to the Coliseum, which he saw by moonlight and writes in
his diary, "Grand magnificent picture." Up early next morning
to go to Grotto Ferate, then Frascati, (CAT. 19) took donkey ride
to Tusculum, again writes of visiting Crawford's studio and
Buchanan Reed's making his studies and sketches everywhere.
Leaving Rome, April 9th and stopping at Florence, (CAT. 20;
FIG. 233), seeing the races, (CAT. 53) of which later he made a
painting, and going to Power's studio. Leaving Florence April
21st [for] Genoa, Spezzia, Milan, stopping some time at all places
of interest for sketches. Venice, Verona, Mantua, Reggio.

His diary is full of descriptions of places he visited all the way
back from Paris. Up early many times at 5–6 a.m. and once at

3.30 to take an early diligence, from one place to another, missing no place on the way, walking up hill and down, [seeing] cathedrals, academy d'art, picture galleries, churches. Mr Henry was never very strong, and on many pages of the diaries, after these long walks and sightseeing is written *"Malade Tout le Nuit."* He seems never to have rested, but with indomitable energy is up the next morning early that he may miss nothing of what he is seeing and making sketches of the interesting scenes. The Messrs Valentines of Richmond, Va., the sculptor and brothers noted for their excavations in the south and southeast, and establishing the Valentine Museum in Richmond, figure largely in the diary at this time: "Going out with Valentine. Going to Valentine's room. Going to cafe with Valentine." I think he traveled extensively with them also.

[The entries continue.] Lake of Como, (CAT. 21, 22; FIG. 234) Lake Maggiore. (CAT. 23, 24). Taking a boat. Rowed on lake. Took sketch. Stuttgart, (CAT. 26; FIG. 236) where he describes the baths and beer gardens and has funny little sketches of them. Frankfort, Dresden, Berlin, (CAT. 27, 28; FIGS. 237, 238) where he stopped July 4th and writes of going to a big Fourth of July dinner at Arum's hotel. *"Beaucoup* Americans, speeches and tracts till 12 p.m." He took lessons in German, but was very ill, being confined to his room; however, using the time by "making sketches *out of the window."* Then comes Potsdam Here he writes of receiving news of defeat at Manassas and account of Battle of Bull Run. Back in Berlin he continues his studies in German. He makes many excursions to neighboring places, going to concerts, museums, churches, picture galleries, "festas," walking and apparently never weary. Düsseldorf, Coblentz, Bingen, Baden-Baden, Heidelburg, Strasburg, Chalon, Paris.

On Monday, November 28th, he went with other students to call on Gen. Winfield Scott at Westminster Hotel. The Gen. so great as a Gen., so great in person, was sitting in a great chair under a draped flag of the stars and stripes, and gave the young men much good advice. January 19th he attended a reception at the U. S. Consul's, [U. S. Minister] where he seems to have been a constant visitor as well as a welcome one. A very amusing incident occurred while in one of the large cathedral cities.

Meeting an acquaintance one day in the street, both walked on to the beautiful building. Close by the street through which they were walking was a narrow rather dark street filled with small

shops. As they both stood looking at the towers (as he thought,)
he said:

"What wonderful carving," Mr. H.

"Yes! most beautiful," friend.

"The coloring is exquisite."

"Wonderful; I have never seen finer."

"It must have taken man many years to do it."

"Y-e-s, but not necessarily so very long."

"Oh, yes it has! Time only could bring out such wonderful
colors in the stone."

"S-to-n-e, there is no stone about it."

"Why! What do you mean? It's all stone, nothing else."

"What are you talking about? It is not made of stone at all my
boy. They never make them of stone."

Turning to look at his friend with astonishment, [the young
student] found *him* standing with his back to the cathedral, look-
ing in a tobacconist's window at a beautifully carved meerschaum,
while Mr Henry had been gazing at the marvelous carving in stone
of the cathedral.

Back again in Paris with its great schools of art, the Luxembourg,
its salon, the Eldorado for artists. Paris held so many attractions
for him. So many friends were there. His diaries are full of
accounts of gatherings in studies and cafés after the day's work had
been accomplished, criticisms upon the salon pictures, and exhibi-
tion as a whole, merits and demerits of certain paintings; which
school of art was the greatest, and which would bear the test of
ages, visions of the great work each one was to do. These sub-
jects are generally discussed.

Oh! how many names I find written in these diaries. Names
so memorable and other names forgotten now—faded visions!
All so happy, so young, heedless of much except the beauty of their
own world, the world of art. What matter to them if sometimes
finances were a little low and economy needed; a little self-denial
did not amount to much. They had something so much greater
in themselves, each in his own way living his own life, his life
so full of dreams and beauty, their dreams of future greatness.
Art had given them dreams, and they were trying to find a way
to make those dreams come true. They were looking beyond a
painted canvas and seeing the deeper meaning, the great difficulties
overcome, the ideal attained.

He is back again in London, walking, walking everywhere,
feeling miserably sick, for he was terribly troubled with dyspepsia,

but still making the most of time. He speaks of hearing Dickens
in Dotheboys hall and the trial scene of Pickwick, and there is a
drawing of Dickens. Here again he finds many friends, Boughton
and others, then the Royal Academy, Derby races. He leaves
London June 9, 1862, stopping at Chester and making sketches,
Holyhead, Kingston. Then cars for Dublin, staying there several
days, then Cork. Then Queenstown. Steamer for home.

He was never a good sailor, and each day on ship passes with
but few entries, just some little note of some particular event of
interest. One day, man overboard. Icebergs (CAT. 32; FIG. 241).
Fogs—"tres froid." A little sketch of the end of the ship. On
June 23d sees land and is home June 24th.

His diaries are full of sketches, sentences in French and in Ger-
man. It was always much easier for him to illustrate a thought
than to write, so the diaries are full of tiny sketches. When he
went to the races in London, there is a drawing of the racing horses
at the top of the page. When he heard Dickens, there is quite a
good portrait of him. Fourth of July is drawn with flags flying
and banners waving. Processions are all drawn out. Boats, R.R.
going and coming, wagons of all kinds, each as it was used.
Of course, everything is necessarily very tiny, as it must be in
these small pages. But there is always character, open the book
anywhere, and one knows in what place he was at that time by
the little drawing found in it.

Young Artist in New York

Arriving in New York he took a studio in the Tenth Street
Studio Building and he told me how the older men who were
there resented such a boy coming there and putting his name on
the door, but after a while how every one of them called on him,
looking at his work and encouraging him in every way.

Mr John Taylor Johnson, remembered as one of the collectors
of American art, gave him one of his first large orders, for one of
the early R.R. paintings (he painted several besides the noted
large one of the trial trip) and paid him $500, an almost
unheard-of price at that time even by a man of reputation, not
speaking of Church, Bierstadt, Gifford and a few others. It (CAT.
58) was placed on an easel at one of Mr Johnson's noted artist
receptions, attracting a good deal of attention, as also the young
artist. It was here he was introduced to Mr S. P. Avery, who at
that time was dealing only in American paintings and who became
one of his earliest patrons.

He kept his studio in the Tenth Street Studio Building for 25 years, and here he painted many of his important canvases, [including] a *Presentation by the Ladies of the Sanitary Commission, New York, to the First Colored Regiment in front of the Union League Club, Union Square, New York, March 1864,* (CAT. 82; FIG. 100) painted for and owned by that club still, [and] the historic painting of *Old Westover, James River,* (CAT. 51; FIG. 102) sketched from a U. S. transport on James river, October 1864, owned by the Century Club, New York. At the breaking out of the War of the Rebellion Mr Henry was very anxious to go but was too young to enlist as a soldier; so there was a position found for him [in 1864] as captain's clerk on a transport taking supplies down the James river to the army. He got all his notes and sketches for his painting *Grant's Head-quarters at City Point* (CAT. 96; FIG. 107) at that time, although the painting was not finished until several years later. One day sitting on deck, he saw a short thick-set man dressed in uniform standing on the shore, watching him. He saw on his shoulders a band with four stars and instantly knew that it was "Grant." Then came to him the thought of the painting. The whole scene was there and his notebook is full of the sketches he made.

Not thinking of war conditions, he started out (as was his custom) to make his drawings. Climbing up the bank he was busy at work making his studies in his sketchbook when suddenly he heard shouting and felt stones falling all around but fortunately none hitting him. A guard was running and calling out to him in no choice language, "What are you doing? What do you mean taking drawings of this place? If I had my gun, there wouldn't be much left of you, I can tell you." Realizing only then his great danger, he said he never ran so fast in all his life, almost tumbling down the bank, and was glad enough to get back on the boat completely out of breath, heart beating almost to suffocation, almost dead with fright. I leave to the imagination what the captain said when hearing of it. As the boat was anchored near the shore, he made his drawings on deck afterwards and at a safe distance.

The painting was exhibited at a dinner given by the Union League Club of Philadelphia to Gen. Grant, who stood so long looking at it that, dinner being ready, he had to be literally pulled away from it. When Gen. Grant was President, Mr Henry was invited to spend an evening at the White House by Mrs Ann S. Stephens, the authoress. On the anniversary of her birthday, she

had received from the President a large basket of flowers and this evening went to the White House to personally thank him.

The President, understanding [that] Mr Henry was an artist, spoke of this painting, praising it highly. But when Mr Henry told him *he* had painted it, he seemed so young that Grant could hardly believe him until Mrs. Stephens said: "Yes, he did truly. I took many a lunch with him when he was at work upon it, and also watched him, sitting beside him at his easel, while he was working, seeing him painting."

He told him how he had climbed the bank, the guard threatening him. The President said, "Why Mr Henry, why did you not send directly to me, telling me what you wanted to do? I would have given you permission to go any and every where, and you could have made all the drawings you wanted." Then he said, "We are the men who make history, but you are the men who perpetuate it."

This painting is so accurate in every detail that Grant could pick out every tent and even the seat he sat on before his own quarters. The painting is owned by the Union League Club of New York City. [It was sold in 1939. See catalog entry.]

When I first met Mr Henry, it was in the old Tenth Street Studio Building [CAT. 132]. It was a reception day, and all the studios were open to the public, but of course invitation was by card. It seemed to me that all of the noted artists of that day were in that building, Mr Church, Mr T. W. Wood, Mr Gifford, Mr William Beard, Mr J. G. Brown, Mr Hubbard, Mr Whittredge, Mr Bierstadt, Mr Casilear, Mr McEntee, and many others, whom it was an honor to know, and oh! what memories these names all call up. They have all passed into the great beyond now; but surely they have left work behind which speaks of a life well spent.

Mr Henry was painting interiors at that time also [1872 ?] but had just finished *Grant's Headquarters on the James River* now owned by the Union League Club of New York) [subsequently sold—E.McC.] which was being exhibited at Schenedecars Galleries, Broadway below Tenth. At this reception, there was the painting of the old clock on the stairs on his easel. The grandfather's clock, the pleasant room in the background with the sun shining on the old lady reading, the kitten playing with the forgotten ball of wool, are faithful portraits of an actual scene in an old house in Philadelphia. The painting (CAT. 70) is owned by Mr Robert Gordon, formerly of New York, but who is living now in Scotland. It was taken there with other American paintings he owned.

It may be interesting to know that Mr Henry sent a photograph of his painting to Longfellow by a friend; and I only wish I had the letter Longfellow wrote back, asking how it came to be painted, as it was exactly his own idea of the poem, especially of the clock standing on the stairs.

> Somewhere back from the village street
> Stands the old fashioned country seat,
> Across its antique portico
> Tall poplar trees their shadows throw:
> And from its station in the hall
> An ancient timepiece says to all
> "Forever—Never!
> Never—Forever!"

Mr Webster claimed the letter for taking [the photograph to Longfellow] although Mr Henry realized its value, but with his usual kindness let him have it. He was lost on a steamer going to California, all his effects with him, and this letter with them also.

[An unidentified newspaper clipping pasted in the manuscript here completes the story.]

> On Monday (says a London letter) last died Una Hawthorne, the eldest daughter of the late Nathaniel Hawthorne. She was affianced to the late Mr Alfred Webster, and from the time of his death steadily sank and faded out of life—an end sad enough for any one who, with the writer of this, remembers the charm of her childhood and girlhood. It was beside this daughter that Hawthorne watched at Rome so anxiously and long during an illness, from the effects of which neither Una nor her father ever recovered. She was endeared to many friends in England by her many lovely qualities, as well as by her sorrows.

Travels in the South

He always said his work needed a wider scope than just the daily surroundings of his home, and felt that seeing other scenes and peoples which traveling could give him would broaden out his work and give him a larger prospective. He always said "art" should be spread over a large "aria." Consequently the many subjects covering so many different phases [to be found in his work.] South [for example, The Temperance Preacher, (CAT. 212)] as well as north yielded subjects for his brush.

Having a very pressing invitation to visit a friend living at Knoxville, Tenn., he thought it would be a good opportunity to see other places as well and find some new and different subjects. Mr George I. Seney of Brooklyn, calling at the studio and hearing of the proposed trip south, asked him to go to Atlanta, Georgia, and make a portrait picture of an old colored woman, "Aunt Dot," for him. She had been a slave in a noted family there; but when

she was given her freedom after the war, would never leave them although they had been very much reduced in circumstances as many of the wealthy families were. Mr Seney, knowing the family, was deeply interested in her, knowing of her faithfulness, hence the portrait. It gave Mr Henry an excuse to extend his trip for which he was very glad, so we went to Atlanta and the portrait was painted with some rather funny experiences.

"Aunt Dot" lived some way out of Atlanta, about a mile, but not hard to get there if plenty time was allowed for the trip. The little one-horse car would often get off the track and then we would all get out and stand waiting while all the men would lift it on the rail, but sometime the women not feeling they wanted the trouble of getting out sat still, so they were lifted with the car! "Joe," the driver, had taken many errands to do from any one meeting us, such as leaving some vegetables at one house on the way, eggs at another, a large tin wash-boiler at another and so on, the people waiting inside for each delivery, telling stories, the news and gossip of the day. We, of course, as strangers were kindly included, asked our names, and introduced to other and oh! how many *Colonels* there were.

One day Mr Henry forgot his painting materials, so I went back for them. As we neared the hotel where we were stopping, I asked "Joe" if he would, or could rather, wait until I ran up to the room to get the things, it might possibly take a few moments. But nothing loath, he seemed very willing and glad for a rest. Neither were the people in any hurry and waited patiently. One evening we were invited out to tea. About 9 o'clock our hostess asked us if we wanted to ride back, as "Joe" said if so, he would keep the car waiting our pleasure——as this would be the last trip for the day.

A picket broken from the fence could lay where it fell, one waited for another to put it back in place. Men sat on the piazza all day, chairs tipped back, feet on rail, no one hurried, every one took life so easy. Of course Mr Henry saw a picture in the dilapidated car, the equally dilapidated driver "Joe," the disconsolate little old horse; but he saw something deeper, touching in the sadness of it all, for indeed sad it was. The old horse had been a frisky young colt once. The car once had been new and bright with fresh paint, and "Joe"——well, "Joe" was still young in years. [He] would go on and on, year after year, driving the same old horse before the same old car, until by and by "Joe" would be an old man, horse and car long since gone, life over. Isn't there

something more than just a painted canvas, or method of work to see in such a picture?

Mr Henry always saw so much in such a subject, and I think it was just that "inner vision" that appealed so greatly to people—everyday commonplace scenes, in which so many see reproduced scenes and events that have taken place in their own lives. He had great power in creating a very human type, the portrayal of character even in an old cartwheel. The critics have not in many cases undervalued this capacity which made him so dear to the people.

Life in New York

It was one of his greatest pleasures to meet people, especially people of distinction. How vividly I recall those delightful evenings at Chief Justice C. P. Daly's, with that dear old man and his charming wife Maria (CAT. 197; FIG. 58) and also the many weeks spent in their summer home, Sag Harbor. They always gathered around their fireside so many interesting people, and the judge's stories and anecdotes of old New York and the people of that time, the intimates of his younger days, were listened to with such interest and pleasure by all.

Paul Du Chaillu was always a most welcome guest, and his personal stories of his African travels lost none of their interest in his telling; for he was a great *raconteur*, and we were told many incidents not found in his books. Some days we all went out in the judge's sailboat, some days only the judge, Toby his faithful dog and ourselves. [See Sketchbook 18 (CAT. 1202).]

Mr Henry made many warm friends, and a friendship once made was rarely ever broken unless by death. [Among these were] Charles Peterson, the publisher of Philadelphia, [and] Mr Chew of Cliveden, the historic "Chew House" at Germantown, where the battle of Germantown was fought, and where two of Mr Henry's paintings. *The Battle of Germantown* (CAT. 144) and *Reception Given to Lafayette* (CAT. 114) (given in that house) painted for Mr Chew, are now hanging. Mr William Astor, seeing this painting in Philadelphia, gave Mr Henry an order for a copy of it, which was made, (CAT. 161) [he] making some changes so that it would not be a faithful copy.

Mr Henry rarely forgot a face even if seen only in print, although a name would often escape his memory. One day when going to the bank in Paris, there was a large fine-looking man coming out; he was buttoning his glove. Mr Henry had a habit of speaking his

thoughts aloud and instantly said: *"C'est Rossini."* The man, of course, looked up and seeing the young boy regarding him so earnestly said with a smile, *"Oui, mon garçon. Je suis Rossini."* When a student in Philadelphia, taking his usual afternoon walk, he saw a quaint looking little old man dressed in the costume of the early [19th century] knee britches with large silver buckles at the side, a long coat, hair tied in a queue, gold-headed cane. "Sully, the artist," he said. A glow came all over him, for he had seen Sully. Could it ever be possible for him to attain such greatness as that little old man?

He was greatly interested in keeping the old landmarks of the city for coming generations. With Mr Kulp, a noted antiquarian of Philadelphia, he made the restoration of Independence Hall as it is today. In scraping a little of the paint off, he saw [that] the original red and black bricks had been painted over and over. With a great deal of opposition from the city fathers, who said they did not need a young "upstart" from New York coming over there telling them what should be done to one of their own buildings, [he] finally prevailed and the paint was scraped off and the old brick brought from Europe was laid bare. Every one then acknowledged the improvement, and it is still the same now, as it was originally, showing the old red and black brick.

The painting (CAT. 79; FIG. 112) of St John's Church in Varick street is now historical. While at work upon this painting, he went down there over and over again as was his custom, to get the absolutely correct drawings; for fortunately the church was still standing and one of the finest, if not the finest, examples of Sir Christopher Wren in America. Varick street, when it was built, was about the "court end" of the city. The park was beautiful, full of large trees, walks, seats, the houses around it occupied by the noted old families who lived there. Sometime before the park was destroyed to give place to the ugly warehouse now occupying its site, Mr Henry had had photographs taken of it, [as also he had had photographs taken of the New York Hospital on lower Broadway and other public buildings, which are still in his collection, and which have given place long since to many skyscrapers and business houses.] So with the aid of them and stories of how it was filled Sunday mornings with people going and coming from church, he has made two very accurate paintings of the church, the park and Varick street in the days of their early greatness.

He made every effort by writing to press and everyone he could meet to take a personal interest in keeping this beautiful example

of early New York for New York and the beautiful architecture
intact, but to no avail. It was necessary to widen the street. He
wrote to Mr McAdoo and others who he thought had influence.
He suggested that the street should go under the park as he had
seen done in London, and I think it was done for a short time.
But the church was sold, and another of N. Y.'s old splendid
landmarks has been destroyed. I think there was some suggestion
that it should be taken down and rebuilt further uptown; but I
am not sure anything was ever done about it.

To be sure, that part of the city is peopled with Italians or at
least it was when we last saw it. But even so, what a great pity
such beautiful architecture which should be the pride of a city must
be destroyed to give place to money-making ugly buildings.

In looking at the paintings, how much they show of the great
changes which have taken place in New York. What a difference
between the present, with the noisy autos making a walk in the
city not only a brain-racking thing, but a menace to life as well,
and the quiet Sunday morning of that day.

Travels Abroad

We were invited when last visiting Europe to spend some time
in the home of a most interesting French family at Rheims, France.
I do not know that that is a pleasure given to many travelers; but
certainly to us it was one of the events of our life. We are so con-
stantly reminded of the trivial life of the French people and gen-
erally think of them as leading just a life of gaiety and frivolity.

There is no word in the French language which expresses our
English word "home." But we *were* entertained in a French
"home!" And although I have been in English homes [and]
American homes, I have never seen anything more beautiful than
this "home" life of that French family. The great honor paid to
father and mother, the kindly consideration shown to brother and
sister, the loving care of parents for children, and the most charm-
ing hospitality to the guest.

In the early morning until breakfast *a la fourchette*, neither
host nor guest were expected to interfere in any way with each
other, but each followed the duties of the day in their own way.
Meeting each other in the early forenoon, there was a bow and
pleasant "good morning" only. The guest was left to read, write
etc.; the hostess attended to her duties of the day.

In my case it was somewhat changed; for with a most thought-
ful kindness, as I was a stranger and young, with a very imperfect

understanding of French, the eldest son and his wife came to stay
at the father's house, so I would have a companion of my own age.
She spoke English as little as I spoke French, and those many morn-
ing hours what jolly times we had, she with her English dictionary,
I with my French. What funny mistakes we made, and how we
would laugh, and I think she enjoyed it, as I am very sure I did.

The afternoon was given up to drives in the surrounding coun-
try, and the evening to entertainments, neighbors coming in to call
on the American artist and his wife, for in France an artist is held
in decided high esteem. One day a *fête champêtre* was given in our
honor. Early in the morning, servants with tables, comfortable
chairs and hampers laden with the delicious breads, cakes, patties
the French cook makes so temptingly were sent ahead to prepare
for our later coming. Then [came] the ride through that interest-
ing country, the long day in the woods, the tables beside a clear,
sparkling stream, the plentiful wild flowers which as I picked them
(the daisies and buttercups of my homeland) brought a twinge
of homesickness. Then the coming back in the gloaming, stopping
for a large and fashionable dinner at the *Juge de la Pays*.

This whole country was all so highly cultivated at that time
because it was the noted champagne country of France. [Here
were] the estates of the Count of Montebello, of Mon. Heidsick
(Piper-Heidsick) and the wonderful place where we were visiting,
Mr Bouchait, where the great wine vaults were so large that the sons
themselves had to take a guide to go through them.

Day after day [it was] one constant effort for our pleasure and
entertainment. Is it any wonder that in looking back upon that
visit I know there is a beauty in the family of France excelled in no
other country?

If I should go back there today, I would see it all changed. War
has passed over it. Those great vineyards are all torn up. Old
Rheims Cathedral, so rich in history, [is] a ruin. And the dead
friends who made our visit one never to be forgotten [are] all
scattered. I shall never go back again. The dear companion who
made this visit possible for me has gone, too, and I am all alone
now with only memories left.

Coming home, we stopped in Paris. Mr Ridgeway Knight,
[CORR. Nov. 8 '75] a lifelong friend of Mr Henry, was living with
his family in Poissy, and wanting to renew a student friendship,
we went to see them. Meissonier's studio and home was adjoining
Mr Knight's, a gate separating the one place from the other. And
although Meissonier was not at home then, his son Charles was,

and Mr Knight, who was an intimate friend, took Mr Henry there to call.

I wonder if the lay public can ever realize what pleasure it is for one artist to meet another who paints in the same school of art as himself; the comradeship, the pleasure of talking over methods of work, mediums used, colors, oils? It was so in this case. A few panels of Meissonier, given to him [E. L. H.] at that time, had a value no money could buy. Mr Henry had made a little study of Mr Knight's boy (the present artist), which was shown to Meissonier, who praised it highly, saying he regretted very much not being home to meet the American artist, who was very often called the "Meissonier of America."

Meissonier always stood to Mr Henry as the greatest artist of his time. And the pleasure of going to his studio, seeing his studies and sketches and through them his methods [was very great.]

The Passion Play

I have said he was a painter of American subjects which indeed he was. But I should say *almost* everything he painted was Americana; for among his paintings is found his picture of *The Passion Play at Oberammergau*, 1860, (CAT. 99) where he passed two or three months. [He painted also] some subjects in War-wick, England, where we spent two summers, a few in London, also a few in France. (CAT. 123–29.)

It was very interesting to hear him tell of those weeks spent at Oberammergau. [In his painting of Oberammergau, Mr Henry is seen sitting in a back seat sketching in his sketchbook. E.McC.] He was allowed to make drawings of the interior of the open air theater and small sketches in his notebook sitting at the extreme back of the building. But I think he was the only one given that privilege, as at that time the reason for this play was purely its great religious significance, and as such was to impress the people, that anything drawing away one's thoughts from the seriousness of it was not allowed. Dean Stanley was there with Lady Stanley and became greatly interested in the young artist, asking him to visit him in London and giving him a card to Westminster Abbey and St Paul's, as a special privilege to go there to make drawings if he so desired. He met many other travelers of interest, drawn to the place as he was by this wonderful play of the life of our Saviour. But the one who left the more lasting memory even than that of the play, was the old white-headed priest about who [sic] the

children gathered in loving embrace, as he walked in the paths, with his hand always raised in blessing, not only for them, but every one whom he met and upon whom his kind benevolent glance fell.

Mr Henry formed a great friendship with him and was often, as he said, one of those upon whom that blessing was bestowed; and he carried away with him the remembrance of the picture of that kind old man, the little children crowding about him, his hand on their heads, and the sun and shadow making a beautiful picture of old age and youth. When he came back to America, he sent him some book and other things representative of America; for he had through long years of study spent amidst those great mountains and in the quiet of his cloistered life attained a knowledge of the outer world and languages, thus could read and speak English and knew a good deal of America.

Life in Cragsmoor

In his walks how much he saw that escaped the notice of others. His great love for dogs, birds, flowers, early spring with its tender soft color, the blossoming plants, late fall with its glowing golden sunshine and falling leaves, [may be seen in many paintings.] Very often when he was painting out of doors, the birds would come on the branches of the tree under which he was sitting and answer his whistle, never seeming to fear, and once one perched on his palette in the vermillion paint, waiting there a moment and then leaving the prints of its little feet on everything as it flew away. Perhaps his two little black-and-tan dogs, Peter and Charlie, his faithful companions who figured so often in his earlier paintings, may still be remembered, as also the great St Bernard, Don.

He felt for all animals a close human companionship that seemed to draw them to him. And how he would stand entranced over our wonderful mountain sunset, a faraway look in his eyes as if he could see far, far into the beauty beyond. This little poem found in his diary will tell better than I can what his thoughts were then.

Do you ever think when the skies are blue
And the clouds in the west are an amber hue
And a shaded red and a shimmering white
That the Great-All-Father takes delight
In seeing his children rest awhile?
Has the day been weary and the task been long?
Lay care aside, and let a song

Rise to your lips as you gaze at the sky,
For the glories of Heaven seem passing by
And the Great-All-Father shifts the scenes.
For some life seems but an idle play,
While others are burdened with care alway,
But idle seeming oft hides the pain
As the sun oft shines in the summer's rain;
Yet the Great-All-Father sees it all.
And the beauty of sun and cloud and sky,
That gilds the west as night draws nigh,
But shows the love that will safely hold
Each trusting heart of this trusting fold
Till the Great-All-Father leads us home.

And when at last the "beauty of sun and cloud and sky" had
faded slowly away, leaving only the wonderful afterglow, and
that, too, giving place to still evening shadows, with that faraway
look in his eyes almost as if he had seen beyond the cloud and sky,
asking not to be spoken to, he would go in his studio, and make a
little memoranda with his pencil, drawing in the shape and color
of the clouds. And after one of these beautiful sunsets, he would
be so very quiet, hardly speaking again all the evening, but in the
early morning with the help of the sketch [he would] make a study
in oil of what he had seen the night before.

Everyone who knew Mr Henry spoke of his unique and charm-
ing personality. [He had] the gentleness of a child yet the strength
of a man, [coupled with] extreme modesty and a passionate love
of nature, seeing beauty in everything, standing absolutely alone
in his method of work. [One critic wrote that he was] "always
true to his own ideals; for when fashion and art changed from the
carefully thought-out detail and close imitation of nature to that
of the impressionist, he never changed his own way of painting, he
painted as he saw everything." He always worked directly from
nature. Often out in a field with a board fastened to his palette,
he would follow a horse around or, sitting at an easel in the field,
watch them as they moved, studying the play of each muscle.

One day sitting thus absorbed in his painting, he felt a breath
on his head, looking up, [he saw a] horse looking over his shoulder
evidently wanting to see what it was all about. Perhaps feeling
satisfied with the result, [the horse] trotted off, and Mr Henry
went on with his work. (CAT. 1032–50)

Nothing seemed to escape his eyes. He rarely painted a picture
but there was sunlight in it, for his own life was so full of sunlight.

But as in every life there are shadows, so had some of his pictures. And when, in an exception, the canvas showed a dark cloud, there was always a pathos that touched the heart.

A good many of his subjects were found in Ellenville and the surrounding country, as also in his home at Cragsmoor. I am sure he had a warm place in the hearts of these people; for they always showed a pride in him and his work and, whenever he asked anything of them, always willingly allowed him to go wherever he wanted to. In offices or homes he was always welcome.

In his *Lawyer's Office*, (CAT. 264; FIG. 150) a lawyer kindly put his office at his disposal (McCausland, June–Aug. '41, p 137). *Before the Days of Rapid Transit*, (CAT. 907) a water color well known by its many reproductions, was painted from the Delaware and Hudson canal which ran through the village. And although the scene of the painting is laid back in the early days of the state waterways, he could sit with [his] easel in a window jutting over the canal and paint the hills and valleys from nature, the same as when canal and ·canal boats were the means of quiet restful travel.

The shrill whistle of the train comes to me as I am writing. "Rapid transit," the hurry and rush of today, has taken the place of the slow gliding boat, gliding so quietly and peacefully through these lovely mountains and valleys. The old canal boat is gone, the canal bed is covered with grass and weeds, restfulness has given place to restlessness, but the everlasting hills, the peaceful valleys, are the same as when God's hand formed them in the long, long ago.

Again quoting from an article taken from a magazine:

> *Much of Mr Henry's work is the portrayal of the homely everyday life of the village and farmers both in New York State and in the south. There is often much insight into character and portrayal in these paintings of country life. The lawyer and his client in the Country Lawyer are lifelike studies of country character. The old, brown, gray or white country nags that amble through Mr Henry's out-of-doors canvases deserve a word to themselves so true to life they are.*

Important Paintings

In answering the question, "Which of his paintings [did] Mr Henry consider the most important?", I should think first of all would be *The First Railroad Train in New York State*, which now hangs in the Albany Institute of History and Art, (CAT. 257; FIG. 162) presented by Mrs Abraham Lansing of that city. It is the largest and has the most figures in it of any he ever painted.

Sunday Morning (The Old Church at Bruynswick), (CAT. 283; FIG. 67) *A Virginia Wedding* (CAT. 231; FIG. 155), *Country Wedding* (CAT. A-912), *Colonial Wedding* (CAT. A-910), *The Election of 1842* (CAT. 373; FIG. 25), are among the most important as to size and detail. *Before the Days of Rapid Transit* (CAT. 907), a water color, is well known by the many reproductions of it. There are so many, however, I could hardly name them all.

One of the last ones he painted is *St Marks in the Bowery* (CAT. 381; FIG. 215). He was as fond of the many small ones and took as much pains in painting them as to details as the larger ones (CAT. 1213). The people in all his paintings were real people to him, and he always seemed to feel as if they were really living.

His painting of *The First Railroad in New York State,* was maturing in his mind fully ten years before he commenced drawing it on canvas. He had studied every work that could possibly help him, bought books, wagons, costumes and had even drawn it all in on the canvas as he thought it should be, but somehow was not satisfied as to the location from where it started.

He went to Albany to see if he was right, and through the kindness of Mr Abraham Lansing was introduced to some of the men who were there at the time and who not only took him to the place from where it really started but told him of many incidents which happened—how great crowds of people came from all over the country in oxcarts or any and every kind of conveyance to be had, how people had to hold umbrellas over them to keep the sparks from the engine from falling on them, and the umbrellas being burned.

The wagons behind the cars (which were stages put on trucks) waiting for the start so they could race with it; many bets being made of which would get to Schenectady, the end of the journey, first; wives bidding husbands goodby with tears, fearing the awful perils of this dangerous journey; the conductor running by the side of the car; the barrels of wood to feed the engine—all are shown in the picture.

He painted most of this painting at Cragsmoor; for he had an opportunity of getting men to pose for him and would have as many as three or four at once to get the natural action he wanted. And as he had his own wagons he could pose his models as he wanted them, stretches of fields are here, and down in the village of Ellenville is the railroad. And although he had been in Albany

to get the exact place from where the train started after making his drawings there, he elaborated them here from nature.

It is a singular thing to know that in painting so many of the historical subjects how many facts known to only a few came to him. He was one evening describing this picture to a very old man and, as was his custom, illustrating it on a bit of paper, when the old man said, "Why, Mr Henry, I was a young man then and was on that trial trip, sitting in the front stage, and heard an argument between the others that steam could never be used for any practical purpose. Feeling I was too young to take a part in the discussion I was a silent listener. But that evening [I] wrote my article to the New York paper (I think it was the Evening Post) saying before the end of this century we would take our breakfast in Albany, our dinner in Syracuse and supper in Buffalo.

"The editor had a note at the bottom of the article, 'That it was very good and well written [and that] the writer was very young and greatly ahead of his time, [that] perhaps at the end of the twentieth century steam would be used as this young man predicted, but it was hardly possible." Remember, this trip was 1832.

This photograph [FIG. 162] is too small to show all the detail; but if one could know all the painstaking labor to be historically correct and how he worked on it. It was to be finished in time for the Chicago Exposition. But it was not, as he was taken very ill from close application and exhaustion. It was accepted, however, as it was still unfinished. He went to the exhibition hardly well enough and much against his doctor's advice, but was greatly pleased to see it splendidly hung and a medal upon it. He stood modestly back of a great crowd before it, hearing criticism upon himself as the artist and upon the painting, which I am glad to say were not at all adverse.

Names of the passengers shown in the picture, on the Mohawk and Hudson Railway train, 1832, [are], from left to right:

1 Unknown
2 Lewis Benedict
3 Jas. Alexander, Prest., Commercial Bank
4 Chas. E. Dudley, Dudley Observatory
5 Jacob Hayes, high constable of New York
6 Major Meggs, sheriff
7 Unknown
8 Billy Winnes, penny postman

9 Unknown
10 Unknown
11 Thurlow Weed
12 Unknown
13 Ex-Gov. Jos. C. Yates
14 Unknown
15 Unknown
16 John Hampson, engineer.

It was exhibited for some weeks in the Metropolitan Museum, as well as in the Rotunda of the Capitol at Washington, and there was a good deal of pressure brought to bear to have the Metropolitan Museum purchase it.

Through Orange and Ulster counties, . . . there are still standing many of the old stone houses built during the time when it was necessary to build so much for protection against attacks of the Indians who were roaming all over this part of the State. Everything that had any history or story greatly appealed to Mr Henry. Friends living in the vicinity of many of these stone houses had not only told him about them, but had described an old church at Bruynswick, Ulster county . . .

When we went to see it, it was one of those quiet, warm, midsummer afternoons when all nature seems to be asleep and at rest. Only the song of birds was in the air. Our ride led us through a farming country noted for its beauty of landscape and rich pasturage. In the fields around the cows chewing their cuds were lying under the shadow of large trees. A soft purple haze was over the mountains in the distance, and over all a few soft white fleecy clouds in the deep blue sky.

When this beautiful old stone church—standing so stately alone in a broad stretch of green grass, its four [five in reality—E. McC.] large round pillars supporting the roof of the porch, the gallery staircase built under it and leading to the upper story, the weeping willows on the one side, the tall shade trees shading the old graveyard with the antique gravestones with the quaint inscriptions of long ago at the side and back—came in view, it was indeed a very lovely scene [McCausland, June–Aug. '41, p. 29–31]. As Mr Henry stood looking at it, he said it seemed suddenly as if the present time passed away and a curtain rolled back, and he saw it again as it was many, many years ago. He saw a clear bright beautiful Sunday at the close of service; people dressed in the costumes of that time, yellow, green, red, blue, pink and white of the

women and only slightly less sober tints in the coats and breeches of the men, walking away or standing about in groups chatting with each other; wagons, gigs, carriages in waiting, each and every type was all carefully seen, and an air of perfect naturalness to it all. He said it was all as vivid as if he was there.

The pastor, a white-haired old man, seemed happy to see us and welcome us. He had preached there a good many years, he had baptized the little ones, married the older ones and blessed for the last time many of those who were lying so quietly sleeping in the old church yard. He loved the old church and told us so much of its history.

It was built in 1700 [?] during the fearsome sudden attacks of Indians, and during services had always to be protected by a guard walking around it outside. As the men of the congregation came in, each one would stack his gun in the middle aisle, letting the "wimmen folks" go in the seat first and themselves taking the end to be ready to snatch their guns at a first alarm of the "Indians are coming," which was very frequent at that time. Some changes had been made during the many years. Many more new-made graves [are to be seen] in the old churchyard, some trees had fallen with age; but the old church is still just about now as it was then.

Mr Henry slept that night with picture in his dreams. So it was an easy thing to go back the next day with easel, brushes and paints, and make all the sketches from the actual scene and after put the figures in from life as he had seen them in his vision. Friends and relatives all furnished models for each character, his own collection furnishing dresses of both men and women and the vehicles too of that time.

Many people motor to see the old church today and, walking in the aisles where the guns were once stacked, see the reproduction of his painting hanging on the wall. Perhaps the curtain may roll back for them as it did for him, and they may see it all again through his eyes and his work. The reproduction is illustrated on the opposite page, [this refers to Mrs Henry's manuscript; here see Figure 67—E.McC.], the original painting was bought by Mr. Myers of Albany, and I think his daughter still owns it.

One Sunday morning just as we were starting for church, he suddenly said "Please go on, I will join you in a moment." There was a "faraway" look in his eyes, as if things present were forgotten. So I left him and went to church. Service ended, and he had not come. I hurried home wondering what had happened. I found him perfectly absorbed in a drawing. As I entered, he

looked up in surprise, saying "What is the matter? I am coming right away. Don't wait." I told him church was all over. "Why," he said, "you only just went out." The hours had passed for him only as moments, and he had drawn in his noted painting, *A Virginia Wedding,* (CAT. 231; FIG. 155).

Of course, this painting is purely imaginary. The building is drawn from the beautiful southern mansions of the large estates or plantations of Virginia. In his own collection he had the costumes both of men and women of that date, also the stately coach of the same period. The bride, bidding her mother goodby, wears a dress of white gauze with a satin leaf woven into it. It was worn over white satin [made with] plain waist and large puffed sleeves. The small close hat, slippers of white satin, etc. [are of the period.] The groom, bidding the father goodby, has over his arm a silk shawl of brilliant colors brought from China by one of my own ancestors.

As a general thing Mr Henry used only the regular professional model for detail in costumes and poses, but found the character he would need in people around him. In his own quaint way, he would ask any one he saw who happened to represent just the person he wanted in the picture he was at work upon if they would not let him make a little drawing of them [as] he would like to put them in the painting. They might be very much astonished and often were, but I cannot remember that he was ever refused.

In this painting Dr Howard Crosby, our pastor and very dear friend coming to call one day, was chosen as the clergyman and is seen standing in the door. It was such a good likeness of him that at the time of his daughter Agnes wedding, the picture was etched on white satin and presented to her as a wedding present.

Colonial Wedding (CAT. A-910) is also a large painting full of figures. Of course, the scene is in a measure purely imaginary as it represents a time before the Revolution. The date on the old stone house is 1600 [?] and it is one of the stone houses built in the early Indian times. My grandmother, who lived to 96 years old, with her sister owned the historic Sir William Johnson Hall, Johnstown, Fulton county, N. Y., now owned as a museum by the State.

One day when Mr Henry was sitting with her she told him about her marriage, which was a large and grand affair. The farm hands were all invited [and] a table was spread for them on the grounds adjoining the mansion. Friends from far and near came

to celebrate the wedding, a separate table for the friends and family being set at the front of the hall. In that early time there were few carriages in the country, and the wedding journey, only one mile to the village, was taken on a pillion behind grandfather's back, she holding on with her arms around his waist. A little horsehair trunk was strapped on the pack horse to follow.

It was only necessary to tell Mr Henry some story of those early days to get his interest so greatly aroused for a painting to be made, and *Colonial Wedding* was the result of her description of her own wedding. Although it in no way represents the hall at Johnstown where my grandmother's wedding took place (for he laid the whole scene in Virginia) the idea came from her story originally.

The scene is laid in Virginia as being more possible for him to depict a fashionable wedding of the early colonies there. The English officers from the boats lying far off shore [and] the peculiar costumes of the women were all carefully studied. He was criticized as to the boats [his critics] saying [that] boats of that kind were Italian catamorans and such boats had never been seen in America, but he proved by history he was correct.

The bride is here seen riding on a pillion behind the groom; and what a time he had to find some sketch of one! Schoolbooks, libraries, histories were all searched in vain. No early drawings or pictures that he could find gave him any clue as to what a pillion looked like, until about this time being in Washington, D. C., and going through the National Museum, he saw carefully preserved in a glass case by itself a worn old ragged pillion. Introducing himself and saying for what he wanted it, it was taken out of the case, hung on two chairs, and he was allowed to make his studies of it.

The pewter dishes (all pewter dishes were used then) were from a set owned by a friend who had an entire dinner set and kindly loaned them to him. A table was set out of doors with them on it. [The friend was Miss Belle Dellenbaugh.] It was not difficult to get the rest of the needed material, [such as] Indians, Indian women with papooses strapped on [the] back, dogs gnawing bones thrown to them from the table. The English officers, the dresses of ladies of wealth and fashion, are historic. Our own surrounding country supplied the old stone house, and imagination the rest.

Another of his large and important paintings painted more recently is the *Election of 1842* (CAT. 373; FIG. 251) when Polk and Henry Clay were the contestants. One evening calling on a

friend, Mr Henry was shown an old scrapbook, made especially for her at that time. It was full of cartoons and the crude engravings of that day of habits and customs now obsolete, such as colored men going through the street with a long pole borne upon their shoulders, upon which was hung perhaps two or three dozen of the high boots men wore at that time, being taken away to be blackened. [Shown, too, was] the little colored chimney sweep who was sent up the chimney to keep it clean on the inside from the accumulation of soot and perhaps swallows' nests, with him his employer carrying the long stick to which was tied the brooms and brushes used for that purpose. There were also songs of that day, [and] there were the posters with names of contestants for offices, for pasting on signboards.

Mr Henry was greatly interested in this book; for he had for a long time thought of painting an election of about that period, and here in this old scrapbook he saw so many things he needed for the painting but never had been able to get such detail as was here shown. I think perhaps his first idea of such a painting came from seeing an election in Ellenville about 1888, which struck him as being very picturesque.

The village street full of wagons, oxcarts, all kinds of vehicles, then especially the old man being carried in a chair to the polls, [all are] seen in the painting. This man was 90 years old, too feeble to walk but still mentally strong. So fearing to lose a vote, friends carried him in that way so he could cast his vote.

Of course, no women were ever seen in the streets which were crowded with men, but were often onlookers from upper piazzas at the taverns or [from] behind jealously closed blinds; perhaps not so tightly closed, however, that one could not look down to see what was going on, or look up to see some pretty face peeping through them. Oxcarts, wagons, men arguing with others who were doubtful as to their vote and thus could be influenced for the wished for man [furnish detail.]

This painting was exhibited at the World's Fair in California, won its medal, and [was] bought by a gentleman in Massachusetts, I think, who wrote Mr Henry a most charming letter in appreciation of it. A very gratifying thing for an artist to receive, especially when he has worked hard and long and himself feels that he has made a success of his subjects. It is not always selling a painting that is compensation to the artist, but sometimes the kindly word of praise gives such encouragement, that even the paintings still to come show the influence.

I should mention another painting he was very fond of and felt he had great success in painting, *The Landing of the Clermont at Cornwall-on-the-Hudson* (CAT. 323; FIG. 242). He had painted most of this on his canvas, when as usual he wanted to get the detail more perfect. So in passing through Cornwall on his way to New York, he got out of the train and, in making the extra notes as he thought it should be, stood drawing in his sketchbook. An old man walking by stopped to see what he was doing. Mr Henry explained to him.

"But," he said, "mister, you are wrong. My father always came from his farm beyond here with his load of vegetables to send to the city by the boat, I, a little boy with him. The boat landed just below here." He then told him many more details, and his picture had to be all repainted. This tells of his great care to get all details perfect. The painting was bought by Mr G. B. Schley.

Another painting (owned by Mrs Arthur V. Hoornbeek of Ellenville) is *The Floating Bridge* (CAT. 380; FIG. 213). Very fortunately Mrs Hoornbeek has the written description given her by Mr Henry as it was written by him, and which Mrs Hoornbeek has allowed me to copy.

THE FLOATING BRIDGE ACROSS THE SCHUYLKILL, PHILADELPHIA

This bridge was made of logs and planked over and floated on the river, being anchored to prevent it from moving with the current. Generally it sank a little when a heavy weight passed over it, causing the water to run over the bridge and the rims of the wheel. If vessels wished to pass up or down, the bridge was unfastened at one end, allowed to drift down the stream with the current and afterwards hauled back and secured at the shore end.

This picture of this stage was made from a drawing in a book of the time, Mellish's Travels in North America, and shows what a heavy cumbersome affair it was. It had four cross seats with no backs except the rear one, and no way of entering it except by a step over the front wheel and then climbing over the front seat. The "Stage Wagon" was drawn by four horses and often carried the mail. And whatever luggage the passengers carried was generally in small parcels and placed under the seats.

It was hard riding, roads very rough and traveling in those days (unless by private conveyance) very wearisome. This route south by land was from New York across the Jerseys by stage to Philadelphia. Then by this route from Philadelphia to Baltimore, via Chester, Wilmington, Delaware, and was the only route south except by sea in "sailing packets."

An excellent account of the above can also be found in Twining's Diary in America, 1795–1800, republished a few years ago in New York. E. L. Henry, 1918.

Mr Henry always tried to give some deeper meaning to a painting than to show just a pleasing picture. So he stepped away from the general subjects of the country wagon when he painted the very modern painting, *Contrasts* (CAT. 371; FIG. 178). His idea was to represent the extremes in life. The small reproduction in black and white cannot show the full meaning he wanted to convey.

[This painting tells its story clearly.] The automobile and people in it portraying all the ease, luxury, wealth and comforts of living for the comparatively few; the hard-working woman with her bare-footed children, her face seamed with lines of care and the heavy responsibility of life; the expression of longing for something in *her* life of what the other had; the little cigar-box wagon with the wheels made of spools; the old rag-doll in the girl's hand; the meager surroundings; the fat pampered dog with a big ribbon bow on its head safe in the car, not wanting to meet in the open the shabby mongrel who on the contrary would be only too glad to meet him in battle. Many asked him to change the car for the old country wagon, saying it was lacking in picturesqueness, who cared for the automobile in a picture? Who wanted it? [It was] modern, commonplace. But his idea was the story he told in *Contrasts,* the great contrast in the lives of some—"some to work, some to play." But after all which life speaks the more eloquently of what life and its needs really are?

St Mark's Church-in-the Bouwerie (CAT. 381; FIG. 215) is the last large painting he ever painted. The Bowery at this time was the "Boston Road." Traveling from New York to Boston and vice versa was by coach. We of today can hardly realize that then pigs were the scavengers of the city. I can remember the ragman with his dogcart and bells hung on a string coming through the street, crying "Rags, rags!"

While Mr Henry was at work upon this picture, he would go down to the church day after day with sketchbook and pencil to make sure every architectural detail should be correct. He felt these old churches and their surroundings represented much of New York's history. St Mark's had its historical value as well as St Paul's, St John's, St George's and others. He could not write a history of them. But at least he could leave behind him a pictured history of them, for he felt that perhaps in the not so far distance they might meet with the same ultimate ending of St John's, and then these pictures would be valuable for reference. Coming years will show the result of his work.

The Artist

His method of painting was very painstaking, that is, in careful detail. Nothing annoyed him more than to see a wheel, a bit of architecture etc. carelessly drawn or out of keeping with the time it was supposed to portray. Often artists would come to him for help in the picture they were at work upon, asking him if such and such a thing was correct. As usual any near piece of paper and little pencil [would be seized] and he would quickly illustrate the correct thing needed.

I remember once an artist coming in his studio and, seeing a finished painting on the wall, asking if he could copy it. Mr Henry, with a very peculiar and quizzical expression on his face, allowed him to do so, such a request being rather uncommon in artist's etiquette.

He was very liberal, however, in his likes and dislikes of others who painted in a different school, and I have often seen him standing before a painting of Manet and finding many things in it to admire. Only it must have some originality in it, for he had no patience with copyists.

He was very quick to see a subject, but very deliberate in painting. He would be walking in the street when he would see something that would attract his attention. [Then he would] make a little drawing of it in his sketchbook or on any little piece of paper in his pocket, going indoors to elaborate it a little, then get canvas and make still another drawing with charcoal. Corrections if needed would be made now, then when satisfactory [he] would draw or paint it in outline, then rarely change it again. He often said he could always see the whole picture fully finished when he commenced. It was only to get it on canvas as he saw it.

This only applies to his smaller out-of-doors canvases. The large historical subjects would seem to flash in his mind and be drawn on paper. Then what study of books, places, dresses, character. The paintings of *The First Railroad Train* and of an *Election of 1842* were maturing in his mind fully ten years before he even commenced his drawing, and oh! what infinite patience it took for perfection.

St Mark's was a labor of love. In truth everything he painted was a labor of love; for he lived in his painting. People and places [from the past] were real [and] living to him. He used models of course all the time, people all around him; but they only represented the *character* he wanted.

The people in his paintings and on his canvas were to him truly alive. Village streets and the country scenes which he loved so to paint, of course, were all from the immediate time; but an old chair, an old clock, an old piece of china, was full of memories of those who had used and handled them. He saw so much; yes! in the present, too, as well as in the past.

He loved the village street, but it was much more often the little village street of a bygone generation. Old carriages, the call being made in them before the door, men and women standing by the side, it all seems quaint to us today; but it was not then, and he, as he painted them, lived in that time.

The Man

I do not think he would ever voluntarily enter any argument which might be going on, unless it might be on art, architecture or perhaps some question of an early period of furniture, vehicle, drawing of wheel or in fact anything pertaining to early colonial life, where indeed his opinion was often asked as he was considered an authority. As it was always easier for him to make a little drawing of what he wanted to describe, out would come a bit of pencil which he always carried, an envelope or handy margin of newspaper, and I wonder how many of these little drawings are still in existence, for they were so often preserved by the one he was talking with.

One evening at the Salmagundi Club there had been a dinner given for an artist or guest. As he was one of the oldest artists there and perhaps representing a special period of art, he was suddenly called upon to make a speech for which he was utterly unprepared.

Looking at the younger men who were very critical of his manner of painting, he said:

"It seems to me that I can see a long bench. Many years ago I was sitting at the near end of it. I was full of ambition, aspiration and dreams; but someone coming in I moved down, and he took my seat. Then another coming in, that end seat was given to him, and I moved on again. Then another and another came, taking that end seat again and again. The place I occupied was taken.

"It seemed only such a short time ago when I sat up at that end. But now at last I am way down, and soon my last place will be occupied by another. Looking back at that other end, I can

see new bright faces as they come in full of life, full of brilliant hope. Along the line faces had grown older as they moved down the bench, life becoming more serious to each one. Their dreams were changing, too, somewhat, perhaps; their eyes were seeing more distant beauty, methods of work were changing."

Then speaking more directly to them, he said:

"You younger men of today look upon the art of the early Hudson River School as old and antiquated. But you who are now on that end of the bench where I once sat, must move on and still again move on. Younger men will take your places. The art of this your day will change, too, for changes are in everything around us. You too will meet with harsh criticism by and by.

"Think of this and remember each year is pushing you on, and by and by you will be looking back as I am. Remember this, and be kindly in your thoughts of those who have gone before you. Think of them not with ridicule of their way of painting the beautiful, but as the men who opened the way which you are walking in now. Your method of work is different; but it all leads up, up into the great realm of art."

He was very fond of collecting not only everything that would be useful in his work; but an old mahogany table, chair, desk, clock, even old china, not only had value to him for its age and beauty of workmanship, but he would draw some story or some allegory from it.

At a dinner given to him on his 75th birthday, after many kind wishes and congratulatory speeches, he in answering [spoke somewhat as follows:]

Often, as he wound up the old tall clock which stands in the hall of his home in Cragsmoor, he thought it seemed so emblematic of life. How well-made and strong it must have been when it left the maker's hands in the early 18th century. How long it had ticked away the many years, months, weeks, days, moments, never losing a moment, just ticking, ticking on and on. But now, after so many years of work, once in a while it would stop and it was necessary to call in the clock doctor, who said some little thing had happened, it only needed a little looking over.

For some time it went on again, almost as well as ever. Then one day it commenced to go a little slower again. The hands did not move quite so easily. They seemed to be getting a little stiffer. The clock doctor was sent for to see it. Looking it over again, he said some of the wheels were out of order now, the cogs were getting worn, the clock was getting pretty old.

A few more years passed, and now the bell, which had always been so clear and loud, seemed hushed. Still the old clock ticked on, but slower, always slower, and losing time more often. Again the clock doctor came. He shook his head, saying the clock was very old, he could do but little more for it. All the works were worn out.

Tick—tack—tick—tack. Just a little while longer, and then the old clock stopped. There was no more use sending for the clock doctor now. For the old clock's work was finished.

This is not my story. I have only tried to tell it as he told it, the story the old clock told him.

Mr Henry was very fond of having his friends come to see him. His hand was always outstretched in welcome at his door, and a warm bright smile on his lips. People have written me, [asking] can they come to see the home where he lived, his studio where he painted so many of his pictures. Oh yes! But the dear hand with its warm clasp of welcome, the bright personality which made the visit so pleasant, is no longer there.

The old clock still stands in the hall as he left it. It is a very old clock; but still its slow solemn tick—tack—tick—tack tells me of quickly passing time. Yet as I wind it, I know it will not be long before its long work will be done, and the old clock will stop for evermore.

Appreciation

Mr Henry was a member of the Lotus Club, the Salmagundi Club, the Union League Club (where he served on the art committee for some time), the Century Club, of course one of the older members of the Academy of Design, the Water Color Society, the Artists' Fund [Society] and the New York Historical Society, when it was on Seventh avenue near Tenth street.

But as he grew older, he grew more fond of his own fireside. Feeling he could not go to all the meetings of the different societies, he resigned his membership in the other clubs and only retained it in the Century Club, where he greatly enjoyed meeting of an evening the friends he had known so long.

The passing years took many of those friends away who like him were growing older, so those evenings together became more and more rare. But the "monthly meetings" were seldom missed; the collection of paintings by artist members, the talks on art; the

meeting of friends was not only a very great attraction but also an inspiration as well.

He generally exhibited one or two of his own paintings and liked to hear a criticism upon them. But his shy pleasure was great when strangers asked to be introduced to him and told him of their admiration of his work.

But perhaps I can introduce here better than elsewhere the appreciation in which he was held in this club by copying from the report of the board of management of 1921:

> Fate has been kinder to the Century membership in 1919 than the year before. But when we read the names, recall the friendly faces and seem to hear again the familiar voices which were so long a part of the club's intimate life, we begin to understand how much it is personality that counts.
>
> In our group of men of art and letters, the hand has touched lightly as to number but heavily when measured by achievement. [J. Alden Weir's death had just been spoken of.] An artist of a curiously different quality ended his career when Edward Lamson Henry died at his home in Cragsmoor. Henry was a painter of American life in its picturesque aspects, past and present. The type of his work was purely national; the interest human and genuinely historic; the touch was always that of the masterly genre artist.
>
> The public, quick to recognize and appreciate such work well done, has long been familiar with The First Railway Train in America and The Erie Canal Packetboat, even when it had not knowledge of the painter. It understood, as the artist meant it to understand, that the canvas was giving a clear and vivid glimpse of life as it really was, in the United States of 1832 and 1840. To Henry, even an oldtime house or church made its own appeal; his interesting study of the Westover mansion of Virginia is on the walls of our club. But he was fondest of bringing human figures upon his canvases with a realism from which, as one of his fellow-artists said of his oldtime coach arriving at a southern ferry, one actually "feels the wind, the slapping of the water," even "the vexation of the travelers."
>
> Mr Henry's house at Cragsmoor was a museum of curios after his own heart and in line with his peculiar genius. A collector of actual stage coaches and postchaises of a century ago stands in a class by himself; and when these unusual relics were supplemented by the actual costumes, the arms, even the tools of that distant period, it is easy to understand how the atmosphere of his mountain retreat, was the atmosphere of his paintings.

|Pasted into the manuscript here is "A Memorial from the Annual Report of the President, Mr Herbert Adams, N.A., read at the Annual Meeting of the National Academy of Design, April 28, 1920," which reads as follows:

> No one can doubt the peculiar historic interest as well as the genuine charm of the paintings of Edward Lamson Henry, a full-fledged Academician for over half a century. Mr Henry was born in Charleston, South Carolina, January 12, 1841; was elected an associate in 1867; an academician in

1869. *Although he studied in Paris under Gleyre (that same Gleyre who had perhaps more influence upon the art of Whistler than is generally admitted), Mr Henry's art has a characteristic American quality, no doubt enhanced by his subjects, yet not wholly due to them. In depicting on canvas the manners and customs, the inventions and habitations, the politics and pioneering of his native country during the first half of the nineteenth century, Mr Henry stands unrivalled. His contribution to our art is historic, unique. No other painter approaches him in the delicate delineation of such subjects as* The First American Railway Train, *Albany Historical Society.*]

Conclusion

In closing, I realize how inadequate this attempt to tell something about the life and work of Mr Henry is. There could have been much more written; for it was such a full and long life of work. I also realize how I have failed in so much I wanted to write.

Those who knew him intimately knew of the charm of his personality, the unconsciousness of himself which was one of his greatest charms. One must have known him personally to know the quaint, quiet humor which rarely left him, that was in himself.

I have also attempted to answer some of the questions asked me about his paintings, but feel the illustrations I have selected are the better answers. I could only select a very few out of the many he painted, equally important as these. His subjects were chosen not because others might care for them, but he cared for them himself. The men and women of his canvases seemed to move before him as living human beings and were as much alive to him as people of today who still walked, breathed and thought.

He was very broad in his outlook of art and always saw much to admire in the early impressionists. He had great love for music. His love for books, his love of nature, his love of everything human, of everything of beauty, his method of work, I have tried to describe.

I was asked what influence the school of art in which he painted had upon the art of today; but I do not feel I am capable of answering such a big question as that. But what influence has a Dickens upon the books of today? Is [sic] *Nicholas Nickleby, Little Dorritt,* forgotten? What influence have the sweet old songs we still so love to hear upon the music of today: *Home, Sweet Home, Annie Laurie?* In exhibitions, before what pictures do we see the greater mass of people standing the longest? In a country home or the farmer's cottage, is it not some print cut from a magazine or newspaper which tells some simple story we see hanging on the wall?

And in galleries and private collections do not people linger a little longer over the Meissoniers and Knauses?

The last winter of Mr Henry's life was spent in Daytona, Fla. [He was] sent there by his doctor after a very serious sickness. Coming home in the early spring, I asked him if he felt he had benefited by it. He answered so full of enthusiasm:

"Oh, yes, I feel I am still to do my best work!"

Two days after, God called him, and he quietly fell asleep.

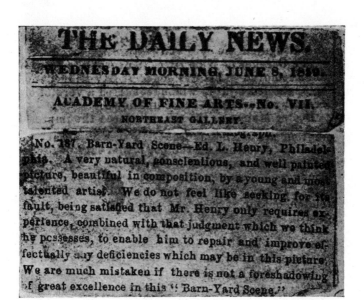

Figure 228 Henry's first press notice in 1859, slightly enlarged, from the original clipping in the New York State Museum

Figure 229 *Off to Europe,* 1860: CAT. 17. A pen-and-ink sketch. Collection, New York State Museum

[347]

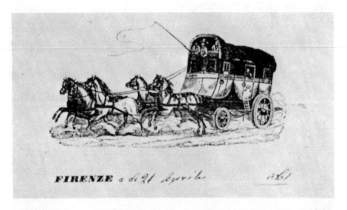

Figure 230 From a ticket for diligence fare from Florence to Genoa,
April 21, 1861. Collection, New York State Museum

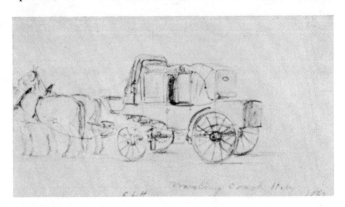

Figure 231 *Traveling Coach, Italy*, 1862. A drawing in Sketch-
book 2: CAT. 1186. Collection, New York State Museum

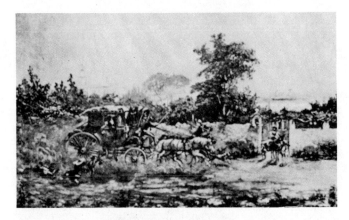

Figure 232 *An Italian Vettura*, 1863: CAT. 34

[348]

Figure 233 *In Bella Firenze*, 1861: CAT. 20. Collection, New York State Museum

Figure 234 *Colico, Lake of Como*, 1861: CAT. 22. Collection, New York State Museum

Figure 235 *Cannstadt in Wurtemberg*, 1861: CAT. 25. Collection, New York State Museum

Figure 236 *In Stuttgart*, 1861: CAT. 26.
Collection, New York State Museum

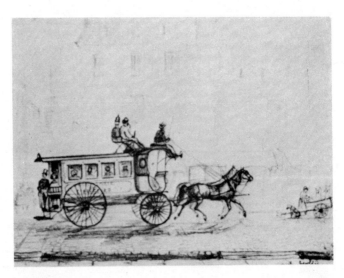

Figure 237 *Berlin Omnibus*, 1861: CAT. 27. Collection, New
York State Museum

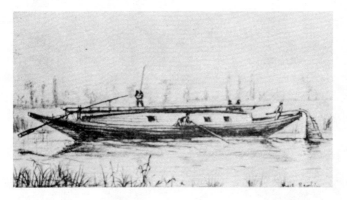

Figure 238 *Prussian Canal Boat*, 1861: CAT. 28. Collection,
New York State Museum

Figure 239 *In Amsterdam*, 1862: CAT. 30.
Collection, New York State Museum

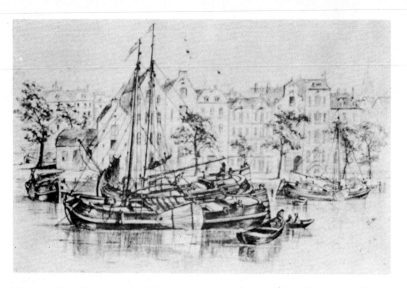

Figure 240 *Rotterdam*, 1862: CAT. 31. Collection, New York State Museum

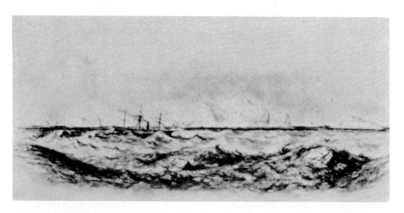

Figure 241 *Icebergs off Banks of Newfoundland*, 1862: CAT. 32. Collection.
New York State Museum

Figure 242 *The Clermont*, 1904: CAT. 323

Figure 243 *Near the Brandywine:* CAT. 939. An etching by
W. G. Bauer from a Henry painting. Collection, New York State
Museum

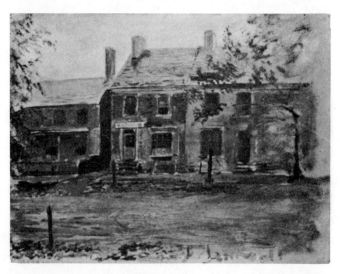

Figure 244 *Stonington:* CAT. 1076. Sketch in oil on canvas.
Collection, New York State Museum

Figure 245 *On the Old Gully Road*, 1889–91:
CAT. 247

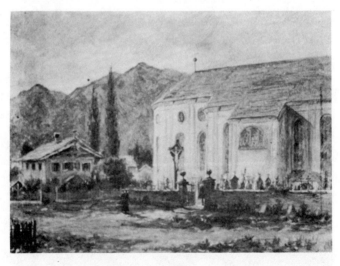

Figure 246 *Study for "Alt Kirche"*: CAT. 1080. Collection,
New York State Museum

Figure 247 *St John's Park and Chapel, New York, 1905;* CAT. 324

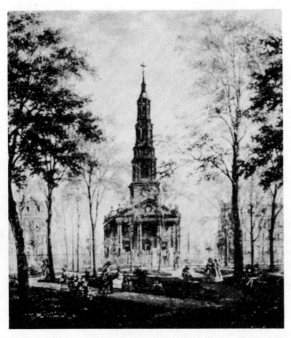

Figure 248 *St John's Chapel,* [1905 ?]: CAT. 325

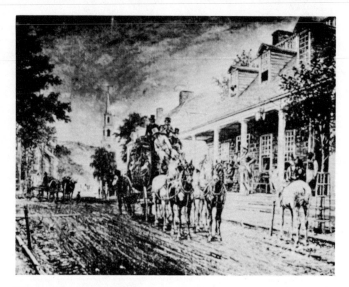

Figure 249 *In the Old Stagecoach Days,* 1907: CAT. 341. Collection, Martin E. Albert

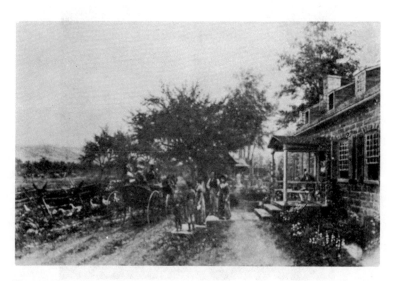

Figure 250 *News of the War of 1812,* 1913: CAT. 366. Collection, Martin E. Albert

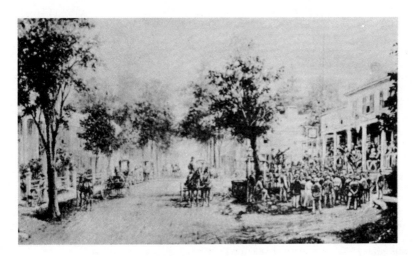

Figure 251 [*Getting Out the Vote*], 1913: CAT. 368

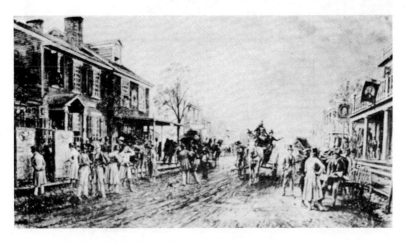

Figure 252 *Election Day*, [1914 ?]: CAT. 373

[357]

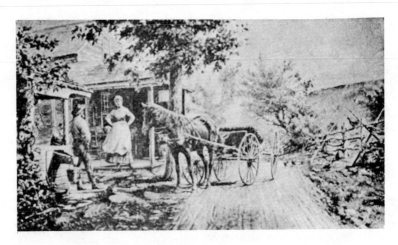

Figure 253 *Forgotten*, 1888: CAT. 208

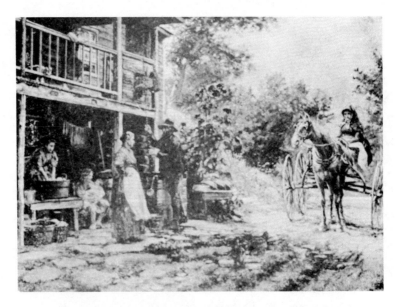

Figure 254 *Off the Main Road:* CAT. 941

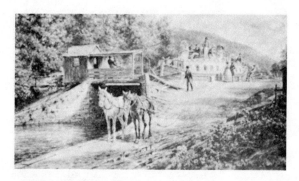

Figure 255 *Entering the Lock*, 1899: CAT. 289. Collection, Albany Institute of History and Art

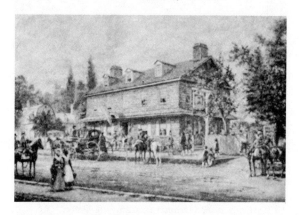

Figure 256 *The MacNett Tavern*, 1904: CAT. 317. From a reproduction in an unidentified catalog. Collection, Albany Institute of History and Art

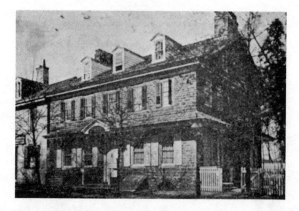

Figure 257 "The MacNett Tavern, Germantown road. Used by Lord Howe as Hd Qtrs . . . Oct. 4, 1777 . . . From Wm Kulp, Antiquary, 1868"

Figure 258 *Tenth Street Studio Building*, 1877: CAT. 132. Collection, National Academy of Design

Figure 259 *Marketing Saturday Morning*: CAT. 936

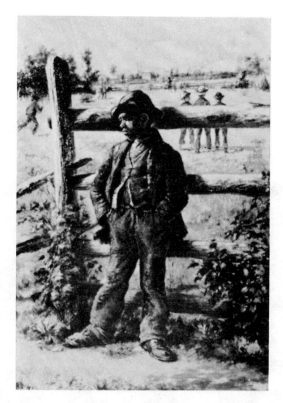

Figure 260 *Happy-Go-Lucky, circa* 1890: CAT.
A-241. Collection, Guy Mayer Gallery

Figure 261 *What Luck,* 1910: CAT. 941

Figure 262 Mrs E. L. Henry at her Cragsmoor home in 1914

Bibliography

Abbott, Berenice
1939 Changing New York. Photographs of New York by Berenice Abbott; explanatory text by Elizabeth McCausland. New York. Dutton. 307p.
1941 A Guide to Better Photography. New York. Crown Publishers. 182p., 71 pl.

Anonymous
1859 "Academy of Fine Arts No. 187." New York Daily News, June 8.
1910 Encyclopedia Britannica, 11th edition, 13:299. New York. Encyclopedia Britannica, Inc.
1912 Cragsmoor Journal, v. 10, Nos. 3–6, August 1, 15, September 1, 15. Cragsmoor, N. Y.
1914 The Birthplace of Mary Baker Eddy: Concerning a painting by Edward L. Henry, entitled The Uplands at Bow portraying the birthplace of Mary Baker Eddy. Concord, N. H. Woodbury E. Hunt Company. 12p.
1917 "In the World of Art." New York Sun. September 30.
1918 Art exhibition for the benefit of the Red Cross, August 6–7. Ellenville, N. Y. 4p.
1918a Ellenville Journal, July 18, p. 1, col. 4; July 25, p. 1, col. 5; August 1, p. 1, col. 4. August 8, p. 1, col. 1. Ellenville, N. Y.
1918b Ellenville Press, July 18, p. 1, col. 5; August 1, p. 1, col. 2; August 8, p. 1, col. 2. Ellenville, N. Y.
1919 Ellenville Press, May 15, p. 1, col. 2. Ellenville, N. Y.
1919a Obituary of E. L. Henry. American Art News. May 17.
1919b Obituary of E. L. Henry. Art Annual, 16.
1928 Cragsmoor Echo, August 6. 4p. Cragsmoor, N. Y.
1928–36 Dictionary of American Biography. 20 vols. New York. Scribner's. 8:547–48
1940 Recollections of Cragsmoor: manuscript notes on a meeting held at Cragsmoor August 30, 1940. Lent by Miss Annette Mason Ham.

Baur, John I. H.
1940 An American Genre Painter: Eastman Johnson, 1824–1906. Brooklyn. Brooklyn Museum. 128p. with plates.
1942 Catalog of an exhibition of drawings and paintings by William Sidney Mount, 1807–68. Brooklyn. Brooklyn Museum. 48p. with plates.
1942a John Quidor, 1801–81. Brooklyn. Brooklyn Museum. 66p. with plates.

Benezit, Emanuel
1924 Dictionnaire critique et documentaire des peintres, sculpteurs, dessinateurs et graveurs. 3 vols. Paris. E. Grund.

Benjamin, S. G. W.
1880 Art in America. New York. Harper. 214p.

Burroughs, Louise
1939 The Moses Tanenbaum Bequest. New York. Metropolitan Museum of Art Bul., 34:137–38.

Cahill, Holger
1936 New Horizons in American Art. New York. Museum of Modern Art. 176p.

Century Association
1942 An Exhibition of Oils and Water Colors by Edward Lamson Henry, N.A. (1841–1919) April 7 to May 9, 1942. 4p.
 With a note of acknowledgment to the New York State Museum for assistance in assembling the exhibition.

Champlin, J. D. jr, and Perkins, C. C.
1886–87 Cyclopedia of Painters and Paintings. 4 vols. New York. Scribner's.

Champney, Lizzie W.
1885 The Summer Haunts of American Artists. Century, 30:845–60.

Corcoran Gallery of Art
 1920 Catalog of Paintings. Washington, D. C.

Cowdrey, Bartlett, *compiler*
 1943 National Academy of Design Exhibition Record: 1826–1860. 2
 vols. New York. New York Historical Society.

Cowdrey, Bartlett, & Williams, Hermann W. jr
 1944 William Sidney Mount: 1807–1868, An American Landscape and
 Genre Painter. New York. Metropolitan Museum of Art and
 Columbia University Press.

Downes, William Howe
 1911 The life and works of Winslow Homer. Boston and New York.
 306p.

Downtown Gallery
 1939 "Nature-Vivre" by William M. Harnett: an exhibition of paintings.
 New York. 16p.

Dunbar, Page
 1908 A Painter of the Good Old Times. Broadway Magazine, 21:221–27.

Earle, Alice Morse
 1900 Stage-coach and Tavern Days. New York. Macmillan. 449p., 7
 illustrations by E. L. Henry.

Fielding, Mantle
 1926 Dictionary of American Painters, Sculptors and Engravers. Phila-
 delphia. 433p.
 Privately printed.

Fuller, Lucia Fairchild, A.N.A.
 1920 The Field of Art: E. L. Henry, N.A. Scribner's Magazine, 68:250–
 56.

Gill, James D.
 1878–1928 Catalogs of the annual Gill exhibitions in Springfield, Mass.
 A complete file may be consulted at the George Walter Vincent
 Smith Art Gallery, Springfield. The Metropolitan Museum of Art
 Library has catalogs for 1903–05, 1908–10, 1912–13, 1915–21.

Goodrich, Lloyd
 1933 Thomas Eakins. New York. Whitney Museum of American Art.
 225p., 72 pl.
 1944 Winslow Homer. 2 vols. New York. Published for the Whitney
 Museum of American Art by the Macmillan Company.

Hartmann, Sadakichi
 1932 History of American Art. 2 vols. Boston. Page.

Henry, E. L.
 1864–68 Photographs of Paintings by E. L. Henry.
 An album 13½ x18½ inches in half leather, with the above title
 and dates tooled on cover. The album, which is in the Henry Col-
 lection, New York State Museum, was annotated by the artist; it
 covers work done as late as the 1890's.

Horwitt, J. B.
 1942 Our Russian Allies in the Civil War: How the Surprise Arrival of
 Two Russian Naval Squadrons Helped Lincoln Preserve the Union.
 Vogue, November 1, p. 62, 63, 83.

Hourticq, Louis
 1937 Harper's Encyclopedia of Art: Architecture, Sculpture, Painting,
 Decorative Arts. 2 vols. New York. Translated under the super-
 vision of Tancred Borenius, Ph.D., D. Litt.; fully revised under the
 supervision of J. Leroy Davidson and Philippa Gerry.

Isham, Samuel
 1905 The History of American Painting. New York. Macmillan. 573p.
 1927 The History of American Painting; with supplementary chapters by
 Royal Cortissoz. New York. 608p.

John Levy Galleries
1941 Our Own—Our Native Art: 1770–1900. Check list for an exhibition of American paintings, May 10–June 15. New York. 4p. Mimeo.

Klackner, C. (hristian)
1906 Reproductions of the works of E. L. Henry, N.A.: etchings, photogravures, fac-similes, platinotypes. With 80 entries and 60 illustrations. 16p. 12x9¼ in.
Another edition, of which there are two copies in the Henry Collection, New York State Museum, has 12p. with 47 entries and 40 illustrations.

Kurtz, Charles M. ed.
1893 Illustrations from the Art Gallery of the World's Columbian Exposition. First edition. Philadelphia. 383p.

Low, Will
1919 New York Evening Post. May 12.

Lutz, Grace Livingston Hill
1908 Marcia Schuyler. With 6 illustrations in tint by E. L. Henry. Philadelphia and London. Lippincott. 348p.
1915 Miranda. With 5 illustrations by E. L. Henry, N.A. Philadelphia and London. Lippincott. 344p.

McCausland, Elizabeth
1941 Field Notes on Henry Survey. Three manuscript volumes with photographs. June 13–August 16. In the Henry Collection, New York State Museum.
1941a E. L. Henry (1841–1919). The Springfield Sunday Union and Republican, August 17, p.6E, cols. 1–6. Springfield, Mass.
1942 Photography as Factor in Social Development. The Springfield Sunday Union and Republican, August 23, 30 and September 6, p. 6E, cols. 1–6. Springfield, Mass.

Marquis, A. N.
1918–19 Who's Who in America. 10:1260

Mayor, A. Hyatt
1944 Photographs by Eakins and Degas. New York. Metropolitan Museum of Art Bul. (new series) v. 3, No. 1, Summer 1944, 1–7.

Metropolitan Museum of Art
1939 Life in America: A Special Loan Exhibition of Paintings held during the period of the New York World's Fair, April 24 to October 29. With a preface by William M. Ivens jr and an introduction by Harry B. Wehle. New York. 230p. with plates.

Miller, Dorothy C.
1943 Romantic Painting in America. With James Thrall Soby. New York. Museum of Modern Art.

Murrell, William
1938 A History of American Graphic Humor (1865–1938). 242 illus. New York. Macmillan. 272p.

Museum of Modern Art
1930 Homer, Ryder, Eakins. With an introduction by Alfred H. Barr jr and essays by Frank Jewett Mather, Bryson Burroughs and Lloyd Goodrich. New York. 64p. with plates.
1932 American Folk Art: The Art of the Common Man in America, 1750–1900. New York. 52p., 172 pl.
1940 Italian Masters. New York. 64p., 34 pl.
1944 American Battle Painting: 1776–1918. Washington, D. C., and New York. Published by the National Gallery of Art and the Museum of Modern Art.

Myers, Jerome
1940 Artist in Manhattan. New York. 263p. with plates.

National Academy of Design
1859–1919 Catalogs of annual exhibitions.
 Henry material is found throughout these years.
1925 Commemorative Exhibition by Members of the National Academy of
 Design, 1825–1925. New York. 160p. with plates.

National Academy Galleries
1942 Our Heritage. New York. 64p. with plates.

National Gallery of Art
1944 American Battle Painting: 1776–1918. *See* Museum of Modern
 Art, 1944.

Neuhaus, Eugen
1931 The History and Ideals of American Art. Stanford University Press.
 444p.

New York Public Library
1932 American Historical Prints. Early Views of American Cities etc. New
 York. 327p.

Ortgies & Company
1887 Catalog of the Collection of Mr E. L. Henry, N.A. Paintings, rare
 old engravings, colonial furniture, bric-a-brac. New York. 24 p.
 Of the two copies in the Henry Collection, New York State Museum,
 one was annotated by the artist with prices brought at the sale.

Pomeroy, E. S.
1943 The Visit of the Russian Fleet in 1863. New York History, v. 24,
 No. 4; p. 512–17.

Porter, James A.
1943 Modern Negro Art. New York. Dryden Press. 272p. 85 halftone
 plates.

Rich, Daniel Catton
1942 Henri Rousseau. New York. 80p.

Richardson, E. P.
1939 The Way of Western Art, 1776–1914. Cambridge, Mass. 204p.

Riverside Museum
1939 Lewis Hine: Retrospective Exhibition, 1905–38, of Documentary
 Photographs, January 11–February 26. With a foreword by Eliza-
 beth McCausland. New York. 12p.

Sciaky, Leon
1941 The Rondout and Its Canal. New York History, 22:272–89.

Sheldon, G. W.
1879 American Painters. New York. Appleton. 184p. 83 pl.
1890 Recent Ideals of American Art. 2 vols. New York and London.
 Appleton.

Soby, James Thrall
1943 American Romantic Painting. *See* Miller.

Story, William W.
1880 *In,* Reports of the United States Commissioners to the Paris Universal
 Exposition, 1878. Vol. 2: Fine Arts, Education, Wood Carving,
 Textile Fabrics. Washington. Government Printing Office. 1–181.
 548p.

Strahan, Edward, *pseud.*
1879 The Art Treasurers of America. 3 vols. Philadelphia. G. Barrie.
 See Shinn, Earl.

Taft. Robert
1939 Photography and the American Scene. New York. Macmillan. 546p.

Thieme, Ulrich and Becker, Felix
1907–39 Allgemeines Lexikon der Bildenden Kunstler. 33 vols. Leipzig.

U. S. Centennial Commission
1876 International Exhibition, 1876, Official Catalog, Art Gallery and Annexes. Philadelphia. John R. Nagle and Company. 346p.

Warner, Lucien Calvin
1914 The Story of My Life during Seventy Eventful Years. 1841–1911. New York. 243p.
 Privately printed.

Waters, Clara E. C. and Hutton, Laurence
1884 Artists of the Nineteenth Century. 2 vols. Boston. Houghton, Mifflin.

Wehle, Harry B.
1932 Samuel F. B. Morse: American Painter. New York. Metropolitan Museum of Art. 49p., 59 pl.

Whitney Museum of American Art
1935 American Genre: The Social Scene in Paintings and Prints. With an introductory essay by Lloyd Goodrich. New York. 32p.
1937 Winslow Homer Centenary Exhibition. With an introductory essay by Lloyd Goodrich. New York. 48p.
1937 New York Realists. New York. 38p.
1938 American Landscape Painting. With an introductory essay by Lloyd Goodrich. New York. 48p.
1942 A History of American Water Color Painting. With an introductory essay by Alan Burroughs. New York. 32p.

Whittredge, Worthington
1942 The Autobiography of Worthington Whittredge, 1820–1910. Edited by John I. H. Baur. Brooklyn. Brooklyn Museum Journal. 116p., 39 ill.

Williams, Hermann W. jr
1944 William Sidney Mount: 1807–1868. See Cowdrey.

Wilson, J. G. and Fiske, John
1887 Appleton's Cyclopedia of American Biography. New York.

INDEX

Abbott, Berenice, cited, 106, 120

Accounts of sales, 57

Acknowledgments, 18–22

Adams, Herbert, memorial to Henry, 344

Addresses, list, 68

After David, 241

After the Battle, 29, 86, 161

After the Rain, 232

After the Shower, 196

Albany Institute of History and Art, 57

All Hallows, Great and Less: Thomas Street, London, 170

[Alone], 221

Alt Kirche, Oberammergau, 32, 166, 246

American Art News, appreciation from, 67; letter from Henry printed in, 173

American artists, lack of support for, 107

An American Railroad Station, 87, 157

Americana, 28; interest in, 312, 314; list, 86

Among the Flowers, 182

The Ancestral Home, 97, 172

Antiques, interest in, 50; sale of, 46

Appearance, 55

Apple Trees, 241

Apple Trees in Bloom, 241

Appreciations, 64; by Mrs Henry, 343; contemporary consensus, 116–24

The Approaching Train, 89, 175

The Arbor, 241

Architecture, alteration of detail, 114; interest in, 27, 48; interest in preservation of St John's Church, 324; photographs of architectural subjects, 99

The Arno, Florence, 28, 85, 153

Arrest of Major William Dyre for Treason in Wrongfully Taxing the People of New York, 94, 213

The Arrival of the Stage, 211

Art, efforts for public support of, 107

Art education, 26

Art standards, esthetic considerations, 107–17; Post-Civil War period, 101–6

Artistic traits, evaluation by Mrs Henry, 340

Asleep, 241

Astor House, 3rd Ave. Line, 27

[At Dusk], 232

At Mrs Terwilliger's, end of Oct. 1867, 37

At Napanoch, 233

At the Ferry, 233

[At the Locks], 195

At the Opera, 233

At the Toll Gate, 90, 96, 192

At the Washtub, 248

At the Watering Trough, 206

Atlanta, experiences in, 322

Au Fond Du Lac, Colico, Lac Du Como, 27, 85, 151

An Autumn Morning in Virginia, 233

An Autumn Study, 233

Avery, S. P., patron, 318

Awards, 56

An Awkward Throw, 174

Ayer, Ed. E., sketch for, 61

The Back Fence, 241

Back Yard at Cragsmoor, 241

[Backdoor Conversation], 189

Banquet Hall, Banbury, 241

Banquet Hall, Banbury: Entrance Door from Alley Way, 241

[Barn Interior], 85, 149

[Barnyard], 85, 150

[Barnyard: 1], 85, 149

[Barnyard: 2], 85, 149

Barnyard Scene, 84, 112, 150

[Barnyard Scene], 85, 150

Barnyard Scene near Philadelphia, 85, 149

Barnyard series, 26

Bathing Hour, East Hampton Beach, 97, 177
The Battery at New York in 1660, 93, 207
The Battle of Germantown, 88, 177
The Battle of Germantown, Pa., Oct. 4, 1777, 48, 88, 175, 323
Baur, John I. H., cited, 64, 102, 103, 110, 114; quoted, 82
Beach Wagon, 97, 241
Bear hill, 37
Bear Hill, 40, 41, 94, 115, 220
Beard, William H., 54
Beekman Coach, about 1772, 52, 248
Before the Days of Rapid Transit, 233, 330, 331
Below Mauch Chunk on the Lehigh River, 149
Benjamin, S. G. W., cited, 104
A Berlin Omnibus, 27, 85, 152
Bessie and Peter, 248
Bethlehem, Pa., 1859, 26, 85, 148
Bibliography, 363–67
Bidding Good Bye, 201
The Bill Collector, 90, 92, 222
Billings, John S., 90, 122, 178
Birthplace, 25
Bloomer, Nelly, 90, 122, 190
Books, use of, 100
Botsford, Legrand W., 38, 41, 45, 98
Botsford, Thomas, 44
Bound to Cut a Shine, 91, 189; price, 58
Bracing Up, 44, 89, 92, 178
Broadway Magazine, quotation from, 312
A Brooklyn Ferryboat, 206
Brooklyn Museum, costume collection given to, 51
The Brooks Post Office, Stratford, Conn., 293
Brown, Mrs Addison, 41
Brown, J. G., Portrait of E. L. Henry, N.A., 254
Brown, Peter P., 44, 90, 182; house, 40, 98; use as model, 44, 89
Bruynswick, old Dutch Church, 114; painting of, described, 333
[Bruynswick Church], 204
[A Buggy Ride], 92, 233

Burgoyne's Army on the March to Saratoga, September 1777, 93, 208
Business career, 313
[Buying a Fowl], 233
By the Lake, 241
By the Ocean, 241

Cahill, Holger, cited, 102; quoted, 82, 101
Calendars, use of Henry's paintings on, 61
The Call by the Way, 218
A Call on the Bride, 190
[Calling the Chickens], 234
The Campagna from Frascati, 27, 85, 151
A Canal Boat Entering a Lock, 93, 222
Canal in Venice, 28, 154
Canal Street, New York, 1830, 291
Canal studies, 46; list, 93, 97
Cannstadt in Wurtemburg, Juni 1861, 27, 85, 152
Capital and Labor, 28, 92, 96, 176
Career as artist, 56; span, 101
Carriages, collection of, 52
Catalog, 147–254; appendix, 291–94
Catalogs, early, of Henry prints, 59
Century Association, exhibition at, 81; gift to, 51; membership in, 53, 343; memorial from, 66, 344
Changing Horses, (1880), 175
Changing Horses, (1905), 94, 97, 216
Character, 55
A Chat after Meeting, 87, 161
Le Chemin de fer du New York, 27
Chew, Mr, 323
Childhood, 25, 311–14
The Childhood of Rapid Transit, 93, 201
[Children in a Graveyard], 111, 169
China Was the Passion of His Soul, 177
A Chip off the Old Block, 92, 204
Chopping Wood, 241
Chronology, 23
City Point, Oct. 1864, 86, 155
City Point, Virginia, Headquarters of General Grant, (1822–1885), 29, 47, 86, 112, 164; anecdote in connection with painting, 319

City Point, Va., Nov. 1864, (oil), 241

City Point, Va., Nov. 1864, (wash), 86, 156

Civil War, service in, sketches during, 87

Civil War sketches, 29, 85, 86; story of painting of General Grant's Headquarters, 319

[A Clean Sweep], 91, 188

The Clermont, Fulton's First Steamboat, 84, 94, 101, 213

The "Clermont" Making a Landing at Cornwall on the Hudson, 1810, 213; incidents in painting of, 338; reproductions, 61

Cleveland, Treadwell, poem, 104

Club memberships, 53, 343

The Coaching Party, 198

["A Cold Deceitful Thing Is the Snow"], 111, 160

Colico, Lake of Como, 85, 151

Collections, varieties of, 313

[Colonial Couple], 88, 168

Colonial Doorway, 242

Colonial Wedding, 294, 331; incidents of painting, 335

Coming from Church, 90, 97, 186

Coming from the Train, 95, 187

Coming Home from Church, 186

[Conference], 195

Contemporaries, list, 103

Contemporary critical opinion, 66, 116–24

Contrasts, 90, 226; comparison with photograph, 99; story of, 339

Corner Cupboard, 242

Corner of Ulster, 48

Correspondence, Cragsmoor people, 42; names appearing in, 48; showing economic pressure, 61; showing mode of life, 47

Cortissoz, Royal, review in New York Herald Tribune, 118

Costumes, collection of, 51

Country Back Yard, 242

The Country Carpenter, 38, 90, 191

A Country Doctor, 90, 182

Country Folks, 218

Country Landscape, 293

A Country Lane, 234

Country Lane, 294

A Country Lawyer, 38, 90, 199

Country Post Office, East Tennessee. 292

A Country Road, 242

A Country Romance, 178

Country Scene, 41, 95, 191

A Country School, 90, 191

The Country Stage, 190

The Country Store (oil on canvas), 42, 90, 95, 116, 181

The Country Store, (oil on wood), 204

A Country Tea Party, 234

Country Wedding, 294, 331

The County Fair, 90, 193

Courtship, 32

A Courtship: Time, 1817, 88, 166

Cowen, Sarah E., E. L. Henry, 254

Cragsmoor, beginning of colony, 37; building of home at, 38; development, 40; life in, 42, 328–30; portraits of residents, 90; summer colony, 45

Cragsmoor genre, list, 89–91

Cragsmoor Scene, 242

Criticisms, consensus, 116–24; contemporary, 66

Crossing the Bridge, 234

Crossing the Ferry, 93, 206

Crossing the Lines, 234

Crossing the Log-Bridge in a Freshet, 207

Curran, Charles C., evaluation by, 120; Portrait of E. L. Henry, N.A., 254

Daly, Judge Charles P., 36, 323; Judge Daly, 236

Dated works, list, 148–232

Dates, chronology, 23

[Day Dreams], 234

Death, 63; estate, 62; obituaries, 64

Dellenbaugh, F. S., 37

Dellenbaugh, Harriet Otis, 41

Departure for the Seat of War from Jersey City, 29, 86, 163

The Departure of the Bride, 191

The Departure of the Brighton Coach, 97, 174

Dickens, Charles, drawing of, 318
A Disturber of the Peace, 90, 92, 216
The Doctor, 87, 97, 166
The Doctor's Buggy, 292
[The Doctor's Call]; 167
The Doctor's Visit, 234
Documentation, 95; altering of details, 114; evaluation of, 121; use of photographs in, 98
[A Dog's Life], 92, 231
[Doing Her Chores], 222
Doorway, 242
Drawing, emphasis on, 314
Drawings, student, 85
Du Chaillu, Paul, 323
Dunbar, Page, quoted, 312

E. L. Henry's home at Cragsmoor, N. Y., 199
Early Autumn, 90, 218
Early life, 25–32
Early November, Ellenville, N. Y., 1905, 242
East Hampton, Long Island, sketches made at, 89
East Hampton Beach, 36, 89, 97, 176
Easthampton, L. I., 248
Economic pressure, 61
Education, 26, 314–18
Election Day (The Election of 1842), 94, 97, 226, 331; incidents of painting, 336
Ellenville, 37, 115; art exhibition at, 44; Delaware and Hudson Canal at, 46; portraits, 90, 122
Ellenville Dutch Reformed Church, 42
Elting, Dick, 98
English scenes, 88, 317
Entering the Lock, 93, 206
Entrance to Henry House, Cragsmoor, N. Y., 199
Environment, Post-Civil War period, 101–6
[The Erie Canal Completed], 234
Estate, inventory, 62
Esthetic considerations, 106–16
European study and travels, 27, 32, 35, 85, 314–18, 325
Evaluation of work, contemporary consensus, 116–24
Evans, Mrs Nancy, 200

Exhibitions, 26; Ellenville, 44; honors and awards at, 56

Facade of Cathedral Piacenza, Lombardy, 161
[A Family at Table], 234
Family Carriage, 249
[Family Party], 91, 100, 188
"Family virtues", as subjects, 103, 111
[The Family Wash], 234
Farm Scene in Pennsylvania, 84, 112, 150
[Feeding the Ducks], 170
Finances, economic pressure, 61; prices received, 57
The First Railway Train on the Mohawk and Hudson Road, 59, 66, 81, 84, 93, 101; catalog, 196, 198; description of work on, 330, 331; models for, 96; price, 57; Study for, 251
The Floating Bridge, 94, 95, 96, 100, 228; incidents in painting, 338
[Florida Landscape], 63, 232
The Flower Seller, 50, 90, 217
Flower Study, 242
Floyd, William, 88, 171
Food for Scandal, 83, 92, 219
Foot of East Broad Street, Stratford, Conn., 294
Forgotten, 58, 187
"Forgotten", 227
Les Fosses Communes, Cimitiere de St Owen, Paris, 94, 171
Four-in-Hand, Central Park, New York, 30, 87, 158
Four O'Clock Tea, 181
The Four Seasons, 41, 95, 99, 113, 226
Frances Livingston Wells (Henry), 168
Fred Thomas Alias Black Fred, 91, 183
French family, visit to, 325
From a Window, Newport, 30, 87, 106, 158
From an Observation Car, 242
From Sam's Point, 242
Fuller, Lucia Fairchild, quoted, 62
Fulton's First Steam Ferryboat, Running from Cortlandt Street to Paulus

Hook, Jersey City, 1813–14, 93, 97, 208

Gansevoort, General, statue of, 252
A Garden, 242
Garden at Henry's Home, 242
Garden Fence, 242
Garden in Warwick, 234
Garden Scene, 242
[Gathering Berries], 235
Gen. Fitzjohn Porter's Headquarters, James River, 86, 161
Genre paintings, 28, 84; Cragsmoor, list, 89–91; decline of, 110; evaluation of, 121; patronage for, 104; revival of interest in, 118
Genre themes, 83
Getting Out the Vote, 94, 97, 223
Getting Ready for Market, 200
The Ghost Room, St John's, 242
Gifts to collection, acknowledgment of, 18
[Going Hunting], 235
Going Out to Ride: New York, about 1796, 88, 168
Going to Market, 186
Going to Town, 235
The Golden Hour, 195
Good-By, Sweetheart, 207
"Good-Bye", 201
Goodbye, Sweetheart, 212
Goodrich, Lloyd, cited, 53, 101; quoted, 82, 103
Gordon, Robert, 320
Gossiping, 235
The Gossips, 220
Gossips, 235
The Governor Goes to the Farm, 291
Graeme Park, near Philadelphia, 88, 98, 163
The Grand Hall, Levens, Westmoreland, 53, 88, 157
Grant's Headquarters at City Point, see City Point, Virginia
Great Bend, Susquehanna, 26, 85, 148
The Great Horse Depot at Giesboro on the Potomac below Washington, 86, 155

The Halt at the Ferry, 175
Happy-Go-Lucky, 92, 292
A Hard Road to Travel, 44, 89, 177

A Hard Scrape, 179
Harnett, William M., 60
Hartshorn, Mrs Eliza, 45
Have You Heard the News?, 222
Henry, Edward Lamson, addresses, 68; birthplace, 25; career as artist, 56–63, 101; chronology, 23; Cragsmoor, life in, 37–47; education and early life, 25–32, 85, 314–18; honors and awards, 56; marriage and maturity, 32–36; maturity as painter, 101–6; method of work, 28, 36, 95–100; personality and interests, 47–56, 329, 341; photographs of, 30; portraits of, 254; sales and success, 30, 57; silhouette of, 252; subject matter, 83–95; death, 63; appreciations and evaluation of work, 64–67, 116–24
Henry, Frances L., biographical data, 32–36; portraits of, 168, 169, 174, 187, 244; silhouette of, 252; sketches by, 35, 254; sketches of, 35, 97
Henry, Frances L., A Memorial Sketch: E. L. Henry N.A. His Life and His Life Work, 311–46
Henry, H. C., letter from, 58
Henry Collection, contents, 15, 81; gifts to, 18; library in, 106
The Henry Home at Cragsmoor, 243. See also pages 199, 242
The Hicksite Quakeress, 166
Hilton, J. G. Myers, 57
Historic landmarks, interest in preservation of, 49, 324
Historic vehicles, sketches of, 52
Historical themes, 84; list, 88, 93
Hollyhocks, 243
Home, building of, 38; list of addresses, 68
"Home Again", (1899), 207
"Home Again", (1908), 221
Home from the Philippines, 207
Home from the War, 292; copyright, 59
The Home of the Squire, 182
Honeymoon abroad, 35
Honors, 56
Hoornbeek, Mrs Arthur V., 338
Horse, 243

Horse-car, traveling by, in south, 322
Horse Facing Left, 243
Horse Facing Right, 243
Horse Grazing, 243
Horse in Harness Facing Left, 243
Horse Looking over Fence, 243
Horse on Tow Path, 243
Horses, (oil on paper), 243
Horses, (oil on wood), 244
Horses, as subject matter, 92, 96
Horse's Head, 243
Horses Standing, 244
Horses with Buggy, 244
Horwitt, J. B., cited, 87
The Huckster, 90, 225
Humorous themes, list, 92; Negro themes as humor, 114

Icebergs off Banks of Newfoundland, 27, 85, 152
Impressionism, influence of, 113
In Amsterdam, 27, 85, 152
In Bella Firenze, 27, 28, 85, 151
In Doubt, 91, 189
In East Tennessee, 92, 218
In Elevated Train, 10 P.M., May 23, 1910, 249
In Sight of Home, 179
In Stuttgart, 27, 85, 152
In the Garden, 292
[In the Garden], 235
In the Old Stage Coach Days, 62, 94, 218
In the Roaring Forties, 96, 179
In the Rondout Valley, 198
[In the Valley], 42, 95, 235
Independence Hall, 88, 164
Independence Hall, restoration of, 324
Indian Encampment, 294
Indian Queen Inn, Bladensburg, Md., in 1795, 93, 206
[An Informal Call], 199
The Inn at Bladensburg, 94, 217
Interests, miscellaneous, 54
Interior, 235
Interior of an Old English Mansion, 170
Interior of Hope Lodge, 163
Interior of St John's, Warwick, England, 235
The Invalid, 111, 160

Isham, Samuel, quoted, 102, 116
The Italian Man-Of-War, Il re Galantuomo, 28, 154
Italian Scene, 28, 152
An Italian Vettura, 28, 153

Jack's Return, 235
The John Hancock House, 29, 48, 87, 157; documented by photograph, 98
John S. Billings, 178
Johnson, John Taylor, order from, 318
[Johnson Hall], 236
Johnson Hall, Johnstown, N. Y., 220
Joseph E. Mance, 38, 183
Judge Daly, 236

Kane, John, 61
Keeler, George G., 38
Kept in: a Study in a Country School, 187
King of the Montauks, 292
Kitchen of Frau Judas, 294
Klackner, C., cited, 53, 59
Klackner catalog, 59
Knight, Ridgeway, 326
Knox Homestead, 217
Knoxville, Tenn., 249
Kraft, Fred G., 39
Kulp, William, 49

A Ladies Reception at the Old Union League, Madison Square, 179
Lady Elizabeth Ferguson Sending a Letter to Gen. Joseph Reed of Revolutionary Memory, July 28, 1778, at Graeme Park near Philadelphia, 88, 100, 164
The Lafayette Coach, 52, 244
Lampton, W. J., quoted, 104
Landscapes, as subject matter, 94
Late Afternoon on the Old Delaware and Hudson Canal, at Port Ben, N. Y., 93, 198
The Latest Village Scandal, 89, 92, 181
Launch, Navy Yard, Brooklyn, 27
Lawyer's Office, 330
Learning the Trade, 46, 236

Leaving in the Early Morn in a Nor'easter, 94, 232

Letters, see Correspondence

Library, in Henry Collection, 106

Library at the Home of Wm Loring Andrews, 16 E. 38, 169

The Library of A. H. Ward, 163

The Library of Jonathan Thorne, 526 Fifth Avenue, 87, 88, 110, 160

Literature, taste in, 106

The Little Chicks, 169

Livorno, Lake Maggiore, 85, 151

London, visit to, 317

The Long Good-Bye, 236

Long Island, sketches made at, 89

A Lover of Old China, 189

Low, Will, evaluation expressed by, 65, 104, 111, 116

Luino, Lake Maggiore, 27, 85, 151

McCausland, Elizabeth, cited, 25, 37, 38, 40, 41, 44, 45, 46, 51, 52, 53, 58, 59, 62, 97, 98, 99, 106, 115, 120, 333

The MacNett Tavern, 94, 211

[The Mail Carrier], 158

The Mail Stage on the Mountain, 90, 187

[The Mail Stage Waiting for the Ferry], 213

Main Stairway, St John's, Warwick, 244

The Main Street, 181

Main Street, Easthampton, L. I., 95, 178

Main Street, Johnstown, 231

Main Street in Johnstown, N. Y., 1862, 94, 227

Mance, Joseph E., 38, 90, 122, 183

Mance family, 38

The Marauders: Sketched from a Window in Warwick, 236

The Market Place, Washington, 86, 155

Marketing Saturday Morning, 236

Marriage, 32–36

Marriage in the Olden Time, 292; price, 57

Martin Terwilliger, 182

Maturity, 32–36

Mauch Chunk, Pa., Sept. 1859, 26, 85, 149

[Maud Powell Plays the Violin], 92, 115, 212

Meditating Revenge, 92, 196

The Meeting of General Washington and Rochambeau, 88, 167

Meeting's Out, about 1849, 88, 178

Meissonier, emulation of, 108, 112, 326

Membership in organizations, 53, 343

Memorial Sketch, by Mrs Henry, 311–46

Memorials, 66

The Message, 292

Method of work, 28, 36, 95–100

[Miss Inness and Friend], 221

Miss X and Sister, 180

Mrs E. L. Henry, London, Oct. 1875, 35, 97

Mrs Frances L. Henry, 244

[Mrs Henry in a Buckboard], 187

Mrs Nancy Evans, 200

Mode of life, 47

Models, use of, 96, 99, 100

A Moment of Peril, 192

A Moment of Terror, 97, 292

The Monastery of St Maria del Sasso, 159

Moore, Mrs Blomfield H., letter from, 31

A Morning Call, 97, 217

[A Morning Call], 52, 236

Morning Call in 1800, 236

A Morning Call on Narragansett Bay, 206

A Morning in June, 222

Morning Prayers; a Study at a Poor Farmer's Home in Ulster Co., N. Y., 90, 201

Morse, Mrs John F., 40

"The Mountain", 37, 40

A Mountain Post Office, 90, 207

Mountain Rainbow, 244

A Mountain Road, 89, 176

The Mountain Stage, 89, 98, 177

Multiple originals, 60

Music, interest in, 36, 54

Myers, Jerome, quoted, 113

Napanoch, 46, 47

National Academy of Design, catalogs
 list Henry's addresses, 68; election
 to, 30; exhibitions at, 26, 56;
 memorial to Henry, 66, 344; politics
 in, 53
[Neapolitan Scene], 201
Near Harrison's Landing, Lower James
 River, 86, 155
Near Palestrina, Italy, 28, 154
Near the Brandywine, 60, 236
Negro Boy and Girl on Oxcart, 244
Negro Boys, 244
Negro Girl, 249
Negro Girl Holding Cat, 244
[Negro Girl Ringing Doorbell], 92,
 189
Negro Stableboy, 245
Negro themes, 91, 114; portrait of
 "Aunt Dot", 321
Negro Woman and Child, 245
Negro Woman in White, 245
Negro Woman with Hands on Hips,
 245
[Neighbors' Meeting], 236
Nelly Bloomer, 190
Neuhaus, Eugen, quoted, 119
The New Scholar, 90, 92, 192
The New Woman, 90, 92, 195
New York, life in, 31, 318, 323
A New York Regiment Leaving for
 the Front to Reenforce the Army of
 Gen. Grant. Scene, New Jersey,
 Railroad Terminal, 1864–5, 29, 86,
 159
"Newly Married", 35, 249
News of the Nomination, 90, 200
News of the War of 1812, 92, 94, 223
[News Office], 90, 92, 199
Newspaper clippings, evaluations of
 work, 64
The 9.45 A.M. Accommodation,
 Stratford, Connecticut, 84, 87, 103,
 112; catalog, 158; reproduction, 61
No. 217 E. 10th, N. Y., 165
Noon Time, 198
North Porch, Cathedral of Bergamo,
 164
November Days, 179
[Nurse and Two Children], 111, 166

Oberammergau, visit to, 327

Obituaries, 64
An October Day, 115, 208
Oddie, Walter M., painting by, 25
Off for the Races, 88, 170; in Paris
 Exposition, 107
Off the Main Road, 237; price, 58
Off to Europe, 26, 85, 151
Oils, dated, 148–232; miscellaneous
 sketches, 248; undated, 232–40
Old Church, 291
Old Church, near Limerick, Pa., 27
Old Church at Bruynswick, see Sunday
 Morning
The Old Clock on the Stairs, (1868),
 111, 160; story of painting of, 320
The Old Clock on the Stairs, (1917),
 59, 228
Old Clock on the Stairs, (oil on wood)
 245
Old Conestoga Wagon, 52, 249
Old Dutch Church, New York, 87, 162
Old Enemies, 237
The Old Forge, 90, 186
Old Grandfather, 237
The Old Grist Mill at Napanoch, 231
Old Hook Mill, East Hampton, 89, 95,
 176
[The Old Lock below Ellenville], 293
The Old Lydig House on the Bronx,
 near Fordham, 100, 184
Old Man Asleep in a Rocking Chair,
 245
Old Man at a Table, 245
Old New York, 293
The Old Paternal Home, 105, 111,
 167
Old Peter Brown of Cragsmoor, N. Y.:
 Taking, as He Called It "an Eye-
 Opener", 227
Old "Rockaway", 1845 to 60, 52,
 249
Old Stage Sleigh, 249
The Old Toll Gate, 186
The Old Trimble House, Chester Co.,
 Penn: Built in 1741, 175
Old Warwick, 237
The Old Westover Mansion, 29, 86,
 163
Old Woman in a Rocking Chair, 245
Old Woman Reading, 245
[Old Woman Reading], 111, 162

Old Woman Writing, 245
On Guard, 237
On the Beach, 97, 245
On the Beach: Waiting for the Bathers, 89, 97, 104, 174
[On the Canal], 237
On the James River, Va., 29, 86, 156
On the Lehigh, Penn., 1859, 26, 85, 148
"On the Lookout", 174
On the "Mountain", 245
On the Old Gully Road above Ellenville, 90, 193
On the Porch, 227
On the Rondout, 189
On the Susquehanna, 98, 150
On the Tow Path: 1, 249
On the Tow Path: 2, 250
On the Tow Path: 3, 250
On the Tow Path: 4, 250
On the Way Home, (1896), 201
On the Way Home, (water color), 237
On the Way to Town, (1890), 95, 192
On the Way to Town, (1907), 220
On Their Vacation, 218
One Hundred Years Ago, 185
One of the Bedrooms, St John's, 245
A One-Sided Bargain, (oil on canvas), 83, 90, 92, 208
One-Sided Bargain, (water color), 204
Orchard and House, (oil on canvas), 245
Orchard and House, (oil on wood), 246
Organizations, memberships in, 53, 343
Otis, Harriet, 37
"Our Lane", 211
Out in the Storm, 111, 227
Oxcart, 250
Oxcart and Oxen, 246

Paintings, most important, 330; reproductions, 59; sales of, 46, 57; use of sketches in, 96
Paris, social life in, 28, 36, 326; study in, 314
A Paris Diligence, 100, 171
A Parlor on Brooklyn Heights, 87, 88, 110, 165

Parton, Mr & Mrs Ernest, reception for, 102
A Passing Shower, 237
Passing the Outposts, (oil on canvas), 93, 209
Passing the Outposts, (water color), 206
The Passion Play, Oberammergau, 32, 165, 327
Patronage, 31; list of patrons, 30, 108; Post-Civil War period, 101–6
[A Pause], 187
The Peddler, (1917), 231
The Pedler, (1897), 92, 174
Pencil and pen and ink, sketches in, 248–51
Personality, 55, 329, 341
Peter Brown, 44, 182
Peter Brown Shaving, 182
Peter Brown Taking a Drink, 179
Peterson, Charles, 323
The Pets, 177
The Phaeton, 237
Philadelphia, restoration of Independence Hall, 324
Photographic reproductions, 60
Photographs, sources, 19; use, to document paintings, 98
Photography, interest in, 52
Picture sales, prices received, 57
The Pillory and Whipping Post, New Castle, Delaware, 39, 201
The Planet (Camden & Amboy R. R.), 237
Platinotype reproductions, 59, 60
Pleasant Memories, 237
Pomeroy, E. S., cited, 87
Popularity, as artist, 58; gradual decline in, 62
The Porch, 246
Porch Scene, Newport, R. I., 30, 87, 158
Porter, James A., cited, 91
A Portrait of Mrs E. L. Henry and the Two Black and Tans: on the Upper Hudson near Fort Miller, Summer of 1879, 174
Portrait of Mrs Henry, 169; sketches for, 35, 97
Portraiture, Ellenville and Cragsmoor subjects, 90

Post Civil War Period, 101- 6

Powell, Major J. W., 37, 115

Powell, Maude, 37, 92, 115, 212

Preparing Dinner, 178

A Presentation of Colors to the First Colored Regiment of New York by the Ladies of the City in Front of the Old Union League Club, Union Square, New York City in 1864, 29, 86, 162, 319

A Presentation of Medals by Sir William Johnson to the Tribesmen of the Six Nations Held at Johnson Hall A.D. 1770, 210

Prince of the Mohawk, 238

Prints, undated, list, 232–40; use of, 100

A Private View: A.D. 1905–1906, 56, 92, 217

Prussian Canal Boat, 27, 85, 152

A Quaker Visit, 173

A Quiet Corner by the Door, 111, 166

A Quiet Little Country Wedding, 190

The Races at Florence, Italy, 27, 28, 29, 156

Railroad pictures, first, 28

The Rainbow, 291

A Rainy Day, 292; price, 58

[*Ralph Mance as Messenger*], 200

Reading the Story of Bluebeard, 91, 175

Ready for the Post, 238

Reception Given to Lafayette (at the Chew House, Germantown, the Contested Point at the Battle of Germantown, Oct. 4th, 1778) by His Brethren of the Masonic Fraternity, Military and Other Organizations, and by the Townspeople, July 20th, 1825, 48, 88, 168, 323

References, bibliography, 363–67

The Relay, 92, 177

The Repast, 238

Reproductions, 59

Reputation, contemporary consensus, 116; gradual decline in, 62; revival of, 119

Residence at Poughkeepsie, 29, 87, 157

Residence of Capt. William Kidd, 1691, 94, 217

Residence of Dudley S. Gregory, 291

The Return from Journey, 238

Return from the Wars, 238

Returning Home, 238

Reverie, 174

[*Revolutionary Interior*], 163

[*Revolutionary Scene*], 88, 177

Rhododendron, painting by Frances Wells Henry, 35, 254

A River Landing, 232

The Road by the River, 221

Roadside Chat, 238

Robinson, Frank T., 66

"*Rockaway*", 1850 to 60, 52, 250

Roses at Cragsmoor, 246

Rotterdam, April '62, 27, 85, 152

Runabout 1835 to 1845, 52, 250

Russian Fleet at Anchor in the North River, 28, 87, 153

Sag Harbor, 246

St Erasme, Gaeta, Italy, 29, 157

St George's Chapel, Beekman and Cliff Street, New York, 87, 169

St John's, Warwick, 35

St John's Chapel, 94, 216

St John's Chapel, Varick Street, New York City, 1909, 293

St John's Church, Varick Street, New York: 1866, 49, 65, 87, 161, 324

St John's Park and Chapel, New York, 94, 214

St Maria Del Sasso, Lago Maggiore, 28, 153

St Mark's in the Bowery in the Early Forties, 94, 97, 111, 331, 339; catalog, 230

St Paul's Church, 1766, 87, 162

Sales, prices received, 57

Salmagundi Club, membership in, 53; speech at, 341

Sam's point, 37, 40, 41

Santa Spirito, Florence, Italy, 159

Sarah Akins Wells, 173

Saturday Morning, 292; price, 58

Scene along the Delaware and Hudson Canal, 93, 219

"School's Out:" below Cragsmoor, N. Y., 90, 91, 186

Sciaky, Leon, cited, 46

A September Afternoon, 207

[A Serious Talk], 221

Sharpening the Saw, 46, 90, 92, 121, 183

Shawangunk mountains, 37

Sheldon, G. W., quoted, 103

"Shongum Church", 114

Sir Wm Johnson Presenting Medals to the Indian Chiefs of the Six Nations at Johnstown, N. Y., 1772, 94, 209

A Sitting Room in Holland, 191

Sketch after Nature, September 30, 291

Sketchbooks, 251

Sketches, 26; Civil War, 85; dated, list, 148–232; Ellenville and Cragsmoor subjects, 90; European, 85; oil and water color, 243–50; pencil and pen and ink, 250–53; undated, list, 232–40; use of, 96

Smoky Mountains, N. C., 91, 188

[The Snowstorm], 111, 164

Social content, example of, 94

Social life, 47

Societies, membership in, 53, 343

Solitude, Coast Scene, 238

South, travels in, 321

[Southern Scene], 91, 100, 188

Souvenir de Lac Maggiore, 28, 154

Souvenir of a Trip to Nantucket, 158

Souvenirs of Long Ago, 174

Spring, 116, 211; frame for, 106

Springtime, 210

Stage Coach, 184

Stage from Brooklyn to East Hampton, 250

"Stage Waggon" of 1821, 52, 251

Stage Wagon: End View, 250

[Stagecoach Days], 232

Standards in art, esthetic considerations, 106–16; Post-Civil War period, 101–6

Station at Orange, N. J., 291

Station on "Morris and Essex Railroad," 28, 84, 86, 154

Statue of General Gansevoort, 252

Stenton, 94, 220

Stephens, Mrs Ann S., 319

Stonington, 246

A Stop at the Carpenter's, 221

[Stopping to Talk], 192

[Stopping to Water His Horses], 213

Stories in pictures, see Genre paintings

"A Stormy Afternoon", 207

Story, W. W., efforts for public support of art, 107

Story-telling pictures, patronage for, 104

Stove, 246

Strahan, Edward, cited, 105

Street in Naples, 246

Street Scene, Knoxville, Tenn., 91, 188

Street Scene in Naples, 28, 85, 154

Student years, 84, 86, 314–18

Studio life, 31, 318

Study for Alt Kirche, 246

Study for "The First Railway Train", 251

Study from Door at Fulham, London, 238

A Study in Black and Tans, 91, 173

A Study near Petersburg, Va., 292

Study of a Church, New York, 246

Studying Her Sunday School Lesson, 92, 192

Style, effects on, 111; visual sentimental image, 110

Subjects, 83–95; architecture, 48; Cragsmoor, 41; Ellenville people, 330; family virtues, 111; interests influencing, 27–29; photographs of, 46; selection and treatment, 113, 340; student years, 314

Success, 30, 57, 58

The Summer Boarders, 90, 176

A Summer Day, 192

A Summer Morning, 167

Sunday Morning (Old Church at Bruynswick), 47, 60, 93, 114, 331; catalog, 202; price, 57; reproduction, 59; time of painting, 98

Sunflowers, 246

Sunset, 246

Sunset at Cragsmoor, 246

A Sunset Painted from Nature at Cragsmoor, 1909, 293

Sunshine and Shadow, 111, 168

The Surprise, 238
The Surrender of New York to the English by Stuyvesant, 1664, 94, 210
[Swapping News], 192
The Sweetest Fruit, 92, 200

Taft, Robert, cited, 30, 37
Taking a Night Cap, (1874), 111, 167
Taking a Night Cap, (oil on paper), 246
Taking His Morning Eye-Opener, 181
Taking Life Easy, 90, 92, 222; comparison with photograph, 99
Talking Politics, 90, 207
A Temperance Preacher, 91, 96, 188, 321
Tenth Street Studio Building, 32, 87, 172
Tenth Street Studio Building, 31, 318; canvases painted at, 319
The Terrace at Haddon, 161
Terwilliger, Martin, 90, 182
Terwilliger, Mrs Nelson, 40, 63
Terwilliger Tavern, 221
Testing His Age, 90, 92, 97, 196
Thanksgiving Sleigh Ride, 90, 183
Thomas, Fred, 90, 122, 183
Thrashing Machine, 238
Time Is No Object, 208
[Toll Gate], 238
The Tow Path, 93, 97, 193
Toward Evening, 95, 192
Training abroad, 85
The Tramp, 92, 222
[The Tramp: 2], 231
Transportation themes, 27, 92
Traveling Coach, Italy, 28
Traveling South in the Thirties, 93, 179
Travels, 27; European, 325; in the South, 321
Tree in Pasture, 246
Two Trees, 247

Undated works, catalog, 232–40
An Unexpected Attack, 111, 164
Unexpected Visitors, 221
Uninvited Guests, 44, 89, 92, 179
Union League Club, 26th Street and

Madison Avenue, in the Old Gerome Mansion, 239
U. S. Sloop of War Lancaster, 27
[U. S. Transport on the Potomac], 86, 164
U. S. Transport on the Potomac below Washington: During the War, 1861–1865, 86, 156
The Uplands at Bow, 223

Vacation Days, 239
Vacation Time, 95, 187
Valentine, Edward, pencil drawing of, 27
Valentine, Messrs., 316
[Vehicle] about 1775, 251
[Vehicle] 1830 to 40, 251
Vehicles, as subject matter, 52, 92
A Vender of Simples, 91, 188
Una Via in Napoli /61, 27, 85, 151
Via Pallomette, Naples, after a Model from Nature, 28, 153
Via San Lucia, 28, 153
Village Gossips, 239
The Village Huckster, 223
Village Post Office, 95, 115, 116, 193
The Village Squire Entertaining the New Dominie, 200
A Village Street, (1886), 182
The Village Street, (1889), 189
The Village Street, (1895), 200
A Village Street, (1899), 95, 206
A Village Street, (1916), 227
A Village Street, (oil on canvas), 239
A Virginia Post Office, 92, 201
A Virginia Wedding, 92, 93, 113, 190, 331; incidents in painting of, 335
Visual sentimental image, style, 110; examples, 111
Vogue, 58; gradual decline in, 62

Waiting at the Ferry, (oil on wood), 247
Waiting at the Ferry, (pencil on paper), 92, 205
Waiting for the Ferry, 239
Waiting for the Ferry, (1896), 201
Waiting for the Ferryman, 205
Waiting for the Ferryman: Time, about 1844, 56, 93, 201

Waiting for the New York Boat at Stonington, Conn., the First Railroad from Stonington to Boston, 94, 99, 216
Waiting for the Stage, 239
Waiting for the Stage, (1917), 232
Waiting for the Stage, (oil on paper), 247
Waiting Up for Him, 239
The Waning of the Year, 181
War Sketches Oct. & Nov. 1864, 29, 85
The Warning, 29, 86, 159
Warwick, England, 170
Warwick from St John's Priory, 291
Water colors, dated, 148–232; undated, 232–40
[Watering the Horses], 210
The Watering Trough, (1884), 90, 181
The Watering Trough, (oil on canvas), 239
The Way Station, 89, 175
A Way Station on a Small Pennsylvania Railroad, 177
Wayside Gossip, 239
Wayside Rest, 220
A Wayside Well, 239
Weary Waiting, 239
The Wedding Day, 294
A Wedding in the Early Forties, 47, 97, 240
Wehle, Harry B., cited, 88
Weir, Robert W., quoted, 117
The Well, 247

Wells, Frances M., see Henry, Frances L.
Wells, Sarah Akins, 173
West Point from Prof. Weir's, 26, 85, 148
Westover, James River, 86, 156, 319
Westover, Va., 1863, 29, 86, 157
What Am Dat?, 91, 181
What Dat For?, 183
What Luck, 221
[What's That You Say?], 92, 216
White Friars, Coventry, 247
Whittredge, Worthington, In the Village of Brunnen, 254; cited, 82
The Widower, 112, 166
Wild Azalea Bush, 247
William Floyd, 88, 171
Woman at a Table, 247
Woman in a City Interior, 247
Woman in a Country Interior, 247
Woman in a Victorian Interior, 247
Woman in Blue, 247
Woman in White, 248
Woman in White with a Red Scarf, 248
Woman with a Basket, 248
Wood, Thomas Waterman, 54; letter from, 62
[Woodland Courtship], 240
Woodland Scene, 248
Woodpile, 85, 150
Woodruff, Mary M., 47

The Young Heir, 111, 166
[Young Merchants], 91, 189